A CULTURAL HISTORY
OF COLOR

VOLUME 2

A Cultural History of Color
General Editors: Carole P. Biggam and Kirsten Wolf

Volume 1
A Cultural History of Color in Antiquity
Edited by David Wharton

Volume 2
A Cultural History of Color in the Medieval Age
Edited by Carole P. Biggam and Kirsten Wolf

Volume 3
A Cultural History of Color in the Renaissance
Edited by Amy Buono and Sven Dupré

Volume 4
A Cultural History of Color in the Age of Enlightenment
Edited by Carole P. Biggam and Kirsten Wolf

Volume 5
A Cultural History of Color in the Age of Industry
Edited by Alexandra Loske

Volume 6
A Cultural History of Color in the Modern Age
Edited by Anders Steinvall and Sarah Street

A CULTURAL HISTORY OF COLOR

IN THE MEDIEVAL AGE

VOLUME 2

Edited by Carole P. Biggam and Kirsten Wolf

BLOOMSBURY ACADEMIC
LONDON • NEW YORK • OXFORD • NEW DELHI • SYDNEY

BLOOMSBURY ACADEMIC
Bloomsbury Publishing Plc
50 Bedford Square, London, WC1B 3DP, UK
1385 Broadway, New York, NY 10018, USA
29 Earlsfort Terrace, Dublin 2, Ireland

BLOOMSBURY, BLOOMSBURY ACADEMIC and the Diana logo are
trademarks of Bloomsbury Publishing Plc

First published in Great Britain 2021
Hardback edition reprinted 2023
Paperback edition published 2024

Series cover design by Raven Design
Cover image: *Les Tres Riches Heures du Duc de Berry,*
Limbourg Brothers 1412–1416 © Getty Images

ISBN: Pack, HB: 978-1-4742-7373-2
 Pack, PB: 978-1-3504-6035-5
 Volume, HB: 978-1-4742-7333-6
 Volume, PB: 978-1-3504-5994-6

Typeset by Integra Software Services Pvt. Ltd.
Printed and bound in Great Britain

To find out more about our authors and books visit www.bloomsbury.com
and sign up for our newsletters.

CONTENTS

ILLUSTRATIONS

PLATES

FIGURES

TABLES

SERIES PREFACE

A Cultural History of Color is a six-volume series examining the changing cultural understandings, interpretations, and utilizations of color throughout history. Each volume has the same structure and begins with a general overview of the major attitudes toward and uses of color in the historical period examined. The introduction is followed by contributions from experts, who investigate color under ten chapter headings that are identical in each of the volumes: philosophy and science; technology and trade; power and identity; religion and ritual; body and clothing; language and psychology; literature and the performing arts; art; architecture and interiors; and artifacts. Accordingly, the reader has the option of taking either a synchronic or a diachronic approach to the information provided. One volume can be read to gain a broad knowledge of color in a specific period or, alternatively, a theme or topic can be followed throughout history by reading the appropriate chapter in several volumes. The six volumes divide the history of color as follows:

Volume 1: A Cultural History of Color in Antiquity (*c.* 3000 BCE–500 CE)
Volume 2: A Cultural History of Color in the Medieval Age (500–1400)
Volume 3: A Cultural History of Color in the Renaissance (1400–1650)
Volume 4: A Cultural History of Color in the Age of Enlightenment (1650–1800)
Volume 5: A Cultural History of Color in the Age of Industry (1800–1920)
Volume 6: A Cultural History of Color in the Modern Age (1920–the present)

The general editors wish to dedicate the *Cultural History of Color* to the memory of their husbands who provided so much love and support: William Biggam (1944–2016) and Phillip Pulsiano (1955–2000).

General Editors, Carole P. Biggam and Kirsten Wolf

EDITORS' ACKNOWLEDGMENTS

The editors' principal acknowledgments and gratitude go, of course, to the chapter and section authors (in alphabetical order)—Wim Blockmans, Mark Cruse, Thomas Dale, Jo Kirby, Roman Krivko, Piera Molinelli, Eva Oledzka, Gale R. Owen-Crocker, Andreas Petzold, A. Mark Smith, and Leslie Webster. Their expert knowledge has made this volume a fascinating, informative, and highly readable work.

Both chapter authors and others kindly donated images, free of charge, and the editors would like to thank them wholeheartedly. They are properly acknowledged in the appropriate chapters: the Hamilton Kerr Institute of the University of Cambridge, Martin Harris, Jo Kirby, the Metropolitan Museum of New York, Eva Oledzka, and A. Mark Smith.

The editors also wish to thank Jean Gilmour Anderson, the former College of Arts Ethics Officer of the University of Glasgow, UK, who volunteered her time to check some of the copyright issues with regard to the images used in the volume; and Tristan Mueller-Vollmer, doctoral student in Scandinavian Studies at the University of Wisconsin–Madison, who helped us with many computer and formatting issues.

Finally, Tristan Palmer of Bloomsbury Publishing, who invited us to undertake this collaborative project, has been enormously helpful in many ways, always responding promptly to our queries during the process of putting this volume together, and helping us to identify experts in the various disciplines included in this work. We also appreciate the help of all those scholars who suggested potential contributors.

Introduction: Color across Medieval Europe

CAROLE P. BIGGAM AND KIRSTEN WOLF

This medieval volume covers the period from *c.* 500 to *c.* 1400. For much of Europe, the fifth century had marked a traumatic change from the centuries-old certainties of life within the Roman Empire. Roman administration had been breaking down for some time in the face of economic problems and barbarian incursions, and Rome itself was sacked in 410. Europe then entered the medieval period, which was, essentially, a long-drawn-out struggle between many powerful families and individuals to establish new ruling dynasties and to extend their territories while coping with internal strife and large migrations of peoples. By the end of the period, many of the new (and old) European states were about to emerge into the early modern world of nation-states and a cultural revolution.

Medieval Europe was, to modern eyes, a chaos of small states, wars and insurrections, and inefficient and often cruel rulers. And yet, this insecure and violent period produced some magnificent art, craftsmanship, and literary works. In this introductory chapter a selection of the European regions and their more colorful products are presented as a background to the detailed studies that follow.

For the majority of ordinary people in the Middle Ages, color consisted of the natural and everyday colors of nature: the blue sky, green grass, and the yellow of ripe cornfields dotted with the red of poppies and the blue of cornflowers. In much of northern Europe, colors were frequently muted by overcast skies and dark seas, but other parts of the continent were more familiar with bright sunshine and the shiny reflections off water and rocks. For most people in Europe, their closest connection with vibrant color occurred in church settings

where they were dazzled and overawed by costly vestments, precious metals, stained glass images, frescoes, and mosaics. Because the majority of people lived with only natural color, most of the magnificent artifacts described and illustrated in this introduction inevitably originated in religious or elite secular contexts.

The rich, not restricted to natural colors, could afford clothing dyed with expensive colorants and trimmed with colorful embroidery or even gold thread, and they could buy or commission jewelry glinting with semiprecious stones, glass, gold, or silver. They could also enjoy interiors decorated with tapestries and paint, while drinking from shiny vessels, often displaying exquisite craftsmanship. Color was used by such people to demonstrate to the world their wealth and power, as on banners and coats of arms, and in the much-admired shininess of weapons and armor.

SPAIN

Roman rule collapsed in the Iberian Peninsula in the fifth century and the region was then invaded by several Germanic peoples, such as the Alans, Suevi, Vandals, and Visigoths. The Visigoths achieved supremacy in the late sixth century but presided over a declining economy as the Roman villas and towns shrank in size with the reduction of imperial trade. Nonetheless, cultural and artistic achievement reached a high level at this period, mostly inspired by Christianity as the Germanic invaders adopted the language and religion of the old Roman province and intermarried with the existing inhabitants (Reilly 1993: 3–4).

Visigothic rule in Spain was challenged and superseded by the invasion, starting in 711, of Muslim newcomers of the Umayyad dynasty with an army of Arabs and Berbers. This began a period of three centuries during which the principal culture of Spain was Islamic, and the economy started a gradual recovery thanks to the establishment of a strong central government, the reorganization of agriculture, and the revival of Mediterranean trade. Muslim Spain was known as *al-Andalus*, and at its furthest extent, its border with Christian Asturias and León lay along the River Duero on the west, and on the east, even further north, bordering the constricted Christian kingdoms of Navarre, Aragon, and Catalonia. At this time, Spain received cultural, religious, and scientific influences from Islamic centers such as Damascus, Alexandria, and Baghdad. Christians in the Muslim region of Spain were known as *Mozarabs* (although this term is often applied to *all* Spanish Christians), and they retained Visigothic church architecture and the Latin language. A comparatively small Jewish population was also tolerated by the Muslim regime (Reilly 1993: 5–7). From the early eleventh century, the Islamic caliphate separated into several small kingdoms, and this allowed the Christian kings to accelerate their efforts

to regain lost territory. This process is known as the Reconquest or *Reconquista*, and it took place, notwithstanding the disunity of the Christians, from the eighth to the late fifteenth century. In spite of this long period of almost unceasing warfare, the cultural achievements of Spain in the Middle Ages, exhibiting Christian, Muslim, and Jewish influences, are varied and impressive.

A feature of the richest Visigothic artifacts is the mounting of colored stones and glass on metalwork of bronze, silver, or gold. One of the finest examples of this work is the votive Recceswinth Crown of the late seventh century, a part of the Guarrazar (Toledo) Treasure. It is a composite item made of gold, garnets, pearls, sapphires, and colored glass. The crown proper consists of openwork gold decorated with inset stones and glass of different sizes and colors. Below the crown are pendant gold letters spelling out the name of King Recceswinth (r.649–72). Below each letter is suspended a sapphire (López 1993: 55, 53–4).

Mozarabic monasticism produced many rich and colorful artifacts, especially illuminated manuscripts. The San Isidoro Bible (also called the León Bible) of the late tenth century contains several examples of stylized figures in a restricted palette of flat colors, as in *David Before the Ark of the Covenant*. The colors used are red, dark blue, dark green, and yellow, but this palette was extended in later works with up to six supplemental colors (Werckmeister 1993: 125–7).

The Islamic art of al-Andalus includes colorful pottery such as glazed and lusterware items and some rare textiles. Dated to the early twelfth century is the Burgo de Osma silk fragment, probably part of a shroud. It has a detailed and elaborate Near Eastern-inspired design that includes lions and harpies, griffins and kneeling men, roundels, floral motifs, and Kufic (a type of Arabic script) inscriptions. The richly detailed design is worked in red, pale brown, dark green, and yellow (Jenkins 1993: 108–9, no. 60).

Commencing in the eleventh century, a style of architecture and art that was later called *Romanesque* developed and spread across Europe. In Spain, this involved increasing stylistic influence from France and a reduction in the dominance of Mozarabic and Islamic styles. The Kingdom of León was an early adopter of the Romanesque style, especially noteworthy in the sculpture and manuscripts of the monastery of Sahagún. A late eleventh-century *Commentary on the Apocalyse* by Beatus of Liébana, made at Sahagún, is a very early example of the style and includes some stunningly colored illustrations such as *Saint John's Vision of Christ*, which features a vivid red background to the seated Christ (Werckmeister 1993: 158, no. 82).

Late Romanesque art flourished in Spain in the twelfth and early thirteenth centuries, producing elegant figure-sculpture and splendid church buildings. Surviving color from this period includes the extensive wall paintings of the mid-twelfth century from the Hermitage of San Baudelio de Berlanga, in Soria (some now located in the USA). The frescoes consist of two cycles, one depicting the life of Christ and another with secular scenes such as hunting. The

human figures in the christological cycle are somewhat stiff, but also solid and powerful, and depicted in bold colors. Scenes such as the *Raising of Lazarus* and the *Last Supper* demonstrate a wide range of colors, both dark and pale, with shaded folds on the drapery and greenish modeling on the faces (Simon 1993: 223–8).

SICILY

After the sack of Rome in 410 and the break-up of the Western Roman Empire, Sicily was conquered by Germanic peoples: firstly, the Vandals in the mid-fifth century, and in the late fifth century, the Ostrogoths. The western and eastern (Byzantine) parts of the Roman Empire had been separately administered since 395 but, under the eastern Emperor Justinian (r.527–65), there were attempts to reconquer crucial parts of the west, such as Italy, and to place them under eastern rule. As part of this plan, the Byzantine general, Belisarius, conquered Sicily from the Ostrogoths in 535, and the predominant culture of the island remained Byzantine until the early ninth century (Gärtner and Schliebitz 1993: 28).

Following earlier attempts, a lengthy and fiercely fought conquest of Sicily by Arab invaders began in 827, and the Emirate of Sicily was later established. By the late tenth century, Muslim rulers were in complete control, and large numbers of Arabs settled on the island. As elsewhere, Christianity and Judaism were tolerated, so Sicilian culture developed into a rich mixture of, in particular, Greek Christian and Arab Muslim (Gärtner and Schliebitz 1993: 28–9).

In the eleventh century, however, a third ethnic group arrived in Sicily: Norman invaders bringing Latin Christianity. The first Norman count of Sicily, Roger I (r.1071–1101), having already conquered Calabria (the "toe" of Italy), completed his conquest of Sicily and Malta in 1091. His son, Roger II, eventually became King of Sicily in 1130, a kingdom that included Norman territory in Italy extending as far north as the Papal States. The Norman rulers presided over a vibrant and flourishing culture based on three languages and three religions: Greek and Latin Christianity and Arabic Islam. Splendid churches, mosques, and palaces were built, and Palermo became a great trading center (Gärtner and Schliebitz 1993: 29–30).

Following various succession difficulties, the Norman dynasty was replaced by the Hohenstaufen (German) dynasty in 1194, but the throne was seized by Charles I of Anjou in 1266. There was a major revolt (known as the "Sicilian Vespers") in 1282 when the French elite was massacred, and this resulted in Spanish rulers from Aragon taking power. In common with much of Europe, Sicily suffered economic disasters and a visitation from the Black Death in the fourteenth century. After the collapse of central authority in 1377 and the resulting civil wars, Sicily lost its independence in 1412 when it became a province of Aragon (Gärtner and Schliebitz 1993: 30–2).

The greatest artistic achievements of Sicily are demonstrated in its mosaics, particularly those of the period of Norman rule. The Cathedral of Monreale, founded in 1172 in the reign of King William II, was adorned with numerous vividly colored mosaics in a principally Byzantine style worked by Greek and local artists. The walls of the nave, side-aisles, transepts, and apse are completely covered with large-scale, high-quality scenes from both the Old and New Testaments, as well as two images of King William. Arguably the most stunning image is that of the huge Christ Pantocrator ("All-Powerful") high up in the apse of the choir (Figure 0.1).

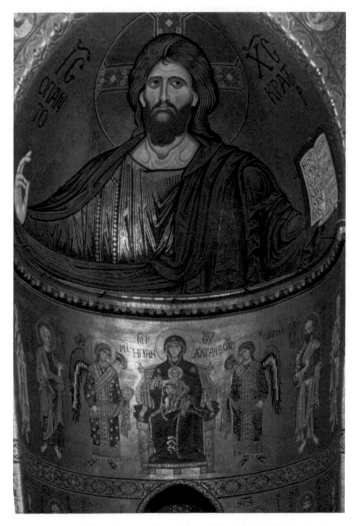

FIGURE 0.1 Mosaic of Christ Pantocrator, Monreale Cathedral, Sicily, late twelfth century. Photograph by Santi Visalli. Courtesy of Getty Images.

The multicolored scenes are set against golden backgrounds that reflect light and amaze modern visitors—how much more would medieval visitors be overawed (Schirò 1992)? But these artistic achievements are not restricted to one building: equally stunning mosaics of similar date can be seen in, for example, the Palatine Chapel in Palermo and the Cathedral of Cefalù.

Sicilian manuscript painting is known principally from the School of Messina, with images in the Byzantine style, perhaps directly influenced by mosaic art. An excellent example of Messina illustration is a sacramentary of the late twelfth century with illuminated initials (Madrid, Biblioteca Nacional, MS 52), a decorated calendar, and full-page illustrations such as *The Virgin and Child* (fol. 80r). The Virgin wears a gown of a rich dark blue, and an outer garment of purple. Her footstool and cushion are both a vibrant red (Wixom 1997: 479–81, no. 316 by Rebecca W. Corrie).

Somewhat later, dating to *c.* 1300, are some cuttings from a Sicilian book of Old Testament prophets with strong late Byzantine influences (Los Angeles, J. Paul Getty Museum, MS 35). *The Vision of Zechariah* (leaf 2) is predominantly pale blue, brownish red, and gray, with areas of gold. It depicts Zechariah's first vision, showing an angel explaining to him that a man seen mounting one of three horses is to travel throughout the world and report any signs of unrest (see J. Paul Getty Museum n.d.).

The textile arts of Sicily were also of a high quality, as instanced by the cloak of King Roger II, dated to 1133 (see Plate 2.4). Another superb survival is the alb of William II, created in Palermo in 1181. This royal outer garment is made of white silk with large areas of embroidery, including gold wire, applied pearls, and precious colored stones such as sapphires, emeralds, and garnets (see Historical Needlework Resources n.d.).

Another genre used to display colorful art in medieval Sicily was painting on wood, particularly on ceilings. A superb example is the huge ceiling of the Sala Magna ("Great Hall") in the Palazzo Chiaramonte, Palermo (also known as the Palazzo Steri). It is a late fourteenth-century work of three known Sicilian artists: Cecco di Naro, Simone da Corleone, and Pellegrino Darenu da Palermo. The ceiling of the hall is entirely covered with polychrome paintings of biblical, mythological, and historical scenes, as well as floral and geometrical designs, and even some coats of arms (Bologna 1975).

BYZANTIUM

The eastern part of the former Roman Empire had been administered separately from the west since 395, and the attempts of the eastern Emperor Justinian I (r.527–65) to extend his empire in the west were mostly unsuccessful, except for the north African coast. The city of Constantinople (the former Byzantium), protected by massive defences, managed to hold its own against the Persians and

various barbarian peoples, and increased steadily in size and wealth during the sixth century (Mango 2008: 26). In the next century, however, Constantinople lost control of most of the Near East to the Persians and then the Arabs, leaving a Byzantine Empire consisting of most of present-day Turkey, Sicily, and relatively small parts of the Balkans, Greece, Italy, and North Africa. In spite of a year's siege, in 717–18, by the Arabs, Constantinople remained secure behind its walls and maintained a semblance of civilized life, such as a currency and taxation system, while other towns in its empire shrank or disappeared (Mango 2008: 27–8).

Emperor Leo III (r.717–41), believing the Byzantine Empire was being punished by God for idolatry, banned the manufacture of images of Christ and the saints, which had a serious effect on religious art. In the ninth century, this was followed by a new conservatism according to which the "correct" forms of language and education were considered to be those of Christian late antiquity of two centuries earlier. This involved the copying of many ancient texts that would otherwise have been lost. The empire succeeded in converting the Bulgarians and Serbs to Christianity, but it also began to suffer attacks from Russian Vikings, which continued into the tenth and eleventh centuries (Mango 2008: 28–31).

The eleventh century was, nonetheless, a period of progress. The Balkan peninsula came once again under Byzantine control, and the economy improved as a result of increased Mediterranean trade and the rise of manufacturing. However, toward the end of the century, the empire lost Asia Minor (present-day Turkey) to the Seljuk Turks and Turcomans, while the Normans encroached on Byzantine territory in Italy and Greece. In the twelfth century, parts of the weakened empire, such as Bulgaria and Serbia, broke away, and western powers such as the Norman kings, German emperors, and the Republic of Venice actively worked toward suppressing the eastern empire. In 1204, Constantinople was sacked by crusaders, and its empire became fragmented, various parts being seized by the Venetians, French, and Greeks. The city experienced a revival under Michael VIII Palaiologos in the late thirteenth century but it could not survive civil war and the expanding Ottoman Empire (Mango 2008: 31–3). It was finally captured by the Ottomans in 1453.

Byzantine art had a major influence across medieval Europe, but the selected items discussed here are specifically products of Constantinople (or judged to be so). The first item is a manuscript Psalter of the mid-ninth century, usually known as the Khludov Psalter (Moscow, State Historical Museum, MS GIM 86795 Khlud. 129-d). It contains numerous colorful images that illustrate, and sometimes comment on, the psalms (Maguire 2008: 101–2, no. 50; also 390, by Robin Cormack).

From the tenth century, there are some wall tiles made from a white ceramic base with illustrations created by means of colored glazes with a transparent

glaze over all. Two of the tiles depict the faces and upper bodies of St. Nicholas and St. Arethas against a rich brown background bearing their names in Greek. Nicholas is clothed mostly in white but Arethas has a dark blue cloak, and both tiles include a border and some other touches in dark green. The colors are subdued rather than vivid but, nonetheless, present an eye-catching result (James 2008: 240–1, nos. 213–14; also 433–4, by Georgi R. Parpulov).

An item that shows the combination of different materials and skills is the Chalice of the Patriarchs, dated to the tenth or early eleventh century. The cup of the chalice is made of dark red sardonyx flecked with white, while the foot and cup-decoration consists of silver-gilt, gold cloisonné enamel (enamel set in gold cells), pearls, and various precious stones. The overall impression is one of startling colors and multiple reflections (Cutler 2008: 137, no. 81, also 402, by Maria da Villa Urbani).

Showing expertise in yet another material is a micromosaic icon of St. Theodore, dated to the early fourteenth century. This richly colorful item has been made of small mosaic pieces (*tesserae*) cut from marble, jasper, lapis lazuli, and other materials, composed on a wooden base. The saint's face is made from marble tesserae, and gilded copper has been used for the background and various detailing on his garments. The dark reds and blues of Theodore's clothes, shield, and halo contrast superbly with his white face and the reflective metallic background (Chatzidakis 2008: 254–5, no. 224; also 436, by Yuri A. Pyatnitsky).

SCANDINAVIA

Little is known about the Scandinavian countries (Denmark, Norway, and Sweden) in the early Middle Ages. There were no unified kingdoms, and the area was inhabited largely by Germanic tribes engaged in agriculture, fishing, and hunting. Archaeological finds, such as coins, metalwork, and glass, however, testify to contact with the culture of the Roman Empire. In Sweden, the period from *c*. 550 to *c*. 800 is known as the Vendel period. It takes its name from the well-preserved inhumation graves at Vendel in Uppland, which, along with those at other sites such as Valsgärde, contained remarkable treasures such as helmets, swords, shield-fittings, drinking horns, bone combs, and even textiles. This was a wealthy and skillful society (Lamm and Nordström 1983).

It was, however, the Viking age (*c*. 800 to *c*. 1100) that made the Scandinavians famous. The reasons for the aggressive expansion characteristic of this period are not fully understood, but over-population, internal dissension, social differences, foreign pressure, climatic disasters, and mercantile conditions have all been advanced as possible explanations (Brøndsted 1965: 24–6). During the three centuries that comprise the Viking age, the three Scandinavian kingdoms were established; Christianity was gradually introduced; and engineers and

shipbuilders refined their technologies, resulting in the construction of advanced fortresses, ramparts, bridges, and exceptionally seaworthy ships (Bill 2008).

Their shipbuilding skills resulted in Viking-age Scandinavians making extensive travels as marauders, traders, and colonists. In the east, they thrust down the rivers of Russia to the Caspian and Black Seas and the city of Constantinople. In the west, they easily reached Britain and Ireland, sailed along the Atlantic coast to Arab Spain and, through the Straits of Gibraltar, into the Mediterranean. They also reached out across unknown waters to the Faroe Islands, Iceland, Greenland, and North America, where they settled. The Norse settlement in Greenland lasted only about five hundred years, and their attempts to settle in North America (for example, at L'Anse-aux-Meadows, Newfoundland) were abortive due to clashes with First Nation peoples (Wallace 2008), but in the Faroe Islands and Iceland their settlements took permanent hold.

By the end of the Viking age, most Scandinavians had converted to Christianity, and the kingdoms of Denmark and Norway had been established. However, this was not a period of stability: in Denmark, peasants and nobles rebelled against the tithes imposed on them to fund monasteries and churches; in Norway, civil war broke out over the succession; and Sweden, where paganism lingered, remained an area of more or less self-governing provinces.

A more prosperous and stable period then ensued. In Denmark, King Valdemar the Great (reigned over all Denmark, 1157–82) managed to regain control of the kingdom and even attempted to expand it, notably in present-day Estonia. Sweden was finally united under King Sverker I (r.1134–55), and Norway enjoyed a period of peace and increased trade. In the fourteenth century, the Hanseatic League, a commercial confederation of merchant guilds and market towns founded in north Germany, took control of Norwegian trade and established an important center in Bergen. In 1380, the Norwegian King Olaf Håkonsson (r.1380–7) inherited both the Norwegian and Danish thrones, and in 1397, under the Danish Queen Margrete I (r.1387–1412), King Olaf's mother, the Kalmar Union was created between the three Scandinavian countries, which lasted, with some interruptions, until 1523.

Scandinavians produced magnificent examples of art and craftwork, of which many metalwork items survive. The Vendel-period burials at Valsgärde, Sweden, include a seventh-century helmet from Grave 7, which, among other decorations, has a nasal ridge and eyebrows in gold decorated with garnets in various shades of red. The nasal ridge, a continuation of the crest of the helmet, is in the form of an animal (or human?) with garnet eyes and a long body consisting of garnets set into gold cells. Similarly, the golden eyebrows, with curled animal terminals, are set with cut garnets (Arwidsson 1977: 21–33).

One of the most distinctive Scandinavian artifact types is the runestone, several of which have pictorial decoration in addition to runic script. They

illustrate the changing art styles of the Viking age, such as Jelling, Ringerike, and Urnes, which have different motifs but which are all based on contorted and interlaced animal bodies (Wilson 2008). The majority of the carved stones date to the Viking age, and around three thousand of them dot the landscape of, especially, Sweden. It is known that color was originally used on the stones, as this is often declared, for example, on a rune stone in Södermanland in Sweden that bears the inscription: "Ásbjörn carved and Úlfr painted" (Brate and Wessén 1924–36: 337–8). On occasion, the original colors have been preserved, particularly where runestones were used as construction material in buildings shortly after they had been carved and painted, as in the case of some stones at Köping Church on the Swedish island of Öland, which have traces of red and black paint, derived from red lead and soot (Graham-Campbell 2013: 149). Other colorants used were red ochre, which was especially common, calcium carbonate (white), and other earth colors (see Plate 0.1). According to Harrison and Svensson (2007: 208), the Scandinavians also imported white lead, green malachite, and blue azurite for use on runestones.

Another medium for works of art was used principally in Iceland, a land that offered little in terms of wood or suitable stone for carving. Icelanders came to excel as verbal artists and, from the end of the twelfth to the fifteenth century, recorded their famous poems and sagas on vellum. Among these manuscripts are masterpieces in which texts are accompanied by beautiful illustrations in color. The most richly illuminated manuscript is *Skarðsbók* (The Book of Skarð), an Icelandic work dated to 1363 (Reykjavík, Stofnun Árna Magnússonar, AM 350 fol.). It has many large initials containing various scenes and figures in the Romanesque style (Jónas Kristjánsson 1980: 43, 64, 86–7). A 1993 study identified six colorants: vermilion (red), orpiment (yellow), realgar (yellowish or reddish orange), red ochre, azurite (blue), and bone white. Some shades of blue-green and blue were not conclusively identified, but they seem to be mixtures containing verdigris. The raw materials for the colors are not found naturally in Iceland and were clearly imported pigments (Soffía Guðný Guðmundsdóttir and Laufey Guðnadóttir 2015: 218).

ENGLAND

As the fifth century opened, the land that was later to be known as England was part of *Britannia*, a province (known as a *diocese* at this time) of the Roman Empire. Britannia was inhabited by Celtic peoples and settlers from across the empire, with the languages of Latin and Brittonic Celtic predominating. All aspects of social, administrative, and cultural life were heavily influenced by the provincial Roman norms, but only a few decades later, the centuries-old Roman province was no more, and a new culture and language were gaining ground.

Around 410 CE, Britain ceased to belong to the empire. Rome had problems with Germanic incursions on the Continent and was unable and unwilling to finance the defence of Britain from Irish and Germanic raiders. Members of several Germanic tribes, including Angles, Saxons, and Jutes, increasingly settled in the lowland areas of Britain and thus laid the foundations of England ("land of the Angles"). Relations with the Britons ranged, in various places, from hostility to mutual tolerance, but the material culture of this early period in England, seen especially in the metalwork and pottery found in burials, has clear links with north Germany and Scandinavia. Archaeology demonstrates the spread of occupation, and the creation of villages and "statelets" (small independent areas), which throughout the sixth century gradually amalgamated to establish the beginnings of the Anglo-Saxon kingdoms of Wessex, Essex, Northumbria, East Anglia, Kent, and Mercia (Campbell 1982).

In 597, Christian missionaries sent by Pope Gregory the Great arrived in Kent and began the process of conversion, which introduced the English to books, Latin learning, manuscript art, sculpture, and southern European art styles. Northumbria enjoyed a golden age in the late seventh and early eighth centuries, when its famous monasteries, such as Monkwearmouth, Jarrow, and Lindisfarne, produced magnificent artworks, and its scholars, such as the Venerable Bede (672/3–735), gained a reputation for learning throughout Europe (Wormald 1982a). This impressive period was brought to an end by Scandinavian raids and invasions, starting with an attack on the island monastery of Lindisfarne in 793. Raids from Denmark were soon followed by wholesale conquest and settlement, resulting in the fall of all the Anglo-Saxon kingdoms except Wessex, which, especially under King Alfred the Great (r.871–99), halted the Danish advance and concluded a treaty with them (Wormald 1982b).

In the tenth century, Alfred's daughter, Æthelflæd of Mercia (c. 870–918), and his son, King Edward the Elder (r.899–924), fought a successful war to regain control over the Danish-settled areas of England, although further Scandinavian incursions in the early eleventh century resulted in the accession to the English throne of Cnut (also spelt *Canute*) in 1016 (Keynes 2018). The old royal line of Wessex was restored in the person of King Edward the Confessor (r.1042–66) whose death resulted in a power struggle between King Harold II of England, King Harald Hardrada of Norway, and the victor at the Battle of Hastings (1066), Duke William of Normandy (Williams 2014).

Culturally, Norman England turned away from the influence of northern Europe and looked more toward France and the south. The use of Old English in administrative documents was replaced by Latin and the new influential language of French. A number of powerful aristocrats fought over lands and positions in both England and Normandy, and attempted to control the monarch's power with the signing of Magna Carta in 1215 (Chibnall 1993). However, this did not stop various uprisings and skirmishes with and between

the barons until the accession of a strong king, Edward I (r.1272–1307). After Edward's death, more unrest and instability followed until the mid- to late fourteenth century saw the triple blows of the so-called "Hundred Years War" with France; the terrible Black Death, which struck in England in the 1340s; and the Peasants' Revolt of 1381.

The Anglo-Saxons excelled in metalwork, and some of the earliest and most colorful examples are the polychrome composite disc brooches of Kent. Accompanying a change in fashion in the seventh century, wealthy women in Kent began to wear large and complex round brooches, and the fashion soon spread to other parts of England. A spectacular example is the Kingston Brooch, which is made of gold and decorated in the cloisonné technique and with filigree in concentric circles around a central boss. The materials used in the Kingston brooch are blue glass, white shell, and red garnets, separated by panels of gold filigree, creating a dazzling pattern of shiny gold and contrasting hues (Webster and Backhouse 1991: 50–1).

The conversion of the Anglo-Saxons to Christianity produced an amazing flowering of the arts, especially in manuscript illumination. The dominant style, today known as "Hiberno-Saxon," was influenced by Irish curvilinear designs, Germanic interlaced animal bodies, and the figural styles of southern Europe. Surviving manuscripts show that English artists (or artists living in England) were experts, both technically and artistically, in such work. Probably the most famous manuscript from the so-called "Golden Age of Northumbria" is *The Lindisfarne Gospels*, probably created between 710 and 721 (London, British Library, Cotton MS Nero D.iv). The full-page illustrations are particularly impressive and include giant initials with decorated words at the beginning of each gospel, as well as astonishingly complex full-page designs based on the motif of the cross, which are known as "carpet pages" (Figure 0.2).

Analysis of the pigments has shown that yellow was derived from orpiment (trisulfide of arsenic), red and orange were from toasted lead, green was verdigris (formed from copper suspended over vinegar), white was chalk or crushed shell, and black was carbon. Beaten egg white was used as a fixative with each color (Brown 2011: 143–8).

The Romanesque style flourished in England during the twelfth century, producing artwork in various media with graceful and boldly colored human figures. The period is famous for illustrated bibles, such as the Lambeth Bible, the Winchester Bible, and the Bury Bible, the last produced at Bury St. Edmunds Abbey in *c.* 1135 (Cambridge, Corpus Christi College, MS 2). It is believed to be the work of Master Hugo, a revered painter and metalworker. The strong colors include royal blue, magenta, vivid red, purple, and green (Kauffmann 1984: 108).

In the fourteenth century, English embroidery enjoyed a high reputation throughout Europe. Known as *opus anglicanum* (English work), it depicted

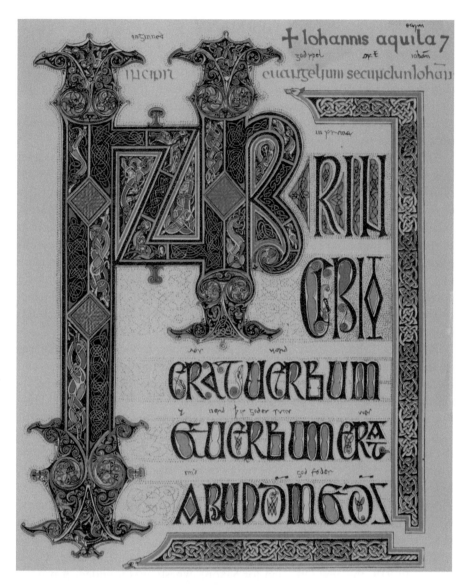

FIGURE 0.2 *The Lindisfarne Gospels* (Northumbria, *c.* 710–21 CE), carpet page of St. John's Gospel. London, British Library, Cotton MS Nero D.iv, fol. 210v. Photograph by Bettmann. Courtesy of Getty Images.

religious scenes on ecclesiastical garments and altar coverings. A superb example is the Bologna Cope, an ecclesiastical vestment made in England between 1310 and 1320, with the linen base covered in silver-gilt thread and colored silks depicting scenes from the life of Christ, and also the martyrdom of St. Thomas Becket (Browne and Zöschg 2016: 176–9).

GERMANY

As the Roman Empire began to fail, many Germanic peoples, such as the Visigoths, Ostrogoths, Vandals, Burgundians, Lombards, Saxons, and Franks, migrated to new territories, often within the borders of the empire. During and after the long decline of Roman power in the fourth and fifth centuries, many of the tribes established kingdoms that fought each other and/or merged into tribal federations.

The Franks were particularly successful. King Clovis I (r.481–511) managed to unite all the Frankish tribes and establish the Merovingian dynasty, which ruled what was to become present-day France and much of present-day Germany. After his death, the Frankish kingdom was divided between his sons, and Theuderic I (r.511–33/34) inherited the "German" part of Francia known as *Austrasia* (James 1988: 78–129). The next few centuries saw numerous power struggles, culminating in the reduction of the Merovingian kings to mere puppets of the Austrasian mayors of the palace, such as Charles Martel (in power, 718–41). The last Merovingian was deposed in 750, and the Carolingian dynasty commenced with Pippin (or Pepin) III (King of the Franks, 751–68) (James 1982: 145–55).

Pippin's son was Charlemagne (King of the Franks, 768–814, and "Emperor of the Romans" from 800), who managed to consolidate his power and considerably expand his territory. His imperial title implied that his authority descended from that of the ancient Roman emperors, and the title "Holy Roman Emperor" is often used of any German ruler who was crowned emperor by a pope although this exact title was not used in contemporary records until the thirteenth century. Charlemagne's son and heir Louis the Pious (emperor from 813) struggled to keep his enormous empire together and, after his death, Francia was again divided, by the Treaty of Verdun (843), between his three sons (Nelson 1994: 71). East Francia (the predecessor of present-day Germany) went to Louis "the German" (r.843–76), but the tripartite division between the brothers was disputed and civil war ensued.

With the election of Henry the Fowler, Duke of Saxony, as king of East Francia in 919, the new Ottonian (or Saxon) dynasty was founded. A process of consolidation began, especially under his son and successor Otto I (king of Germany, 936–73, and emperor from 962) who by his victorious campaigns established the German *Reich*. The Ottonian dynasty gave way to the Salian dynasty in 1024 with the accession of Conrad II (king of Germany, 1024–39, and emperor from 1027).

In the late eleventh and early twelfth centuries, the so-called Investiture Controversy, over whether the pope or secular rulers should fill church appointments, was a major cause of civil war in Germany (Leyser 1983). This unedifying period was brought to a temporary end with the Concordat of Worms

(1122) whereby a distinction was made between the conferring of secular and sacred authority. The Hohenstaufen dynasty came to power in 1138, followed by the long-lived Hapsburg dynasty in 1273. The fourteenth century was a time of disaster for Germany and much of Europe. In addition to almost endemic warfare, the Black Death killed a third or more of the population, and the Western Schism (1378–1417) was a period in which there were two, or even three, rival popes, causing a destabilizing loss of respect for the church.

Charlemagne promoted literacy and eagerly encouraged education, making his court at Aachen in North Rhine–Westphalia a magnet for international scholars. Under Charlemagne and succeeding rulers, it is recorded that skillful works of art were produced in the form of mosaics, metalwork, frescoes, and ivory carving, but few of these survive in Germany or elsewhere. The principal surviving art form of the Carolingian period is manuscript painting, the best extant representative medium of the so-called "Carolingian Renaissance." Charlemagne's court was probably the earliest center of Carolingian manuscript painting, and seven complete manuscripts are extant from what is now known as the *Ada School*. One of the finest is the *Ada Gospels* (Trier, Stadtbibliothek, MS 22) of the late eighth or early ninth century, with highly decorated great initials, full-page illustrations, and generous use of gold and silver. The portraits of the Evangelists are full of color with various shades of red, purple, blue, green, yellow, and brown (Dodwell 1993: 52–6).

Under Otto I's and his successors' rule, which is now referred to as the "Ottonian" period, a further cultural flowering of the visual arts began. The best documented art from this period is, once again, illuminated manuscripts. A particularly exquisite example is the *Gospel Book of Otto III* (Munich, Bayerische Stattsbibliothek, Clm 4453), dated to 998–1001, and believed to be the work of the abbey at Reichenau. A famous illustration shows a queue of four women of different complexions and hair colors bringing tribute to Otto. They are personifications of the areas ruled by the emperor: Sclavinia (the Slavic lands), dressed in purple and pale blue; Germania in green and blue; Gallia in red and pale blue; and Roma in orange and blue (Mayr-Harting 1999: 157–78).

One magnificent surviving example of Ottonian metalwork is the *ambo* (a predecessor of the pulpit) found in the Palatine Chapel (now the Cathedral) in Aachen. It was built by Emperor Henry II between 1002 and 1014, and is now partly restored. It consists of a wooden base covered with gilded copper and is decorated with fifteen panels containing ivory carvings of the four Evangelists as well as martial and mythological scenes. The panels are surrounded by colorful inset stones, rock crystal, and enamels (Garrison 2012: 88).

Another important survival is the earliest stained glass on the south side of the nave in Augsburg Cathedral. The windows are variously dated from the late eleventh to the early twelfth century, and the figures are depicted in the elongated Romanesque style. Only four original figures now survive, the prophets Hosea,

David, Daniel, and Jonah, depicted in strong, vibrant colors: red, green, blue, pale and dark brown, against much paler backgrounds (Dodwell 1993: 391–2).

In the thirteenth century, the Romanesque style evolved into Gothic with its smaller, more animated figures. An expert German painter in this style is Master Bertram of Minden (c. 1345–c. 1415), the painter of the Grabow Altarpiece now in the Kunsthalle, Hamburg, dated to c. 1400. It depicts forty-five scenes from the Apocalypse in a strong and varied palette (see V&A 2017).

POLAND

Early medieval Poland (as it later became) was a patchwork quilt of Celtic, Germanic, Slavic, and other tribal territories, and its geography enabled the migration of many peoples across its lands. Major movements occurred after c. 370 when the Huns crossed the River Volga and, as they pushed westwards, displaced Germanic peoples such as the Ostrogoths, Visigoths, and Vandals, greatly reducing the population of "Poland." In the late fifth century, it is believed that Slavic peoples moved into present-day Poland in greater numbers and established settlements (Buko 2008: 55–63).

The documentary history of Poland begins in the mid-tenth century, when information about the first Polish dynasty, the Piasts, who came from Greater Poland, was recorded (Davies 1984). Before then, several tribes—the most important being the Vistulans and the Polanians—had lived in the area that eventually became the Polish state. These tribes lived in Greater Poland, Silesia, Lesser Poland, Masovia, Cuiavia, Pomerania, and Prussia (Kowalska-Pietrzak 2007: 61–2). The Polanians would prove of decisive historical importance.

The first Polanian ruler mentioned in written records is Duke Mieszko I (r. c. 960–92) who ruled Greater Poland, a region of west-central Poland based on Poznań. Mieszko expanded his territories considerably, taking over regions such as Masovia and parts of Pomerania. His marriage to Dobrava, daughter of Duke Boleslaw I of Bohemia, led to his and his people's conversion to Roman Catholicism in 966 (Kowalska-Pietrzak 2007: 63). At his death, the Polish state stretched from the Baltic Sea to the Carpathian Mountains.

Mieszko I's son, Bolesław I "the Brave" (duke of Poland, 992–1025, and king of Poland, 1025), expanded and consolidated his territories and established the church in Poland as independent from that of Germany by founding the Archbishopric of Gniezno in 1000 at the head of a new ecclesiastic organization. He also pursued an active building program and introduced a Polish monetary unit. Several weeks before his death, Bolesław was crowned the first king of Poland (Kowalska-Pietrzak 2007: 64–5).

The reign of Mieszko II (r.1025–31) was beset by threats and attacks from Germany, Bohemia, and Kiev, sometimes in league with Mieszko's brothers. Following invasion by Germany and Kiev, Mieszko had to abandon his throne

and flee the country in 1031. He returned to Poland in 1032, but the country was considerably weakened by civil war, division into three duchies, and the loss of its status as a kingdom. Mieszko died in 1034. His son, Duke Casimir I "the Restorer" (r.1040–58), who had lived in exile in Germany, returned in 1038, and during his rule the state was rebuilt (Kowalska-Pietrzak 2007: 65–6). His son, Bolesław II "the Generous" became duke in 1058 and was crowned as the third king of Poland in 1076.

Davies (1984: 62) divides the rule of the Piasts into three periods: a time when Piast rulers succeeded each other in direct line (see above); a time, from 1138 to 1320, of fragmentation and civil war; and a time that began with Władisław I's coronation in Kraków in 1320, a process of reunification. Władisław I "the Short" (r.1320–33) began the restoration of the kingdom, and it was then further strengthened and expanded by his son, Casimir III "the Great" (r.1333–70), the last king of the long-lived Piast dynasty. He reconquered the western provinces of Silesia and Pomerania and began the conquest of Lithuania. His reign has been characterized as the golden era of the Polish Middle Ages. He reformed the army and the law and founded Poland's oldest university, the University of Kraków, in 1364. He also welcomed thousands of Jewish immigrants, who were being persecuted in western Europe, and this helped both the financial well-being and the quality of education in the Polish state.

Casimir the Great had no legitimate son, so his nephew Louis "the Hungarian" of the House of Anjou, who had been King of Hungary and Croatia from 1342, was crowned king of Poland in 1370. This period is normally referred to as the Polish-Hungarian Union but Louis's preference for Hungary caused resentment in Poland. Like Casimir, Louis had no son and chose his elder daughter Mary as his successor. He died in 1382, and Mary became queen of Hungary. However, the Polish noblemen decided to elect her younger sister Hedwig (Jadwiga) as their queen, and she was crowned queen of Poland in 1384. The Polish barons chose the pagan Jogaila, grand duke of Lithuania, as a husband for her in the hope that the marriage would put an end to the Lithuanian invasions (Kowalska-Pietrzak 2007: 77–8). In 1386, they married, and Jogaila was baptized as Władysław II Jagiełło to become coruler of Poland with his wife. When she died in 1399, her widower became sole ruler, establishing the Polish-Lithuanian Union, one of the largest states in Christendom.

In surviving early medieval hoards, silver is the predominant material of jewelry, ornaments, and coins. Although such items are often richly decorated with techniques such as granulation (the attachment of tiny silver granules in various patterns) and filigree, the inclusion or association of such items with colors is rare. One example is a predominantly silver hoard of ornaments and coins found in a pottery vessel in the Koszalin district of Western Pomerania. It contains vivid orange-red amber beads and is dated to the end of the tenth century (see National Museum in Szczecin n.d.).

Much of medieval Polish art was, however, inspired by Christianity and sponsored by the Catholic Church. Dated to the period 1225–50 is a painting on lime wood depicting two standing female saints carrying palm fronds. It is usually called *Saints from Dębno*, and a damaged inscription identifies them as Saints Catherine and Agnes. The scene is a fragment of a larger artwork, probably an altarpiece, in the Romanesque style (Daniec 1971; Wischermann 1997). The women wear long tunics, one in darkish red and the other in dark green, with outer garments in dark green and orange.

The Gothic style arrived in Poland with the Franciscan and Dominican orders during the first half of the thirteenth century. In architecture, the style was adopted not only by the church for cathedrals but also by governors for castles, town halls, and wall gates. It can also be seen in various works of art, for example, the *Madonna from Krużlowa*. This painted wooden figure of the Virgin and Child dates to around 1400 with Mary in a graceful so-called "S" pose (not standing straight). She wears a long dress in vivid red, covered by a voluminous gilded outer garment which forms deep folds all round her figure.

ROMANIA

The origins of Romania lie in the Roman province of Dacia, located west of the Black Sea on the Lower Danube. One of the major routes for migrating tribes in the late Roman period was through Dacia so that, after great efforts to retain the province, the Romans had to abandon it in 271 or a few years later, although they still maintained a presence on the Danube frontier. In the late fourth century, however, several tribes invaded the empire through the former province of Dacia, culminating in the Battle of Adrianople (Edirne in present-day European Turkey) in 378 when the eastern Roman emperor, Valens, was killed fighting the Goths and other tribes.

The dominance of the Goths in former Dacia was ended in the late fourth century by the arrival of the Huns who controlled much of eastern and central Europe by 400. After the death in 453 of their famous king, Attila, however, their subject peoples revolted and the Huns retreated. The region continued to suffer incursions from various peoples, such as the Antes and the Sclavenes, but increased stability was achieved with the establishment of the Avar Empire in the mid-sixth century. Then, in the late seventh century, the Bulgars arrived and the region came increasingly under the control of the Bulgar Empire. Under Boris I (r.852–89), the empire was converted to Orthodox Christianity, using the vernacular for church services and the Cyrillic script.

In the tenth century, the region had to face further incursions, from Hungarians and Pechenegs, as well as the revival of Byzantine power in their province of Paristrion on the Lower Danube (Spinei 2009). King Stephen I of Hungary (king from 1000/1001–38) occupied Transylvania (present-day central

Romania) in 1003 and reorganized ecclesiastical administration in the area. In the mid-twelfth century, Transylvania, still part of the Kingdom of Hungary, received new settlers from Hungary, Germany, Flanders, and elsewhere. The non-Hungarians were collectively known as the "Transylvanian Saxons" from the early thirteenth century, and the first recorded mention of "Romanians" dates to the first years of that century. Between 1241 and 1242, the Kingdom of Hungary, including Transylvania, was invaded by Mongols, who attacked and destroyed towns, villages, and abbeys, inflicting great loss of life.

After a devastating year, the Mongols withdrew to the north side of the Lower Danube where they established a khanate (an area ruled by a khan). In the territory of present-day Romania, many succeeding years were taken up with improving the economy and legal system, the building of stone fortresses, and colonization by Germans and Romanians in the depopulated areas, although this does not mean that the area was free from war, or even a (failed) second Mongol invasion.

According to later chronicles, the region of Wallachia (in present-day Romania) was founded by Radu Negru in c. 1290. He arrived in the region of the Lower Danube with numbers of colonists, and he became the first *voivode* (war-leader and/or ruler). Wallachia was still under the authority of Hungary, however, until Basarab I, Voivode of Wallachia (independent ruler, c. 1325–51/2) rebelled against King Charles I of Hungary in c. 1325. When Charles invaded Wallachia, his forces were defeated at the Battle of Posada in 1330, and Wallachia became an independent principality.

Western Moldavia, part of the former Principality of Moldavia, is located in eastern and northeastern present-day Romania. The first voivode of Moldavia was Dragoş, who ruled in the middle of the fourteenth century as a vassal of the king of Hungary. However, this situation displeased several Vlach (Romanian) nobles, and this must have encouraged Bogdan, a voivode of the Romanians in Maramureş, to move to Moldavia with his followers in the early 1360s and to seize power from Dragoş'grandson to become Bogdan I of Moldavia. He rejected the overlordship of the king of Hungary; accordingly, he is regarded as the founder of independent Moldavia. The modern state of Romania was not established until 1859 with a union of Wallachia and Moldavia, and the acquisition of Transylvania and other territories after the First World War.

Evidence of early delight in color in the area of present-day Romania can be found in the splendid gold and garnet jewelry of the late fifth century. Some of the best-known items were found in the elite burials at Apahida, Transylvania, and are believed to represent graves of Germanic people, probably Gepids or Ostrogoths (Adams 2014: 103). In the burial known as Apahida II was found a small mount in the form of a bird of prey worked in gold and cloisonné garnets with white inlay for the eye. It must have been originally fixed to a leather or

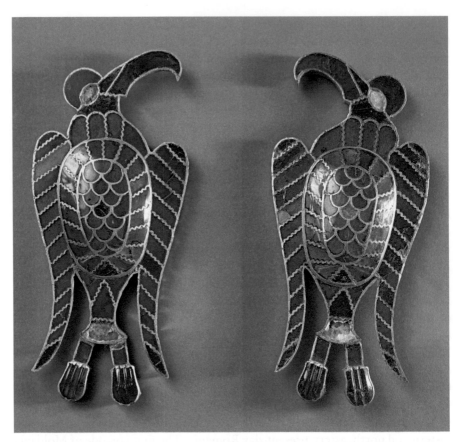

FIGURE 0.3 Gold and garnet mounts, Apahida burial II, Romania, late fifth century. Photograph by DeAgostini / G. dagli Orti. Courtesy of Getty Images.

textile backing. From the same burial came two elegant gold and garnet mounts in the form of eagles with long, hooked beaks and curved wings (Figure 0.3).

They are from horse-trappings and include small areas of cloisonné green glass (Adams 2014: 94). The casual find of a gold and garnet buckle in 1979 suggests a third princely grave at Apahida, now known as Apahida III. Unfortunately, it was taken apart and all the garnets removed. It was later donated in 130 pieces to the National History Museum of Romania and was painstakingly restored. The buckle-plate and tongue are decorated with cloisonné garnets in differing shades of red (Oanta-Marghitu et al. 2009).

Romania is famous for its beautiful churches and monastery buildings, of which the earliest survivor is Cârța Monastery in southern Transylvania, completed in the early years of the thirteenth century. At other sites, the visitor can see the use of color on and in ecclesiastical buildings. St. Nicholas' Church in Curtea de Argeș, Wallachia, has some frescoes surviving from the period

1364–9, although many such works, both here and in other churches, have been over-painted at a later date. This occurs at Cozia Monastery, also in Wallachia, where Holy Trinity Church was completed in 1391. It is built with decorative horizontal layers of red brick in the Byzantine style. Most of the paintings were "restored" in the eighteenth century but a few works dating to 1390–1 survive. A church with colorful exterior is Holy Trinity at Siret, Moldavia, which was built in the mid- or late fourteenth century (Simionescu 2015). The gray-green stone of the church building is enlivened by the addition of ceramic ornament set into the walls and taking the form of mushrooms and flowers. At about two-thirds of the wall height is a frieze consisting of a double row of pale blue and pale mauve glazed ceramic discs, alternating with two rows of black cruciform "flowers." The four rows of ornament are bordered by a row of red bricks above and below and more decorative brickwork below that. The discs and flowers also outline the heads of arches around the apse. Most of the windows have rectangular areas above them with further ceramic discs and red and blue bricks.

UKRAINE

During the Middle Ages, the area that is now the Ukraine, was a key center of East Slavic culture. The ancestors of the Ukrainians are the Antes—a Slavic polity that existed in the sixth century in regions around the Don River and the northwestern Black Sea area (Magocsi 1996: 34, 40). It consisted of White Croats, Severians, Polans, Drevlyans, Dulebes, Ulichians, and Tiverians. An Avar raid in 602 resulted in the collapse of the Antes Union, and most of these people then lived as separate tribes until the beginning of the eleventh century.

The city of Kiev was established when the area around the middle and lower Dnieper River was a part of the kingdom of the Khazars, a semi-nomadic tribe from Central Asia. However, according to the *Primary Chronicle*, the Varangian Oleg of Novgorod conquered Kiev in 882 and thus started the long rule there of the Rurikid princes (the dynasty of Rurik of Novgorod) (Subtelny 2000: 28). Situated on profitable trade routes, Kiev soon emerged as the center of the powerful Slavic state of Kievan Rus', which at its greatest extent was geographically the largest state in Europe (Martin 2009: 34).

Vladimir the Great, ruler of the Kievan Rus' from 980 to 1015, was baptized, and promoted Christianity in his territories in the late 980s (Magocsi 1996: 70). He founded numerous churches, including the Church of the Dormition of the Virgin in Kiev (also known as the Tithe Church), which was completed in 996 (Magocsi 1996: 99). Like most of the early churches, it was built in the Byzantine style, but it was destroyed in the Mongol invasions of the thirteenth century.

The period 1132–1240 witnessed political disintegration. Magocsi notes that "whereas during the first two and a half centuries of Kievan Rus'

(878–1132) there were fourteen grand princes, in the initial decades of the era of disintegration (1132–1169) there were eighteen" (1996: 80). Kiev declined as a political center, and power was disseminated to other principalities, notably Galicia–Volhynia in the southwest, Vladimir–Suzdal' in the northeast, and Novgorod in the north (Magocsi 1996: 80).

Mongol rule began with the capture of Kiev, which was followed only a year later, in 1241, by the capture of Volodymyr (Volhynia) and Halych (Galicia). Several Mongol conquests followed, not only in the Ukraine but also in Poland and Hungary. The only Rus' principality on Ukrainian territory that survived as an independent state was Galicia–Volhynia (Magocsi 1996: 113), though internal dissension and the expansionist policies of the Polish ruler Casimir the Great (r.1333–70), who had reached an agreement with Hungary not to block expansion to the east, eventually led to its demise. Poland attacked Galicia in 1340, in 1344 Lithuania annexed Volhynia, and in 1349 Casimir's armies conquered Galicia. This marked the end of the last independent political entity on Ukrainian territory, and with the fall of Galicia–Volhynia the heritage of Kievan Rus' ceased to exist (Magocsi 1996: 123).

The Rus' chronicles relate that Vladimir the Great brought in the first architects and artists from Chersonesus (in the Crimea), and these, together with artists from Constantinople, created the first Kievan mosaics and frescoes. A well-known example of the art and architecture of the Ukraine is the St. Sophia Cathedral in Kiev, supposedly built on the spot where a main pagan sanctuary had been destroyed and after a wooden, thirteen-dome cathedral had been destroyed by fire (Mezentsev 1987: 366). The current St. Sophia Cathedral, which was completed in 1100 (Magocsi 1996: 99), is a remarkable structure with five naves, five apses, and thirteen cupolas. Although its exterior has been altered over the centuries, the original interior is still intact (Magocsi 1996: 99). It is decorated with magnificent mosaics and frescoes. The most famous mosaic is the *Virgin Orans*, a well-known Orthodox Christian depiction of the Virgin Mary with extended arms. This six-meter-high image with colors primarily in shades of gold, yellow, brown, and blue is considered one of the greatest sacred symbols in the Ukraine. The image is often referred to as the "Indestructible Wall" due to a legend that states that as long as the Theotokos ("Mother of God") extends her arm over Kiev, the city will remain indestructible. However, this did not help Kiev in the Mongol invasion of 1238–40 (Martin 2009: 34).

Following a short period in which Byzantine icons and icon painters were imported, an indigenous school of icon painting developed in Kiev. An icon painting studio was founded in the Kievan Cave Monastery at the end of the eleventh century, and it remained the main center of Ukranian icon painting for centuries. Its early artists include Master Olimpii (d.1114), who is credited with painting the famous icon *Great Penagia* (now in the Tretiakov Gallery in Moscow), which glows in warm reds, gold, browns, and yellows. Another

early artist was Deacon Hryhorii (eleventh century), who is believed to have illuminated the *Ostromir Gospel* (now in the Imperial Public Library in St. Petersburg), the oldest known manuscript (1056–7) produced in Kievan Rus' and famous for its brilliant miniatures.

Following the rise of the principality of Galicia–Volhynia, a Galician tradition of icon painting arose. The chief icon painting schools in Galicia were those of Peremyshl and Lviv, and many samples of their work have been preserved, especially dating from the fourteenth and fifteen centuries. The late-medieval Galician icons are characterized by their pure style with figures that are carefully balanced against the background. Reds, greens, and blues contrast beautifully with the prevalent muted colors. Typically, the background is monotonic, usually a light color or bluish gray, and gold is used only for the halo.

CHAPTER ONE

Philosophy and Science: Scholastic Color Theory

A. MARK SMITH

Like so many other facets of natural philosophy during the European high and late Middle Ages (*c.* 1150–1500), color theory was firmly rooted in Aristotelian sources translated from Greek and Syriac into Arabic during the ninth and tenth centuries and then from Arabic into Latin between roughly 1120 and 1230. Key among such sources were Aristotle's *De anima* ("On the Soul," 1984c), *De sensu et sensibilia* ("On Sense and Sensibles," 1984b), and *Meteorologica* ("Meteorology," 1984a), and the Pseudo-Aristotelian *De coloribus* ("On Colors," 1984), all of which contain explicit accounts of color and color formation.

Along with these primary sources came several influential Arabic commentaries and derivatives, foremost among them the *Liber de anima* (Book of the Soul) of Avicenna (d.1037), the epitome of Aristotle's *De sensu,* the long commentary on Aristotle's *De anima* by Averroes (d.1198), and Alhacen's *De aspectibus* (On Visual Appearances), which was composed under the title *Kitāb al-Manāẓir* (Book of Optics) around 1030 (Smith 2015: 155–8 and 242–5). Rendered from Arabic into Latin around 1200, most likely in Spain, the last-mentioned work provides a comprehensive account of visual perception within a distinctly Aristotelian conceptual framework (Smith 2015: 13–15). That account in turn formed the basis for the perspectivist optical tradition that emerged in the 1260s and 1270s at the hands of Roger Bacon (d. *c.* 1292), Witelo (died after 1280), and John Pecham (d.1292) (Smith 2015: 256–77).

From the late thirteenth century on, scholastic accounts of sight, light, and color fell predominantly within this tradition.

The Arabic thinkers mentioned above were themselves heavily influenced by such late-antique, Grecophone thinkers as Alexander of Aphrodisias (fl. *c*. 200), Plotinus (fl. *c*. 250), Themistius (fl. *c*. 360), and John Philoponus (fl. *c*. 530), the last two of whom, in a spirit of reconciliation, interpreted Aristotle's thought through a Neoplatonist filter. Accordingly, by around 950 Arabic thinkers could tap directly into the rich tradition of Greek philosophy, as it had evolved from the pre-Socratic era to the sixth century CE (Smith 2015: 134–50). Not so in the contemporary Latin-speaking West, however, where fluency or even competence in Greek became increasingly rare during late antiquity, even among intellectuals such as Saint Augustine (O'Donnell 2005: 126).

For the most part, therefore, early medieval Western thinkers relied either on Latin translations of Greek sources or on secondary Latin sources based on them. An example of the former is Chalcidius' translation, with commentary, of about a third of Plato's *Timaeus*, which includes Plato's account of visual fire but not the subsequent account of color perception (Plato 2000). Among the secondary Latin sources, Seneca's *Naturales quaestiones* (*Natural Questions*) looms especially large because of its extensive discussion of the rainbow's formation according to several different theories with Aristotle's theory being prominent among them (Seneca 2010: 144–53). Pliny's encyclopedic *Historia naturalis* (*Natural History*) and Macrobius' scattershot *Saturnalia* were also popular secondary sources.

Strictly speaking, then, the main line of development for color theory during the Middle Ages (that is, from roughly 500 to 1500) extended from Greek to Arabic thinkers during the early Middle Ages and thence to Latin thinkers from around 1120 on. Distinctly secondary was the line passing from Greek through secondary Latin sources before the translation movement of the twelfth century brought both primary Greek sources, Aristotle in particular, and various Arabic offshoots within the ken of Western Latin intellectuals. The following concentrates on the main line of Greek-to-Arabic-to-Latin development, but not entirely to the exclusion of its Latin-to-Latin tributary.

COLOR AS THE PROPER OBJECT OF SIGHT

Virtually every classical, late antique, and medieval thinker who dealt with color and color perception shared with Aristotle the assumption that color is per se visible—or, as Aristotle himself put it, the "special sensible object" (*idios aisthêtos*) of sight. By this, he meant that the visual faculty is designed to apprehend color and color alone, just as hearing is designed to apprehend nothing but sound or taste nothing but flavor (Aristotle 1984c: 665–6; see also Averroes 1550: 192r, col. b; Vincent of Beauvais 1591: 20v, col. b;

Augustine 2010: 36). Color, for its part, was understood to define the surfaces of physical objects, thereby rendering them visible. "It is manifest," Aristotle says in elaboration of this point, that "colour [is] actually either at the limit, or [...] itself that limit, in bodies (Hence it was that the Pythagoreans named the superficies of a body its hue)" (Aristotle 1984b: 697). A clear echo of this point can be found some five centuries later in Ptolemy's *Optika* (Optics; 1996: 74).

Apprehension of the surface colors of those objects was, therefore, thought to provide the necessary grounds for visually perceiving such physical characteristics as shape, size, distance, texture, and even the fact that objects occupy space. Since, as was believed, none of these characteristics is per se visible, they are necessarily implied by, and inferred by means of, the object-surfaces to which they belong. In short, without color nothing about physical objects, not even their very existence, could be visually perceived. These things are therefore apprehended secondarily from the primal sensation of color. This, of course, is not to deny that such physical characteristics as shape, size, distance, and texture are also perceptible by means of other senses, touch in particular; hence Aristotle's designation of them as "common sensibles" (Aristotle 1984c: 665).

Another assumption shared by classical, late antique, and medieval thinkers was that in order to be seen, an object had to be spatially separated from the eye; direct contact between the two simply would not do. How, then, was visual contact between eye and object established? One alternative, action at a distance, was rejected pretty much out of hand. The remaining alternative was mediation of some sort: that is, something had to pass between eye and object or, conversely, between object and eye. Most classical thinkers, especially those who took a mathematical approach to optics, preferred a theory based on visual radiation continuously emitted in straight lines from the eye to the object. Visually sensing the object's surface, this stream of radiation formed a pathway, along which the resulting visual data, based on the object's color, could pass back to the eye for perceptual judgment. The analogy with touch is obvious. Just like outstretched fingers, the lines of visual flux reach out to visible surfaces in order to "feel" their visible characteristics. This feeling is then transmitted back through the radial "fingers" to the seat of judgment for perceptual discrimination.

Reversing the direction of emission, Aristotle and his subsequent followers supposed that vision depends on something passing radially from object to eye rather than from eye to object and back again. Alhacen, for instance, makes it quite clear that this latter supposition is logically unsound; why, after all, assume an outward flow of visual flux and a subsequent inward flow of visual information along it, when the inward flow alone will do (Smith 2015: 184)? Five centuries earlier, in fact, the Neoplatonist thinker John Philoponus offered a similar argument (Smith 2015: 148). What passes to the eye is color, but not the actual, physical color defining the object's surface. Instead, it has to

be transmitted and thus seen through—and supported by—an appropriately transparent medium, such as air, water, or glass. Clearly, then, the color's mode of existence in such media must be different from its mode of existence in the object, and the same holds for its mode of existence in the eye. To *see* red is not actually to *be* red, as, for example, a ripe delicious apple or a strawberry is red.

The color sensed by the eye and subsequently perceived by the psyche was thus understood to be a virtual representation of the color existing physically in the object in much the same way as a painted portrait is a virtual representation of the subject it portrays. Visual perception, therefore, entailed interpreting that representation according to its sensed color in order for the perceiver to realize what it represents. Although veridical under the proper conditions, such perception could always go awry if the color data were misinterpreted. For instance, we might mistakenly assume that the sun at horizon is actually orange because of its appearance at that point, which is deceptive. Nonetheless, for Aristotle and his followers what is presented to the visual faculty is actually orange, so in seeing it as such the visual faculty is inerrant. It is in judging the sun to be *actually* orange that one falls into error, the result being one form of visual deception (Aristotle 1984c: 665 and 681).

According to this theory of color and color perception, color is a real and invariant quality of visible objects, existing independently and objectively apart from any perceiver. Yet its visibility is clearly dependent upon the presence of light. There were two basic responses to the question of precisely how light renders color visible. One, offered by Aristotle and several of his commentators, was that light acts as a sort of catalyst by transforming such media as air, water, and glass from potentially to actually transparent. Instead of illuminating the object directly in order to make it visible, light renders the potentially transparent medium susceptible to color transmission, thus enabling the color to reach the eye. Presumably, then, the quality of transparency due to the quality of light affects the quality of the color transmitted through the transparent medium to the eye.

Other commentators, Avicenna in particular, argued not only that light renders color visible by illuminating it directly but also that light itself is per se visible. Among these commentators, some, such as Averroes, attempted to reconcile this position with that of Aristotle by claiming that color is only potentially and not actually visible until it is illuminated. Averroes added, however, that light also perfects the transparency of appropriate media, which implies that it transforms that transparency from potential to actual. Thus, as he puts it in his epitome of Aristotle's *De sensu*, "[a] transparent body is innately disposed to admit light and to be perfected by it" (Averroes 1550: 192r, col. b). On the whole, though, later thinkers followed Alhacen in assuming that transparent media, such as air, water, and glass, are actually and intrinsically transparent, whether light is present or not.

Alhacen also represented a consensus among medieval Latin thinkers (Roger Bacon prominent among them) that color, like transparency, actually exists with or without the presence of light. Not only that, but Bacon assumed that color radiates freely through transparent media on its own power even in the absence of light, although it radiates too weakly to be seen (Bacon 1996: 109). These thinkers also assumed that such media are actually transparent, whether or not light is present. They assumed as well that light exists in two modes: as the intrinsic luminosity of light sources such as the sun, it takes the form of *lux*, whereas its visible, illuminative effect in transparent media as well as on opaque objects takes the form of *lumen*. Light and color were therefore regarded as ontologically distinct, although as far as visibility is concerned, the two were regarded as absolutely inseparable. Without color to reveal its effect, light could not be seen, and without light to reveal its effect, color could not be seen. Hence, luminous color, not color per se, was regarded as the proper object of sight, from which it follows that both light and color were understood to be totally interdependent, each affected by the other (Smith 2015: 186). In his *Speculum naturale* (Mirror of Nature) written around 1260, however, Vincent of Beauvais argued that because "color is seen by means of light, it follows that light constitutes the object of vision more than does color" (Vincent of Beauvais 1591: 20r, col. a; see also Bacon 1937: 30–4).

LIGHT, TRANSPARENCY, AND COLOR: A PROBLEMATIC CONVERGENCE

Until now, one view of color that was common from classical antiquity to the later Middle Ages has been discussed: namely, that color is an objective, intrinsic, and fixed quality of colored bodies. As such, it defines their surfaces in such a way as to reveal such spatial aspects as shape, size, distance, and so forth. But color is also defined by those surfaces insofar as they can be appropriately illuminated. Clearly, then, in order to possess color, a body must be opaque so that it can assimilate the light that makes it visible. Otherwise, the impinging light will simply pass into or through the body without visible effect.

Opacity has gradations, though. Even transparent bodies can possess enough opacity to take on color, and they can do so in at least three ways. One is by being physically and materially colored by colorants. Another is by weakening light as it passes ever deeper through the bodies. This is evident from the way in which water becomes murkier with depth or air becomes hazier with distance; the color seen in both cases is affected by the depth of the medium. A third way is through reflection at the surface, as happens with both water and glass when their surfaces are viewed at enough of a slant to be transformed into mirrors. In this case, of course, the color is accidental or adventitious and not intrinsic, because it is not fixed in the reflecting surface the way, say, red is

fixed in the skin of an apple. That some early thinkers actually did assume that mirror images were fixed by impression on the reflecting surface is clear from Alhacen's effort to refute it (Alhacen 2006: 324–5).

It may well have been with these considerations in mind that Aristotle made the somewhat enigmatic claim in *De sensu* that color is "the limit of the transparent in [a] determinately bounded body" (Aristotle 1984b: 698), a claim that is echoed by many medieval thinkers (for example, Vincent of Beauvais 1591: 21r, col. a; Bacon 1937: 39; and Thomas Aquinas 2005: 60). One obvious way of interpreting this dictum is that color is a function of opacity, which is itself a bounding condition of bodiliness as far as visibility is concerned. Without some measure of opacity, then, a body cannot have color. Opacity in turn represents a limit to transparency according to its absence, just as darkness represents a limit to light according to its absence. Understood in this way, opacity and transparency, like light and darkness, represent Aristotelian contraries, each relative to the other. Another way of interpreting Aristotle's dictum is that, as the limit of transparency, color somehow *is* opacity. This being the case, the hue of the surface would presumably be determined by the surface's relative opacity and the light's relative brightness, variation in one or both resulting in a change of hue. The more the variation, therefore, the greater the change in hue.

That color can indeed be dependent on the interplay between light and transparency is evident in the production of the spectrum that occurs when light refracts through transparent bodies of a certain shape. Roger Bacon and Witelo, for instance, remark on the fact that directing light in a certain way through a hexagonal crystal or chunk of glass will create a spectrum (Witelo 1572: 473–4; Bacon 1900: 173). Likewise, light refracted through a water-filled sphere, such as the bottom of a urinal flask, will create a spectrum. Moreover, the order of colors in this spectrum is precisely the same as that in the rainbow, which led certain medieval thinkers, Kamāl al-Dīn al-Fārisī and Dietrich of Freiburg foremost among them, to assume that the rainbow was created by a combination of refraction and reflection through and within individual drops in the raincloud. Others, such as Robert Grosseteste, imputed the rainbow to refraction into the raincloud taken as a whole rather than drop by drop (Della Porta 2018: lxiii–lxv).

Not everyone pinpointed refraction as the cause of the rainbow's color bands. Many thinkers followed Aristotle in supposing that the rainbow and its color bands were due to reflection. Although Aristotle himself argued that reflection involved visual rays passing from the eye to individual raindrops and thence to the sun (Aristotle 1984a: 601–4), later thinkers replaced visual radiation with light radiation passing from the sun via the raindrops to the eye. Each raindrop therefore contained an image of the sun, but because the raindrop was so small the "image" was not of the sun itself but of its color. This color image, however, was assumed to vary according to the strength or weakness

of the radiation reaching from eye to sun or from sun to eye. The weaker that radiation, the less vivid the resulting color image, and the primary reason for such weakening was the distance the radiation had to travel from start to finish. Whatever the purported cause of the weakening, the crucial point here is that color was thought to be a function of the strength or force of radiation, albeit visual radiation.

That the quality of illumination can also affect the apparent color of minimally transparent or opaque bodies is clearly acknowledged in chapter 3 of the Pseudo-Aristotelian *De coloribus*: "We never see a colour in absolute purity," the author claims there; "it is always blent if not with another colour, then with rays of light or shadow [which is why] objects assume different tints when seen in shade and in light and sunshine, and according as the rays of light are strong or weak." Everything considered, the text continues, "all hues represent a threefold mixture of light, a translucent medium [...] and underlying colours from which the light is reflected" (Pseudo-Aristotle 1984: 1222). Three factors are at play here: the quality of the light according to its intensity and the angle at which it strikes the visible surface, the quality of the medium according to its relative translucency, and the quality of the color defining the visible surface.

This understanding of color and its variability is at odds with Aristotle's supposition in *De anima* and *De sensu* that light simply transforms such media as air, water, and glass from potentially to actually transparent, thus allowing the color to pervade it visibly. After all, a medium's relative transparency would seem to be due not to the amount of light shining on it but to the quality of the medium itself, whether, for instance, it is murky or clear, or whether it extends a long or short distance between object and eye. If the medium is clear, then as soon as its transparency is actualized by light, the color seen through it should be subject to no variation at all. Hence, there should be no difference between an object's apparent and real color, no matter how much light pervades the medium, or how intense the light source that renders the medium actually transparent.

It is, of course, empirically obvious that the quality of light and the quality of the medium, whether singly or in concert, have a crucial bearing on how color appears. As mentioned above, the Pseudo-Aristotelian *De coloribus* gives full recognition to the fact that a given color can look quite different in bright light than it does in shadow or when dimly illuminated. Likewise, color seen through thick haze looks different than it does when seen through clear air. But, as Alhacen and his medieval followers acknowledged, other factors can affect how colors appear. For instance, if a parti-colored object is viewed at an inordinate distance, its constituent colors may appear as a homogeneous blend, and the same may happen if the object is rotated swiftly.

Altogether, Alhacen and his subsequent followers list eight preconditions that determine how things, color included, are perceived or misperceived, all

eight working either alone or in various combinations (Smith 2015: 192–3; see also Bacon 1996: 109–45 and 176–95). Some involve the external physical circumstances under which objects are seen, while others involve the internal perceptual mechanisms. An example of the latter is jaundice, which was thought to result from an influx of yellow bile into the eye, thus giving a yellowish cast to everything seen. On the other hand, if the physical circumstances interfere with the visual faculty's proper functioning, the resulting perception of any object's characteristics, including its color, can be distorted. If, for instance, the eye does not have time to apprehend the object properly, or if the object is seen at an inordinate slant, its color may be misapprehended. The implication is clear: even if color is somehow objectively and absolutely fixed in external objects, the way it presents itself both physically and visually is infinitely variable according to always-shifting conditions.

THE COLOR SPECTRUM AND ITS FORMATION

As with most other aspects of premodern color theory, so with the color spectrum and its generation, Aristotle laid the foundations for subsequent ideas well into the Renaissance. Far from stable, however, these foundations were laid inconsistently in a variety of Aristotelian works ranging from *De anima* and *De sensu* to the spurious *De coloribus*. One key tenet in all those works, a tenet that is repeated over and over in later accounts of color, is that each color within the spectrum results from a specific mixture of white and black. The rationale underlying this claim lies in Aristotle's doctrine of contraries, which are the polarities that govern and limit the process of change or transformation. Thus, as he puts it in Book One of *Physica*, "everything that comes to be or passes away comes from, or passes into, its contrary or an intermediate state [that derives] from the contraries." By that logic, he continues, "colours [are intermediates deriving] from black and white" (Aristotle 1984d: 322).

In *De sensu*, Aristotle discusses at length how these colors might actually be formed as intermediates from the contraries. He suggests three possibilities, all based on the assumption that any particular color is due to a particular ratio of black to white. "It is," for instance, "conceivable that the white and the black should be juxtaposed [such that] their product could [result in] a species of colour different from either." A second possibility is superposition, in which case "the black and white appear the one through the medium of the other, giving an effect like that sometimes produced by painters overlaying a less vivid upon a more vivid colour" (Aristotle 1984b: 698). The stock justification for this possibility is that, when seen through fog or smoke, the sun takes on a reddish hue.

Dismissing both of these options, Aristotle plumps for a third: namely, that the black and white "are wholly blent together by interpenetration" (Aristotle

1984b: 699), just as two substances may form a compound that is unlike either of its original constituents. This, Aristotle argues, is the correct explanation, because no matter whether it is examined from afar or from up close, any true color remains uniform and homogeneous. "For when bodies are thus mixed," he concludes, "their resultant colour presents itself as one and the same at all distances alike; not varying as it is seen nearer or farther away" (Aristotle 1984b: 699). If, on the other hand, it were due to either the juxtaposition or the superposition of black and white, the resulting color would begin to appear mottled, as its individual black and white constituents became increasingly visible from an ever-closer distance. However, the blending alternative would seem to be belied by the stock example mentioned above: that the sun (the whitening agent) seen through fog or smoke (the blackening agent) appears red, or at least reddish. This observation clearly favors the theory of superposition over that of blending, insofar as the reddening is due to the sun's whiteness being seen *through* the smoke's blackness rather than actually commingled with it.

Key to Aristotle's conception of color is that each hue is determined according to a specific ratio of white and black. As a result, Aristotle argues, "colours will [...] be many in number on account of the fact that the ingredients may be combined with another in a multitude of ratios" (Aristotle 1984b: 699). Some of the blacks and whites may be combined in simple numerical ratios, such as 3 to 2 or 4 to 3, in which case "we may regard all [such] colors as analogous to the sounds that enter into music, and suppose that those involving simple numerical ratios, like the concords in music, may be those generally regarded as most agreeable" (698). Accordingly, such agreeable colors as purple and crimson might correspond analogously to the perfect fifth (3:2) or major third (4:3) in music.

These sorts of colors are as limited as the set of simple numerical ratios within the set of all possible ratios, the overwhelming majority of which are composed of incommensurable quantities. Furthermore, the set of all possible ratios is potentially infinite, so the set of all possible colors must be potentially infinite as well, which means that the full spectrum of colors should form a perfect continuum. Why, then, Aristotle asks, are the species of color limited? The answer lies in the limitations of human perception: just as we are incapable of seeing the "ten-thousandth part in a grain of millet [or hearing] the sound contained in a quarter-tone" (Aristotle 1984b: 707), so we are unable to perceive tiny gradations in the continuum of color. Consequently, even though the spectrum of colors may be perfectly continuous, it is only potentially so with respect to human sight, which can only discern discrete colors, as well as kinds of colors, within the spectrum.

All of these ideas about the color spectrum and its generation crop up, sometimes with modifications, in subsequent works within both the medieval

Arabic and Latin traditions. In the section on vision in his epitome of Aristotle's *De sensu*, for instance, Averroes follows Aristotle in arguing that:

> colors are produced from white and black according to the greater or lesser [predominance of one], and they are differentiated in this regard by infinite diversity according to material composition; it was therefore necessary that colors be infinite in nature.
>
> (Averroes 1550: 192v, col. a)

Earlier, however, he traced the white-black contrarieties to luminosity on the one hand and transparency on the other. "Consequently," as he sums it up,

> it is necessary that colors be composed from these two natures, namely the nature of what is transparent and the nature of what is luminous, and [it is also necessary] that the diversity of those colors be due to a difference in the amount and quality of those two natures.
>
> (Averroes 1550: 192r, col. b)

In short, colors are differentiated according to the ratio of the two contraries in their composition.

Taking much the same tack as Averroes, Albertus Magnus bases his account of color in the *Liber de sensu* (Book concerning [Aristotle's] *De Sensu*) on Aristotle's contention that color is the limit of transparency. With that in mind, Albertus argues that "every color is a participation of light in some transparent body or another," which follows from the fact that "illumination truly is the actuality of colors insofar as they are colors" (Albertus 1890: 39a). Therefore, he continues,

> when light is [shining] on the outer limit of a transparent body, and the very transparency of the bounded body is clear, then the participation of the light in the transparency is called *white*. On the other hand, when transparency is totally or almost totally lacking, then this is called *black*. Hence, since there is both light and darkness in translucent bodies, this constitutes white and black in bounded bodies—from which it is clear that blackness is the privation of whiteness.
>
> (Albertus 1890: 41b)

Not surprisingly, Albertus agrees that colors are formed from the contraries of black and white, but since those contraries are contingent on relative opacity or transparency, the colors produced by them require light in order to be realized. By themselves, they are therefore not sufficient. Light, in short, would seem to be a necessary third element in the formation of color. Albertus also concurs with Aristotle that individual colors arise from a true mixture of the black and white contraries, not by juxtaposition or superposition (Albertus 1890: 48a–51a). On this basis, he concludes that "the multitude of intermediate colors will be due to the fact that there are many ways in which bodies can be composed of transparent and opaque constituents" (53a).

Averroes also argues that the intermediate colors are ultimately formed from a mixture of varying degrees of transparency and opacity, but he goes a bit further to tie the two explicitly to chemical composition:

> Thus, a white color is formed from the mixture of bright light with an extremely transparent substance—that is, air—whereas a black color is formed from dim light that mingles with the least transparent element—that is, earth—and the intermediate colors between white and black are differentiated according to how these two differ in their relative preponderance.
>
> (Averroes 1550: 192r, col. b)

Robert Grosseteste—and Roger Bacon following him—also contends that "colour is light incorporated in a transparent body," arguing in addition that "transparent bodies are of two kinds: for a transparent body is either pure and free from earthiness or impure through mingling with earthiness." Light, for its part, is subject to a fourfold differentiation, insofar as it can be "bright or dim, or diffuse or concentrated." Accordingly, Grosseteste concludes that "[a] bright, concentrated light in a pure transparent body is whiteness, whereas diffuse, dim light on an impure transparent body is blackness" (Grosseteste 2013: 16; my translation). "In this account," Grosseteste adds, "Aristotle and Averroes's contention that blackness is a privation and whiteness a property or form is explained" (16). Grosseteste's influence on Bacon is clear from chapter 17 of Bacon's commentary on Aristotle's *De sensu*, almost all of which consists of an essentially verbatim copy of Grosseteste's *De colore* (Bacon 1937: 77–9).

In order to clarify the distinction between the brightness and the concentration of light, which would seem to be correlated, Grosseteste explains the latter in terms of how a concave mirror brings light to a focus. Furthermore, since light becomes increasingly diffuse as it gets farther from its source, a body of a particular transparency close to a dim light source might well be more brightly illuminated than it would be when lying at a greater distance from a bright light source. The very same body with the very same mixture of transparency and opacity might therefore appear differently colored, depending not only on the intrinsic brightness of the light source but also on the diffuseness of its illumination.

All told, then, Grosseteste was fairly typical of his day in tracing color to the interaction of light and bodies of varying degrees of transparency. He was untypical, however, in distinguishing the quality of light according to two variables (brightness/dimness and concentration/diffuseness) rather than one. As the recent editors of Grosseteste's *De colore* show, it is possible to represent his theory according to a three-dimensional model (see Figure 1.1), where each variable is confined to one of the three axes defining the cube.

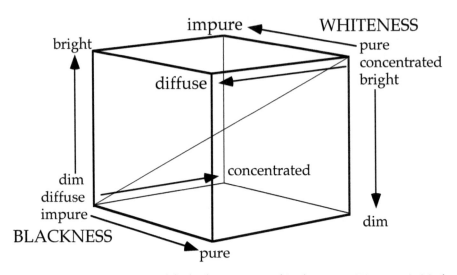

FIGURE 1.1 Grosseteste's model of color represented in three axes. Diagram: A. Mark Smith.

Thus, at the vertex of all three axes on the lower left-hand side of the cube, where the transparency is impure and the light dim and diffuse, the color will verge toward absolute blackness. At the opposite vertex connected by the cube's diagonal, on the other hand, the transparency will be pure and the light bright and concentrated, so the resulting color will verge toward absolute whiteness. Every intermediate color will therefore lie within the cube at a point determined by the level of the three variables on their respective axes (Grosseteste 2013: 48–57).

Whether Grosseteste actually had such a three-dimensional model in mind and, along with it, a conception of "color space" equivalent to that of modern color theorists, is questionable; there is certainly nothing explicit in his account of color formation to indicate that he did. Equally questionable is that he understood color in terms of the threefold distinction between hue, saturation, and value (or lightness) that might be inferred from his model, the first, for example, represented by the pure-impure axis, the second by the bright-dim axis, and the third by the concentrated-diffuse axis (Grosseteste 2013: 57–66). Nonetheless, the very fact that Grosseteste's model is susceptible to such interpretations indicates that his approach to color was more nuanced and sophisticated than that of his contemporaries. It also indicates that he was groping toward a theory of color that has certain resonances, if only relatively vague ones, with its modern counterpart. Especially salient in this regard is Grosseteste's radical separation of brightness and dimness from concentration and diffuseness, each couple thus representing a different quality of the light and, thus, of the color resulting from it.

THE PROBLEM OF PRIMARY COLORS

As mentioned in the previous section, Aristotle suggested that particular colors are due to a particular ratio of black and white. Moreover, since black and white can be mixed in an infinitude of varying amounts, the spectrum of colors arising from such a mixture will be infinite as well. Nonetheless, Aristotle contends that certain colors come to the fore as particularly agreeable. Especially agreeable, according to Aristotle, is green, which is the most restful color for the eyes and therefore therapeutic according to such medieval opthalmological authorities as Peter of Spain (Aristotle 1984e: 1510; Smith and Pinto Cardoso 2008: 39b). What makes such colors agreeable, Aristotle suggests, is that their black and white constituents are mixed in simple numerical ratios, such as 3:2 or 4:3 that correspond to pleasing musical intervals. Consequently, there will be a limited palette of such colors according to the limitations of such ratios, which form a small set among an infinitude of otherwise incommensurable ratios (Aristotle 1984b: 702; Albertus 1890: 53a; Vincent of Beauvais 1591: 22r).

Just how limited the palette of such colors is according to Aristotle becomes clear from his discussion in chapter 4 of *De sensu*, where he limits the colors to seven kinds or species, ranging from white through crimson, violet, leek green, blue, to black. To these six he adds gray (*phaion*), which he characterizes as a variety of black, although he admits it might be classed with yellow (*xanthon*) with reference to white. All other colors, he concludes, are formed by mixtures of these (Aristotle 1984b: 702). In fact, if Aristotle means to count gray separately from yellow, then he actually has eight rather than seven species of color in mind (Parkhurst 1990: 159).

In the third book of his *Meteorologica*, however, Aristotle gives a more truncated list of color species based on the rainbow. There he limits the intermediate colors to three, which range from red, which is nearest white and strongest, through green to violet, which is nearest black and weakest. These colors are truly primary in that, according to Aristotle, they cannot be created by mixing other colors as artists do to create a broad palette (Aristotle 1984a: 600). Meanwhile, the yellow that is clearly visible between the red and green bands of the rainbow is not a true color. On the contrary, "it is due to contrast; for the red is whitened by its juxtaposition with green" (603), so it is only apparent.

These two accounts of color from *De sensu* and *Meteorologica* are clearly incompatible not only because the one includes five (or six) rather than three primary colors—excluding black and white—but also because it includes gray or yellow, which the account in *Meteorologica* dismisses as merely psychological in origin. In addition, there is the problem of color terms themselves, which are often ambiguous (see Tachau 2014: esp. 349–65). Violet, after all, comprehends a range of colors from fairly deep, bluish purple to what is essentially lavender.

More to the point, Aristotle's apparent conflation of gray with yellow seems to reflect not so much an equivalence of actual hue as an equivalence in the relative amount of black and white in their composition. This is certainly how Roger Bacon interpreted it, likening "grey" (*glaucus*) to a particular form of "yellow" (*karopon*) that is like the relatively light dun of a camel's coat, which might be described as a sort of dingy yellow (Bacon 1937: 71).

Not only was the number of primary or basic colors in the spectrum at issue from the time of Aristotle to the Middle Ages, but how that spectrum should be understood conceptually was also a matter of differing opinions. Underlying Aristotle's account in chapter 4 of *De sensu*, for instance, seems to be a conception of the spectrum as unilinear and therefore one-dimensional, each color succeeding the next in a straightforward transition from black at one end to white at the other. Not everyone visualized the spectrum this way, however. Writing in the early eleventh century, Avicenna (Ibn Sīnā) conceived of the spectrum and its formation according to three distinct lines or paths, one running from white through pale and dark gray to black, a second running from white through red and red-brown to black, and a third running from white through green and indigo to black. The thirteenth-century Muslim scholar Naşīr al-Dīn al-Tūsī went even further, suggesting a five-path formation: the first comprising a range of yellowish shades, the second a range of reddish shades, the third a range of greenish shades, the fourth a range of bluish shades, and the last a relatively small range of grays (Kirchner and Bagheri 2013; see also Vincent of Beauvais 1591: 22r, col. b).

Clearly two-dimensional, these schemes seem to envision distinct sets of color species, each with its own line of formation. Accordingly, Avicenna's threefold set consists of grays, reds, and greens, whereas Tūsī's fivefold set consists of yellows, reds, greens, blues, and grays. Neither of these sets corresponds perfectly with either of the sets of color species favored by Aristotle in *Meteorologica* (red-green-blue) or *De sensu* (yellow-red-violet-green-blue), although Tūsī's comes somewhat closer to the latter than does Avicenna's to the former.

The color scheme of Robert Grosseteste, briefly discussed above, was even more divergent than that of Avicenna and Tūsī. Grosseteste's most obvious departure from Aristotle lay in his insistence that there are sixteen distinct colors altogether, including the extremes of blackness and whiteness that produce the rest. Accordingly, as Grosseteste describes it in *De colore*, one set of colors arises from whiteness in seven separate lines that descend toward blackness. Likewise, the other set of colors arises from the pole of blackness in seven separate lines that ascend toward whiteness. As a result, the two sets of color lines form symmetrical arrays that meet at a sort of middle ground (*medio*) between the black and white extremes (Grosseteste 2013: 16).

The rationale behind this scheme is fairly clear according to its basis in the three variables of transparency, brightness, and intensity. Pure blackness, for

instance, would be minimally transparent, bright, and concentrated. This set of variables can be represented numerically as –1, –1, –1, according to a lack of each quality. On the other hand, pure whiteness, being maximally transparent, bright, and concentrated, can be represented numerically as +1, +1, +1. Each of the seven color lines arising from black will therefore be defined by some combination of these variables.

One such color line, for instance, can be defined as 0, –1, –1, where transparency alone has been relatively minimized (as represented by 0), the other two remaining unchanged. Another color line would be –1, 0, –1, yet another 0, 0, –1, and so forth. Corresponding color lines on the black side would be 0, +1, +1; +1, 0, +1; and 0, 0, +1, 0 also representing the relative minimum for each variable. Within each of the three-variable sets based on –1, –1, –1 and +1, +1, +1, there are seven possible combinations, including 0, 0, 0, so the total number of colors adds up to sixteen when pure blackness and whiteness are taken into account (Grosseteste 2013: 49–51).

One way of representing this scheme is according to Figure 1.2, which is based on the color cube discussed in the previous section (see, especially, Figure 1.1).

Vertex W represents the point at which maximal transparency, brightness, and concentration produce pure whiteness. Each of the variables can therefore change individually along one of three axes: from pure toward impure along WA, from bright toward dim along WE, and from concentrated toward diffuse along WG. A change in pairs can occur along WD (from bright and concentrated to dim and diffuse), along WC (from pure and concentrated to impure and

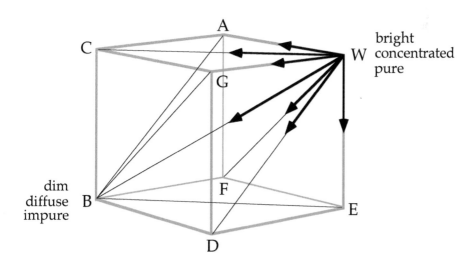

FIGURE 1.2 Variation of color according to each axis of the three-axis color model. Diagram: A. Mark Smith.

diffuse), and along WF (from pure and bright to impure and dim). Finally, a threefold change will occur along WB (from pure, bright, and concentrated toward impure, dim, and diffuse). The same holds symmetrically for the colors arising from blackness at vertex B along axes BC, BD, BF, BE, BA, BG, and BW.

Aside from blackness and whiteness at the contrary poles of his model, Grosseteste does not specify the actual colors, or color paths, arising from those poles. According to Parkhurst, it was Roger Bacon, Grosseteste's enthusiastic advocate, who provided this specification in a set of seven color species (excluding black and white) arrayed in order as follows: *lividus* (ivory or light gray), *flavus* (light yellow), *puniceus* (orange), *rubeus* (red), *purpureus* (purple or violet), *ceruleus*, and *lazulus*. The English versions of these seven hues are at best tentative, and Bacon himself is not always consistent in naming them in Latin. However ambiguous the terminology may be, though, the key point is that this sevenfold array seems to define the middle ground (*medio*) of Grosseteste's model, where the seven color paths arising from whiteness meet with, or at least converge toward, the seven color paths arising from blackness (Parkhurst 1990: 163–73 and 183–96).

THE RAINBOW: REAL VERSUS APPARENT COLORS

As mentioned above, there were two general explanations of the rainbow and the formation of its color bands. One, harking back to Aristotle, imputed the rainbow to reflection. This explanation had two fundamental variants. Aristotle's own, which was accepted among others by Roger Bacon, supposed that the reflection occurs from individual drops in the raincloud, each drop containing an image of the sun. So tiny and vague is this image, however, that it is not of the sun itself but of its color (Aristotle 1984a: 602; Lindberg 1966). The other variant, supported by Seneca and several thinkers after him, had the reflection occurring from the cloud as a whole, which faces the viewer in the form of a concave mirror. Accordingly, "the rainbow is an image of the Sun that is poorly reproduced" in what amounts to a misshapen mirror. The variation in color results from the interplay of sunlight on the matter of the cloud, so that "the liquid now produces blue lines, now green, now purplish, yellow or fiery" (Seneca 2010: 147).

The second general explanation depended on refraction rather than reflection. This explanation had two fundamental variants as well. One, championed by Grosseteste, was based on the idea that the raincloud, as a whole, acts like a lens of sorts, refracting the incoming light to create a spectrum, which is presumably then projected onto a dark cloud behind it. Since, moreover, "color is light mixed with a transparent body," the spectrum itself is due both to variations in the refracting cloud's purity, which is greatest toward the top and least toward the bottom, and to the relative brightness of the incoming light (Grosseteste

1912: 76–9). The second variant, already briefly discussed, was proposed contemporaneously by Kamāl al-Dīn al-Fārisī (c. 1265–c. 1320) and Dietrich of Freiburg (c. 1250–c.1310). According to their theory, the rainbow is produced by rays refracted into and reflected within individual raindrops, so the colors that result are associated with the angles at which the light rays enter and exit the drops.

Whether it appealed to reflection, refraction, or a combination of both, the ancient and medieval analysis of the rainbow raised two key issues. The first involved the number of the rainbow's main constituent color bands. Aristotle, as we have seen, limited such bands to three, that is, red, green, and violet in order from top to bottom in the primary bow, although he admitted that an illusory yellow band can be seen between the red and green ones. As expected, a number of medieval thinkers, such as Witelo and Nicole Oresme, agreed with Aristotle on this matter (Witelo 1572: 400–2; Oresme 1974: 341–5). Others, most notably Dietrich of Freiburg, argued against Aristotle that the yellow band was real, not illusory, so the colors of the rainbow totaled four, not three (Boyer 1959: 113). Even earlier, in fact, certain Arabic thinkers had parted ways with Aristotle over the number of colors in the rainbow, a number of them including yellow along with red, green, and blue (Kirchner 2015).

The second key issue centered on the status of the colors in the rainbow, whether they are somehow real or only apparent. On the face of it, this would seem to be a nonissue. After all, as Seneca observed, anyone approaching a cloud containing a rainbow will see the colors disappear, even though the cloud itself will remain visible (Seneca 2010: 150–2). In other words, rather than belonging inherently to the cloud as colors do to physical objects, those of the rainbow are obviously viewer-dependent and therefore subjective. Albertus Magnus mentions one other differentiating factor between physical colors in the form of pigments and those of the rainbow. Pigments, he claims, are formed from earthy matter, which is impervious to light, whereas the colors of the rainbow are formed in matter that is penetrable by light. That is why painters cannot reproduce the colors of the rainbow with perfect fidelity, since their pigments are necessarily created from earthy materials (Albertus 1890: 674a).

The question of whether the rainbow's colors are real or only apparent was complicated by the fact that the spectrum projected by a hexagonal crystal or a water-filled urinal flask is precisely the same as that produced within the rainbow. Unlike that of the rainbow, however, this projected spectrum is "fixed," insofar as it remains in one place no matter the viewpoint from which one looks at it, whereas the rainbow shifts with every shift in that viewpoint. This is not to say that the colors of the rainbow are merely imaginary, though; after all, they have a material cause in the water-laden cloud and its physical structure according to the relative density of constituent drops, which increases from top to bottom (Oresme 1974: 281–99; Albertus 1890: 682b–4a). It follows,

therefore, that each of the colors in the rainbow has a distinct and constant physical cause in the quality of the aqueous medium producing it: the denser and more impure that medium, the less vivid the color and the more it tends toward black according to the weakening of the refracted light.

On the whole, therefore, medieval thinkers distinguished the colors on the surfaces of physical objects from those created by sunlight shining at an appropriate angle on rainclouds according to the former's "fixity" and the latter's viewer-dependence. It is not surprising that certain thinkers, such as Bacon and Witelo, recognized that the spectrum produced by projecting sunlight through crystals and water-filled urinal flasks is identical in type and order to the spectrum of color bands in the primary rainbow. Somewhat surprising is the fact that some of these thinkers failed to draw a clear connection between the two spectra.

CONCLUSION

A few key points emerge fairly clearly from this account of medieval color theory. First, and perhaps foremost, is that, although medieval thinkers understood light and color to be utterly interdependent, they nonetheless made a clear ontological distinction between the two. In that regard, there is a conceptual abyss between the medieval and the post-Newtonian understanding of light and color, the latter of which elides the two by reducing light to constituent colors. Likewise, the medieval view of colors as objective qualities, actually *in* physical bodies, is at odds with the post-Newtonian view of colors as subjective impressions arising from, but wholly unlike, their physical causes. It is also at odds with the assumption on the part of most medieval thinkers that the rainbow consists of bands of color that are not in the cloud and are thus apparent rather than real.

A second salient point is that virtually every medieval theorist supposed that black and white—not necessarily colors themselves—formed the contrary extremes for the production of color. These extremes, moreover, were often tied to the clarity or obscurity of light according to its interaction with relatively transparent or opaque bodies. In addition, there was no clear agreement about whether the spectrum of colors produced by various proportions of black and white was unilinear or multilinear. The most extreme proposal in this regard was that of Grosseteste, who proposed fourteen separate lines of production and thus what amounts to sixteen "primary" colors, including the white and black extremes.

A final and perhaps most salient point is that there was considerable disagreement among medieval theorists about color. The clearest example of this is Grosseteste, who not only posited what amounts to sixteen primary colors (all unnamed except for black and white) but also proposed a model

of color based on three variables rather than the two (that is, transparency and brightness) normally accepted by his contemporaries. In this, he seems to have groped toward something like a modern conception of color space. Yet he seems to have been something of a voice crying in the wilderness, unheard by virtually everyone but Roger Bacon.

CHAPTER TWO

Technology and Trade

JO KIRBY

Many of the dyes and pigments used during the medieval period were already known in earlier centuries—for example, the pigments lead white and verdigris, mordant dyeing with madder and other dyes, and vat dyeing with woad—although some new dyes were introduced from Southeast Asia. In contrast, the production and working of colored glass, initially based on Roman and Near-Eastern practice, developed throughout the period.

Knowledge of the technology and use of the materials that gave color to painted surfaces, textiles, glass, and other artifacts between 500 and 1400 is derived primarily from the artifacts themselves, enabled by information provided by scientific analysis, although information is also obtained from contemporary written sources describing manufacturing, use of materials, and their trade.

WRITTEN SOURCES FOR THE PRODUCTION OF COLORING MATERIALS

Few practical texts describing materials and their use in painting and dyeing survive from the earlier part of the period, but there are several from the thirteenth and fourteenth centuries when sources were copied throughout Europe. By about 1200, the sources also included Latin translations of important Arabic and Greek texts.

An early example is the so-called *Compositiones variae* (Various Compounds) from around 800. Much of its content dates from Hellenistic times, but some of the early recipes are for materials still used and made in the same way centuries later (Burns 2017). Recipes are also found in the *Mappae clavicula* ("Mappae

clavicula: A Little Key to the World of Medieval Techniques";[1] which contains instructions for working with metals, glass and mosaics, dyeing and some pigments. The work is known from manuscripts dating from the ninth to the late eleventh century, but individual recipes are found in other manuscripts. It is possible to trace some recipes back to such early collections as the *Papyrus Graecus Holmiensis* (The (Greek) Stockholm Papyrus). The text includes recipes for dyeing wool with dyes such as woad, madder, and orchil lichens.

Other texts were original to the medieval period. An example is the *Schedula diversarium artium* (List of Various Arts) compiled in the early twelfth century under the pseudonym Theophilus Presbyter (Hawthorne and Smith 1979; Theophilus 1986). This influential work describes aspects of painting, glassmaking, and metalwork. Another useful text is the *Liber diversarum arcium* (Book of Various Arts) (Clarke 2011). The best-known source of all is Cennino d'Andrea's *Il libro dell'arte* written in the 1390s; it deals primarily with painting and gives precise descriptions of pigments and their use (Thompson 1960; Broecke 2015).

PIGMENTS AND PAINT

Paint consists of an insoluble, powdered pigment mixed with a suitable binding material. Gums, animal glues, egg, and oil were all used as binders, depending partly on the surface to be decorated (compare Plates 2.1 and 2.2).[2]

Physical or chemical properties of the pigment, its cost, the purpose of the object, and the status of the owner might all be significant factors in the choice of materials. The pigments available included natural minerals, crushed, washed, and levigated (reduced to a fine powder or paste) to remove impurities. Others were manufactured and included mineral pigments, such as lead white, and pigments made from natural dyes. As most of the dyes available were water-soluble, they usually needed to be converted into a solid form by precipitating or absorbing the dye onto a suitable substrate, so that they could be used as pigments, although for use in watercolor on parchment or paper this was not always necessary. Metals—gold and silver, tin and brass—were also used, generally in the form of thin leaves or thicker foils.

Blue

The most prestigious and expensive of all pigments was ultramarine, used in European painting from the tenth century (see Plate 2.1). It was extracted from the semiprecious stone lapis lazuli, found in the Koksha river valley in northeastern Afghanistan. This region had been mined from the seventh century BCE and appears to have been the only source exploited for lapis at the time and for centuries later. The thirteenth-century Venetian merchant Marco Polo describes the stones as originating in a vein in the mountains (Latham

1976: 76–7). Lazurite retains its strong blue color even when finely ground (Plesters 1993); however, as it is associated with calcite and other minerals, merely grinding it gives a rather pale blue. During the thirteenth century, an elaborate extraction method was invented. Cennini describes the process: the ground mineral was kneaded in a paste made of oil, wax, and resin under a solution of lye. The blue lazurite particles were released into the lye, the largest first, while the impurities and smaller particles were retained in the greasy mass. The liquid with the blue particles was decanted off and the pigment allowed to settle out, while the kneading process was repeated with another portion of lye (Thompson 1960: 36–9; Broecke 2015: 87–93). Eventually, several grades of pigment were obtained, the last containing the smallest blue particles and a higher proportion of mineral impurities. The method works because lazurite is hydrophilic (has a tendency to mix with water) and is not retained in the greasy paste.

Another important blue pigment was azurite, a basic copper carbonate mineral that usually occurs in association with the related green mineral, malachite. The use of azurite increased from the twelfth century onwards. Sources included mountainous regions of Saxony and Bohemia, France, Slovakia, and Hungary and, in early times, Armenia (see Figure 2.1). The color varies from pure blue

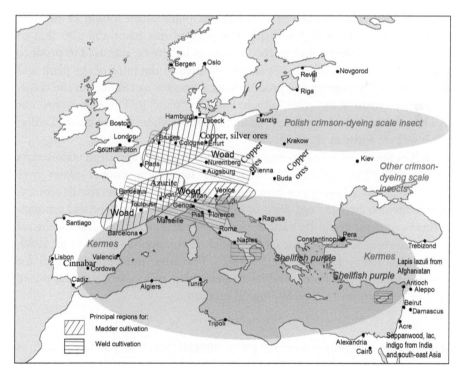

FIGURE 2.1 Map showing the principal regions in Europe where dyes were cultivated and copper ores, including azurite, mined up to c. 1400. © Jo Kirby, 2018.

to greenish blue (see Plate 2.2). The more coarsely it is ground, the stronger the color (Gettens and FitzHugh 1993a). The best grades were the most expensive, rivalling ultramarine in price, and a test, using hot coals, helped merchants distinguish between the two stones (ultramarine is unaffected; azurite is converted to black copper oxide). It is described by the fourteenth-century merchant Francesco Balducci Pegolotti (1936: 372).

Indigo, a deep blue of very fine particle size and a dye, has been identified in manuscripts from the eighth century onwards (see Plate 2.3). It is insoluble once extracted from its plant source and could therefore be used as a pigment without the processing necessary for most other dyes. The principal European source was woad (*Isatis tinctoria* L.). The pigment was a byproduct of the dyeing process: during dyeing, a blue scum of insoluble indigo collected on the surface of the vat, which could be skimmed off, washed, and dried (Schweppe 1997).

The other source of indigo was the indigo plant itself (for example, *Indigofera tinctoria* L.), native to India. It was imported into Europe in the twelfth century in the form of dark blue lumps. It was used more as a pigment than a dye, partly due to the resistance of the European woad industry, even though it was identical to the indigo produced in the woad vat.

Mention should also be made of other plant dyes, which were used as blue pigments in watercolor and so in manuscripts. Typical of these is a blue color obtained from the sap of a herbaceous plant called *folium* or *turnsole* (*Chrozophora tinctoria* (L.) A. Juss). The juice of this plant and also that of other flowers or berries, such as cornflowers or bilberries, was used to produce clothlets. Small pieces of clean linen were soaked in the juice of the plant and allowed to dry, repeating the procedure as necessary to strengthen the color, and perhaps treating the color with an alkali to "blue" it. This was carried out on a large scale in the Languedoc region of France, where folium grew (Cardon 2007: 492–3; Kirby et al. 2014: 20).

Recipes for copper-containing synthetic blue pigments appear in manuscripts from *c.* 800. The earliest recipes describe suspending copper plates over vinegar to produce blue-green basic copper acetates. By the fourteenth century, ingredients also included egg shells or lime and sal ammoniac. The end products of these reactions could be basic copper carbonates or, in the case of the sal ammoniac recipes, darker blue cuprammonium compounds (Orna et al. 1980; Orna et al. 1985; Howard 2003: 50–7). The large number of recipes for synthetic blues at this time could be a result either of a shortage of the mined blues or an interest in the technological processes.

Green

Many of the naturally occurring green minerals used as pigments, such as malachite, contain copper. In Europe, local copper ore deposits were probably used as a source of green pigment (Richter 1988). All are similar in color, a

strong bluish green in mass, but a light bluish green once ground to a usable powder (see Plate 2.1). Geologically, malachite occurs frequently, usually with azurite and the copper silicate chrysocolla. Like azurite, it is a basic copper carbonate and as a mineral well known for its attractive banded appearance (Gettens and FitzHugh 1993b). For years, it was assumed that any pale green pigment seen in an art work was malachite; however, sophisticated methods of analysis have revealed a more complex picture. It is now known that the original copper-containing pigment used may have altered chemically over time due to environmental factors (Howard 2003: 78–92).

Green earth is the pigment recommended by Cennino Cennini for use as an underpaint when painting flesh. Fourteenth-century Florentine painting provides typical examples (Thompson 1960: 30, 93–4; Bomford et al. 1990: 40–1; Broecke 2015: 77–8, 190–1). Green earth is a soft, clay-rich material found throughout Europe and easily prepared for use by grinding.

Green copper-containing pigments were also prepared synthetically. Recipes for synthetic copper carbonate blues (other than the cuprammonium blues) might yield greens, depending on the conditions (Mactaggart and Mactaggart 1980). The most important was verdigris. It is a bluish color in powder, but once painted, it becomes green because the copper gradually reacts with the binding medium. If the binding medium is oil or an oil-resin varnish, the paint layer has the appearance of a transparent, richly colored green glaze (Kühn 1993b). It was rarely used in an egg tempera binding medium, and recipes for its use in manuscript illumination (where it occurs from the eighth century) often recommend the addition of saffron or plant juices, partly to modify its initially bluish color and partly to halt its corrosion of the parchment (Davies 2003). Verdigris was prepared by the action of fumes of vinegar, wine lees, or similar substances on copper plates. Montpellier in southern France was noted for its preparation (Benhamou 1984).

Sap green was used in watercolor only and usually consists of the expressed juice of ripe buckthorn berries (*Rhamnus* species) stored in small pieces of pig's bladder until needed for use.

Vergaut is a mixed green, very commonly found in manuscripts and also in easel paintings. It usually consists of indigo mixed with the yellow arsenic sulfide pigment.

Red

Red lead or *minium* was known from Roman times as a product of the smelting of lead ore. Natural mineral minium is uncommon and was probably never used as a pigment. In medieval times, red lead was prepared by heating lead white in air. It was widely available, inexpensive, and a brilliant orange color. Moreover, it encouraged the drying of the oils used in painting. Red lead has been identified in illuminated manuscripts from the early eighth century

onwards (see Plate 2.3) and in European easel painting of all periods (FitzHugh 1986). It was commonly used in northern European wall painting in the late Middle Ages, but areas painted with red lead have frequently darkened or lightened because of humidity and other conditions (Howard 2003: 134–40).

Vermilion (red mercuric sulfide) is an opaque, brilliant scarlet red available from Roman times as the ground mineral, cinnabar. Almadén, Spain, was an important source for centuries (see Figure 2.1), since mercuric sulfide was the source of mercury (Gettens et al. 1993a). The method of making vermilion was known from around 800. Because of the cyclical nature of the mercuric sulfide, it was of interest to alchemists, and there are many recipes for the production of vermilion from this time onwards. Vermilion was used all over Europe in all forms of painting from the late eleventh century (see Plate 2.1), although it appears to have been used as early as the ninth century in manuscript illumination in parts of continental Europe.

The cheapest and most widely available red pigments were the red earths containing hematite, perhaps other iron oxides, and various clay minerals. Their color ranges from orange to warm brown, and red earths were useful pigments for all forms of painting, since they are stable. Mineral hematite itself is extremely hard, varying from black to dark red in color. Ground, it provides a dark purplish-red pigment particularly useful in wall painting. Red earths are found in deposits all over Europe (Helwig 2007).

The most expensive red pigments were made from red dyestuffs (see Plates 2.1 and 2.2). They were water-soluble and had to be precipitated onto a suitable substrate for use. The pigments were translucent, crimson to scarlet, or orange-toned reds, depending on the dye used. The most expensive were prepared from the dyes extracted from scale insects, such as Lac, *Kerria lacca,* (Kerr, 1782), which was imported from India and gradually spread west by the Muslim Arabic conquests. Lac insects are parasitic on certain trees and secrete a protective coating, enveloping the twig on which they are living in a thick, hard, brown mass. This material was exported, broken from the twigs or with the twigs still in place, and is described in fourteenth-century merchants' handbooks (Pegolotti 1936: 366). Pigment recipes from the ninth century onwards indicate that lac was an important source of dyestuff for pigment preparation. The raw material was treated with alkali to dissolve the dyestuff, and alum was added, giving a purplish-red precipitate of the pigment. This was dried for use (Kirby et al. 2014: 69–70, 84).

Dye extracted from the root of the herbaceous plant Dyer's Madder (*Rubia tinctorum* L.) and from the expensive scale insect Kermes, *Kermes vermilio* (Planchon, 1864), parasitic on the kermes oak, could also have been used. Both dyes became economically important in Europe (see Figure 2.1): madder was grown in northern and southern France, Belgium, northern Spain, and Lombardy; kermes was harvested particularly in southern France, Spain, and

Greece (Cardon 2007: 120, 611–12). Sappanwood (*Biancaea sappan* (L.) Tod.), imported from Southeast Asia into Europe by the twelfth century, was the source of an easily soluble red dye and was widely used for the preparation of pigments and inks, particularly for use in manuscripts.

In the last decades of the fourteenth century, pigments made from the expensive kermes dye, and possibly also the even more expensive dyes extracted from crimson-dyeing scale insects, such as the Polish "cochineal," used dye extracted from dyed textile material rather than from the insects directly. The more orange-toned madder lakes were also frequently made in this way; in fact, the color produced was often brighter, since impurities in the madder root were eliminated during the process (Kirby et al. 2014: 82–3).[3] This recycling process was an economical way of obtaining expensive dye from waste textiles.

Purple

The only purple coloring matters available were shellfish purple and those obtained from lichens and certain berries. After the fifth century, occurrences of shellfish purple used as a pigment have rarely been confirmed. Shellfish purple—including Tyrian purple—was extremely expensive. It is produced by marine mollusks, especially those found around the Mediterranean coast, in the case of Europe (see Figure 2.1). The most important are the Spiny Dye Murex, *Bolinus brandaris* (Linnaeus, 1758), the Banded Dye Murex, *Hexaplex trunculus* (Linnaeus, 1758), and the Red-mouthed Rockshell, *Stramonita haemastoma* (Linnaeus, 1767). The purple dye produced is closely related to indigo, the principal component being dibromoindigotin, which is a slightly reddish purple. The dye produced by the spiny dye murex consists entirely of dibromoindigotin and related products, and it is likely that this mollusk was the main source of Tyrian purple itself (Cardon 2007: 569, 579–80).

Orchil lichens (*Roccella tinctoria* DC) found all over Europe produce purple solutions on treatment of the powdered lichen with an alkaline, ammoniacal solution. The solution, a direct dye, was used to color the vellum or parchment of the manuscript before writing was carried out. Lichen purples have been identified on manuscripts dating from the eighth century onwards (Bioletti et al. 2009).

Yellow

Mineral orpiment, an arsenic sulfide, derives its name from the Latin *auripigmentum* (gold pigment) due to its glistening appearance and golden-yellow color (see Plate 2.3). It is found in mountainous or volcanic regions of Europe and was also imported from Turkey (FitzHugh 1997). In late medieval times, it was also synthesized by the sublimation of sulfur and arsenic ores (Howard 2003: 155). Although it was attractive in appearance and was used

in easel painting and for polychromed sculpture, its tendency to react with pigments containing lead or copper, which caused darkening, limited its use and made it unsuitable for use in frescoes due to its alkali sensitivity.

Yellow ochres are earth pigments gaining their color from iron oxide-hydroxides. Clay minerals and quartz are also often present. Like the red earths, yellow ochres are stable pigments varying in color from bright yellow to dull light brown. They are widespread in Europe, although Italy and France produced particularly bright yellow ochres (Helwig 2007).

Organic yellow pigments included bright golden-yellow saffron (from the Saffron Crocus, *Crocus sativus* L.), which was used in manuscript illumination. The yellow colorant was extracted in water and used as a paint. Other yellow dyes were usually converted into insoluble pigments in much the same way as the red dyes by precipitating or adsorbing them directly onto a suitable substrate. The dyes used included weld (*Reseda luteola* L.), a plant dye of considerable economic importance grown all over Europe (see Figure 2.1), and Dyer's Broom (*Genista tinctoria* L.) found on heaths and in dry woodland (Cardon 2007: 169, 175–6, 179–81). These pigments were used in manuscript illumination and easel painting by the fourteenth century.

Yellow lead monoxide could be prepared by heating lead white. However, its rapid darkening made it a poor pigment. In the thirteenth century, pale yellow pigments made from lead and tin became available: lead-tin yellow (type unspecified) was identified in a late thirteenth-century wall painting in Angers Cathedral, France (Howard 2003: 162). Unlike lead monoxide, lead-tin yellows are stable. The use of lead-tin and lead-antimony oxides as opacifiers for glass was known centuries earlier, and one of the two forms of the pigment (lead-tin yellow type II) is associated with the glass industry. This appears to be the earlier form used and has been identified in fourteenth-century Bohemian, Florentine, and Venetian easel painting (Kühn 1993a; Bomford et al. 1990: 37–9), all places associated with glassmaking (see Plate 2.1). Lead-tin yellow type I, which appears to be more closely associated with the ceramics industry, was made by heating lead and tin oxides together to 650–800°C or by calcining lead and tin and then adding more red lead.

White and black

Lead white was prepared by suspending lead over vinegar fumes in a warm environment, a method known from classical times. It was opaque in all binding media and was used all over Europe throughout the medieval period, in all forms of painting, although it sometimes darkens in aqueous binders and was not suitable for use in frescoes.

One white pigment was used only in frescoes: lime white. It was made by allowing quicklime to absorb water and carbon dioxide from the air, giving so-called "air-slaked lime," which was then combined with water and stirred for eight days (Howard 2003: 165–70). Since it still retained a proportion of

unreacted calcium hydroxide, it was able to set—and bind other pigments—on drying in a similar way to the calcium hydroxide plaster of frescoes, but it is more opaque than calcium hydroxide so that the exact hue of other pigments mixed with it is easier to assess. It also shrinks very little on drying. For other forms of wall painting, however, it had no advantage over chalk. Both chalk and gypsum were used as white pigments in manuscript illumination and in preparatory or ground layers in easel painting and for polychromed sculpture. Both are too translucent to serve as white pigments in oil paint, where lead white was used (Gettens et al. 1993b).

Black pigments were usually based on carbon and obtained by burning. Charcoal was made by burning wood to provide brittle black sticks that could be used for drawing or used as a pigment. Mixed with white, charcoal also produced a bluish-gray, which served as a blue color in wall painting. Moreover, the mixture was used beneath areas painted with expensive blue pigments, such as ultramarine or azurite.

METALS

Metals contributed a luxurious shine and reflection to medieval painting (see Plates 2.1 and 2.2). The most important was gold, applied in the form of a thin leaf over a layer of clay-containing bole (a ground or foundation) in an animal-skin glue binding medium. The bole was commonly red in color. For fine detail, gold could also be applied over a mordant, essentially a fairly quick-drying oleo-resinous varnish colored with ochres and other pigments, applied in the desired pattern. The thin leaf adhered to the sticky mordant, and the excess could be brushed away for reuse. Silver leaf and a mixed leaf made of gold and silver beaten together were also used. Silver tends to tarnish over time, and this unfortunate property affects the mixed leaf. During the thirteenth century, powdered gold and silver (known much earlier in countries further east) began to be used, particularly in manuscript illumination and later in easel painting. It was often stored in shells and could be applied with a brush or pen in fine delicate lines in a gum or egg white binding medium (Bomford et al. 1990: 21–6, 43–7).

On walls in particular, more robust tin foils colored with tinted varnishes were often used. For cheaper work, a foil made of brass was available. From the fourteenth century, mosaic gold, gold-colored tin sulfide, made by prolonged heating of metallic tin and sulfur with mercury and ammonium chloride was occasionally used.

DYES

Natural dyes can be divided into several, chemically different classes as well as different categories from a technological point of view, depending on the ways in which they have to be treated in order to dye the textile. In all cases,

however, the dye is in solution, and dyeing takes place in a bath or vat of liquid, usually water, sometimes an alkaline solution, such as the ammoniacal solution provided by stale urine. Textile fibers themselves fall into two categories: cellulosic, such as linen and cotton, and proteinaceous, such as wool and silk. Wool and silk dye quite readily; linen and cotton require a more intensive treatment, if mordant dyes are to be used.

A wool textile could be dyed at any stage in the manufacturing process. If dyed as a fleece, the wool fibers are well penetrated by the mordanting and dyeing solutions, and the final color is very strong and saturated. Differently colored fibers could be blended to give a mixed color or other effects. Very commonly, however, dyeing was carried out once the fibers had been spun. This, too, allowed color effects, such as stripes and checks, in the final fabric. In the case of silk, the shimmering effect of shot silk could be obtained by using one color for the warp thread and another for the weft. Textiles, particularly wool, were also dyed in one piece. This required large vessels to ensure thorough and even penetration of the fabric with the solutions and was more economical, as less mordant and dye was needed in proportion to the weight of textile dyed. As wool fabrics were fulled (scoured or washed with urine or soap and fuller's earth and then thickened by matting the fibers), they were dense, so only the surface was treated.

TECHNIQUES OF DYEING

The simplest dyeing method was direct dyeing, since the dye bonds directly to the textile without the need for any particular preparation of the textile fibers or of the dye solution itself. However, the dye was not very fast to either light or washing.

Most dyes are mordant dyes. These require the addition of a mordant salt to the fiber before dyeing. This salt contains a coordination metal, which attaches to both the fiber and the dye molecule and forms a bridge between the two. During the medieval period, the mordants were salts of aluminum and iron, although copper salts could also be used.

Alum was one of the most important items of trade in the medieval period, and methods to obtain it from aluminum-containing rocks, principally alunite, were already well known in classical times. The stone was roasted and weathered until it crumbled; it was then extracted with hot water; and the potash alum was allowed to crystallize out. The main sources of alunite were in Anatolia, particularly Phocæa (present-day Foça). By the 1270s Phocæa and the rich alum resources had been leased to Genoa, which thus had control of this profitable part of the alum trade until the 1450s (Cardon 2007: 23–4).

Iron as a mordant appears to have been known even earlier than aluminum. The principal mordant was ferrous sulfate, which was obtained by the weathering

of marcasite. Pyrite itself or chalcopyrite were also sources. In addition, the acetate prepared by dissolving iron rust, turnings, or other waste in vinegar was used. Unlike aluminum, iron mordants affect the colors of dyes with which they are used, making them duller or darker. With tannin dyes, such as the bark of oak or alder, iron mordants give grays and blacks (Cardon 2007: 40–2).

Vat dyes, such as indigo and shellfish purple, are present in the plant or shellfish in the form of precursors that need to be extracted for dyeing to take place. In the case of indigo, this is done by fermentation, and the almost white, soluble precursor molecule formed is known as indoxyl: two indoxyl molecules combined by air oxidation give one insoluble dark blue indigotin molecule. Dyeing can be done before the indoxyl is oxidized; usually, however, the dyeing process was separate. It consisted of reducing the indigotin in processed plant matter, such as dried woad (or indigo powder), to a pale greenish-yellow soluble form known as indigo white, which can then penetrate the textile fibers (Cardon 2007: 338–40). When the textile is removed from the vat, the blue color develops as a result of air oxidation of the white precursor to insoluble indigo within the textile fibers. It can be repeated to give a stronger color (345–6). The dyeing mechanism for shellfish purple, based on the formation of a reduced, soluble form of the dye, is similar, although the exact procedure carried out in medieval times is still uncertain.

Apart from berries that might be used for domestic dyeing, all blue dyeing was carried out almost exclusively by using woad. Imported indigo was occasionally used in the thirteenth and fourteenth centuries, but generally not for wool (Cardon 2007: 364). To prepare the woad for use, and also as a commercial commodity, the harvested leaves were crushed to a paste and molded into balls that were allowed to dry. In this form, the woad could be transported and traded. For use, the dried balls were broken with mallets to give a lumpy powder, which was spread out in thick layers, watered, and allowed to ferment. After a few weeks, small grains were formed from the paste and the woad was ready for use (367–70). The woad industry was of importance in, for example, Toulouse (France) and the Erfurt (Germany) region, where it was grown on a commercial scale, but it was also grown locally all over Europe (see Figure 2.1).

There was no naturally occurring green dye. Green was obtained by dyeing blue with indigotin and then mordanting with alum and dyeing with a yellow dye, such as weld or dyer's broom.

The most expensive red dyes were the scale insect dyes. Kermes was used on the finest grades of wool and on silk to give a bright scarlet red (see Plate 2.4). The dye was obtained from the bodies of the adult female insects or from the eggs alone, and the insects were carefully harvested by hand around mid-summer. As the use of shellfish purple gradually died out, kermes came to be the dye used for the most precious royal and ecclesiastical robes throughout the medieval period (Cardon 2007: 610–18).

Even more expensive than kermes were the crimson-dyeing scale insects of the genus *Porphyrophora*, commonly but incorrectly called the Old World "cochineals" (see Figure 2.1). These dyes, too, were already in use in the sixth century. The best known of these are Polish and Armenian "cochineal." Polish "cochineal" is found as small, parasitic cysts feeding on the roots of the perennial knawel and other plants. Either the cysts or the adult insects that hatch from them were harvested and used for dyeing (Cardon 2007: 637–40). Armenian or Ararat "cochineal" is found in sandy regions from the Caspian Sea across central Asia. It is larger than the Polish insect, but is less efficient in dyeing. These insects were used to dye crimson, a bluer red than that given by kermes. The dyestuff they contain is principally carminic acid: the same as that in the American cochineal, but in much smaller quantity. They were only used to dye silk, which takes up less dye than wool; it was too expensive to use them even for the finest wool (Cardon 2007: 635–52).

Madder was the principal red dye. It was cultivated widely, particularly in northern and southern France, the Low Countries, and Lombardy (see Figure 2.1), and produced a wide range of colors either alone or in combination with other dyes. It was traded in large quantities across Europe. By the mid-fourteenth century, mills were in use to crush the roots, and the powdered root was graded according to quality. Madder dye is complex; the manipulation of its constituents contributes to the wide range of colors—oranges, reds, and browns—the root can give, even without the aid of other dyes (Cardon 2007: 110–20).

Sappanwood was imported into Europe by the twelfth century. The dye is obtained from the heartwood, which had to be cut up and ground to powder for use. A better result was obtained if the solution resulting from boiling the powdered wood in water was allowed to stand for several days; it then gave a beautiful crimson-red color. However, the dye was known to fade. Throughout Europe it was forbidden to use it alone, but it could be used to give bluer-toned reds or purplish shades on wools previously dyed with madder or woad (Cardon 2007: 281–6).

Shellfish purple—including Tyrian purple—is a vat dye. The dye is present in the hypobranchial gland of the shellfish in the form of soluble precursors, which are converted to the final purple form, following rupturing of the gland, by a combination of enzymatic reactions, air oxidation, and exposure to light. Tyrian purple—dibromoindigotin with related constituents—is produced by the spiny dye murex; the dye produced by the banded dye murex gives a bluer purple as it also contains indigotin (Cardon 2007: 554–7). It is unclear precisely how purple dyeing took place, but it seems that as long as the vat is kept in darkness with the correct pH and temperature maintained, the bacterial process required to achieve fermentation continues because of the presence of some of the flesh of the mollusks inevitably present (559–62).

The high prestige of purple resulted from its association with the Roman emperors. With the fall of the Roman state, purple-dyeing workshops declined across the Mediterranean region, although they still functioned in Athens and other parts of Greece and particularly in Constantinople in the twelfth century. Purple dyeing only came to an end in Constantinople, when the city fell to Turkish invaders in 1453 (Cardon 2007: 571–6).

Lichen purples were used all over Europe. The dyeing solution is prepared by treating the crushed lichen with an alkali, such as calcined wine lees, and stale urine. After some days, the liquid turns dark brown and then reddish, and it is ready after several weeks. For use, more water is added, the liquid is heated slowly, the textile to be dyed is added, and heating is continued until the desired color is obtained. Lichen dyes were often used with indigo to give more purple blues and also to give purple tones with the red mordant dyes (Cardon 2007: 489–91, 497–502).

Saffron could be used as a direct dye, giving an orange or yellow, depending on the quantity used. It was expensive and faded rapidly, but it was used on silk and fine linen and also for underwear, to which it gave its particular scent. However, the most important yellow dyes were mordant dyes obtained from weld and dyer's broom, species of buckthorn, various dyewoods such as young fustic (*Cotinus coggygria* Scop), and other plants.

Unlike red and blue dyes, yellow dyes tended to be local, primarily because important plants were readily available and could easily be delivered to dyeing centers. Furthermore, flavonoids, the chemical constituents responsible for the yellow coloration in mordant dyes, occur in many plants. As a result, certain plants were important in particular areas, but were not traded widely. An example is Flax-leaved Daphne (*Daphne gnidium* L.), used to provide yellows and greens in southern France and parts of Spain where it grows extensively. Another was Sawwort (*Serratula tinctoria* L.) used in fourteenth-century Tuscany, since it was rich in coloring matter (Cardon 2007: 169–95). However, where the demand from textile dyeing centers increased considerably, commercial production often resulted, as in the weld-growing industry of southern France and parts of Italy, established by the fourteenth century.

Tannin-containing dyes often give browns with alum mordants; with iron mordants they give grays and blacks. Tannins are complex polyphenols found widely in the wood and bark of trees and shrubs such as species of oak and alder. In thirteenth-century Europe, the bark of Sticky Alder (*Alnus glutinosa* (L.) Gaertner) and other species was used with an iron mordant to dye black, although its use was strictly regulated and forbidden on high-quality wool textiles, because the combination of iron and tannin had a corrosive effect on that fiber.

Oak galls, produced on young oak twigs by female oak gall wasps puncturing the twig to lay their eggs, were also used with iron mordants to give blacks,

particularly on silk. The most widely traded galls were obtained from the Aleppo or Gall Oak (*Quercus infectoria* Oliv.) found in eastern Mediterranean countries. The use of galls with iron mordants was also regulated, but black dyeing was too necessary to maintain a ban. Accordingly, iron-gall dyes were used on silk and linen-based textiles and were eventually permitted on wool. Moreover, galls were used throughout the medieval period to make black ink, with ferrous sulfate and a little gum arabic. Finally, for high-quality textiles, blacks were obtained by dyeing a very dark blue with woad, then mordanting the textile with alum and dyeing with madder. This was the most expensive color-fast black available in the medieval period (Cardon 2007: 374, 410–18, 423–7).

COLORING OF GLASS AND RELATED TECHNOLOGIES

Color in glass is due to the presence of traces of particular metals in the matrix, primarily copper, iron, manganese, and cobalt; lead, tin, and antimony also contribute, the latter two in the role of opacifying agents (see Figure 2.2). As some of these metals were present in the raw materials used for glass manufacture, even nominally white or colorless glass might be slightly colored (frequently green due to the presence of iron in the sand). Iron also gives yellow, copper gives a stronger blue-green, cobalt gives blue, and manganese gives a purplish color but was also used to decolorize glass, which would have been colored an unwanted green by iron. In fact, both iron and manganese can give a yellow color to glass, depending on how long it is heated. This is described by Theophilus in *De diversis artibus* (Hawthorne and Smith 1979: 54–7; Theophilus 1986: 41–2; Freestone 1992).

For making glass, plant ash alkali was, from the eighth or ninth centuries, used as a flux, potassium-containing wood ash in the north and a sodium-containing plant ash in the south, replacing the natron (natural sodium carbonate) used earlier. Recycled Roman glass was also used for a time and the use of Roman *tesserae* (small mosaic pieces) to color glass remained popular for several centuries. Theophilus wrote that French glass workers used blue *tesserae* to make blue window glass (Hawthorne and Smith 1979: 59; Theophilus 1986: 44–5; Freestone 1992). By the late twelfth century, however, a source of cobalt ore in Freiburg, Germany, had become available so the use of *tesserae* gradually died out (Gratuze et al. 1995).

The production of red glass required different conditions to the other colors, which are produced in a furnace under oxidizing conditions. Red glass required reducing conditions so its production may have become a separate activity. The red color is due to the presence of nanoparticles of copper, and the production of red glass was not straightforward. One method, identified in opaque red-glass Anglo-Saxon beads dating from the fifth to the seventh century, was to

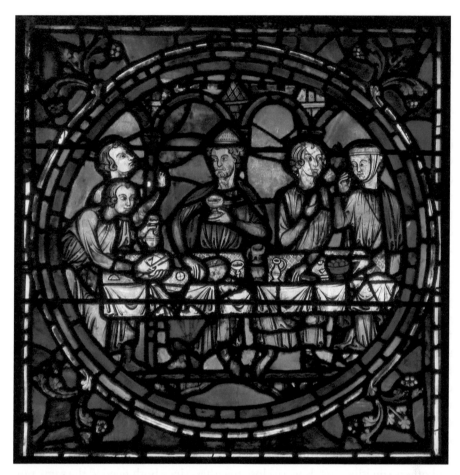

FIGURE 2.2 *Notre-Dame de la Belle Verrière* (detail), the Marriage at Cana, Cathedral of Notre-Dame de Chartres, thirteenth century. Stained glass window. Photograph by Vassil. Wikimedia Commons. Available online: https://commons.wikimedia.org/wiki/File:Vitrail_Chartres_210209_07.jpg. Public domain.

incorporate iron-rich metal slags derived from iron and copper smelting into the glass (Peake and Freestone 2012).

Red glass from the twelfth to the fourteenth century was produced by a complex method in southern and western Europe. Molten glass containing oxidized dissolved copper was mixed with a reduced low-copper glass (covered to avoid oxidation). A small amount of reduced low-copper glass was then dipped into this mixed glass, and a cylinder was blown. This was opened out to form a sheet, and subsequent heat treatment caused copper to diffuse from the copper-rich glass to the low-copper glass. Copper nanoparticles precipitated in

the low-copper glass, giving the appearance of fine striations, alternating with thicker regions of white glass. Manipulation of these initially faintly colored glasses to give red was a specialized craft, restricted to few workshops (Kunicki-Goldfinger et al. 2014).

Around the late fourteenth century, the way of making red glass changed, and a method known as "flashing" was used. It involved taking up a small amount of red glass in a blowpipe, dipping it into colorless glass, and blowing it into a cylinder, thus creating thin, differently coloured layers. The cylinder was cut and flattened while hot to produce a layered sheet of red and white (colorless) glass. The nanoparticles of reduced copper and thus the red color were probably produced during subsequent heat treatment of the flashed glass (Kunicki-Goldfinger et al. 2014). In parts of Italy and France, late fourteenth-century sources suggest that red glass was imported from Germany (Foy 2000: 162).

The red glass beads mentioned above also contained lead-tin oxide, which gives an opaque yellow glass. It is likely that the development of the yellow lead-tin oxide pigment in northern Europe resulted from lead and tin metalworking processes, such as the production of solder and pewter: the waste from calcined mixtures of lead and tin metals is pale yellow, which may have suggested a colorant (Tite et al. 2008). While the yellow pigment and the glass for the artifact could have been made together, remains from a seventh-century crucible found in Schleitheim, Switzerland, suggest that the yellow pigment was made separately, then added to another glass to make, in this case, yellow beads (Heck et al. 2003). Its presence in the red glass Anglo-Saxon beads could be explained by the reuse of a crucible used to produce the yellow pigment in a similar way. Conceivably workshops producing red and yellow opaque glasses and others smelting metals were close together, since both needed the same raw materials (Peake and Freestone 2012). The chemistry of the lead-tin compounds formed during the process is intricate and temperature dependent, and this also contributes to the development of white, opaque lead- and tin-containing glass and glazes for ceramics, a technique that was developed by Islamic potters in the ninth century (Tite et al. 2008) The opaque yellow glass is strongly colored, and it is not surprising that it became appealing to painters wanting an opaque yellow pigment.

In the early fourteenth century, another technique for coloring glass yellow was discovered: "silver stain." Silver salts were painted onto the surface of the glass and fired in a kiln. The silver diffused into the surface of the hot glass, forming a thin layer that could vary in color from lemon to orange yellow.

Enamels were made using opaque colored glass, which was powdered, applied to another surface, such as glass or metal, and then fused by melting. In the case of glass, it was important to avoid melting the artifact to which the decoration was to be applied while fusing it to the surface (Freestone and

Bimson 1995). *Cloisonné* enamel, typically seen in the decorative artifacts produced in Celtic and Germanic Europe from the fourth to the eighth century, consisted of fusing gold or, later, silver wire or thin metal strips to the metal surface to be decorated. The compartments (*cloisons*) thus formed could be filled with precious stones or powdered colored glass, which was then fused. In *champlevé* (raised field) enamel, the fields to be filled by the glass were carved out of the metal surface, leaving walls of metal, a much simpler technique. The most familiar *champlevé*-decorated artifacts are those produced in Limoges, France, from the twelfth century to the fall of the town to the English in 1370. The metal surface decorated was commonly copper (Biron et al. 1996; La Niece et al. 2010).

THE SUPPLY OF MATERIALS

It was not until after the eighth century that most of Europe benefited from the scientific advances brought to them through contact with Arabic scholarship via Greek literature, and that new materials gradually appeared in the artifacts produced in Europe. Vermilion red and ultramarine blue are both absent from manuscripts in the eighth century. Two or three centuries later, both pigments had been added to the painter's palette even as far away as Norway (Plahter 2010). Lac dye, which had already been brought to Egypt from India, spread to Spain with the Muslim invasion. It was followed into Europe by sappanwood from Southeast Asia.

Muslim shipping had dominated the Mediterranean throughout this period, but the impact of the Crusades to retake the Holy Land for Christendom encouraged Italian city states, such as Genoa, Pisa, and Venice, to trade with the eastern Mediterranean. Initially, the trade was productive and lucrative, spreading goods across Europe. However, the peace did not last. The fall of Jerusalem in 1187 was followed by further Crusades attempting to retake the city, and by the sack of Constantinople by the Venetians in 1204. Shortly after this, and throughout the thirteenth century, Mongol invasions from the east moved through China to Persia, southern Russia, west toward Poland, and south to Palestine (Frankopan 2015: 130–74). This disrupted supplies of ultramarine from Badakhshan (parts of modern Afghanistan and Tajikistan) to Europe. The Mongols were probably inadvertently responsible for a further significant interruption to trade and normal life: the Black Death, which devastated Europe in the 1340s and 1350s.

Genoa was a significant player in European trade during this period and a serious competitor to Venice, but the role of Venice in Mediterranean trade and especially in the color industries cannot be overstated (see Figure 2.3).

By the twelfth century, Venice was trading with Byzantine regions, Egypt, the Muslim world, and the other Italian city states, particularly through the

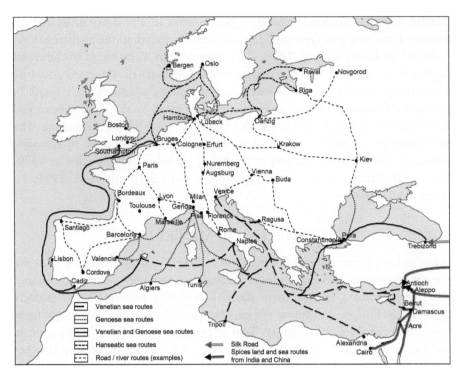

FIGURE 2.3 Map showing the principal European trade routes up to *c*. 1400. © Jo Kirby, 2018.

Adriatic Sea (Jacoby 2009). By the 1370s, after Genoa had faded as a rival, Venice had control over sea trade throughout the Mediterranean (Frankopan 2015: 193–5). Among other things, the city developed a reputation for the supply of ultramarine and other high-quality pigments.

The northern seas were also significant, allowing transport of goods through the Baltic and North seas, between Danzig (Gdansk) on the Baltic coast to Bergen (Norway), Bruges (Belgium), London and Southampton (England), and around the European coast to the Mediterranean (Childs 2010; Norseng 2010).

By the fourteenth century, Europe was crossed by road and river routes, allowing the passage of merchandise between large trading centers and regularly occurring market fairs (Spufford 2002, 2010). The spices sold included those used for painting and dyeing. While in many cities, including Cologne, Paris, and London, painters had their own guild, in Florence, the painters belonged to a section of the Guild of Doctors and Apothecaries along with other craftsmen, such as barbers and saddlemakers, and they used some of the same materials. Merchants, therefore, often traded in a wide range of goods, and an example

is provided by Francesco di Marco Datini, a late fourteenth-century merchant based in Prato (Italy), who traded with many cities in Europe. His main interest was in textile manufacture and trade, but he also ran a dyeing company, and the merchandise carried by his ships included dyestuffs, such as indigo, lac, sappanwood, and pigments (DeLancey 2010). The list of spices given in Pegolotti's handbook shows how very varied and substantial this trade was (1936: 293–7).

In larger towns, materials could be sold by apothecaries or traders. The inventory of the goods in the Pinerolo shop of Pietro Fasolis (Piedmont, Italy) made in 1398 reveals a range of materials, including azurite, verdigris, realgar, lead white, indigo from Baghdad, sappanwood, resins, waxes and ready-prepared varnish as well as pepper, mace, and medicinal preparations (Gabrieli 2012, 2013). Accounts for the painting and other materials required for building and refurbishment projects carried out between 1375 and 1419 at Argilly, Germolles, and the Chartreuse de Champmol for the dukes of Burgundy, reveal that, although in the early stages materials were supplied by grocers and others living in Paris, Bruges, and Troyes, by 1386, several grocers living locally in Dijon supplied most of the materials necessary (Nash 2010).

Power and Identity

WIM BLOCKMANS

INTRODUCTION

Power, identity, and color are intimately connected. In the Middle Ages, strong and distinctive colors could only be produced by complex techniques and by applying expensive dye-stuffs and pigments, many of which were to be found only in very specific and distant locations. Cheaper coloring matter was less durable and less brilliant so, accordingly, it was usually only wealthy and powerful persons who could afford highly colored objects. Since medieval societies were fundamentally hierarchical, powerful people had to be visible. In the context of the technology available at the time, nothing could demonstrate this as effectively as an outfit in striking colors, often combined with banners, and the clothing of followers who thus announced their affiliation with a powerful and/or high-ranking person. Any eminent position in society had to be recognizable at a distance in order to constantly reaffirm status vis-à-vis the general public and possible contenders. People of lower rank, on the other hand, had to be prepared to show deference. For sure, there were other means of demonstrating power, whether spiritual, political, judicial, military, economic, or a combination of these, but color had an immediate impact. For this reason, it was one of the most efficient means of expressing an individual or collective identity and showing distinction.[1]

The use of color as a distinctive device is, therefore, associated with its appreciation or interpretation within a particular society. Accordingly, intercultural generalizations are purely speculative, and even within the context of medieval Europe one must be aware of major changes in the use of particular

colors and the meanings attributed to them. For example, Pastoureau (2000) points to the emergence of the prominent use of blue from the mid-twelfth century onwards after its near absence as a background decoration in previous centuries. Red, on the other hand, has been in very high esteem since biblical times and earlier, and was dominant in heraldic blazons until the fourteenth century, although it then lost some of its appeal at least for that purpose. In addition, modern terminology is often misleading with reference to descriptions of historical artifacts, since both the objects (the material colors) and the vocabulary were diverse and changed over time.[2] The technical composition of dyes and pigments varies considerably, since they were produced with various ingredients applied on different materials and, moreover, the colors preserved on medieval objects have often deteriorated over time, depending on their usage, storage, and interaction with their environment. As a result, contemporary perceptions of objects may differ from today's observation of similar artifacts. Nonetheless, it is possible to retrieve evidence for the use of color to indicate power (or lack of it) and identity with a particular group.

THE BYZANTINE EMPIRE

After the deposition of the last western Roman emperor in 476, Europe became divided into three different regions. The western parts of the empire developed into "barbarian" (non-Roman) kingdoms, while the eastern parts continued to exist as an empire for nearly a millennium. In the non-Romanized regions north of the Danube and east of the Rhine, migrations and successive conquests led to centuries of instability. The Eastern Roman Empire with Constantinople as its capital underwent its own evolution. Greek became the dominant language, a law code was established, and a complicated court ritual, based on Roman traditions, was maintained. The classic colors of power were purple and gold. The emperors dressed in purple, and their heirs were said to have been "born in the purple" (*porphyrogenetos*). Purple was the color most frequently mentioned in describing prominent persons. Various shades of purple and red were used for the decoration of holy objects in the interior of temples and churches. Gold became the most used background decoration in mosaics and painted images of saints (icons), as demonstrated by the marvelously preserved monumental complex in Ravenna built in the latter half of the sixth century.

As soon as the former late Roman and Ostrogothic capital of Ravenna was conquered by the Byzantine Empire in 540, it became the center of an exarchate (the territory of an *exarch* or governor). The exarch, in this case the local bishop, launched an intense campaign for the construction of basilicas and mausoleums, including an impressive decoration program intended to celebrate the new Byzantine authority as well as the new orthodoxy. The Ostrogothic rulers had espoused Arianism, which maintained that, since Christ was God's

son, he could not be his equal, but the new masters supported the Trinitarian interpretation of the Christian deity. They made their message very clear in the apsidal mosaic of the Basilica Sant'Apollinare in Classe, which was consecrated in 549 and dedicated to the first bishop of nearby Ravenna.

In the Basilica Sant'Apollinare, the importance of white as a color of Christianity and ecclesiastical power can be seen. The bishop is depicted in a white gown in the middle of a green landscape surrounded by twelve lambs. Directly above him, Christ's face appears in the center of a gemmed, golden cross enclosed within a large starry, dark blue sky disc. Two prophets, Moses and Elijah, both dressed in white, signify the resurrection of the dead, and three lambs around the disc allude to Christ's transubstantiation. God's hand descends from the top, illustrating the heavenly order. The entire apse is surrounded by a triumphal arch showing Christ's face surrounded by lambs and the winged symbols of the Evangelists. Christ's gown appears purple, and St. Apollinaris wears a dark, embroidered stole over his white robe, but all other figures are depicted in entirely white garments.

Secular power is more usually associated with the colors purple and red. A seventh-century mosaic on a side wall of Sant'Apollinare in Classe depicts the Emperor Constantine IV, wearing a purple robe. On this occasion, he grants a charter (probably a tax concession) to Archbishop Reparatus of Ravenna, who wears a golden stole over his white robe. Other features are more colorful than in the preceding century: there is a red curtain and a blue background, as well as other colorful decorative elements. However, it seems that a convention has been established, whereby purple is reserved for elite figures, such as Christ, St. Martin, and the emperors.

In the Basilica of Sant'Apollinare Nuovo, in Ravenna, the Trinitarian message is conveyed by the figure of St. Martin, fourth-century Bishop of Tours, as the first in a long row of saints in white robes with only him and Christ wearing dark purple robes. Martin was celebrated as a vigorous fighter against Arianism both in his home country of Illyria (in the western Balkans) and in Italy. In the same basilica, the Virgin Mary is dressed in a blue robe, a color which becomes closely associated with her. In general, gold and also dark or white robes are used for eminent saints and the highest clergy, while other saints, prophets, angels, and courtiers wear white garments.

The most famous mosaics are those in the Basilica San Vitale, also in Ravenna, which include depictions of Christ, the Emperor Justinian, the Empress Theodora, and Bishop Maximianus. Christ is clothed in a dark gown, and Justinian is dressed in purple and gold. Like Christ, Theodora is portrayed wearing a dark robe, but her jewelry is rather prominent (see Figure 3.1).

Bishop Maximianus wears a golden stole over his white robe with embroideries in black. Angels, courtiers, clergy, and patricians are all dressed in white garments (see Plate 3.1).

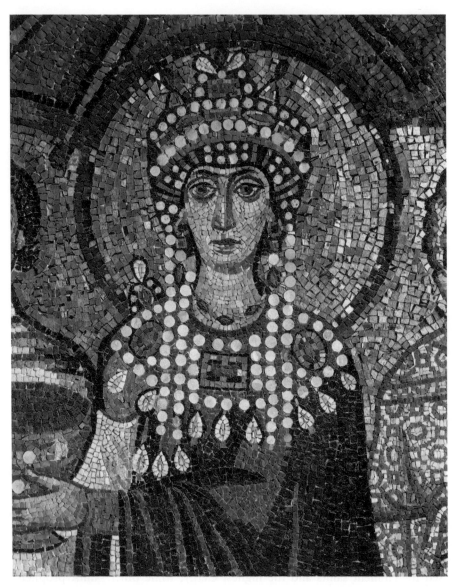

FIGURE 3.1 Mosaic (detail), the Empress Theodora, Basilica San Vitale, Ravenna, sixth century. Photograph by DeAgostini / A. de Gregorio. Courtesy of Getty Images.

The mosaics in Ravenna are an exceptionally important testimony to Byzantine culture, since art from that period was largely destroyed in the empire's core lands during the period of iconoclasm (730–843). By that time, the empire had already lost control over the northern Adriatic, allowing the older tradition to be preserved in this region.

From the late ninth century onwards, new mosaics were crafted in the Hagia Sophia in Constantinople, which include an enthroned *Virgin with Child* in the apse and another late tenth-century enthroned *Virgin with Child* in the vestibule, where she is situated with the emperors Constantine I (presenting a model of the city) and Justinian (holding a model of the Hagia Sophia). Emperor Leo VI (r.886–912) had himself depicted prostrated before Christ in a contemporary mosaic above the imperial door on the west side, and images of a series of patriarchs, including John Chrysostom, decorate niches of the north tympanum. Leo is wearing white and gold with just a sleeve in blue. The Madonna is repeatedly presented wearing a long, dark blue dress marked with gilded crosses on her head and shoulders. Like the kneeling Leo VI, Christ Pantokrator ("Ruler of All") is depicted in a long, white gown with gold and blue decorations. The patriarchs have three large gilded crosses on their white gowns, and all their backgrounds are in gold.

Since religious issues were closely associated with political matters in Byzantium, colors also indicated political identity. Horse races were as popular there as they had been in Rome, and their supporters were organized around the colors blue and green displayed on banners in the hippodrome (the horse-racing stadium) of Constantinople and in other towns. Since the fifth century BC, local militias had formed the basis of the political organization in towns and districts (*demes*). In the Byzantine period, the government appointed the leaders of the popular parties. The social composition of their membership did not make much of a difference, but the leadership of the so-called "Blue Party" had its roots primarily in the old land-owning senatorial class, while that of the so-called "Green Party" was recruited mostly from the officials of the court, the state bureaucracy, and the tradesmen.

Originally, the two "political" colors did not have a symbolic function. However, since blue became so commonly associated with Mary's dress, the party color blue came to signify religious orthodoxy. Members of the Green Party, however, were predominantly nonorthodox Monophysites, who believed in the single nature of Christ, that is, either divine or divine and human combined. The Council of Chalcedon in 451 declared all eastern sects (including the Monophysites) heretical, which caused violent conflicts throughout the empire, especially in the hippodrome. It was not until the end of the ninth century that Emperor Leo VI was able to reduce the party leaders (*demarchs*) to obedient state officials (Ostrogorsky 1996: 42–4, 48–9, 60–2, 108, 204).

WESTERN EUROPE

In Archaic and preindustrial societies, strong colors were exceptional for clothes, for the simple reason that it was difficult to make them durable in textiles. In early monasticism, monks' habits had no particular color; they were

made of undyed wool hardly different from that of poor laymen. In the ninth century, the Benedictine *Rule* prescribed a black habit (which in practice meant dark brown, gray, or even blue) as an expression of humility and temperance, and as other monastic orders were established, color provided a recognizable identity for each one.

The foundation of the abbey of Cluny in 910 initiated a wave of reform movements in the Western church, which used color as one of their outward expressions. Because of its enormous endowment, Cluny and its dependent monasteries developed an impressive liturgy, and their monks dressed in well-dyed black habits. Their intellectual drive was what brought about the reform movement that emerged in the mid-eleventh century. The movement prescribed stricter rules for the clergy's lifestyle, insisted on independence from lay rulers, and developed more rigorous norms for believers. However, new monastic orders sought to return to the ideal of poverty and reacted rather strongly to the luxury of the Cluny community.

The order of Cîteaux (founded in 1098) returned to the use of undyed wool, resulting in gray habits. The conflicting identities of black and white monks' habits were more symbolic than real, since both these colors were difficult to achieve in medieval times. The best that could be done to achieve "white" was to bleach garments or fabrics in the sun, which required a lot of space and time and was impossible in a northern winter. Moreover, white garments or fabrics rapidly turned gray or yellow (Pastoureau 2008: 80–2).

The color red was of great significance in medieval Christianity, since it was associated with fire and blood in both positive and negative senses. Fire indicated not only Hell, demons, and the dragons of the Apocalypse but also the holy fire of Pentecost, love, and the blood of Christ spilled on the cross for humankind (Pastoureau 2016: 58–64). In the third crusade (1189–92), in which Emperor Frederic Barbarossa, King Richard the Lionheart of England, and King Philip Augustus of France participated, the official banner, a red cross on a white background, symbolized Christ's blood. The knights wore this emblem on their left shoulder, identifying themselves as bearers of Christ's cross (66–8).

In an endeavor to regulate the rapidly expanding western European Christian community, Cardinal Lotharius, who later became Pope Innocent III (r.1198–1216), systematized the use of colors in the liturgy of the Mass in 1194–5. White was reserved for the feasts of Christ and the angels, virgins, and confessors; red was reserved for the apostles, martyrs, the Holy Cross, the Holy Ghost, and Pentecost; and black was prescribed as a color to be worn during Advent and Fast, Innocents' Day, and the Mass of the Dead (Pastoureau 2008: 50–1). During the thirteenth century, the popes' ceremonial mantle was red, furnished with the *pallium*, a white woolen strip with black crosses. It was not until the sixteenth century that the pope's robe became white, while the mantle and shoes remained red. In addition, the church's banner was red with a white

cross. Since 1245, cardinals have worn a red robe with a red hat; the color is understood as a symbol of their role as the first soldiers of the faith, thus indicating both their power and their identity.

Charlemagne had been dressed entirely in red on the occasion of his imperial coronation in 800, and from the coronation of Otto III as Holy Roman Emperor in 996 until the end of the eighteenth century, the empire's coronation mantle was red. In the twelfth century, the mantle and the banner were decorated with a white cross, a clear reference to the emperors' special mission as protectors of the church. As a vassal of the pope, King Roger II of Sicily was crowned in 1130 wearing a red mantle with golden and silver embroidery and thousands of pearls (see Plate 2.4).

Coronation mantles were also typically red in England, Iberia, Scotland, and Poland, and many lower lords imitated this symbol of worldly power par excellence. From 1124 to 1465, the French royal military banner, the *oriflamme*, which was kept in the abbey of St. Denis north of Paris, displayed red flames. In general, red and its "noble" hues tending toward purple were the eminent colors of power (Pastoureau 2016: 68–73). In 1179, however, Philip Augustus of France introduced a coronation mantle in heavenly blue with golden lilies (*azur semé de fleurs de lis d'or*), a tradition that continued until 1825.[3] Two breakthroughs occurred in the heartland of the kingdom of France around the middle of the twelfth century, which explain Philip Augustus's preference for blue as the symbol of royal power. A close interaction between the monarchy and prelates in and around Paris fostered the development of a new ecclesiastical architecture, later known as "Gothic," that supported the glorious celebration of the liturgy and the veneration of relics by growing crowds of believers. In his autobiography, Abbot Suger of St. Denis (1081–1151) describes his initial role in the reconstruction of the choir of his church (Grodecki 1976; Rudolph 1990a; Grosse 2004). Significantly, he doubled the area of the windows, inspired by the vision that light is a manifestation of God and colors an expression of His glory. The reconstruction of the choir was realized between 1140 and 1144, and windows in stained glass followed suit (Suger 1867: XXXIV). The most spectacular innovation at St. Denis, however, was the unprecedented variety of splendid colors in these radiant windows: pulsating yellow, red, green, and above all, what Suger called *saphir* (blue). Because of Suger's close connections with the court and beyond, his model was immediately imitated in the cathedrals of Chartres and Le Mans. Suger's representations were complex illustrations of Scripture based on the writings of the sixth-century theologian Dionysius the Pseudo-Areopagite, traditionally identified with St. Denis and venerated in the monastery (Kessler 1996: 179–203).

As a result, blue, which until then had been prominent only in depictions of Mary's mantle in Byzantine mosaics, now came to the fore in the public space, and Philip Augustus appropriated the innovation to mark the unique position

of the "very Christian" king of France. The rapid spread of Gothic cathedrals in the Île-de-France, many of which were dedicated to Our Lady, symbolized the unity of the church and the monarchy (along with the local community). King and Saint Louis IX (r.1226–70), who undertook several crusades, further strengthened the role of kingship as champion of the faith, especially by sponsoring the cult of the Virgin Mary. The Sainte-Chapelle in Paris, built close to the royal castle in the middle of the thirteenth century as a magnificent shrine for the relics of the Holy Cross, is an architectural masterpiece that maximizes space for the windows that radiate heavenly blue light.

The second development that favored the rise of the color blue was the twelfth-century perfection of enamel-working for all kinds of liturgical and devotional purposes. The most skilled artists worked in Limoges and combined mainly gold, blue, and green. Since cobalt (a blue pigment) was a scarce commodity, alternatives were found in the use of copper or manganese granulates, which, however, produce a dark, less limpid blue, as evident from the windows in Canterbury Cathedral dating from around 1220. Fifty years after Archbishop Thomas Becket's martyrdom, which resulted from his conflict with King Henry II, the shrine with his remains was placed in the newly constructed Trinity Chapel, the north and south aisles of which were decorated with a series of stained glass windows representing St. Thomas, his murderers, pilgrims at his shrine, and several of the miracles performed by the saint (see Plate 3.2). The windows are vivid in their range of colors, including a liberal use of blue. So it was that, from the late twelfth century, blue joined red, purple, and gold as the colors of power in Europe.

In the highly dynamic twelfth century, colors began to play an entirely new role in Europe, linked with the emerging concept of chivalry. Colored banners had always identified sides on the battlefield because of their long-distance visibility, but the use of color to identify specific families and power groups now became better developed. During the period from around 1000 to 1300, local and regional aristocracies succeeded in consolidating their power as owners of extensive domains, in which they effectively held judicial and military power and were economically dominant. This was a period in which the population grew steadily, and urban centers favorably located on crossroads, rivers, and coasts strove toward autonomy. Beyond the towns, however, powerful land-owning families remained dominant. Kingdoms emerged everywhere, but the reality of royal power was determined by its ability to manage the regional and local power centers. The power dynamic in a kingdom thus depended on relations between three classes of contender: kings or territorial princes; the local and regional aristocracy; and the cities.

As a matter of course, all contenders strove toward the consolidation and expansion of their own power, so that the period of feudalism might be best described as an era of constant power play, where everyone sought opportunities

through contractual relations of a feudal and matrimonial character. It all rested on the private interests of aristocratic families desperately wanting to raise their status, and because the aristocracy had always been a military class, that competitive struggle expressed itself in knighthood as a means of attaining a higher social status either independently or as a follower of a mighty lord. Recognition and reward for prowess in combat could be achieved on the battlefield or in staged "games" known as tournaments or jousts.

Aristocratic families consisted of extended kinship groups layered by ties of descent, as well as of followers bound by loyalty and service instead of blood. Each competitor in a tournament or on a battlefield was, therefore, regarded as a more or less prominent member of a lineage. This is where color enters the picture. In the twelfth century, helmets covered the face and rendered the knight unrecognizable, so knights soon began to decorate their shields with images of animals, plants, or geometric figures as a means of identification. While figures could be chosen freely, the colors were limited to six, which were named after the French codification and divided into two categories. First, *or* (gold, yellow) and *argent* (silver, white); and second, *gules* (red), *azure* (blue), *sable* (black), and *vert* (in France *sinople* [green]). Since coats of arms were derived from banners, on which (for reasons of visibility) mostly just one or two colors were applied, from its very beginnings, heraldry followed the general rule that colors belonging to the same group could not be juxtaposed.

Aristocratic lineages were not associated with a particular territory or nation. Instead, they were mobile, exchanges were frequent, and tournaments were international meetings. Consequently, the use of escutcheons (coats of arms) and their standardization disseminated rapidly throughout Europe in the twelfth and thirteenth centuries. Heralds were specialists who kept track of all escutcheons and, in some cases, created full-color illustrated catalogs of such designs. Their work makes it possible to conduct a statistical analysis of the frequency of colors used. Of the approximately seven thousand descriptions traced from the mid-twelfth to the early fourteenth centuries: red was applied in 60 percent of the shields; black in 55 percent; and yellow in 45 percent. The popularity of blue grew from 5 percent in 1200 to 25 percent in 1300, but green never exceeded 5 percent (Pastoureau 2000: 20–58, 113–21, 298–309; 2008: 82–6; 2016: 74–7).

Coats of arms were shown during events and ceremonies. In addition, they were attached to the facade of a house or a castle, in which an aristocrat resided, temporarily or permanently, with his retinue. On permanent residences, the shields were carved in stone and painted. Several shields are still hanging in the thirteenth-century north and south quire aisles of Westminster Abbey showing the owners' role as patrons.

Heraldry became a widespread means of identification. It was not limited to aristocratic families but extended also to institutions, such as towns and

universities, and appeared on seals and coins. Although green seems to have been scarcely used in coats of arms, it was omnipresent at tournaments on clothing, banners, and horsecloths. Chivalric novels in the Arthurian tradition depict scores of "green knights," who were considered courageous, reckless, and wild. The fourteenth-century Middle English poem, *Sir Gawain and the Green Knight*, features one such character. Green is also abundant in the 137 colored figures in the famous *Codex Manesse* composed shortly after 1300, which contains 140 chivalric novels dealing with love stories from the twelfth and thirteenth centuries (Pastoureau 2016: 84–5).[4] These colors provided a palette that could be used to identify powerful and influential families and institutions.

THE LATE MIDDLE AGES

Charles IV, King of Bohemia (r.1346–78) also became Holy Roman Emperor in 1355. Charles was a great patron of the arts and architecture, and initiated the building of the spectacular castle Karlstein (Karlštejn) in 1348. Because of his good relations with the pope, he was able to promote his minister Jan Očko of Vlašim to Cardinal Archbishop of Prague. A votive painting for Jan, now in the National Gallery in Prague, has been dated to around 1370, and the upper section shows the emperor and his son King Wenceslas IV, each protected by their royal patron saint and kneeling in front of Mary and Jesus. The Madonna wears a deep blue mantle, Charles is dressed in white with lavish gold embroidery, and Wenceslas wears red clothing. The background to the figures is gold. In the lower part of the painting, Jan is depicted kneeling among four Bohemian saints. He wears white and gold, and faces St. Adalbert, who is wearing red and gold, while St. Vitus stands at his back, wearing red. The two outermost saints are not attired in the long-established elite colours of white, gold, red, and blue. On one side is St. Procopius wearing black, probably because he lived most of his life as a hermit in a cave, and black may associate him with humility and poverty. On the other side is St. Ludmila wearing yellow and green. She was an aristocrat who was martyred in 921. Royal and spiritual power was clearly associated with saintly predecessors in a conspicuous painting visible to all visitors to the cathedral.

A similar picture may be obtained from the English court, where Charles's daughter, Queen Anne of Bohemia, nourished close relations with intellectuals in her homeland. Accordingly, her influence is probably evident in the famous Wilton Diptych in the National Gallery in London, which has been dated to shortly after her death in 1394 (Thomas 1998: 13). The left-hand panel shows the young King Richard II being presented by three saints to Mary with the Christ Child, the last two appearing in the right-hand panel. Eleven angels surround Mary, and all of them have blue garments painted with a pigment made from the semiprecious stone lapis lazuli. In addition, the angels all have

partly blue wings. Richard's outer robe is cloth-of-gold and red vermilion, and the fabric is decorated with white harts and sprigs of rosemary, the emblem of his wife, Anne of Bohemia. The panel shows an interesting contrast between the red, white, and gold of the secular elite, and the blue of heavenly figures.

The thirteenth-century Sainte-Chapelle in Paris with its vividly colored stained glass windows inspired other royal and aristocratic builders, including Charles IV of Bohemia and Duke Philip the Good of Burgundy. Duke Philip intended to create the seat of his newly established chivalric Order of the Golden Fleece in Dijon on the occasion of his marriage to Isabella of Portugal in 1430. The chapel, however, did not really fulfill this mission, since the Chapters of the Order were held in different cities and only once, in 1433, in Dijon, but the duke did commission valuable liturgical objects, including vestments, such as altar cloths, chasubles, tunics, dalmatics, and copes, some of which are displayed today in the Kaiserliche Schatzkammer (Imperial Treasury) in Vienna. The fabric consists of silk, gold thread, pearls, and gems. These materials are very difficult to handle, but the artists succeeded in creating a subtle expressivity in the saintly figures. The overwhelming impression is that of gold and brilliant precious stones. The colors of the robes of God, Christ, Mary, St. John the Baptist, and St. Catherine have lost much of their radiance, but they are very similar to those in the contemporary Ghent Altar in St. Bavo's Cathedral, Ghent, painted by Hubert and Jan van Eyck in red, blue, brown, and green (Schmitz-von Ledebur 2008: 63–71, 194–202).[5] Both grandiose ensembles celebrate in the first place the heavenly order, but the gold-thread embroideries were by far more labor-intensive and costly than the painted altarpiece, and they indirectly express the glory of the Duke of Burgundy, who was approaching the height of his power.

With no established capital city, the dukes of Burgundy resided in several cities and castles without a clear preference. They invested in jewelry for devotional purposes and as gifts (Van der Velden 2000). Most of their artistic investments were in mobile objects, some of which they took with them when traveling. The most valuable and impressive objects were the huge tapestries representing biblical, historical, and mythological themes, created to cover palace walls. The combination of richly colored woolen and silk fabrics with threads of silver or gold imparted a warm luster to these exclusive products of highly specialized and labor-intensive textile craftsmanship in cities such as Arras, Tournai, Brussels, and others in the southern Low Countries (Rapp-Buri and Stucky-Schürer 2001).

In line with the tradition of the Valois monarchy, the dukes and their high noblemen and prelates also collected impressive libraries and commissioned scores of richly illuminated books. Their decorations and colorful illustrations were a way for them to affirm the fame of their genealogy. Heraldic emblems on the front page display the ownership or commission of such books, and

thousands of miniatures depict courtly life. They show, for example, how under Duke Philip the Good's rule black became the most fashionable color for his own clothing at the Burgundian court, where luxurious robes in the finest scarlet and velvet were continuously displayed in a great variety of colors (Prevenier 1998: 29, 34).[6] His younger contemporary and ally René d'Anjou, King of Naples, likewise preferred to be dressed in black (Pastoureau 2000: 88–9). This would seem to impart the statement that the top rank in society was so powerful it did not have to proclaim that power with rich attire. Those of a lower rank than the rulers usually maintained the desire to proclaim their status in expensive fabrics and vivid colors, as can be seen in the robes of the ladies depicted in paintings and numerous miniatures of ceremonies and feasts (Prevenier 1998: 309–33; Marti et al. 2008: 221, 258–9, 302–15).

Because of the relatively high standard of living in the Low Countries in the fifteenth century and the intensive commercial relations with the whole continent, velvets and damasks were imported from Italy, the most exquisite of which were red with motifs in gold brocade. Some families from the specialized silk-producing city of Lucca managed to become regular providers of large quantities of luxury textiles for the court, moneylenders, and councilors to the Duke of Burgundy and the city of Bruges, as well as to investors in building projects (de Gruben 1997: 111–12, 148–9, 205, 230–8; Lambert 2006: 98–101; Staufer 2008: 234–7). In sum, colorful clothing remained a privilege of the rich and powerful. Their servants and followers were dressed in liveries showing their masters' heraldic colors dyed with cheaper, indigenous vegetable materials, especially woad for blue and madder for red. While proclaiming identification with a powerful person, the use of these dyes also proclaimed a *lack* of individual power on the part of the retainer.

Heraldic identification also appeared on buildings. Town houses featured colors on their facades, often on heraldic shields or signboards linked to the name of the building or its owners. Nowadays, many of these have badly faded, but archival investigation of three cities in Brabant and Flanders revealed that, in the 379 cases of the study, gold occurred most often, followed by white, red, black, and blue, while brown, green, and yellow were nearly absent (Van Uytven 1998: 100).

One of the most expensive dyestuffs was kermes, which was imported at highly fluctuating prices from Provence, Valencia, and Georgia. Kermes was essential for the production of the warmest red color on textiles. It was derived from the crushed bodies of certain insects that live in the Mediterranean region, feeding off the sap of the Kermes Oak. This dye was applied only to cloth woven from the finest Cotswold (England) wool, and finished by intensive fulling and repeated shearing and napping. The process obliterated any visible weave and made the woolen surface finer and softer than that of any other contemporary fabric, except silk and velvet. Kermes dye accounted for up to 40 percent of the production costs of vermilion scarlet cloth, which caused the price of

kermes-dyed red scarlet in Bruges around 1400 to be on average 56 percent higher than the second most expensive dyed woolens of the same dimensions.

Each year, the municipal governments bought various woolens for their officers, including, in the case of the city and the rural district of Bruges, red kermes-dyed scarlet, as well as other fabrics at around half the price and measuring one-third less. The city's scarlets were colored red, rose, purple, brown, and (rarely) green. The quality of the dyeing and finishing obviously mattered more than any particular color except for the important red (Munro 1983: 28–60). Figures are very revealing as regards indications of high social status. A master mason earned 10d (Flemish groats) a day. For the price of the cheapest kermes-dyed cloths, which the Bruges aldermen bought each year for themselves in the period 1400–1410, a master mason would have had to work for three years and four months. For the most expensive cloths, he would have had to work for more than six years, assuming that he could work full time. A journeyman earned just half of his master's salary (Munro 1983: 49, table 3.11; Sosson 1977: 226). No wonder, then, that ordinary people are depicted in short and roughly woven clothes in indiscriminate gray, light brown, or pale yellow. Some combinations of colors, such as yellow and green, were usually considered hideous and therefore reserved for the court's jester or an occasional fool (Prevenier 1998: 260).

The red color of aldermen's robes may well refer to their role as judges. The members of the French royal high court, the Parlement de Paris, wore red, as did their counterparts in the Parlement and Great Council of Mechelen in the Low Countries (Prevenier and Blockmans 1984: 264–5). Red was often used for the hangman's jacket, since he was the executioner of a judgment. However, there was no universal standard, and negative connotations could also be expressed by yellow, brown, green, black, stripes, and various combinations of colors (Klemettilä 2006: 110–28; Prevenier 1998: 275).

Ceremonies at court and in cities offered an occasion to show off the importance and power of a ruling dynasty. In the Duchy of Brabant, which was then ruled by a younger branch of the House of Valois-Burgundy, around 250 members of the court received various qualities and quantities of black cloth for mourning services, differentiated by social rank (Stein 1999: 51–80). Chapters of the Order of the Golden Fleece followed a precise ritual with regard to dress code. Mantles and bonnets in vermilion scarlet were worn on St. Andrew's feast day and during meetings, and the knights wore black mourning robes when they went in procession to church for the Mass of the Dead (de Gruben 1997: 49–53, 379–80).

The choir of the church where the chapter met was decorated with tapestries, banners, and other precious objects. Painted panels with the coat of arms of the duke and the participating knights were fixed above the stalls where they were seated, and kept the memory of the glorious event. Such series have been preserved in several locations.

A lasting memory was also left in the form of devotional stained glass windows, such as those featuring King Edward IV of England and Queen Elizabeth Woodville with their children, all crowned and sumptuously dressed in red mantles, in the northwest transept of Canterbury Cathedral, which was completed by 1482. Similarly, King Philip I of Castile donated a window to St. Waudru Church in Mons, which features the king himself and his two sons in armor, protected by their patron saints. The king wears a deep blue mantle with a white ermine collar. Such public depictions of important persons used color to advertise their wealth and power.

Across Europe, ceremonial princely entries into cities, inaugurations, diplomatic negotiations, marriages, tournaments, and processions offered many opportunities to show off the established order in a colorful spectacle for which the urban public space provided the scenery. All ranks of society used the occasion to dress up in the colors and liveries of their militia, guild, devotional confraternity, office, rank, or class, displaying banners and coats of arms to demonstrate the position and identity of each one (Blockmans and Donckers 1999: 81–111; Lecuppre-Desjardin 2004; Marti et al. 2008: 262–315) (Figure 3.2).

FIGURE 3.2 The Luttrell Psalter (*c.* 1340), Sir Geoffrey Luttrell with his wife and daughter-in-law. British Library, London, Add. MS 42130, fol. 202v. Photograph by Heritage Images. Courtesy of Getty Images.

The same use of color to proclaim affiliation occurred during clashes between rival factions, such as those between black and white Guelfs in fourteenth-century Florence (Najemy 2008: 88–95; Ricciardelli 2007) or those between the red adherents of the Habsburgs and the blacks of Wittelsbach in Colmar in the 1330s. In 1358, the Parisian mob imitated the "White Hoods" militia of Ghent, and in the conflict between Bourguignons and Armagnacs around 1410, the parties dressed in blue, and red with white, respectively.

Those in power made great efforts to demonstrate the unity they had fostered. An extraordinary example is Cosimo de Medici (1389–1464), the first *signore* (lord) and pacifier of Florence after more than a century of violent civil wars. In 1459, he commissioned the construction of the Medici palace and the decoration of its chapel with frescoes by Benozzo Gozzoli. An impressive *cavalcata* in a gorgeous landscape alludes to the Adoration of the Magi set in the historical context of the Council held in Florence (1439–45). Following the difficulties surrounding the papacy in Avignon, the Western Schism, and the conciliar movement, the goal was to unify the Latin with the Greek Church. An impressive delegation had come from Byzantium, headed by Emperor John VIII Paleologus himself and the four eastern patriarchs.

At the time of the design of the murals, however, the Council's compromise had long been rejected by the clergy and the people of Constantinople, and their empire had been annihilated by the Ottoman occupation in 1453. This sheds an interesting light on the entire representation. The Magi are personalized as Emperor John in dark green with golden embroidery, Patriarch Joseph of Constantinople in gold-embroidered red, and Lorenzo, the young heir of the Medici family, in gold with red-embroidered sleeves. (It was, of course, blatantly presumptuous for the young *signore* to be represented as one of the Magi.) These three characters are situated centrally, and Lorenzo is accompanied by a crowd of the Medici family along with their clients and allies. Among the latter, Galeazzo Sforza, Duke of Milan, and Sigismondo Malatesta, Lord of Rimini, occupy the places of honor. While only the patriarch is fully dressed in red, the entire Medici clan wears red bonnets. Although the patron Cosimo is not represented, the Medici family glorified itself as peacemakers not only in the city, but also in Italy and wider Christendom. Red, the color of power par excellence, suited them well. John H. Munro, a great specialist of medieval cloth, pointedly concludes:

> Of course such extravagance in dress, such sartorial splendor, is far beyond the average person's notion of luxury. The world of the scarlet was for the few, the very few indeed: a world of popes, emperors, archbishops, princes—and also of Flemish civic aldermen.
>
> (Munro 1983: 70)

CHAPTER FOUR

Religion and Ritual

ANDREAS PETZOLD

INTRODUCTION

The role of color in religion and ritual in the medieval period has been underestimated. Color in this period was a potent signifier that would have been taken into account in the interpretation of works of art and architecture. Both the exterior and the interior of churches would usually have been painted, as would the sculptures attached to them. Only a small fraction of the original colored interior decoration of churches—in the form of wall paintings, mosaics and stained glass, and occasionally the fabric of the building—has survived to provide an idea of their original appearance. On the rare occasions that colored portable objects, such as icons, portable sculpture, textiles, and precious metalwork, survive, they have usually been displaced from their original location and are now exhibited in display cases in museums or church treasuries under modern lighting conditions.

To a certain extent, this picture has been modified in the last few decades by technical analysis of paint surfaces, typically undertaken in association with conservation programs, which has made it easier to identify their original colored appearance. In England, for example, this has been undertaken for the west facades of Wells, Salisbury, and Exeter cathedrals, and in central Europe on the portals of Amiens, Bourges, and Lausanne cathedrals (Park 2002: 31–53). This identification of the original pigmentation has been controversially taken further at Chartres Cathedral, where the original colored appearance of the interior has been reconstructed, consisting primarily of rendering the main architectural members in white set against pale ochre, patterned masonry (Michler 1989). Occasionally, columns are painted in simulation of marble,

with the overall color scheme giving a greater lightness to the interior than was previously the case and resulting in greater clarity in the constituent parts. An even more imaginative reconstruction has been undertaken at Amiens Cathedral where the original colored appearance of the west facade is reconstituted by means of the digital projection of colored beams. It used to be thought that the chronicler Raoul Glaber's famous statement that at the beginning of the eleventh century "all the earth, but especially in Italy and Gaul" was covered in a "white mantle of churches" was intended metaphorically rather than literally, but increasing evidence suggests that the exteriors of churches were actually frequently whitewashed and painted (Norton and Park 2012: xxiv and 181–210; Hiscock 2003; Fernie 2014: 208).

Nor can the role that color would have played in ephemeral displays and processions celebrating important rites, feast days, and events in the liturgical calendar, which would have turned the church into an arena for performance and transformed its appearance, be appreciated. For example, the color green has been connected with the liturgical performance of the time as enacted at Amiens on the feast of Saint Firmin, when the exterior and interior of the cathedral were bedecked with flowers and greenery, in memory of a miracle in which the saint had caused the trees to blossom in the middle of winter (Camille 1996: 136). This is alluded to in the green foliage band that runs at the level of the triforium sill in the nave. At Whitsun (the day the Holy Spirit was celebrated) in certain regions, both the inside and outside of churches were decked out in red, the liturgical and symbolic color of the Holy Spirit (Pastoureau 2012: 101), though in England white was preferred.

This chapter focuses on the symbolic role of color. Symbolism permeated the mentality of western European thinking. A succinct definition for it is provided by Hugh of St. Victor (Hugo de S. Victore 1854) in the twelfth century in his commentary on the heavenly hierarchy, in which he defined a symbol as "a collecting of visible forms for the demonstration of invisible things."[1] In discussing color symbolism, it should be emphasized that one meaning never exclusively resided in a specific color, with colors having both positive and negative associations (though white is an exception with predominantly positive associations). It should also be noted that in the medieval period black and white would have been perceived as colors just as much as the spectral colors. The key variables are diachronic, geographic, and the concrete context. To quote Schapiro: "There is never exclusively one symbolic meaning attached to a color, for in every concrete situation, the color or colors are not only outer surfaces, but also expressions of the situation itself " (Schapiro 1973: 47).

TEXTUAL SOURCES

A greater appreciation of the role played by color in religion can be gained by looking at textual sources from the period relating to this theme. The usual

caution needs to be provided regarding the lack of precision in medieval color terms, which cannot be blandly equated with their modern equivalents. The Latin color term for black (*niger*), for example, especially when used in relation to fabrics, is more likely to refer to a dark hue than what we would identify as the color black. Often technological constraints, especially having to do with dyeing, may have played a role here. It was not, for example, until the late fourteenth century that it was possible to achieve a high-quality, color-fast, and saturated dye for black fabrics (Pastoureau 2009: 90–1). This has implications for color symbolism especially in relation to clothing.

The Bible provides the primary source for much of the imagery in Christian art. (The observations here are restricted to the Vulgate version.) In the Bible, references to color are relatively few and sporadic. Of particular significance are chapters from the Books of Exodus and Revelation. In the Book of Exodus particular emphasis is given to the colors of the curtains of the tabernacle (26:1 and 27:16), which are identified as *hyacinthinus* (light blue, literally the color of hyacinth), *purpureus* (purple), *bysinnus* (white, literally linen), and *coccinus* (scarlet), as are those of the garments worn by the high priest. Of particular importance in the Book of Revelation is the description of the twelve precious stones that form the foundation of the heavenly Jerusalem (21:19–21), the color of each stone is discussed by later commentators and invested with moral or mystical significance. These biblical references form the basis for interpretations in exegetical, patristic, and encyclopedic sources in the early Middle Ages, which frequently refer back to one another. To cite two examples. In the eighth century, Bede, in his treatise *On the Tabernacle*, provides an interpretation of the colors of the curtains. He associates *byssinus* with chastity, light blue with "the mind that is desiring things above," purple "with the flesh that is subject to afflictions," and scarlet with divine love (Bede 1994: 48–50).

In his picture poem, *De laudibus sanctae crucis* (Veneration of the Holy Cross), the Carolingian theologian Hrabanus Maurus (*c.* 780–856) modifies this interpretation, associating white with Christ's chastity, light blue with his divinity, scarlet with his love, and purple with his blood (Perrin 1997). Elsewhere in the poem, he compares Christ's chastity to the white of the lily and his blood to the red of a rose. Similarly, the colors of the gemstones, described in the Book of Revelation, are frequently invested with symbolic significance. Characteristic is Bede's account in his commentary on the Book of Revelation (2013: 268–77). He associates the greenness of the jasper stone with faith (an idea derived from St. Jerome), the blue of the sapphire stone with the celestial sphere, the red of the sardine stone (probably ruby or carnelian) with blood and martyrdom, and the purple of the amethyst stone with heaven. The association of these colors are invoked in the twelfth- and thirteenth-century stained glass windows at Chartres with their intense jewel-like colors, which have been interpreted as an invocation of the heavenly Jerusalem (Prache 2008).

From the twelfth century and beyond, the base provided for the interpretation of colors in patristic texts was expanded to include new types of textual sources, such as the visions of female mystics, of whom the most famous was Hildegard of Bingen (1098–1173), whose work was illustrated in her lifetime and incorporates significant color imagery (discussed below). New, specialized codes of color imagery also evolve, such as liturgical colors (discussed below), and colors are frequently arranged into sets relating to specific attributes. For example, a color set relating to the three theological virtues, with white, green, and red associated respectively with faith, hope, and charity. This color triad can be seen reflected in art, for example, in the allegorical figures of faith, hope, and charity in Ambrogio Lorenzetti's *Maestà* altarpiece in Massa Marittima, Tuscany, Italy, where it even extends to the steps upon which the figures are seated (Gage 1993: plate 56) (see Plate 4.1).

COLOR AND THE CHURCH: LITURGY AND DRESS

Color played a central role in the Christian liturgy. Certain colors have been designated as liturgical, as they relate to specific events in the liturgical calendar and were regarded as appropriate for vestments and church furnishings relating to these events. A distinct canon of liturgical colors only emerges in the twelfth century, and even then its use was far from systematic.

Prior to this, there is more limited evidence for the use of colors in a liturgical context, especially white, which takes its cue from the New Testament, where angels and holy figures are frequently described as being dressed in white. In the scene of the holy women at the tomb, as described in the Gospel of Matthew (28:3), for example, the angel's garment is described as "white as snow," and this description is frequently adhered to in pictorial art and specified in stage directions for Easter liturgical plays (Petzold 1992: 149–55). This provides an antecedent for the practice of using white garments for vestments at Easter, which is recorded as early as the sixth century. Similarly, from the beginning of the ninth century, black is recorded for liturgical vestments for Candlemas and Good Friday.

A pivotal figure in the codification of liturgical practice and its allegorical interpretation was Amalarius of Metz (*c*. 775–*c*. 850). In his authoritative text, the *Liber officialis* (Book of the Liturgy) written around 820, he describes the various liturgical garments and invests them with an allegorical significance. For example, he describes the alb (from Latin *albus*, "white"), an undergarment worn by the priest, which was made of linen and was white (hence its name) (Amalarius 2014: 1:453). In his description of the dalmatic, a long, wide-sleeved tunic worn by deacons and occasionally bishops, he comments on the two scarlet stripes on the back and front (*clavi*) (1:456). He interprets the scarlet as a symbol of divine and neighborly love and associates it with acts of mercy,

while he interprets white as a symbol of purity. By the early twelfth century, there is greater evidence for a more systematic use of liturgical colors: Beroldus of Milan, for example, specifies that in Milan the color for altars during seasons of fasting should be black and that for Passiontide red (Reynolds 1999: 11).

The key text in the codification of liturgical colors is that of *De sacro altaris mysterio* (On the Sacred Mystery of the Altar), which was written on the subject of the Mass at the end of the twelfth century by Cardinal Lothar of Segni (*c.* 1160–1216), later to become Pope Innocent III. This appears to reflect practice in Rome at the time and became canonical for the Roman rite. The four colors were white, black, red, and green. To these may be added purple and dark blue, which could be substituted for black on Good Friday and at times of mourning and repentance. Lothar discussed their symbolism and specified the days on which they were to be used.

White was seen as a symbol of purity, joy, and glory and specified for Easter and for all feasts relating to the Virgin Mary and confessor. Black was associated with mourning and penitence and specified for Good Friday and masses for the dead. Red was specified for Whitsun and for the feast days of martyrs and apostles. Red was especially appropriate for martyrs, as it symbolized the blood that they had shed, while at Whitsun it represented the tongues of fire indicating the descent of the Holy Spirit. In the image of the Pentecost in a thirteenth-century German psalter, not only are the tongues of fire represented as bright red but also the entire figure of the dove of the Holy Spirit (Plate 4.2). The most interesting addition is that of green, which was seen as a color of hope in life eternal and was specified for the Sundays between Trinity and Advent and between Epiphany and Lent.

In the thirteenth century, a more systematic use of liturgical colors emerged, and this is reflected in texts written by Durandus, Bishop of Mende (1285–96) in southern France, the most important of which was the *Rationale divinorum officiorum* (*Rationale for the Divine Mass*; Thibodeau 2007, 2010). Durandus provided a more detailed account than that of Lothar and expanded it to include, for example, the colors used by priests for footwear (consisting of sandals and stockings) at Mass, which should be blue or violet.

Durandus's account is not restricted to vestments but extends to church furnishings. According to him, the altar cloth should be of white linen, which designated the flesh or humility of Christ (Thibodeau 2007: 30). He further equates it with the pure heart when adorned with good works. But hangings used for feast days could be of various colors reflecting different Christian virtues: white for pure life, red for charity, green for contemplation, black for mortification of the flesh, and gray for tribulation (44). He also recorded special practices for Easter, when the altar should be decorated with costly coverings and cloths of three different colors. These were black, gray, and red, denoting, respectively, the time before the law, the time under the law, and finally the

time of grace made possible by Christ's Passion (45). Each cloth was to be removed after a reading was completed.

Durandus also comments on the covering of images with veils during Lent (Thibodeau 2007: 43), a practice that may go back as early as the tenth century (Johnstone 2002: 22–3; Packer and Sliwka 2017: 35 and 214n18). On fast days during Lent, the altar itself was hidden by curtains drawn across the chancel. In England, church accounts record the practice of suspending a white cloth in front of the rood cross at Lent as well as that of covering effigies and pictures with white cloths. Simple, plain crosses, painted in either red or green, depending on whether they were for Sarum or London use, and without an effigy of Christ on them, are also specified for use in Lent processions (Park 2002: 46).

The most spectacular artifact associated with Lent liturgical practice that survives is the *Parement* de Narbonne, an altar cloth made of white silk and painted in grisaille (black and gray) with scenes from the Passion of Christ (Nash 2000: 77–8). It was made in the late fourteenth century, commissioned by the French King Charles V (r.1364–80), and possibly painted by Jean d'Orléans (Figure 4.1).

It has been convincingly argued that the Parement formed part of a *chapelle*, a matching set of vestments for the clergy and hangings for the altar, with which a bishop's miter, also surviving, has been associated. A large number of these chapelles are described in inventories of the time in different colors corresponding to events in the liturgical calendar, but the *Parement* is exceptional in surviving.

In practice, however, the canon of liturgical colors, as outlined by Lothar and Durandus, was not uniformly applied, but varied from region to region and was dependent on such practical constraints as the availability of vestments in different colors. The size and wealth of a church was a significant factor in determining whether it was able to own a full set of vestments corresponding to the liturgical colors, so that the best vestments would have been used for the most important feasts regardless of their color. In his discussion of English Gothic liturgical garments, Morgan notes the widespread use of red as a background color, which even extends to garments with Marian imagery on them (Morgan 2016a: 26–7). He notes that the Sarum use differed from Lothar's canon in important respects and stipulated red for all Sundays of the year except during Lent and Easter, which may explain why a high proportion of surviving English vestments from this period are red. He further observes that many vestments were multicolored, with no single dominant color, which would have enabled them to have been used for different occasions.

White dress was also seen as appropriate from at least the fourth century for the sacrament of baptism, where it was seen as a symbol of innocence and purity (Daniélou 1960: 51–2). The neophytes wore their robes for the whole

FIGURE 4.1 Anonymous, the *Parement* of Narbonne (detail), *The Entombment of Christ*, c. 1375. French grisaille painting on silk. Musée du Louvre, Département des Arts Graphiques, MI 1121. Photograph by Sailko. Wikimedia Commons.

of Easter week. The fourth-century St. Ambrose in his treatise *De mysteriis* (On the Mysteries) describes how "after Baptism, you have received white garments, that they be the sign that you have taken off the clothing of sin and you have been clad in the pure garments of innocence" (Daniélou 1960: 49). He further suggests a connection with Christ's white robe as described

in the transfiguration. Black from an early period was seen as appropriate for mourning and for masses for the dead, though in fourteenth-century France white became the fashion for royal mourning among women. The red of the eucharistic wine was frequently invoked in altarpieces, in front of which masses were enacted by representing Christ in a wine-red garment, as in the case of the scene of the carrying of the cross in Duccio's *Maestà*.

Color may also have played a role in church furnishings, such as doors, screens, and crosses. Three examples are discussed here. The first of these is the practice of painting red those external doors of churches in front of which court cases were held (Deimling 1997: 324–5). The practice of painting doors red is described in Theophilus's technical manual *De diversis artibus* (On Various Arts, 1961) written in the early twelfth century. Red doors serving such a function are known to have existed in German cathedrals, and one such red door is recorded in the thirteenth century in the south portal at Frankfurt Cathedral. The red could be an allusion to blood and the potential judgment of court cases, which might result in the execution of the miscreant. In the late Middle Ages, Christ is often represented in red in Last Judgment scenes as can be seen in the early fifteenth-century *Last Judgement* panel by Stephan Lochner in Cologne, underlying his role as divine judge.

The second example relates to rood screens, which in the Middle Ages separated the most sacred part of the church from the nave. The color of the doors inserted into the screens or side walls of choirs may also be significant, as in the case of those painted in their original red at Halberstadt Cathedral. Bucklow (2014: 155–6) has drawn attention to the way in which in certain Norfolk churches the west front of the rood screen has been decorated with alternating red and green panels arranged in an asymmetric pattern (see Plate 4.3). He relates these colors to planetary codes of the period, which linked red to Mars and green to Venus, thus giving them gender-specific associations. He further notes the way in which this gender-specific code is taken up in the church of St. Helen's, Ranworth in Norfolk, where the altars to the right and left of the rood screen are also red and green, respectively.

The third example is taken from portable furnishings, the color of which may be significant. The most obvious example is wooden painted crosses, which are decorated most often with blue, red, and gold backgrounds, but occasionally also green. A spectacular, surviving example of a cross painted green to which an effigy of Christ is attached and which retains its original polychromy, is that of the early thirteenth-century triumphal cross suspended above the screen at Halberstadt Cathedral (Munns 2016: 121). Munns also discusses a group of images with green crosses in Anglo-Norman illumination (116–20). Green crosses, which are a frequent feature in manuscript illumination (either plain or formed of rough timber beams), may have a symbolic significance attached to them. The color may be linked with the Tree of Life in the Garden of

Eden, as described in the Book of Genesis, the wood of which was thought to have been reused for the cross on which Christ was crucified, and can also be seen as a symbol for the resurrection. Hugh of St. Victor in the twelfth century describes green as "an image of future resurrection" (Dronke 1972: 84). Thoby (1959: 120) in discussing the green crosses in the mid-twelfth-century Passion window at Chartres has suggested that the green is a reference to a passage in Luke, where Christ states: "For if they do this when the wood is green, what will happen when it is dead" (23:31). He connects this verse with the liturgy of the time, noting that an antiphon based on this passage was used in the Adoration of the Cross during the Good Friday liturgy: "O crux, viride lignum, quia in te pependit Redemptor gentium" (O, crucifix of green wood, because on you the Redeemer of the gentiles hung). Green crosses were also used in the rites associated with the Easter Sepulcher in England; one such green cross is recorded in an early sixteenth-century account from the church of St. Peter Mancroft in Norwich for use in the liturgy on Easter morning (Park 2002: 46).

Color symbolism also played an important role in monastic dress. The Rule of St. Benedict does not specify what color monks' habits should be, but from the late Carolingian period black became the standard for Benedictine monks, and this was later taken up by the Cluniacs, and from the thirteenth century by the newly created Dominican order. The early twelfth-century Cluniac abbot, Peter the Venerable, analyzed the black color of Cluniac habits as a sign of humility and penitence (Constable 1967: 55–8; 1987: 822–31).

At the end of the eleventh century, the Cistercian order (which took its name from the town of Cîteaux in Burgundy, where its first monastery was established) was founded in reaction to the Cluniacs. They advocated a more ascetic and simpler way of life. The earliest Cistercian monks appear to have worn habits of undyed wool rather than the white that has come to be associated with them. According to one legend, the Virgin Mary appeared to the second abbot of the mother house of Cîteaux, St. Alberic (abbot 1099–1109), in a dream and ordered that from then on Cistercian monks should wear white. Whether this was the case is doubtful, as they are not represented as such in the illustrations to the manuscript of the *Moralia in Job* (Commentary on Job) made at Cîteaux in 1111, but in gray and brown habits.[2] By the time St. Bernard became abbot of Clairvaux, however, white had been adopted as the color for their habits. This practice was the subject of heated correspondence between the Cluniac abbot, Peter the Venerable, and his Cistercian counterpart, St. Bernard. The white of the woolen cloth would not have been a pure white, as this was not technically possible to achieve at this time, but an off-white. What Peter appears to have objected to was the appropriation by the Cistercians of the symbolism of the color white for glory, joy, resurrection, and festive solemnity, which he saw as demonstrating a lack of humility on their part. Peter refers to "gleaming

white" (*candidus*). St. Bernard responded that black was the color of the devil, the color of "death and sin," whereas white was the color of purity, innocence, and all the virtues. Nor were the Cistercians the first monks to dress in white, since the practice had been anticipated earlier in the eleventh century by the Camoldolese order and soon after adopted by other monastic orders, such as the Premonstratensians.

In the thirteenth century, the newly created Dominican order came to wear the distinctive black cloak combined with a white undergarment, which caused them to be likened to magpies (Figure 4.2).

Black was seen as a sign of humility and temperance. The robes of the Dominican black friars were said to have been revealed to St. Dominic by the Virgin in a vision, which is occasionally represented in paintings of the time. The Franciscans from an early period wore a gray or brown habit, and St. Francis's original habit still survives (Warr 2010: 111).

FIGURE 4.2 Tommaso da Modena (1326–79), *Cycle of Forty Illustrious Members of the Dominican Order* (detail), Dominican convent, Treviso, Italy. Fresco. Photograph by DeAgostini / DeAgostini Picture Library. Courtesy of Getty Images.

At the other end of the social spectrum was the color of the garments worn by the highest-ranking members of the church. Popes were frequently dressed in red, as can be seen in the early thirteenth-century wall painting of Innocent III in the monastery of Subiaco, near Rome. Garments of bright red or scarlet produced from madder or kermes were very costly and the prerogative of the wealthiest in society, such as kings or emperors. From the thirteenth century, cardinals were permitted to wear red hats, and this was later extended to their entire robes (Pastoureau 2017: 68). Attempts to regulate the color of the dress of the clergy by the church were made at an early date. The Council of Narbonne in 589, for example, specifically banned the clerical wearing of purple. But this tendency became more pronounced in the later Middle Ages, as can be seen in Canon 16 on the subject of clerical dress in the acts of the Fourth Lateran Council (1215), which prohibited clerics from dressing in red and green, thus anticipating the sumptuary laws of the later Middle Ages.

Colors were also used increasingly in the later Middle Ages in an emblematic way on badges to distinguish specific groups. An early example of this practice is that of distinguishing the participants in the Crusades by means of a red cross attached to an item of their clothing (Pastoureau 2017: 68). (Red was associated with Christ's sacrifice and the shedding of his blood.) This practice is known as "taking the cross." It became institutionalized during the Second Crusade (1147–9), when in sermons given by St. Bernard to encourage participation in the crusade, small crosses cut from red cloth were distributed among the audience to be placed on the left shoulder in memory of Christ bearing the cross.

The most famous or infamous example of this practice of distinguishing a group by means of a colored badge is that of the Jews. At the Fourth Lateran Council in 1215, it was stipulated that Jews had to distinguish themselves by means of their dress (Petzold 1999: 131). The nature of this distinction was not specified, but at an early date it came increasingly to take the form of a badge, most commonly, though not exclusively, yellow in color. This practice informed the convention of representing Judas in yellow. Similarly, the female personification of the Jewish faith, Synagoga, is frequently represented in yellow in contrast to that of the Christian Church, which is represented in red (131).

DEVELOPMENTS IN THE USE OF COLOR RELATING TO THE CHURCH

In this section, specific developments in the use of color relating to the church are discussed. In the early Christian and Byzantine periods, particular preference was given to purple and gold. During these periods, purple was the prestige color, and its association was primarily with power and heaven, but it was also seen as a sign of sinful luxury and worldliness, and it could be used as a symbol

for mourning (this may underpin its use for the Virgin Mary) (Pastoureau 2009: 60–1). The primary association of purple is with regality, as is made explicit in the early ninth century by the Irish poet, Sedulius Scottus, who described purple as a sign of sovereignty and the monarch's glory: "purple is the colour revered throughout the world" (Godman 1985: 283).[3] In theology, it was associated with both Christ's Incarnation and his Passion. Its prestige was inherited from antiquity and related to the practice of clothing Roman emperors in garments dyed in Tyrian purple, which was taken up by the Byzantine emperors. This practice was grafted onto representations of Christ and the Virgin Mary, and by the sixth century it had become widespread. Examples can be seen in the sixth-century mosaics in the church of Sant'Apollinare Nuovo in Ravenna, where Christ is represented wearing a purple garment with gold *clavi* (bands), and in a sumptuously illustrated late ninth-century manuscript of the *Homilies* of St. Gregory of Nazianzus, where Christ is similarly clothed (Paris, Bibliothèque Nationale, MS Grec. 510).

At the Council of Ephesus in 431, representations of the Virgin Mary dressed in purple were first officially allowed. When, in the seventh century, her mantle was transferred for safekeeping from the church at Blachernae, in the northwest of Constantinople, to Hagia Sophia, it was found to be of miraculous purple wool (Gage 1993: 130). A factor in the adoption of purple in representations of the Virgin Mary may have been an early Christian apocryphal text, the *Protoevangelium of James*, in which it is described how Mary was one of the pure virgins chosen to help spin the curtain for the temple, and that she was allocated the task of spinning the "true purple and the scarlet" threads (Evangelatou 2003: 261–79). According to the text, when Gabriel entered the Virgin Mary's home to announce the Incarnation, she was in the act of spinning the purple wool. Later Byzantine commentators interpreted the scarlet and especially the purple as alluding to the royal lineage of the Virgin back to the house of David. The purple yarn has also been linked with the Incarnation. By the sixth century, the practice of representing the Virgin Mary in purple had become ubiquitous, as can be seen, for example, in the Ascension image in the Syrian Rabbula Gospels (Florence, Biblioteca Mediceo Laurenziana, Cod. Plut. I, MS 56), completed in 586.

The practice of representing Christ and the Virgin Mary in purple was taken up in Western art. An early example can be seen in the eighth-century insular Book of Kells in the image representing the Virgin and Child (Dublin, Trinity College Library, MS A. I, fol. 7v), where the Virgin is represented in purple, and this appears to directly reflect Byzantine sources (Pulliam 2011). The practice is particularly evident in Ottonian painting of the late tenth and early eleventh centuries. The most highly prized Byzantine woven silks were those dyed purple, as can be seen from a tenth-century surviving fragment in Auxerre, which was used to wrap the relics of St. Germain.[4] There was

a fashion for staining or painting parchment purple (the so-called *codici purpurei*), which originated in Byzantium in the fifth century and extended to Carolingian, Anglo-Saxon, and Ottonian manuscript illumination. In manuscript illumination, the material most commonly used to represent purple has been identified as that of orchil, a relatively cheap material, suggesting that the prestige of purple lay in the symbolism of the color rather than the value of the materials (Panayotova et al. 2016: 30). By the late twelfth century, the prestige of purple had been eclipsed by that of blue, though it is still a marked feature in the garments of Christ and the Virgin Mary, especially in the stained glass of the period.

Another marked feature of the medieval color aesthetic is the preference given to gold, which is especially prominent in the early Middle Ages. Gold was used in the production of precious metalwork often for use in the liturgy or for reliquaries. It was used in panel painting and manuscript illumination (frequently as a background color), as a veneer for wooden sculpture (for example, in the tenth-century golden Madonna at Essen), as a thread in fabrics (as can be seen in the tenth-century Cuthbert stoles at Durham), and above all as a background for wall and ceiling mosaics. One particularly appealing aspect of gold was its reflective properties accentuated by oil lamps and candles. By the sixth century, gold backgrounds in mosaics had become commonplace, as can be seen in Rome and Ravenna, and created a timeless and supramundane space. An early example (early seventh century) is the apse mosaic in the church of Sant'Agnese fuori le mura in Rome, where the figure of St. Agnes is superimposed against a glittering gold background. Gold was regarded as a symbol of the divine and associated with the heavenly Jerusalem.

Three developments relating to the use of color in the twelfth and thirteenth centuries are discussed in the following. The first of these, which has been emphasized by Pastoureau (2001a), is the valorization of the color blue in northern Europe, supplanting purple as the prestige color. This blue is characteristically saturated and has a dark tone to it, to which appropriately the name *royal blue* has been given. This development can be seen reflected in the saturated blue backgrounds found in the stained glass of the period (at St. Denis and Chartres, for example), to which Abbot Suger (1081–1151) gave the name "sapphire," the increasing use of blue for the mantle of Christ, and to an even greater extent that of the Virgin Mary with whom the color has become virtually synonymous. It may be that Pastoureau has overstated his case, as saturated blue is found as a color in earlier art, in the case of manuscript illumination, for example, in the eighth-century insular Codex Aureus (Stockholm, National Library, MS A 135) or in mosaics, for example, in the sixth-century apse mosaic representing the Second Coming in the church of Saints Cosmas and Damian in Rome with its blue background. Nevertheless, as a trajectory, Pastoureau would seem to be justified in emphasizing the greater prominence given to blue from

the twelfth century. One factor in explaining this phenomenon is the equation of blue with divine light by theologians and churchmen, such as Abbot Suger, under the influence of Pseudo-Dionysus' light aesthetic (Gage 1993: 69–73).

Prior to the twelfth century in Western art, the Virgin Mary is represented in a variety of colors, though Pastoureau (2009: 60) has noted a predominance of dark colors, which he regards as appropriate for her activity of mourning. In Byzantine art, there is, as mentioned above, greater standardization with purple, and from the eleventh century, increasingly, though not exclusively, examples of blue as the favored color for her, as evident from the eleventh-century mosaic of the crucifixion at Daphni, and it may be that Western artists adopted the convention from a Byzantine source, given the prestige of Byzantine art at the time. The increasing rise in the cult of the Virgin Mary in the west in the twelfth and thirteenth centuries and the adoption of blue as the primary (though far from exclusive) color for her dress must have in turn further promoted the status of the color. Blue is used for the ceilings of the royal chapel of Sainte Chapelle in Paris, completed in 1248, and that of the early fourteenth-century Arena Chapel in Padua. The primary associations of blue were with the celestial, the spiritual, and the heavenly. In his late twelfth-century treatise *De tripartito tabernaculo* (On the Tripartite Tabernacle), Adam of Dryburgh (also known as Adam Scotus) identified blue with the clerical and contemplative life, and associated it with the spiritual and the heavenly (Adam Scotus 1855).

A second development is the reaction against what was perceived in terms of color as the excessive polychromy and use of gold in church art, as exemplified in the artistic patronage of Abbot Suger at St. Denis and reflected in his writings. This reaction is primarily associated with the Cistercians and their leader, St. Bernard. In his *Apologia* (*Apology*; Rudolph 1990b) written for St. William of Thierry, which has been dated to 1124, St. Bernard spoke out against the use of luxurious materials and figurative imagery in monastic art and architecture. This reaction is also reflected in the legislation of the order. One twelfth-century statute, for example, specified that initials should be of one color and nonrepresentational, and that windows should be white and without crosses or pictures (Packer and Sliwka 2017: 27–8 and 213).[5] This statute was closely adhered to, as is evident from surviving Cistercian manuscript illumination and stained glass, which is gray or grisaille in appearance, as demonstrated by a surviving panel from the abbey of Aubazine in France (29). Cistercian abbeys were whitewashed with simple masonry patterns inscribed, though it is now realized that this practice was by no means restricted to them but was widespread.

A third development is the use of color imagery in religious texts that are personal in nature, such as religious visions, rather than exegetical, and yet draw upon this tradition. Examples of this development are the visions of the

twelfth-century religious mystic, Hildegard of Bingen (1098–1179), which are illustrated in two texts: *Scivias* (Know the Ways of God, 1990) and *Liber divinorum operum* (The Book of Divine Works, 2018) (Meier 1972). One scholar has gone so far as to suggest that Hildegard was not only the author of the *Scivias* text but also designed its illustrations (Caviness 1998). The illustrated copy of *Liber divinorum operum* postdates her death and was executed in the early thirteenth century, possibly as part of a strategy to have her canonized (Lucca, Biblioteca Statale, MS 1942, fol. 1v; Petzold 1995: 138).[6]

It is illustrated with ten of her personal visions and has a highly idiosyncratic color scheme. The first vision, for example, is that of divine love as a supreme and fiery force, which is represented as an angelic figure with wings. The figure is entirely bright red, including the head and feet, with the exception of the wings, which are white and edged in gray. The use of red invokes the traditional association with divine love (*caritas*) and the element of fire. The figure tramples on Satan, a demonic figure painted black with red eyes like coal fire, and on Discord, represented as a serpent. All this is set against a glittering gold background, which gives the image a supramundane quality. As we move into the later Middle Ages, a more naturalistic use of color emerges, reflecting the influence of Aristotelian thought and a tendency for artists to turn outwards and imitate external appearances. This is exemplified in the work of Giotto, above all in the early fourteenth-century wall paintings in the Arena Chapel, Padua.

CHAPTER FIVE

Body and Clothing

GALE R. OWEN-CROCKER

BODY COLOR

"Not Angles but Angels," the traditional catchy paraphrase of Pope Gregory the Great's response to the appearance of fair-haired, blue-eyed English boys on sale in the Roman marketplace has indelibly influenced perception of Anglo-Saxon physiognomy.[1] Gregory was presumably drawing upon depictions of angels in art.[2] In fact, the population of England is unlikely to have been uniformly Nordic-looking. Their mixed origins included Celts and descendants of Roman soldiers from various parts of the empire.[3] Missionaries came from continental Europe near and far; Abbot Hadrian came from North Africa. Traders ranged wide, bringing elephant ivory pouch-rings, ultimately from Africa, in the sixth century, and silks originating in the eastern Mediterranean and beyond, from the seventh. Three women of African origin were buried in late Saxon cemeteries[4] and the Vikings allegedly settled in Ireland a group of captives taken in Morocco in the ninth century (Green 2015).

Anglo-Saxon writers rarely mention body coloring, certainly not in terms of what was considered normal or beautiful. Bede's physical description of the missionary Paulinus is unusual: Paulinus had black hair (*nigro capillo*; Bede n.d.: II.16). In Old English texts, if body color is mentioned (Roberts and Kay with Grundy 1995: 1.55), it is likely to be unusual or unnatural. When the body is jaundiced through sickness, we are told, it "yellows" (*āgeolwaþ*) like the yellow of silk: jaundice itself is "yellow sickness" (*geolwe ādl*; Cockayne 1865: 10, section xlii; 106, sections xli, xlii). Illness can also cause yellowing of those parts of the eye that should be red (348, line 12). The pallor of fear (*blāc-hlēor*;

Krapp 1931: 59, line 1970) and the blushing that indicated embarrassment (*mid rōsan rude*; Goolden 1958: 34, line 2) are also conveyed in Old English, though the observation of these color changes, respectively in the poem "Genesis A" and the prose *Apollonius of Tyre*, probably came with Latin source material.

Western Europe inherited stories of dark-skinned people from Greek legend and especially from the Roman author Pliny. Africans and Indians were usually conflated as "Ethiopians," associated with exotic and monstrous races (Friedman 2000: 5–9, 15). The Anglo-Saxon *Wonders of the East* refers to the dark coloring of the Ethiopians or *Sigelwara*, illustrated in a manuscript (London, British Library, Cotton MS Tiberius B. v, fol. 86r), with slight darkness of skin.[5]

The Anglo-Saxons were conscious of color changes that came with aging: yellowing of teeth (Porck 2019: 101; 2020) and graying of hair. In fact, gray is the most often mentioned hair color in Old English (Roberts and Kay with Grundy 1995: 1.56), with several words for it, of which *hār* is the most frequent, but also *grǣg* and *wylfen* ("wolf-color"; Biggam 1998: 219–22, 44, 310 respectively). That elderly people had gray or white hair was evidently so commonplace that they might be referred to as "old-haired" (*gomelfeax*) as in *The Seafarer* (Krapp and Dobbie 1936: 146, line 92).

Eye color is not something Anglo-Saxon authors described, though glossaries record descriptive terms for gray and, possibly, green eyes, *glæsenēage* and *waldenīge* respectively (Roberts and Kay with Grundy 1995: 1.52; Biggam 2001). Probably the gray eyes of Old and Middle English (see below) were what would be described as light blue today.

Old Norse-Icelandic texts reflect more sensitivity to body color, with the skin of Africans, hair, beard, and a blackened tooth sometimes said to be blue (*blár*), hair and eyebrows sometimes black (*svartr*), while "the eyes of Icelandic poets unlucky in love are black" (Straubhaar 2005: 55–6). Straubhaar suggests this color would be called brown today.

In Anglo-Saxon/Anglo-Norman art human skin is generally left blank, and outlines indicating hands and faces are inconsistently colored using whatever shades were available in ink, paint, or, in the case of the Bayeux Tapestry (Figure 5.1), vegetable-dyed wools.

In the Old English illustrated *Hexateuch* (London, British Library, Cotton MS Claudius B iv) brunette hair is conveyed by bright blue. In the Tapestry, figures may have, for example, one hand outlined in red, the other in black, while hair is usually outlined in one color and filled with another color: red, yellow, brown, dark green, or what was originally pale blue. There is no continuity—the same character appears with different coloring—except for King Edward, obviously growing older, his beard becoming silver as the narrative progresses, and with perhaps the suggestion of fever in the redness of his face and beard as he lies dying (see Plate 5.1).

FIGURE 5.1 The Bayeux Tapestry (detail), King Edward's funeral showing differently colored hair and outlines for hands and face, eleventh century. Image by special authorization of the City of Bayeux.

Black-skinned figures begin to appear in manuscript art from the twelfth century. A naked black figure is part of an illuminated letter in a French manuscript from Corbie Abbey (Paris, Bibliothèque Nationale de France, Latin MS 11576; Pastoureau 2009: 29, plate) of Florus's *Commentaries on the Letters of Paul* (1164). In a Spanish thirteenth-century manuscript of the *Libro de Juegos* of King Alfonso X the Wise, dark-skinned, turbaned Moors play chess, attended by servants both pale and dark skinned (Madrid, El Escorial Library, MS T.I.6, fol. 22; Pastoureau 2009: 42, plate). This may represent social reality in Arab-occupied Spain (though dark skin is uncommon in this manuscript). More often, apparently, artists used skin color, sometimes with foreign dress, to indicate the universality of the Christian message. A twelfth-century depiction of Pentecost (Florence, Laurentian Library, Plut. MS 7.32, fol. 18v, *Homilies of Gregory Nazianzen*) represents the assembly of nations present in Jerusalem at that time by contrasting a dark-skinned figure "in pagan robes and an Arab headdress" with a lighter-skinned figure in Byzantine dress (Friedman 2000: 62–4 and fig. 25). The early fifteenth-century *Très riches heures du Duc de Berry* by the Limbourg brothers (Chantilly, Musée Condé, MS 65, fol. 27v, 28r) depicts black men, women, and children with African features and sometimes tightly curled hair acknowledging Christ (Jolly 2002),

and at fol. 44v shows the shepherds in the background to a Nativity scene as redder and darker than the very pink-skinned Holy Family, a subtle social distinction. From the thirteenth century dark-skinned attendants to the Magi appear at the Adoration of the infant Christ (Jolly 2002: 148) and, from the fourteenth century, a black Magus, identified with Saint Balthasar,[6] is depicted often wearing colorful exotic clothes, which added richness and interest to paintings,[7] and which contrasted with the other Magi's costume.[8]

Simultaneously, the biblical association of light with goodness and Heaven, and dark with evil and Hell led to dark-skinned figures being depicted in art as wicked: black-skinned people are cast as torturers, for example, in the *Très riches heures* (fol. 19v), the persecutors of St. Mark, and a man flagellating Christ on the *Marnhull Orphrey*, an *opus anglicanum* embroidery *c.* 1310–25 in the Victoria and Albert Museum, London. A Last Judgment scene in the *Très riches heures* (fol. 34v) depicts those burning within the hell mouth on the right with dark hair and darker (reddish) skin than the blond, saved souls on the left.

Many light-skinned medieval Europeans must have interacted with darker-skinned Arabs and Jews. Between the eleventh and thirteenth centuries, a series of Crusades took European men and women to the Holy Land. Areas to the northwest of the Mediterranean Sea were multicultural for much of the medieval period, with Christian, Jewish, and Arab populations in the Iberian Peninsula from the eighth to the fifteenth century. Southern France was dominated by Arabic culture in the eighth century, and Arabs ruled Sicily from the ninth to the late eleventh centuries. Inhabitants of Italy were aware of Saracen pirates and Moorish mercenaries, many of whom became settlers. However, difference in skin color was not sufficient to preclude a Christian disguising himself as a Saracen (with appropriate clothing and a full beard) or vice versa, at least in literature (Grinberg 2017). Darker-skinned African traders would have been familiar around the Mediterranean throughout the Middle Ages and the advance of the Mongols into Poland and Hungary in the thirteenth century exposed central Europeans at least to a further ethnic type.

In northwest Europe, however, white skin was the norm and, from the twelfth century, a literary convention emerged emphasizing pallor in ladies. In Middle English this might be expressed in similes that described a woman's complexion as being as white as whale-bone, or as a lily flower, while in French, hyperboles that described a woman as being whiter than a lily or hawthorn flower were common. Lips and cheeks were conventionally red, and again described in terms of pleasing comparisons, such as the rose. Although dark eyebrows (slender and arched) were admired, ladies were conventionally blonde, their hair compared, in English poetry, to golden wire, and in French sometimes described as brighter or shinier than gold. The English ideal for eye color was gray, so the brown-browed, black-eyed Alisoun of the *Harley Lyrics*

is unusual, perhaps hinting at friskiness (Brook 1964: 33, line 14). In French literature ladies' eyes are compared to jewels of various colors.[9]

The whiteness of idealized ladies' skin probably reflects the reality of aristocratic female life lived largely indoors. Women who worked outdoors would be more weathered, so in literature a dark complexion is an inherent feature of lower social status (Friedman 2018). The Wife of Bath in Chaucer's *Canterbury Tales* is not unattractive: "Boold was hir face, and fair, and reed of hue" (Chaucer 1987: 30, line 458) but her ruddy coloring indicates that she was not refined and corresponds with her biography: she had traveled on many pilgrimages and consequently been exposed to the elements.

Medieval medicine inherited from classical thinking the theory that the body's welfare, and characteristics of human beings, were dependent on the balance of four bodily fluids called *humors*: blood, bile (*choler*) both black and yellow, and phlegm. Thus when Chaucer described the Reeve as "a sclendre [slender], colerik man" (Chaucer 1987: 32, line 587) his audience understood that in this person yellow bile was the dominant humor, and he could be expected to behave accordingly: he might be sharp witted, quick tempered, and of untrustworthy morality, both sexual and social.

The most startling use of body color in medieval English literature is, however, supernatural. In a late fourteenth- to early fifteenth-century poem, a strange knight interrupts New Year celebrations at Camelot, riding his horse right into the royal hall. The visitor is *aghlich* (fearsome) yet handsome, of gigantic size but of aristocratic physique, and—the poet holds back this information until the end of his verse—entirely green! The poem, *Sir Gawain and the Green Knight*, continues to invite scholarly discussion. The Green Man, it has been suggested, may derive from folklore belief in a wild man of the woods, yet the Green Knight is a courtly figure. The poem itself is ambiguous. However it is interpreted, the frisson of the climax, "And overall enker-grene" (and overall bright green), must be felt by every new reader of the poem (Winny 2007).

CLOTHING

Secular life and color

Primitive breeds of sheep and goats came in various colors. Indiscriminate use of wool might produce a mottled effect of grayish brown. However, diligent sorting of fibers might result in garments ranging from white to gray to brown to black, or with woven stripes and checks. Linen could be various shades of cream and brown, but when freshly laundered and sun bleached, might be creamy white. Silk, in its natural state, is iridescent, golden yellow. All these natural colors were exploited for garments in the Middle Ages, sometimes offset by contrasting edgings. The earliest surviving garment from the British Isles, a

hood found in a peat bog in Orkney, Scotland, carbon-14 dated to 250–615, is of undyed wool cloth, originally of the reddish-brown color called *moorit*, now golden brown through exposure to peat. It is bordered with a narrow tablet-woven band in three colors: and a wider, fringed band of two colors (Coatsworth and Owen-Crocker 2018: 32–4).

Most dress fragments found in early medieval graves in Anglo-Saxon England retain no traces of dye. The rare exceptions are women's cuffs, which have been found to be tablet-woven in blue, white, and red purple (Owen-Crocker 2004: 58). Since garments with colored borders were traditional to the Anglo-Saxons (137) and contrasting necklines, hems, and cuffs appear in Anglo-Saxon art (215–16, 246–9), it is likely that sometimes the body of a garment was of undyed cloth and dyed color was confined to edgings. Figures in Ottonian and Carolingian illuminations often wear colorful strips of ornament down the fronts of their garments, frequently decorated with circles or ovals, which perhaps represent silk trimmings (217). Viking women decorated their wool and linen garments with fragments of colorful, patterned, imported silks. These appliqués were mostly rectangular, but occasionally other shapes such as circles and leaf forms occur, apparently cut regardless of the woven pattern. They have been found in the ninth-century Oseberg ship burial in Norway, and in graves of wealthy women elsewhere in Scandinavia (Vedeler 2014: 3–19, 33–4, 38–9). It was the Vikings, too, who exploited natural colored silk for headdresses, found in both York and Lincoln (Coatsworth and Owen-Crocker 2018: 40–2).

It is not known to what extent early medieval people dyed their clothes before the development of trade in dyestuffs and the commercialization of the dyeing industry, or whether dyeing was practiced as a domestic craft throughout the Middle Ages alongside professional production; but it is possible. Dyestuffs could be acquired from the countryside or grown as farm crops. Plant sources include woad (blue), the madder family and bedstraws (red), weld and dyer's greenweed (yellow), tree bark and nuts that contain tannins (browns), and lichens (red purple) (Uzzell 2012). Professional dye production was certainly taking place in England by the Anglo-Viking/late Anglo-Saxon period and may have existed earlier elsewhere, particularly in Ireland.

Penelope Walton Rogers recognizes ethnic preferences for colors from analysis of archaeological textiles, suggesting that the English and the York Anglo-Scandinavians liked red, dyed with madder; that Dubliners and the Norse Greenlanders favored lichen purple; Scandinavians blue; and mainland north-continental people, Frisians, and North Saxons, natural fleece colors including black. She cites an eleventh-century poem, "Conflictus ovis et lini" by Winric of Trèves, mentioning the green of Flanders, the black dye of the Rhineland, and the natural tawny red of Suevia (Walton Rogers 1997: 1769).

The Bayeux Tapestry, a wool embroidery on linen (1070s–80s) gives first-hand evidence of eleventh-century dyers' skill. Using only three vegetable dyes,

ten shades were produced: pinkish or orange red, and brownish-violet red from madder; mustard yellow and beige from woad; blue black, dark blue, and mid-blue dyed with indigotin, probably from the pastel plant; and dark green, mid-green, and light green from a combination of woad and indigotin. On the front of the Tapestry, which has been exposed to light, reds have darkened and blues have turned greener, but overall the lack of fading over more than 900 years is remarkable (Bédat and Girault-Kurtzeman 2004: 91). Although experts studying the back of the Tapestry (unexposed through most of its existence) have identified different shades of the same color—and recent research using scientific imaging is revealing more (Boust et al. 2018)—the dyers achieved a remarkable consistency over this enormous artwork (now 68.38 meters long) and differences in dye lots are certainly not obvious.[10]

The most precious dye was Tyrian purple (murex), derived from the glandular mucus of shellfish (Munro and Owen-Crocker 2012). It was exploited as part of the Byzantine Empire's use of precious silks for diplomatic purposes. Purple carried special status and symbolism in the west, albeit sometimes achieved through other, cheaper colorants. Apart from Tyrian purple, kermes was the most expensive and prestigious dyestuff. Extracted from the dried eggs of insects found in countries around the Mediterranean and the Caucasus, kermes was also known as *grain*. It characteristically produced scarlet red, but combination with other dyestuffs achieved other shades and colors. An outstanding example of a surviving kermes-dyed garment is the mantle made in the royal workshop of Palermo for King Roger II of Sicily in 1133–4, which eventually became the coronation robe of the Holy Roman emperors. Contextualized and dated by its Islamic inscription, the red silk is woven with a pattern of scrolls and plants and embroidered with silks and gold thread, tens of thousands of pearls, gems, and enamels (Coatsworth and Owen-Crocker 2018: 85–8) (see Plate 2.4).

Although kermes was used to dye silk, it reached its peak of importance as a dyestuff for a category of woollen broadcloths, known as *scarlets*. These high-quality products, which were repeatedly fulled, teaselled, and shorn and, essentially, kermes-dyed, were immensely fashionable in the fourteenth and fifteenth centuries. The term *scarlet* also came to be used of the bright red color that was a characteristic product of kermes, and it is as a color term that the word survives today; but in the medieval era the cloth itself was not exclusively red. By the addition of woad or other dyestuffs, scarlet could be made in other colors and stripes (Munro 1983, 2012).

White, associated with cleanliness and purity, was used for shirts and underwear in the form of bleached linen, but was not popular for outer garments except for women's veils and for baptism.[11] The fourteenth-/fifteenth-century English mystic Margery Kemp chose to dress in white (having a gown, kirtle, hood, and cloak made in that color), and subsequently "sufferyd meche despyte

and meche schame" for this choice; she probably appeared quite conspicuous (Staley 1996: chs. 43–4).

The richest medieval textiles incorporated gold, initially (from about the sixth century) as metal brocading on tablet-woven bands. In the high Middle Ages, very rich people, both secular and ecclesiastical, wore cloth-of-gold, in which gold threads were woven into a textile, usually silk, often in figured weaves depicting plants, exotic birds, and animals (Monnas 2012: 133). Rare survivals include the pourpoint (quilted doublet) of Charles of Blois, *c.* 1370, preserved in the Musée de Tissus, Lyon, France, decorated with heraldic beasts in medallions, alternating with four-pointed stars or crosses, probably woven in what is now Iraq or Iran (Coatsworth and Owen-Crocker 2018: 258–61); and a woman's gown in Uppsala Cathedral, Sweden, traditionally associated with Queen Margrethe of Denmark (1353–1412), but more likely to have been a later royal wedding gown. Probably woven in Lucca, Italy, 1403–1439, the gold thread depicts a pattern of a fruit, framed with laurels and pomegranates, on a base of red silk (Coatsworth and Owen-Crocker 2018: 210–14). Gold-thread and colored-silk embroidery, most famously *opus anglicanum* (English work) was also in demand. No secular *opus anglicanum* garments survive, but Richard II may be wearing one in his portrait on the Wilton diptych. The red cloth is richly encrusted in gold with royal emblems, including the hart and peascods (peapods) (see Plate 5.2a).

Multicolored and patterned clothing was popular throughout Europe in the thirteenth and fourteenth centuries. In some cases, the colorful effect was achieved during weaving: *marbled* cloth used different colors in warp and weft; *medley* had differently colored yarns mixed in both warp and weft; *rays* had weft stripes, cloths with bands of three colors being particularly popular (Crowfoot et al. 1992: 54). Checks were achieved by systematic inclusion of warps of a contrasting color or colors as well as wefts. Colorful effects might also be achieved by attaching ribbons or contrasting bands; or by combining more than one cloth to make a garment. A common form of this was *mi-parti*, where the garment was divided medially with different textiles on each side. The two cloths were not just different colors. One might be patterned, the other plain; or both might be patterned differently (Dahl 2009).

By the fourteenth century, European royal courts were using color to reflect power and identity. New clothes in coordinating colors and hierarchical levels of materials were ordered for family and households for public events, such as coronations, weddings, baptisms, tournaments, and major Christian festivals. Red and blue were particular favorites. Green, being associated especially with nature, spring, and fertility, was particularly exploited for May Day celebrations. In a study of Maytime in medieval courts, Crane notes that people wore fresh green leaves and flowers as belts or chaplets, as well as garments embroidered with these motifs and green clothing: in 1400 King Charles VI of France ordered

352 green houppelands (very full, belted garments worn by both sexes) for his household and wore green himself (Crane 2002: 39–72, esp. 40). At Christmas 1360 the English royal family and their guests were all equipped with outfits of *marbryn* (marbled, or variegated textile), the quantity of cloth and quality of fur differing according to status. King Edward III's clothing was enhanced with narrow gold ribbon, ermine, and *miniver* (white fur of the Baltic squirrel); Queen Philippa's with miniver, ermine and five ells (lengths, mostly 45 inches in England, but variable in different places) of sanguine-colored (blood-red) cloth. Edward's sister Joan, Queen of Scotland, had similar cloth to Philippa, but fewer furs and no sanguine. Of the royal daughters, Isabel had a suit like her mother's, but with contrasting brown cloth. Her sisters and sisters-in-law had no contrasting cloth. Guest John de Montford had gold ribbon with his suit, but less ermine than the royal family. His sister had a suit like the princesses', but with some additional garnet-colored cloth. Two newly created knights wore dress of *mi-parti* green and marbryn *in grain* (kermes dyed); other knights had *mi-parti* of tan and striped cloths. Household servants were given liveries, evidently *mi-parti* since they consisted of half plain cloth and half striped, with the hierarchy indicated by fur: *budge* (lambskin) for the highest, white lamb below that, and no fur for those of lowest rank (Newton 1980: 65–7).

The fashion for multicolored garments was widespread across Europe, and not confined to the highest classes. In late fourteenth-century Italy, many small craftsmen/traders from the city of Lucca or surrounding areas ran businesses by means of credit and sometimes could not pay, so had items of clothing distrained for debt. Many garments specified in the Lucca records are of *mischium*, a mixture of colors that produced a marbled or medley effect, often with one predominant color, such as green, violet, bright blue, pale blue, sanguine, or vermilion. *Mi-parti* garments are frequent and usually vivid: combinations include striped sanguine with bright blue; bright blue with violet; black with beige; brown (or dark) with vermilion; dark mischium with vermilion mischium; striped velvet with scarlet; vermilion with sanguine mischium; and *baudekyn* (a patterned silk cloth) with carnation pink (Meek 2014).

Dahl (2009) notes a diminishing in the popularity of marbled cloth garments in Scandinavia after the mid-fourteenth century. However, *mi-parti* clothing and garments with bright contrasting linings continued to be popular throughout the fourteenth century, with black appearing in *mi-parti* combinations.

The end of the fifteenth century saw an abrupt change in fashion from scarlet and other brightly colored clothing to more sombre, monochrome hues, predominantly black, also dark blue, gray, and purple. This change was manifested in both luxury-quality woollen broadcloths and silk textiles—satin and velvet; also furs, with a new emphasis on dark browns, and black sable. Reasons for this transformation have been discussed inconclusively (Munro 2007). Suggestions include the possibility that the fashion may have come from

Spain, possibly through Islamic culture—though the latter had produced some of the most colorful medieval patterned textiles surviving, among the grave-clothes of the Castile-León royal family (Herrero Carretero 1988; Yarza Luaces and Mancini 2005). Influence of individual monarchs, particularly Philip the Good, Duke of Burgundy (r.1419–67), believed to have adopted black after his father's death, may have popularized the color, although it was worn in court circles even earlier. Pastoureau plausibly suggests it began in Italy as a reaction against Sumptuary Laws (see below), which precluded wealthy merchants from wearing scarlet or peacock blue because they were not of aristocratic birth. Instead they adopted black and could afford to have it dyed to the highest standard. The resulting austere appearance made their fashion acceptable to moralists (Pastoureau 2009: 100). Black continued to be held in high esteem until the seventeenth century and in some respects continues so today.

Furs made an important contribution to the appearance of medieval dress. Used as warm winter linings from at least the eleventh century, they also made desirable trimmings at cuff or neck edge. Sometimes cheaper furs were used for unseen linings, and more expensive ones at the turned-back edges for the most attractive—and ostentatious—effect. In the thirteenth and fourteenth centuries light-colored fur was most desirable. The priciest was ermine, the white winter coat of the stoat, sometimes "powdered" with black tail tips (and small pieces of black sheep skin). Ermine was confined to royalty in the fourteenth century and is used in art as a sign of rank. *Lettice*, the white fur of the snow weasel, was a less expensive alternative. *Miniver*, cheaper but still luxurious, was the white belly skin of the winter coats of Baltic squirrels. *Vair*, the gray winter coat of the squirrel, was also prized. In art, vair is usually depicted as grayish blue, arranged in panes to line cloaks. Lambskin was found in a wide range of colors from black through brown to cream or white. *Budge*, usually black, was high-quality, imported lambskin. Fox, red brown, or grayish white in the case of the Arctic fox, was favored by middle and lower social groups, and *coney* (rabbit) was also less expensive. *Marten*, a brown fur with a thick, silky texture, was more costly. Used from early in the medieval period, it became particularly desirable when fashions for darker clothing began in the fifteenth century; the darkest shades (*sable*) were the dearest, and favored by royalty (Veale 1966; Hayward 2012a–j).

The Byzantine Empire led the way in formalizing colors, in particular purple: members of the royal family were literally "born to the purple" in a chamber with walls of porphyry, a deep reddish-purple colored stone. Murex-dyed silks, specific kinds of gold borders, and garments tailored in particular ways were reserved for imperial use from the fourth to the tenth centuries (Muthesius 2008: 15). The imperial household wore purple on specific occasions, such as Christmas, top officials wore it with green-yellow medallions and Officers of the Imperial Bedchamber with peacock decorations. The imperial blue and

purple *chlamys* (formal cloaks) and imperial green *chlamys* were given to newly appointed officials (19–20).

From the second quarter of the twelfth century, heraldry became established in western Europe, originally to distinguish combatants in battles and tournaments. It specified seven colors (or *tinctures*): two metallic: *or* (gold) and *argent* (silver); and five *stains*: *gules* (red), *azure* (blue), *sable* (black), *vert* (green), and *purpura* (purple).[12] The colors developed symbolic interpretations, such as theological and cardinal virtues, and links to precious stones and emotional associations, as explained in the mid-fifteenth-century *Le Blason des couleurs en armes* (Cocheris 1860;[13] Koslin 2002: 235). By the fourteenth century, the servants of great families wore livery reflecting heraldic colors, along with badges, depicting their master's arms or emblems (Wild 2012a: 338). Giotto's early fourteenth-century fresco in the Arena Chapel, Padua, Italy, depicting a devotional topic, the *Virgin Returning from her Marriage*, includes musicians wearing the heraldic colors of their patron Enrico Scrovegni (blue and silver stripes). Slightly later, the interior of the Dominican church of St. John in Bozen, Italy, included depictions of servants and dependent daughters wearing the black and silver of the Botsch family (Anderson 2019).

Guilds, religious associations, and chivalric orders adopted emblems and colors. The English Order of the Garter, traditionally founded in 1348, deliberately appropriated the blue and gold which were the royal colors of France, a reflection of Edward III's ambitions (though the distinctive robes worn by the Order today were not adopted until the sixteenth century) (Wild 2012b: 397).

Consciousness of colored dress appears in the tenth century, when some of the few Anglo-Saxon testators to bequeath clothes identify individual garments in terms of color (Owen-Crocker 2004: 211, 299). As technology and commercialization progressed, textiles were often named in later English according to color: *burnet* was originally brown; *russet* a natural wool in red, brown, or dull gray; *plunket* light or gray blue; *blanket* and *diaper* white. However, just as *purpura*, a luxurious silk cloth, is documented in Anglo-Saxon times as existing in colors other than purple (Dodwell 1982: 145–9), and by the thirteenth century even signified wool (Monnas 2014: 48), all of these later medieval cloths eventually came in a variety of colors: black and blue burnets; red, violet, and red-striped plunkets; dyed russets; and red "diapered" cloth (Owen-Crocker 2012: 375–6). As the textile industry expanded, and fashion demanded seasonal innovation, more and fanciful names of colored textiles appeared, including *solsickle* (marigold) (375), *rosa secca* (dry rose or old rose), and *murrey* (mulberry) (Monnas 2014: 52–3). The tunic and long shirt bequeathed by Thomas Harpham in his 1341 will are described as *coloris de appelblome* (appleblossom colored). Harpham evidently had a colorful wardrobe: his bequests included a robe and hood of white camelin (a luxury

cloth), a tunic, long shirt, and furred hood of the orange-brown color he called *taune* (tawny), and a supertunic and hood of *bluet* (Sylvester et al. 2014: 28–31). By the end of the Middle Ages, with the increased popularity of black, this range diminishes. In her study of Scottish royal accounts documenting court clothes between 1543 and 1553, Melanie Schuessler Bond finds a preference for black among both sexes (Bond 2019).

From the thirteenth century, European rulers made so-called Sumptuary Laws attempting to confine personal expenditure, especially by curbing extravagance in clothing. The English Act of October 1363 (37 Edward III) attempts to establish a hierarchy of dress with social categories ranging from grooms to knights and ladies with incomes of 400 marks to £1,000 per year. Only the latter were permitted free choice in dress, and even they were allowed ermine, lettice fur, and jewels only on their heads (Sylvester et al. 2014: 200–7). Modern scholarship suggests Sumptuary Laws were ineffective, an attempt to close the stable door after the horse had bolted! Medieval people in general chose to dress as well as they could afford, striving for upward mobility and taking prestige from fashionable colors, valuable furs, and accessories of precious metal.

Christianity and color

The Christian Church's use of clothing polarized into magnificence for the celebration of Mass and the Eucharist, and plainness as an expression of humility and personal poverty of those vowed to monasticism.

Ecclesiastical vestments originally arose from a formalizing of secular, mostly Roman garments. From about the tenth century, vestments of the Western church began to increase in richness (Miller 2014), and throughout the Middle Ages, they multiplied in quantity. The surviving silk vestments of Pope Clement II (d.1047) demonstrate the visual and spiritual impact of undyed silk, golden, iridescent, and enriched with woven patterns. The only artificially colored silk vestment in the set is the cope, dyed red in respect of his papal office, with a green border (Müller-Christensen 1960).[14]

The cope, a voluminous processional garment, and chasuble, the essential mass-vestment, were particularly colorful, often made of expensive silk fabrics and decorated with silk and metallic embroidery, gems, enamels, metal attachments, and tassels. Many survive, many more are described in detail in church inventories such as the 1245 inventory of St. Paul's, London (Sylvester et al. 2014: 90–101). One of the most magnificent early medieval vestments surviving, the tenth- to eleventh-century Bressanone (Brixen) Chasuble, though faded to brown today, was dyed with Tyrian purple, with green-black and yellow threads for the complex woven depiction of large eagles, the soaring flight of which represented Resurrection. Narrow orphreys, tablet-woven bands brocaded with gold thread, cover the central seam of the back

and form a cross with upswept arms. The cloth is Byzantine. The vestment was probably given to a bishop of Brixen (probably Albuin, *c.* 967–1005/1006) by the Holy Roman Emperor Henry II (Coatsworth and Owen-Crocker 2018: 126–8).

The richest ecclesiastical textiles were silks, especially velvet, enhanced with gold. The 1402 inventory of St. Paul's mentions vestments of white, red, black, and *blavius* (blue or dark colored) cloth-of-gold (Sylvester et al. 2014: 110–13). Such textiles do not survive. They were probably burnt to recover the precious metal when they became old or rendered obsolete by the Reformation. *Opus anglicanum* vestments, however, survive in considerable numbers (Browne et al. 2016). The Butler-Bowden Cope (see Figure 5.2), red velvet embroidered in gold and silver threads and colored silks, depicting events from the life of the Virgin Mary and images of saints in settings that reflect the "decorated" phase of English Gothic architecture, remains a magnificent example despite its history. Cut up into separate vestments and church furnishings, it was reassembled in the nineteenth century and remounted in the twentieth.

In contrast, monks and nuns were expected to dress in inexpensive material and neutral colors, mostly undyed wool of white, black, gray, or brown. Carmelites caused horror when they first appeared in France in 1254 in the train of King Louis IX on his return from the Holy Land, since they wore brown and white striped cloaks. In the face of strong opposition and papal

FIGURE 5.2 The Butler-Bowden Cope, red velvet with *opus anglicanum* embroidery, 1330–50, restored in the nineteenth century and remounted in the twentieth century. Photograph © The Victoria and Albert Museum, London.

proscription, they finally abandoned the offensive stripes for white in 1287 (Pastoureau 2001b: 7–11). Color was used to distinguish between different ranks of the same order, for instance novice nuns changing the color of their veils from white to black, at their final consecration ceremony.

Holy Wars inspired some austerity in dress for the secular participants. In England, scarlet was forbidden in 1188, also the luxurious furs, vair, gris, and sable (Sylvester et al. 2014: 200–1). King Louis IX of France, on returning from the Seventh Crusade (1249–54), allegedly adopted more sober colors than before, abandoning scarlet, green, and bright shades in favor of blue, blue green, brown, and black, and substituting for vair the more homely rabbit, hare, sheepskin, or basic squirrel furs (Le Nain de Tillemont 1847–51: 3, 177–8; quoted in Le Goff 2009: 132).

Color of clothing in art

In tenth- and eleventh-century manuscript painting, people are usually depicted in colorful clothing. Since paint colors and textile dyes are unlikely to have been identical, there were probably differences between colors of clothing in art and reality, with the pictured image being sometimes "larger than life." King Edgar, in a manuscript of the second half of the tenth century (London, British Library, Cotton MS Vespasian A viii, fol. 2v), wears a bright red tunic enhanced with bands, or bracelets, of gold, under a blue cloak edged and apparently lined with gold. His shoes are also depicted as gold. Blue and red textiles were achievable with native plant dyes, or with imported kermes for the red. Gold-brocaded or gold-embroidered bands certainly existed, as did metal rings. Gilded shoes are a possibility for a king, though probably just an artist's flourish. However, a gold lining for a cloak is improbable, since cloth-of-gold had not yet been developed, and even if it had, a fabric of this weight and value is unlikely to have been used for the secondary purpose of a lining. This is an artist embellishing his picture. An earlier Anglo-Saxon king, Athelstan, is depicted (in Cambridge, Corpus Christi College MS 183, fol. 1v), making a donation to St. Cuthbert's shrine, an event that took place in 934. The king wears a purple cloak, clasped by a small gold brooch over a gold-edged tunic and bright red hose. The combination of purple, scarlet, and gold is indicative of wealth and power. Whether Athelstan really wore these colors on ceremonial occasions or whether this is the artist's invention is unknown. Possibly he did; Athelstan was said to have been invested with a scarlet cloak, jeweled belt, and gold ring as a child by his grandfather King Alfred (Stubbs 1887–9: 1:145), so he had grown up accustomed to the symbolism of rich dress. He might have owned hose dyed with kermes, though madder would have produced a strong color; he is unlikely to have owned a cloak of Tyrian purple, but there were lower grades of whelk-dyed textiles, still expensive but less exclusive, which might have been imported to England (Biggam 2006a). There were also vegetable sources of purple dyestuff available at home. Purple cloth, however dyed, would have carried the connotation of royalty.

Artists used different colors to distinguish different garments, the variety of shades adding to the attractiveness of their picture, though in reality people may have appeared both in garments of undyed cloth and in sets of garments of matching cloth. For example, the Bocksten (Sweden) Man, buried in a peat bog in 1350–70, wore an outfit of woollen garments of the same cloth: a fashionable hood with a tippet (a long extension like a tail), cloak, tunic, and hose. The textile is now all dark brown apart from a decorative red patch, which has been added to the hood in a modern reconstruction (Nockert 1985; Coatsworth and Owen-Crocker 2018: 10, 36–9, 162–3). In artworks, additional garments may be added to indicate high status; for example, the figure of the Virgin Mary in a manuscript of the second half of the tenth century (London, British Library, Cotton MS Vespasian A viii, fol. 2v), wears a red headdress over a green cloak, over a yellow, long-sleeved gown, over a longer blue gown.

In later medieval art, the Virgin Mary generally wears blue. This may be because the lapis lazuli pigment used to create blue was the most expensive, or further symbolism may have lain behind the choice. Certainly, symbolic meanings came to be associated with it: that blue, as the color of the sky or heaven indicated Mary's spirituality; or that it arose from references in the Old Testament to blue cloths, particularly instructions that the Ark of the Covenant was to be covered with a cloth of this color (Num. 4:6) and that Mary, as the container of Christ, was the new Ark of the Covenant. The Wilton Diptych (c. 1395–9) presents a striking image of the Virgin surrounded by blue-clad angels with only the Christ Child dressed in cloth-of-gold (see Plate 5.2b). The Virgin is sometimes also depicted in red shoes, which were a privilege of Byzantine emperors.

The French royal insignia of gold *fleurs de lis* on a deep blue background is sometimes depicted not just upon the bodies of French kings, and the dress of some accompanying figures (Figure 5.3), but around them in terms of furnishings and horse trappings, as in, for example, the copy of the *Grandes chroniques de France* in the early fifteenth-century manuscript (London, British Library, Cotton Nero MS E.ii, parts 1 and 2). While this may have some basis in reality for grand ceremonies, the characteristic blue and gold cloth is widely used in illustrations of other occasions as identification and propaganda. In reality, French kings did not confine themselves to these heraldic colors at all times. Joinville, the biographer of Louis IX, described the young monarch in an outfit of blue satin, vermilion satin, and ermine (quoted in Le Goff 2009: 92).

Art historians observe that highly colorful, striped, and *mi-parti* garments are pictured as signs of "otherness" along with fashionable details, such as a very tight fit and *dagging*, the edges of the cloth being cut into fancy shapes (Mellinkoff 1993; Friedman 2013). In art, it is often minstrels who wear these distinctive clothes; and brightness and stripes are often associated with morally "bad" figures. Mellinkoff (1993: 20–1) notes that in art, although stripes may be worn by all classes of people, striped hose are confined to sinister people and rustics. Dahl's example of a mural painting in Barup Church, Denmark, in

FIGURE 5.3 From *The Coronation Book of Charles V of France* (1365–80, detail), the anointing of King Charles V of France. London, British Library, Cotton MS Tiberius B.viii, fol. 55v. By permission of the Trustees of the British Library.

which Cain, the murderer, wears striped hose, and his brother and victim, Abel, wears plain hose (Dahl 2009: 129), is a typical case of the artist signaling the judgmental nature of clothing to the viewer. Mellinkoff explains the difference between general acceptance of fashionable styles for personal use and artists' exploitation of them to discriminate against reprehensible characters:

> Members of all classes of society were remarkably capable of ignoring not only criticism of trendy fashions but also the sumptuary regulations outlawing them. The criticism of pious moralists and other conservatives is faithfully mirrored, however, in religious art, where enemies of the faith are repeatedly depicted in brightly coloured, skintight clothes.
>
> (Mellinkoff 1993: 39)

It is inevitable that artwork will be used in our own time as evidence of medieval dress. It should, however, be used along with documentary evidence and remaining examples of garments or textile fragments in order to appreciate that artists used clothing color semiotically, and that while their signals were no doubt recognized by audiences then as now, the customs and values of everyday life were somewhat different.

CHAPTER SIX

Language and Psychology

CAROLE P. BIGGAM, ROMAN KRIVKO, PIERA MOLINELLI,

AND KIRSTEN WOLF

INTRODUCTION (CAROLE P. BIGGAM)

In color semantics, a distinction is often made between basic color terms (BCTs) and non-basic color terms (sometimes ambiguously known as "secondary" color terms).[1] BCTs are the names that societies give to their principal divisions or categories of color. Examples of BCTs in Modern English are *red*, *green*, and *yellow*, and these principal terms show that English-speakers make a distinction between the categories of RED, GREEN, and YELLOW. Other societies may make different distinctions. Readers will note that it is a convention in linguistics to show words under discussion in italics (*red*) and to show basic color categories (BCCs) (categories in psychological color space) in small capitals (RED). There are tests to apply to the color terms of a language to ascertain whether they are BCTs or non-basic terms (Biggam 2012: 21–43). To give just two examples: firstly, a hyponym of a color term cannot be a BCT, that is, a color term whose meaning is contained within that of another color term, as the meaning of *scarlet* is contained within that of *red*, cannot be basic; secondly, a color term that is contextually restricted, that is, can only be used of one subject, such as human hair or animal coat, likewise cannot be basic. Color terms can also be assessed with regards to their *relative basicness* in a language, that is, their position on a continuum ranging from low to high cognitive salience (Kerttula 2002). Those non-BCTs found to have high salience can be regarded as potential future BCTs.

Some societies use basic color categories that would surprise English-speakers, and others. For example, they may consider green and blue to be shades of

the same color and label them with just one BCT. Such a BCT is known as a *macro-color* term, and it names a macro-color category. The example just given is a green+blue macro-color category, which for convenience, is called GRUE (a combination of English *green* and *blue*). It has been discovered, after considerable research, that a society usually develops BCCs gradually over the centuries, and that they are frequently acquired in a near-predictable order. For example, RED is always developed as an abstract cognitive category before BLUE, and BLUE is developed before ORANGE. Before a separate term and abstract concept of, for example, ORANGE is developed, a society is likely to include this hue in their RED or YELLOW category (or in both). A speech community will change its color system over the years, acquiring new terms, losing others, and always reflecting the current concerns of and communication pressures on that society.[2]

OLD AND MIDDLE ENGLISH (CAROLE P. BIGGAM)

Old English (OE) refers to the phase of English dated from the earliest records of the language to about 1150 CE. The earliest records of any substance date from the seventh century. Following the establishment of French as a prestige language in England, after the Norman Conquest of 1066, and the adoption into English of much French vocabulary, the language gradually developed into what is now termed "Middle English" (ME), which flourished from about 1150 to about 1500 when Modern English (ModE) evolved.

Old English had the following basic color terms: *blæc, hwīt, rēad, grēne, geolu,* and *grǣg,* the earlier forms of the modern terms "black," "white," "red," "green," "yellow," and "gray." However, it should not be assumed that they all had the same meanings as their modern equivalents: in particular, *rēad* could be used for the colors orange, pink, red purple, and some browns, and *grǣg* could denote any dull hue, for example, dull green, dull red, and so on. These are colors we might today describe as *grayish,* but Old English required no suffix.

Blæc can be translated as "dark" as well as "black" and it was used in a wide variety of contexts.[3] Examples include: human hair and skin; birds (thrush, raven); animals (horse, snake, panther); fruit (blackberry); minerals (jet, jasper, flint); and substances (tar or resin). Another field in which *blæc* can be found is health and medicine where it is used, for example, of bile, boils or ulcers, and of dead bodies. It also features in landscape descriptions and place-names (moors, hills, streams, pools, and much more). Occasionally it also describes clothing (tunic, cloak). *Blæc* often carries connotations of gloom, misery, evil, and/or sin, and is used of devils and sinister beings.

Hwīt meant much more than "white" as it could also denote "bright (light)," "fair (hair, complexion)," "shining," "gleaming," "clear," and similar senses. As with its opposing color term, *blæc, hwīt* had an immense range of application,

sometimes describing items that may be considered prototypical of whiteness, such as snow, milk, and salt, but often referring simply to paleness, cleanness, or purity. Examples of its use include: human hair (indicating "blonde"); birds (goose); animals (horse, sheep, cattle); plants (lily, hazel), often distinguishing one type of plant from a darker one considered to be similar; minerals and metals (marble, silver); and food items (bread, wheat). In the field of health and medicine, *hwīt* bodies indicated good health and even saintliness and holiness, but *hwīt* also describes skin problems, which may sometimes indicate leprosy. It is used of the landscape (meadows, valleys, hills, and more) and of clothing and textiles (wool, linen).

Rēad is prototypically, but not exclusively, the color of blood, but its hue range is greater than that of ModE *red* because Old English had no basic categories for ORANGE, PINK, or PURPLE, and probably not for BROWN either.[4] As a result, we find OE *rēad* used of gold and rust (orange), of the (wild) rose (pink), of whelk-dye (purple), and of horses and cattle (brown).[5] Other *rēad* entities are: birds (fowl, the unidentified "redmouth"); animals (ant, snake); plants (maple, clover, nettle); health and medicine (tumor, healthy body, face, an inflamed wound); landscape features (earth, river, lichen); food (apple); and clothes and textiles (dye, fine cloth, thread, jewelry).

It is hardly surprising to find that *grēne* is closely associated with the plant world, usually implying healthy, verdant growth. It is used of a long list of specific trees, of groups of trees such as forests and groves, and parts of plants, for example, leaves. As a common descriptor of grass, *grēne* is also used of grassy places such as plains, hills, slopes, and (little-used) pathways, often in place-names and land boundaries. It features strongly in Anglo-Saxon herbal texts in connection with specific plants to be included in medical recipes, but this has the added force of "fresh" as opposed to dried ingredients. *Grēne* also describes gemstones (jasper, emerald), and metals, probably with reference to their patina (copper, brass). In certain contexts, it implies "unfinished" as in unripe (fruit, nuts), uncooked (vegetables), and untanned (hides).

Geolu is probably the least commonly occurring of the Old English BCTs. It is cognate with OE *geoloca*, "(egg) yolk," suggesting that yolk is the prototype for this hue category, although it also includes a variety of golden, reddish, yellowish brown, and saffron-colored shades. *Geolu* appears most often in the context of health and medicine, describing various plants to be included in herbal recipes, and indicating the faces, teeth, and eyes of sick people. Jaundice, for example, is called the "yellow disease" (*geolwe ādl*). In addition, it describes, for example, human hair, a bird (goldfinch), a horse (probably a bay), a linden-wood shield, gleaming metalwork, wine, and silk.

Grǣg, indicating "gray" or "grayish," is found in unsurprising contexts such as: human hair (of elderly people); birds (seabird, goose); and animals (wolf, horse, pig). The wolf is considered the typical gray animal, being known as

"the gray one," and it is probably also the wolf that is described as *grǣghama* "gray-coated (one)." Also unsurprising is the use of *grǣg* of stones (frequently, boundary markers), a stormy sea, flint, and ash. In poetry, it is also used of the gray metals, iron and steel, describing a sword, a spearhead, and a mailcoat (see Biggam 1998: 31–99).

While the basic categories all had principal terms (BCTs), as described above, they also included a varying number of non-basic terms. All of these exhibit features, including those descibed in the introduction above, which preclude them from being considered basic. In addition, they may occur only rarely in the texts, or their establishment in the language may be recent and tenuous. Examples include: *sweart* (dark, black), rarer than *blæc*; *basu* (purple, red, crimson), always a vivid shade, used especially of dyes, feathers, and fine fabrics; *fealu*, denoting varied color senses involving yellow with tints of red, brown, and gray, usually pale, and always unsaturated; and *hasu* (gray, gray-brown), strongly connected with birds.[6]

Old English speakers were also developing basic color categories for BLUE and BROWN, but the evidence suggests that they were not fully established before the language evolved into Middle English. The most prominent blue word in Old English is *hǣwen* (or *hǣwe*), which can denote blue, gray, and several combinations with these colors, such as blue-green, gray-blue, and others (Biggam 1997: 115–270, esp. 128). It describes, for example, gemstones, probably including the sapphire, blue-dyed cloth, the sky, the sea, leaves, and flowers. It may seem to speakers of Modern English that another Old English blue term, namely, *blǣwen*, is a more likely predecessor of ModE *blue*, but the modern word is traced back to Norman French *bleu* not OE *blǣwen*. *Hǣwen* occurs much more frequently in the Old English texts than other non-basic blue terms and, unlike them, it is contextually unrestricted. However, it does not have the stability of reference to BLUE, which is required for a blue BCT as, on occasion, it denotes gray, and even green. Furthermore, the evidence suggests that the meaning of "blue" had become the dominant sense in the written usage of literate people, but probably not in ordinary Old English speech (255–6). Although the evidence is not as extensive as we might wish, it appears that *hǣwen* was nearly a BCT but had not yet reached that stage of development. The fact that it was lost in Middle English, whereas the other Old English principal terms, as mentioned above, were retained, suggests that its importance in Old English was not firmly established.

Similarly, OE *brūn*, which developed into ModE *brown*, was probably not a BCT. Its principal meaning was "brown" or "dark," but it also translated Latin color terms meaning "black, purple, red, dun." More surprising still is its use in poetic contexts to mean "shining" or "burnished," usually of weapons. Here we have a word that can mean both "dark" and "shining," and has been the subject of much discussion over the years (see also *brúnn* in the Old

Norse-Icelandic section). Biggam has presented the various theories about this apparent contradiction (Biggam 2010: 256–8) but believes the crucial point is that the sense of "shining" only occurs in poetry, a genre that often contains archaic elements. It is suggested that *brūn* originated in a FIRE-term, cognate with ModE *burn*, in which it denoted the brightness of flames and also the color of burnt or scorched things, such as cooked meat (258). In Old English we see the brightness sense diminishing and the dark reddish sense already normal for *brūn* in nonpoetic usage, but this still involves a lack of stability of reference, a requirement for a BCT. The reason why non-basic *brūn* survived to become a Middle English BCT when non-basic *hǣwen* did not is almost certainly because the French equivalent (*brun*) was almost identical in form and pronunciation.

After the Norman Conquest of 1066, the principal language of government and the church was Latin, and that of the new aristocracy and royalty was Norman French, both languages replacing Old English in these spheres. As a result of this change, it is difficult to observe the early stages of the adoption of Latin and French vocabulary into English at this time.

French *bleu* (which is spelled in many ways) later developed into the principal English blue term, but it appears in Anglo-Norman texts with unexpected meanings. One example is a description of King William II as having *crine bloie*, referring to the color of his hair, which is known to have been red or blond, and certainly not blue (Biggam 2006b: 162). The *Anglo-Norman Dictionary* defines *bleu* as (1) discolored, livid, bluish; (2) fair, golden; and (3) dark. This explains that the king's hair color was actually blond (or fair). It seems that this word was borrowed into English with the blue sense dominant, in or just before the late thirteenth century. Over the following years ME *bleu* showed signs of becoming a naturalized English word: it occurs as a compound personal name with an English word (*Bluhod*, "Blue hood"); it acquires variants in the English manner (for example, *bluish*); and it takes on connotations such as "sad" and "faithful," the latter first recorded from before 1420. This situation hints that ME *bleu* may have become the Middle English BCT for BLUE in the early fifteenth century (169). Old English *hǣwen*, which took the form of *hawe* in Middle English, gradually retreated northwards, being last glimpsed, as *haw*, in a Scottish novel of 1929. Middle English probably also developed a basic category for BROWN.

The likelihood, therefore, is that Middle English added a further two basic categories to the Old English tally of six, resulting in the following BCTs before 1500: *blak, whīt, rēd, grēne, yelwe, grei, bleu,* and *broun*.

OLD NORSE-ICELANDIC (KIRSTEN WOLF)

It is generally agreed that Old Norse-Icelandic, which covers the written language of Norway from *c.* 1150 to *c.* 1370, and of Iceland from *c.* 1150 to

c. 1540, has eight basic color terms: *blár, brúnn, grár, grœnn, gulr, hvítr, rauðr,* and *svartr* (Wolf 2006b: 181–5; Brückmann 2012: 11). These color terms may be translated roughly as "blue/black," "brown," "gray," "green," "yellow," "white," "red," and "black," and they reveal the basic cognitive color categories of Old Norse society (see the Introduction to this chapter).

Rauðr (red) is by far the most frequently used color term in Old Norse-Icelandic literature. It is used of a large variety of objects, including honey, silk, horses, fire, gold, human facial hair, and wine. It is frequently equated with the color of blood, a noun that appears regularly in this literature, which concerns itself to a considerable extent with warfare, feuds, and killings.

The second most commonly used color term is *hvítr* (white). This color adjective, too, covers a wide range of objects from human hair and teeth to bread and flowers. Among other things, it is used of silver to indicate that it is pure, and about food in connection with religious fasting (a diet of milk, curds, and the like, as opposed to a diet that includes meat), and it is equated with, for example, the color of snow and the white membrane of an egg.

Blár (blue/black) is the third most frequent color term and one that has puzzled scholars because of its semantic overlap with *svartr* (black) and its equation with the place of the dead (*Hel*), the raven, and coal. The association of *blár* with the underworld is likely a symbolic one, and this association probably extends also to the raven, which, too, has pagan connections, especially with the god Odin, whose two ravens, Hugin ("thought") and Munin ("memory"), purportedly flew throughout the worlds of Scandinavian mythology, collecting news for him. The equation of *blár* with the color of coal suggests a dark color, because *svartr*, too, was used to describe the color of coal and was further identified with the color of pitch, earth, and tar. The noun *blámaðr*, literally "blue/black man" is, for example, often used to describe people from various parts of Africa. It seems, therefore, that in origin *blár* simply meant a dark color, and that in response to a need to express the hue of a dye (either a local product or woad) the term eventually became associated with the blue part of the spectrum (Wolf 2006a: 74).

Svartr is almost as common as *blár* and covers a wide range of objects, including animals (especially horses, but also cows and bears), supernatural beings (notably devils, but also elves, giants, and spirits), clothing, and the darkness of the night. It is frequently used about human hair and complexion, and it is probably for this reason that the color term also appears as a byname (nickname).

Grár (gray) is considerably less common than *svartr*, though it covers a fairly wide range of objects, such as skin, cloth, clothing, human hair, animals, armor, silver (to indicate that it is not pure), stones, and boulders. In the earliest texts (eddic and skaldic poetry), the color term is used predominantly to describe the color of wolves and metallic objects (weapons and armor) (Wolf 2009: 234).[7]

Grœnn (green) does not appear often, though it covers a range of objects, including trees, fruit, fields, clothing, tents, swords, and wounds. It is also used of meat and fish, but obviously here in the sense of "fresh." Among other things, it is equated with the color of grass, the sea, and the emerald.

Brúnn (brown) and *gulr* (yellow) are rare. In the earliest compositions, the main collocation of the former is blood, which indicates a reddish-brown color, though there are also other referents, including wood and shiny objects (metal) (see also *brūn* in the Old English section). In later texts, that is, in the mythical-heroic sagas and the romances, the color is applied to a greater variety of objects, such as animals, clothing and cloth, and facial hair. The referents indicate that, over the centuries, the color term came to designate a more general brown or a dark color rather than the reddish-brown or shiny hue suggested by its use to describe blood and metal. In addition, *brúnn* appears to cover the color purple. Admittedly, the use of *brúnn* to designate purple is limited to the *Book of Simples* (see Larsen 1931) and the field of horticulture, and presumably its use was because Old Norse-Icelandic did not have a basic term for this particular color. A non-basic color term for purple, *purpuralitr*, is attested, but it appears not to have been widely used. Finally, it should be noted that *brúnn* competed with *jarpr*, a non-basic color term, which is used almost exclusively about human hair. It is difficult to assess the precise color(s) to which *jarpr* refers, but "dark, dusky, swarthy" would seem reasonable candidates in the earliest compositions. It appears that as *brúnn* began to shed some of its semantic portfolio, especially reddish brown, and came to be used about a more general brown hue, *jarpr* attached itself more firmly to BROWN and assumed a specific sense of reddish brown to fill the gap left by *brúnn* (Wolf 2017: 32–3). Interestingly, in Icelandic texts dating from the early eighteenth to the twentieth century, there are no examples of *brúnn* suggestive of purple or used to describe metal, and *jarpr* remains a restricted term used primarily about the color of horses, human hair, and human skin tone (34).

Gulr (yellow) is the most infrequent color term. In fact, Crawford (2016: 248) disputed the inclusion of *gulr* in the list of basic color terms, arguing that it should be omitted from the list in favor of *bleikr*, which Wolf (2005: 257; 2006b: 187–8; 2015: 394–5) considers a macro-color term covering pale or light colors. *Gulr* is used primarily to describe human hair color and is in this connection often likened to silk.

In addition to being the most frequently used color terms, *hvítr, rauðr,* and *svartr* are also the oldest color terms attested in Old Norse-Icelandic literature. *Grár* does not appear very often in the early texts, but it has stability of reference across Old Norse-Icelandic texts spanning several centuries and across various types of vocabulary. By the time of the earliest literary documents, it shows a well-established achromatic meaning (without hue) and should therefore be assigned to the early stages of the development of basic color terms in this

language (Wolf 2009: 238). *Grœnn* should be placed after *grár* but before *gulr* in a temporal-evolutionary order of color term acquisition, although in the earliest texts *grœnn* seems contextually restricted and appears seemingly without connection to the color and closer to the sense of "fertile." While *gulr* certainly existed, the color was expressed primarily by means of derivatives of *gull* (gold) before the thirteenth century. When *gulr* begins to appear, the chief collocations (eyes, hair, teeth, stones) suggest that "shiny" was the concept it usually denoted, and that its use as a hue term came later. Presumably, as *gulr* attached itself more firmly to the yellow part of the spectrum, *bleikr* began to shed some of its semantic portfolio, including the yellowish hues suggested by its use to describe the sun and gold, both strong collocates of this term (Wolf 2010: 123–4). *Brúnn* and *blár* should probably be assigned to a late stage.

In addition to these basic color terms, very many non-basic color terms are attested in Old Norse-Icelandic literature. By far the largest category is comprised of compound terms consisting of a noun and a color term, such as *biksvartr* (pitch black) or *járngrár* (iron gray). This is followed by compounds of two color terms, such as *gulgrœnn* (yellow green) or *rauðbrúnn* (red brown), and terms with the suffix *-ligr* (-ish), such as *blóðligr* (literally, bloodish). Terms with prefixes or suffixes, such as *døkkr-* (dark-), *-ljós* (-light), and *-litr* (-colored), are less common. The smallest category consists of simplex or monolexemic terms, which comprises *blakkr* (dark or black), *hárr* (hoary), *höss* (gray), *jarpr* (see above), and *rjóðr* (ruddy or red). Since *hárr* refers more to old age than to color, its color sense is subordinate to that of age (Wolf 2015: 423).

LATIN (PIERA MOLINELLI)

In 500 CE, the Latin language already had a thousand years of history from the date of its first written records, and in the Roman world it had occupied different positions in different social contexts. Historians date the end of the Roman Empire to the year 476 CE, when the last emperor, Romulus Augustulus, was deposed. This was at the beginning of a period when the Roman Church acted as a unifying force, using Latin as the main written language throughout Christian western Europe. In fact, Latin long remained the language of the Catholic Church, of culture and education, and of the administrative and juridical spheres. From the point of view of the history of the Latin language, and following a generally agreed periodization, Late Latin covers the period from *c.* 200 to *c.* 600 CE, while after *c.* 600, the language is referred to as Medieval Latin. As a spoken language, however, Latin ceased to be used and was replaced by its various Vulgar Latin (later Romance) descendants, probably around 600–700 CE.

Thus, as a result of the long history of Latin and the diversification of the Roman world, both chronologically and geographically, a great deal of careful

consideration is involved in describing the semantic system of Latin basic color terms, other color terms, and the conceptual organization that they denoted.

In Latin, it is traditional to state that the main basic color categories, namely, WHITE, BLACK, and RED, are denoted by opposing terms based on the distinctive feature of brightness or intensity (strength of light-effects or saturation): *albus/candidus*; *ater/niger*; and *ruber/rutilus*.[8] The system is exemplified in Table 6.1.

The term *caerul(e)us* (sky blue) is the subject of discussion as to whether it was a BCT in Latin,[9] because its origin from *caelu-* (sky) would have been transparent for Romans (Oniga 2007: 276), and such semantic transparency causes suspicion that the term may not be basic.[10] Although *caerul(e)us* was unlikely to have been fully basic in Archaic (preclassical) Latin, it was in common usage as one of the terms for BLUE in Classical and Late Latin, although its use declined in the medieval period. It describes deep sea and water, the sky with heavy rain, and stormclouds; but it also describes blue objects, for instance, eyes (especially of barbarians), gems, and pigments (Bradley 2009: 9–12).

According to Arias Abellán (1994: 79), GRAY is not an autonomous BCC in Latin, but represents the chromatic periphery of *albus* (denoted by *canus*) and of *ater* (denoted by *ravus* and *pullus*).

Generally speaking, according to Grossmann (1988: 105–12), Latin has 194 color words that are clustered around six hyperonyms.[11] On the basis of her analysis, Table 6.2 shows their distribution.

TABLE 6.1 The Color System of Latin.

–BRIGHT	+BRIGHT	
albus	*candidus*	"white"
ater	*niger*	"black"
ruber (rufus)	*rutilus*	"red"
	flavus	"yellow"
	viridis	"green"

TABLE 6.2 The Classification of Latin Color Words.

Hyperonym	*albus*	*ater*	*flavus*	*ruber*	*viridis*	*caeruleus*
Associated color words	36	36	45	58	19	9

Source: Data from Grossmann 1988.

Consideration of the size of these clusters, rather than of the color terms in isolation, provides evidence for the centrality of *flavus* and *ruber* in Latin, that is, for the importance of the chromatic domain ranging across the various tones of yellow, orange, and red.

Before 500 CE, the most frequently occurring color adjectives in the texts are *viridis* (green), *niger* (shiny black), and *candidus* (bright white), followed by *albus* (matt white), *ater* (matt black), and *flavus* (yellow). *Rutilus* (bright red) and *ruber* (*rufus*; dull red) have a comparably low frequency.[12]

Viridis can be used to indicate the color category GREEN, which is typical of plants, leaves, rocks, and minerals such as emerald, but it also represents the abstract quality of vigor. The same holds for the verb *vireo*, with which both *viridis* and ModE *verdant* are cognate. *Viridis* is used of water, the sea, supernatural beings such as sea divinities, and rarely of birds, for example, the parrot.

Niger indicates a shiny black in opposition to *ater* (matt black), and it describes hair, eyes, the night, birds such as the crow, clouds, and the sky under certain conditions, for example, *caelum pice nigrius* ("a sky blacker than pitch"). Its meaning extends to symbolic values related to blood, and it is associated with badness, and with things, such as clothes, related to death and mourning. *Ater*, occurring much less frequently and almost disappearing in Medieval Latin, is the color of coal, smoke, caves, and the stormy sea; it also has an abstract meaning, indicating the color of souls, bad men, and death.

Candidus principally indicates bright white in opposition to *albus* (matt white); it is used to refer to iron, the planets and stars, and flowers such as the lily. With reference to human beings, it is an attribute of the complexion, beards, and hair, indicating old age. *Candidus* is often used in contexts of brightness and light.

Albus is the color of lead, teeth, horses, wool, and of the complexion and hair in the same way as *candidus*. The distinction between *albus* and *candidus* is curiously explained by the grammarian Flavius Sosipater Charisius (fourth century CE) in his *Ars grammatica* (Book 5, *De differentiis*; Charisius 1964: 388), in which he writes "album natura fit, candidum cura" (matt white is for nature, bright white is for man-made things). However, the brightness distinction between the two words was becoming less clear at that date, and several contexts demonstrate the increasingly interchangeable use of *candidus* and *albus*. One example occurs in the New Testament: "caput autem ejus, et capilli erant candidi tamquam lana alba, et tamquam nix" (and his head and hairs were white, like white wool, and like snow; Rev. 1:14). Although *albus* is less frequent than *candidus* before 500 CE, the case of "white snow" illustrates its increase: *candida nix* (bright white snow) and *alba nix* (dull white snow) are more or less equally used by *c.* 500; and, in the following centuries, *alba nix* predominates. As regards the co-occurrence of BLACK and WHITE, before 500 CE in Latin the opposing pair *albus* (matt white) and *niger* (shiny black), which

contrast the features of dullness and brightness, is more common than *candidus* and *niger* (both bright/shiny). *Candidus* with *ater* is not attested.

Flavus is used of hair, (pale) blood, and sometimes sea waves.

Ruber (dull red) and *rutilus* (bright red) are the opposing brightness pair for RED. *Ruber* is the basic color term, and its category includes many other terms to denote various shades then included in the category, such as pink, purple, orange, and brown (André 1949: 76–7). In general, *ruber* is used of earth, blood, and clothing, and in some place-names, for example, *Saxa Rubra* (a location with red rocks to the north of Rome) and *Mare Rubrum* (Red Sea). The bright *rutilus* is used of fire, the sun, planets and stars, and hair, especially women's dyed hair. *Rutilae comae* (vivid red hair) is associated with northern barbarians such as Britons and Germans. *Ruber* tends to increase in usage from ancient times, including in contexts where one might expect to find *rutilus*, as in the example *rubrum solem* (red sun) in Livy, dating to the first century CE (*History of Rome*, bk 31, ch. 12).[13]

Already in the centuries before the Christian era, some colors had taken on symbolic values: white was the color of *candidati*, that is, aspirants for offices of the Republic who wore a white toga, while red was the color of Roman nobles who surrounded the emperor, and were called *purpurati* (clothed in purple). The use of purple was a symbol of luxury, recalling the expensive dye derived from shellfish, in Rome as well as in eastern cultures such as those of the Phoenicians, Egyptians, and Babylonians, from whom the Romans imported the material and its symbolic value. *Rutilus* and *caeruleus*, on the other hand, are often associated with the northern barbarians, and the latter may result from observations of eye color or of body-painting. Tacitus refers to northern eyes as "truces et caerulei" (fierce and blue) in his *Germania* (bk 4, ch. 4), and Julius Caesar in his *Gallic War* (bk 5, ch. 14) writes "omnes vero se Britanni vitro inficiunt, quod caeruleum efficit colorem, atque hoc horribiliores sunt in pugna aspectu" (all the Britons, indeed, dye themselves with woad, which provides a bluish color, and thereby have a more terrible appearance in fight).[14]

In the first centuries of our era, Christian authors assign symbolic values to *candidus*, *ruber* (with variants), and *niger*. *Candidus* is linked to the eternal light and the glory of the Resurrection, and it therefore assumes a meaning of brightness and splendor more than of hue. *Ruber* is the color of blood and of passion, and *niger* is the color of the evil soul. Although the bright colors *candidus*, *niger*, and *ruber* assume symbolic values in Christian tradition,[15] the distinctive sense of brightness is lost in the Romance languages (Oniga 2007: 278). Indeed, in the time span from 500 to 1000, a new semantic system emerges, with new oppositions and new balances: to denote WHITE, the adjective *albus* becomes much more frequent than *candidus*, while for BLACK the adjective *niger* prevails over its counterpart *ater*. For this reason the pair *albus* and *niger* becomes the norm. Among the adjectives for RED, the terms without brightness, *ruber* and *rufus*, also prevail, and the most frequent is *rufus*.[16]

In the period ranging from 1000 to 1400, the loss of brightness in hue terms is evident. The most frequent color adjectives are *albus*, *niger*, *viridis*, *candidus*, and *rufus*, with *flavus* and *caeruleus* considerably less common. Yet in 1100, the so-called "blue revolution" (in the words of Pastoureau 1987: 21) starts from France and spreads throughout the western Christian area. Two reasons motivate this diffusion: the emergence of new dyeing techniques and the adoption of blue as the color of the Virgin by the Christian Church. However, the Latin language did not provide an appropriate term for BLUE, and this is why a new loanword, *blavus*, entered from Germanic **blawa*. A manual on making coloring agents (*Liber de coloribus faciendis*), ascribed to the twelfth century, explains: "Tercium azurium si uis facere, accipe flores blauos, id est celestini coloris" (If you want to make a third azure, take blue flowers, that is, of a light blue color). In this passage, a new loanword, *azurium*, appears in Latin, ultimately from the Persian *lāžward* "lapis lazuli," a term which arrived in Europe via Arabic (Grossmann and D'Achille 2016: 30).

In the late Middle Ages a new sensibility to hues emerged along with a tendency to separate hue terms from brightness terms. The ancient basic categories of the WHITE–RED–BLACK scheme were joined by other hues and, above all, blue prevailed, in all its nuances, to such an extent that the thirteenth century is called the "century of blue" (Pastoureau 1985: 8).

OLD EAST SLAVIC (ROMAN KRIVKO)

Old East Slavic (OES; also known as "Old Russian," "Old Rusian," or other terms, depending on scholarly tradition) was the common ancestor of the modern East Slavic languages (Russian, Ukrainian, Belarusian, and Rusyn) and existed in the eleventh to fourteenth centuries. The fourteenth to seventeenth centuries are considered to be the period of Middle Russian, Middle Ukrainian, and Middle Belarusian. Old East Slavic color terms developed from Common Slavic, and some of them can be traced back to Proto-Indo-European or Proto-Balto-Slavic: *čьrnyjь* (black), *bělyjь* (white), *rumänyj* and related forms (red), *zelenyjь* (green), *žьltyjь* (yellow), and probably *sinijь* (dark; blue). The history and the typology of the East Slavic color terms is well studied (Herne 1954; Bakhilina 1975; Normanskaya 2005; Vasilevich et al. 2005; Kul'pina 2007; Rakhilina 2007; Murjanov 2008; Hill 2014), and most of the OES terms of color have been comprehensively defined in the historical dictionaries of the Russian language (*Slovar' russkogo jazyka 11–17 vekov* [SRJa]; *Slovar' drevnerusskogo jazyka 11–14 vekov* [SDRJa]; *Materialy dlja slovarja drevnerusskogo jazyka* [MSDRJa]).

The biggest group of color terms in OES belongs to the category of RED. It originally consisted of several words, but none of them, however, was a general designation for RED: *čьrvlenyjь* (*čьrlenyjь* or *čьrvenyjь*), *červonyjь*, *čьrtьnyjь*;

bagъrъ, bagъränyjь; *rumänyjь, redryjь*, and *ryžijь*. Grammatically, *čьrvlenyjь* (*čьrlenyjь, čьrvenyjь*) is a past passive participle of the verb *čьrviti*, "to paint red," literally, "to make like a (red) worm" (from *čьrvь*, "worm"), therefore it mostly designated artificially colored objects, such as textiles, shields, tents, and so on. The Middle and Modern Russian adjective *červon(n)yjь* goes back to Middle Polish *czerwony, czyrwiony, czerwiony*, which has the same grammatical structure (past passive participle). Middle Russian *červonyjь* was originally used to describe a kind of foreign coin made of gold (*Etimologicheskij slovar' russkogo jazyka* [ESRJa]: 4:335). Unlike *čьrvlenyjь* and *červonyjь*, the adjective *čьrtьnyjь* (from *čьrtь*, "worm," literally, "worm-like") was applied primarily to natural objects, for example, human lips, skin, or hair; earth; fire; blood; and so on (compare also Upper Sorbian *čork* and Lower Sorbian *cenk* [from *čьrtьnъkъ*, "yolk"]). In some contexts, *čьrtnyjь* could mean a reddish brown and denoted the color of sunburned skin (*Etimologicheskij slovar' slavjanskikh jazykov* [ESSJa]: 4:149–50; MSDRJa: 3:1558–9).

The adjectives *bagrъ* and *bagränyjь* are assumed to be etymologically related to *bagno* (marsh, bog, swamp) (ESSJa: 1:132–3; *Russkij etimologicheskij slovar'* [RES]: 2:56–7). Both words designate natural as well as artificially colored objects, including those of a dark or brownish-red color (SRJa: 1:64; SDRJa: 1:103–4), and are in some contexts difficult to distinguish semantically from *čьrvlenyjь*.

The words *rumänyjь, redryjь, ryžijь*, and *rusyjь* go back to the Proto-Indo-European BCT for RED (**roudh-/*reud-/*rudh-*), the cognates of which became contextually restricted in OES. *Ryžijь* designated colors of living creatures, for instance, the red fur of animals (compare *rysь*, "lynx") or red human hair, and probably the yellowish pink, or orange red, or even light brown and orange color of some mushrooms and of the acorn (SRJa: 22:274; SDRJa: 10:509). *Rumänyjь* was contextually restricted, and it described—almost without exception—the ruddy skin of a human face and red human lips. Only in Middle Russian documents could *rumänyjь* be used to describe the hue of freshly baked bread, and as the translation of Latin *rubeum*, the color of fresh grain of high quality (SRJa: 22:255–6; SDRJa: 11:493). The adjective *krasnyjь* (fine; beautiful) became a general designation for RED in Middle Russian by the beginning of the sixteenth century (SRJa: 8:20).

By the time of the earliest OES written sources in the eleventh century, the BLACK category consisted of the BCT *čьrnyjь* (Modern Russian *čërnyj*), "black." It is the most archaic Slavic color term, the cognates of which are attested in all modern Slavic languages, and it goes back to the Proto-Indo-European basic root **krsn-* (compare Old Prussian *kirsnan*, "black; dark," and others [ESSJa: 4:157]). The use of the adjective *čьrnyjь* in Old East Slavic and Middle Russian in its direct meaning was identical to that of Modern Russian; the word *čьrnyjь* was applicable to a wide range of natural and artificial objects (MSDRJa: 3:1562–4).

Its symbolic meanings are typical of many Indo-European languages: *čьrnyjь* is the color of evil, sorrow, devils, and similar things (consider the expression *čьrnaja kručina*, "black sorrow," as the translation of Classical and Middle Greek *melancholia* (μελαγχολία) (MSDRJa: 3:1564). The monks and nuns of the Eastern Byzantine rite were obliged to wear primarily black garments, so they could be described as *čьrnьcь* (masculine) and *čьrnica* (feminine), "a person in black," or *čьrnorizьcь* (m.) and *čьrnorizica* (f.), "the one who wears black garments." Correspondingly, the collocation *čьrnyjь popъ* "black priest" means "a priest-monk, hieromonk,"[17] while *bělyjь popъ* (white priest) meant "married (or widowed) priest, who normally lives in a secular community." The adjective *čьrnyjь* was applied to lower social groups or to the social layers and communities that were obliged to pay taxes to the state. The collective noun *čьrnь* designated the lowest social classes and groups until the modern period of the history of Russian.

The BCT *bělyjь* (white; clear, clean) is one of the most frequently used color terms in OES written documents. As a term of color, this word is probably as old as *čьrnyjь* and goes back to Proto-Indo-European **bʰěl-* (bright; clear), which came to designate WHITE in several Indo-European languages: compare Sanskrit *bhāla* (splendor), Old Norse-Icelandic *bál*, and OE *bǣl* (fire; bonfire); Celtic **belos* (clear, bright; white) and Old Greek *phalos, phalios* (φαλός, φαλιός; white, clear) (ESSJa: 2:79–81). *Bělyjь* designated the white color of numerous natural and artificial objects, such as snow, milk, wool, human skin and hair, plants, and textiles. It could also describe any clear and colorless object as well as natural colors of a bright or light hue, for example, the color of cheese, or the transparency of the air; clear and lucid "white tears" could fall down "like drops of wax" (Bakhilina 1975: 25–6). *Bělyjь* is the symbolic color of holiness, angels, and similar things. The white color was also metaphorically used to designate the so-called "white land" (*bělaja zemlja*) and the "white plough people" (*bělosošennyje*), who were exempt from paying taxes to the state.

In the earliest period, the BLUE category was represented by the Common Slavic adjective *sinijь* (dark; blue), the association of which with the verb *sijati* (shine) (ESRJa: 3:624) seems doubtful (*Etymologický slovník jazyka staroslověnského* [ESJS]: 14:815–16). A remarkable feature of the adjective *sinijь* is that it could denote "dark," "black," or "brown," on the one hand, and "pale blue" or "pale gray," on the other. This is comparable with the cognates of Proto-Germanic **blawa* in old Germanic languages (Biggam 1997: 93–100; Normanskaya 2005: 223–4; see also the section above on Old Norse-Icelandic). The adjective *sinijь* described the colors of natural objects, for instance, the sea, a river, or the sky. In biblical translations, quotations, and allusions, it was used of the colors of stones and dyes. *Sinijь* was a typical designation of the human skin covered by bruises. As the translation of Greek *pelidnos* (πελιδνός; dark blue, black), the word *sinijь* in the collocation *sini oči* (blue eyes) described the muddy, befogged

gaze of a drunk person (Bakhilina 1975: 36; SRJa: 24:150). *Sinijъ* was also used to describe black human skin, the noun *sinьcь*, literally, "dark or blue person" meant "African, Ethiopian" (compare Old Norse-Icelandic *blámaðr*, literally, "dark or black man"; see the section above on Old Norse-Icelandic). Thus, St. Moses the Black, who is also known as Moses the Ethiopian, was liturgically honored as *sinijъ tělomъ*, "with dark body" (Murjanov 2008: 253–4), while he was pictured with brown skin on medieval frescoes, such as on the narthex fresco of 1349 at Lesnovo (Macedonia) Monastery. At the same time, the noun *sinьcь*, literally, "dark or blue person," and the adjective *sinijъ*, "dark; blue," designated the devil and demons.

Demons, however, could be painted not only black and brown, but also blue or even gray or greenish gray in medieval paintings (Kvlividze 2002: 686; Murjanov 2008: 254). The pale version of this color was usually described by the adjective *blědъ* (pale), which was used of the color of the apocalyptic horse of Death as the translation of Greek *chlōros* (χλωρός; greenish yellow, pale green) (Rev. 6:8). Semantic overlap of the pale tones of BLUE, GRAY, and GREEN is also revealed by the translated collocation *sineje lice* (blue face), in which the adjective *sinijъ* is the equivalent of Greek *melanos* (μελανός; dark; black) and describes the unhealthy pale color of the faces of sinful men (SRJa: 24:150). The verb *posinet'* (to become blue) in Modern Russian means "to become pale because of shock, sickness or death" (while *pozelenet'*, "to become green," describes pallor caused rather by fury or rage).

The Modern Russian adjective *goluboj*, "light blue" (derived from *golubь*, "pigeon"), was originally used to describe the light gray color of animals and birds, and came to designate "light blue" in Middle Russian by the end of the sixteenth century (SRJa: 4:70; SDRJa: 2:360). The semantic evolution of OES *golubyjъ* (gray) to Middle and Modern Russian *goluboj* (light blue) once again testifies to the overlap of the light tones of BLUE and GRAY as attested by OES color terms.

The OES color terms in the categories of GREEN (*zelenyjъ*, "green") and YELLOW (*žъltyjъ*, "yellow") are very archaic, semantically identical with their Baltic cognates, and hence going back to Proto-Balto-Slavic. Unlike Slavic **zelen-* (green) and related Baltic forms, other Indo-European cognates of OES *zelenyjъ* (green) mean "yellow," "green yellow," and/or "golden" (compare Latin *helvus*, "yellowish, bay," or English *yellow*) (ESRJa: 2:43–4, 92). As to the cognates of OES *žъltyjъ* (yellow), they denote YELLOW only in the Baltic languages, and usually mean "gall; bile" in other Indo-European languages (compare also OES *zъlčь*, "gall," which is etymologically related to *zelenyjъ*, "green"). The color terms *zelenyjъ* (green) and *žъltyjъ* (yellow) covered a wide range of natural and artificial green and yellow objects, including dyes. Unlike Modern Russian *žëltyj*, the OES adjective *žъltyjъ* could describe the light of the sun or light hue of human hair. *Zelenyjъ* regularly described fresh plants and grass, and it could

also mean "unripe" (SDRJa: 3:272, 367) (for the semantic shift of "green" to "fresh" in Old Norse-Icelandic see above).

Another color term belonging to the category of YELLOW was *polovyjь* (Church Slavonic *plavyjь*), which denoted a bright yellow color. This word is etymologically related to OE *fealu*, Old High German *falo*, "pale; light (of human hair)," Greek *palios* (παλιός), "gray (of human hair)," and Latin *pallidus*, "pale" (ESRJa: 3:313). In other Slavic languages, the cognates of Common Slavic **polv-* can also mean "light blue; pale; faded." The OES adjective *polovyjь* (*plavyjь*) denoted the color of natural objects, such as human hair or the skin of horses. In the Old Church Slavonic version of the Gospel, the word *plavyjь* was used to translate Greek *leukos* (λευκός; white) with reference to the color of ripe rye that is ready for harvest (Jn 4:35).

The category of GRAY was represented by the adjectives *sĕryjь*, *sĕdyjь*, *sivyjь*, and *sizyjь* (*sizovyjь*). *Sĕryjь* and *sĕdyjь* are etymologically related to Germanic **haira-* (gray), while their relation to *sivyjь* and *sizyjь* remains obscure (ESRJa: 3:611, 619). *Sĕryjь* was used to describe a wide range of natural and artificial objects, for example, the skin or the fur of animals, tree trunks, cloth, paper, and so on. As opposed to *bĕlyjь* (white), *sĕryjь* metaphorically described artifacts and natural objects of low quality (SRJa: 24:93). Besides its gray sense, *sĕryjь* could also describe an uncolored cloth or other material, as with *χĕrъ* (uncolored material) in Novgorod birch-bark letters (Zaliznjak 2004: 597). The other color terms, *sĕdyjь* and *sivyjь*, were both contextually restricted: while *sĕdyjь* denoted gray human hair, *sivyjь* was the technical term for the gray color of horses. *Sizyjь* and *sizovyjь* described a dark bluish gray and were applied to natural as well as to artificial objects (SRJa: 24:132).

The category of BROWN comprised the color terms *smaglyjь* (*smuglyjь*, *smäglyjь*), *gnĕdyjь*, and *buryjь*. *Smaglyjь* (*smuglyjь*, *smäglyjь*) is etymologically related to Modern English *smoke* and its Germanic cognates (ESRJa: 3:693) and often means "dark." It was used to describe cloth, textiles, and human skin (SRJa: 25:152; SDRJa: 11:406), while its cognate in Modern Russian (*smuglyj*, "swarthy") came to be contextually restricted to human skin of a brown hue. The adjective *gnĕdyjь* (dark red, reddish brown) is probably a derivative from the verb *gnĕtiti* (to kindle fire) (RES: 11:39–40), and it was used to describe only the skin of horses and the fur of some other animals, such as the cow, elk, or aurochs. The adjective *buryjь* is assumed to be a loan word of Iranian origin (RES: 5:196–8), and it was also contextually restricted to natural objects of brown or reddish-brown hues, primarily animals (especially horses), or human hair. The adjective *korič(ь)nevyjь* (from *korič(ь)nyjь*, "related to the cinnamon tree or made of cinnamon" from *korica*, "cinnamon," from *kora*, "bark of trees") became the general designation of BROWN by the end of the seventeenth century (SRJa: 7:314–15).

Literature and the Performing Arts

MARK CRUSE

INTRODUCTION

To appreciate the fundamental importance of color to the cultural history of medieval Europe, one need look no further than to the opening verses of the Bible. Creation is a remarkably colorful event: it entails the separation of light from darkness; the appearance of plants upon the earth; of the sun, moon, and stars; of animals; and of people. The first color mentioned in the Vulgate is the green of vegetation (*herbam virentem*), but other colors—of sky, earth, water, heavenly bodies, plants, animals, and humans—are implied throughout these verses. Genesis emphasizes an obvious yet crucial aspect of the material universe, which is that it is visible: "God saw [*vidit*] that the light was good" (Gen. 1:4). God brings forth not only light and matter but through them color, such that the cosmic sweep of creation described in these opening verses evokes the visible spectrum (Figure 7.1). Genesis makes clear that color is an essential feature of the world as God created it—an expression of God's creative power.

Medieval European literature was in many ways a gloss on and an elaboration of the creation story. It attempted to interpret the book of the world in all of its complexity, from the material and mundane to the spiritual and sacred. Arguably, most works of medieval literature, whether encyclopedias or romances, whether in Latin or the vernacular, shared the desire to describe, classify, and analyze visible and invisible phenomena. Color was crucial to this project because it was understood to have profound symbolic value and to communicate hidden

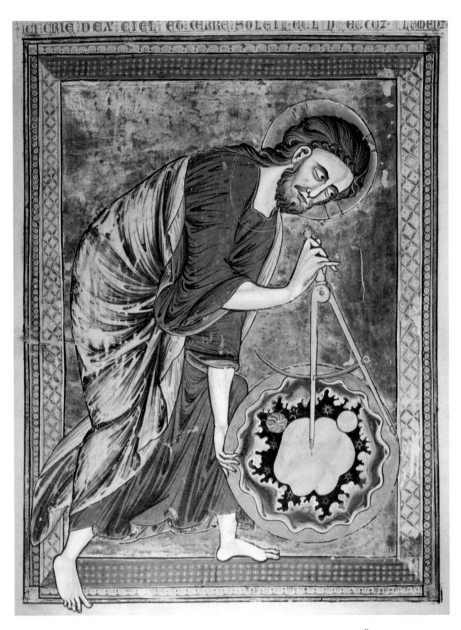

FIGURE 7.1 *Bible moralisée* (*c.* 1250), the Divine Architect. Vienna, Österreichische Nationalbibliothek, Codex Vindobonensis 2554, fol. 1r. Photograph by Bettmann. Courtesy of Getty Images.

meanings; because it allowed for memorable categorization; and because it enabled vivid description. Like form, number, proportion, and size, color was an ordering principle of the universe endowed with aesthetic and ethical significance. It was a code through which humanity might read God's intentions and gain insight into the divine plan.

This chapter focuses on the use and meaning of color terminology in the literature and theater of western Europe in the period between the seventh and fifteenth centuries. It begins with an examination of encyclopedic texts, ranging from the *Etymologies* of Isidore of Seville to the fictional travel account of John Mandeville. It then discusses major genres of vernacular literature: epic, lyric, romance, novella/tale, and hagiography. The final section discusses color in medieval theater. It should be obviously that a thorough history of color in medieval "literature" broadly defined would be the subject of multiple monographs.[1] This essay's goal is to outline the principal meanings of color in medieval European literature, but in so doing it may raise as many questions as it answers.

ENCYCLOPEDIC TEXTS

Medieval encyclopedias took many forms, some of which may surprise the modern reader. Fundamentally, an encyclopedic text was one that described and classified phenomena, often by compiling passages and observations from authoritative works. A medieval encyclopedia might resemble a modern one in its breadth of topics, but it might also focus on subjects that we today consider folklore, superstition, magic, or exotica. Encyclopedic texts included compilations on history, society, and nature such as Isidore of Seville's *Etymologies* (seventh century) or Vincent of Beauvais's *Speculum maius* ("Great Mirror," thirteenth century), lapidaries (on stones and gems), herbals (on plants), bestiaries (on animals real and mythical), and travel texts. After the Bible, encyclopedic texts were the most studied and influential in medieval European society.

As accounts of the material world, encyclopedic texts were necessarily concerned with the appearances of things and thus with color. The earliest medieval encyclopedia, Isidore of Seville's *Etymologies*, is important to the cultural history of color because it gathers for the first time many of the fundamental concepts and questions about color that endured throughout the Middle Ages. Isidore understood color in practical, historical, proto-racial, symbolic, mystical, and many other ways. He furthermore addresses a question that continues to vex philosophers and scientists: What is color? Isidore distinguishes between light as substance (*lux*), and its illumination or visible effect (*lumen*) (Isidore 2006: 274). *Lux* is part of material creation but is immaterial and thus closer to God than other created things. In Isidore's

conception, which was derived from the Bible and common throughout the Middle Ages, divinity is bright, illuminating, clear, splendid, but not colorful.[2] Color is a physical phenomenon and an essential feature of all material things that arises from *lumen*, as Isidore makes clear in his comments on the origins and extraction of pigments, and on the colors of people, animals, gems, and others. It is important to note that Isidore does not condemn color but accepts it as a necessary, useful, and even beautiful part of existence, which puts him on one side of a long medieval debate about the nature and meaning of color, which will be discussed below.

In *Etymologies*, as in later encyclopedias, color is a phenomenon to be explained and interpreted, and a feature that allows the encyclopedist to categorize objects. Isidore explains what causes the rainbow, and notes that darkness is not a color or thing in itself but the absence of light (Isidore 2006: 274). He organizes horses by color, and later does the same for gemstones, which he notes are often named for animals whose color they resemble (250, 322–8). He observes that Moors have bodies black as night, while the skin of the Gauls is white; he employs a climatological theory of racial difference that equates heat and the southern regions with dark skin, cold and the northern regions with whiteness (198, 386). Isidore comments too on color and social custom: for example, in ancient Rome social distinctions were indicated by the color of robe one wore (white togas for those seeking public office, purple for kings and emperors; 386). In Isidore it can be seen that color offered a way to organize knowledge about natural and social phenomena. Color was particularly useful to an epistemological approach that sought resemblances between disparate phenomena and ordered the world accordingly.

Other medieval encyclopedic works were similarly concerned with color as symbol and classifier. Lapidaries, herbals, and bestiaries all originated in antiquity and enjoyed great success in both Latin (in schools) and the vernacular (at courts and in other lay milieus). Lapidaries described the color, physical properties, location of origin, and virtues or uses of stones. For example, the green of the emerald was said to be soothing to the eyes, while the red of the ruby was related to comfort and healing (Pannier 1882: 294–5).

Herbals were similarly concerned with the forms and powers of plants. In his poem *Hortulus* ("On the Cultivation of Gardens," ninth century), composed in praise of gardens, Walahfrid Strabo writes that sage deserves to grow green forever, enjoying perpetual youth, because it is rich in virtue (Strabo 2009: 32–3). As herbals demonstrate, much color symbolism that obtains to the present—green plants for youth and life, red roses for love and passion, white lilies for purity and the Virgin Mary—originated in antiquity and the Middle Ages. Bestiaries described the appearance, nature, and symbolism of different animals and marvelous creatures. Following Isidore, many bestiaries explain that animals' names derive from their colors: thus the crocodile is named for

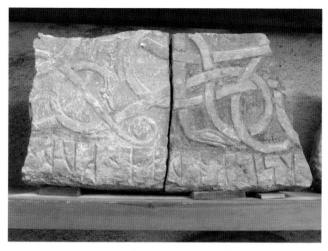

PLATE 0.1 Runestone fragment from Köping Church, Öland, Sweden, late eleventh century. Catalogue no. Öl Köping 39. Photograph by Christer Hamp, July 20, 2007.

PLATE 2.1 Jacopo di Cione and workshop, altarpiece (left main tier panel, detail of lower right section), *The San Pier Maggiore Altarpiece: Adoring Saints: Left Main Tier Panel*; detail of lower right section, 1370–1. Egg tempera on poplar panel, 169 × 113 cm. The National Gallery, London (Inventory: NG569.2). The blue garment of Saint Peter (front row, right) has been painted using ultramarine with lead white. Lead-tin yellow type II was used for his yellow robe, modeled with yellow and red earths and a yellow lake pigment. The purplish-pink robe of Saint Stephen (front row, center) was painted using a red lake pigment, while his green sleeve was painted using a mixture of azurite, a yellow lake pigment and lead white. Vermilion was used for Saint Mary Magdalene's red dress. Malachite was used for the green textile on the floor (Bomford et al. 1990: 156–89). © The National Gallery, London, 2018.

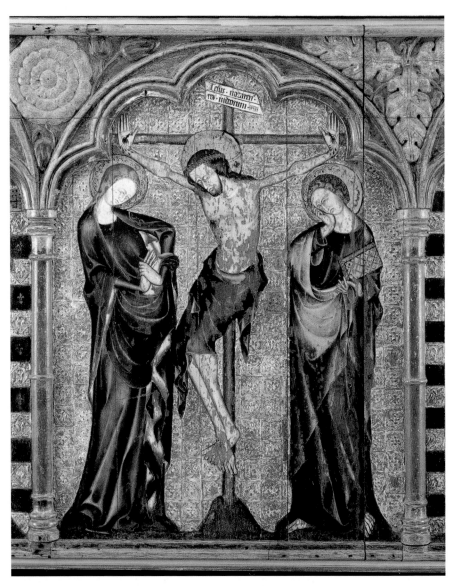

PLATE 2.2 *Thornham Parva Retable* (central panel), *The Crucifixion*, St. Mary's
Church, Thornham Parva, Suffolk, 1330s. Oil on oak panel, 110.5 × 390.5 cm (whole
retable, including modern frame). An example of a more saturated color given by the
oil medium can be seen in the red lake pigment used for the Virgin Mary's red dress.
Azurite was used for Mary's blue robe (Massing 2004). Reproduced by permission of
the Hamilton Kerr Institute, University of Cambridge. © Chris Titmus, Hamilton Kerr
Institute, University of Cambridge, 2018.

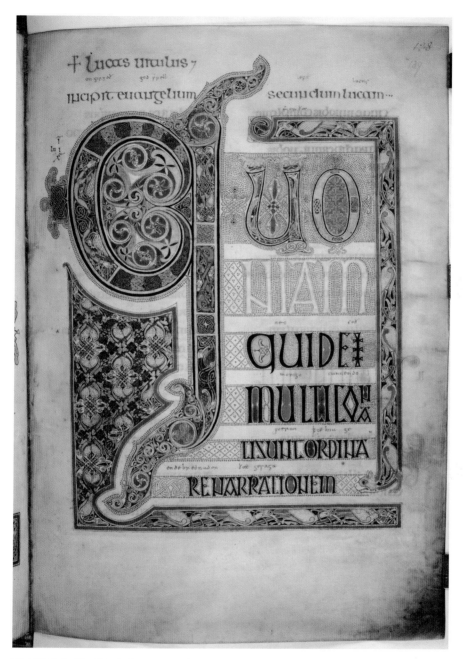

PLATE 2.3 *The Lindisfarne Gospels* (*c*. 710–21 CE), incipit page to St. Luke's Gospel. Ink, pigments, and gold on parchment, approximately 365 × 275 mm. The British Library Board, (Cotton Nero D.iv, f.139), 2018. The pigments present include indigo (blue), orpiment (yellow), red lead (red, orange), verdigris (green), and probably metallic gold (Brown and Clark 2004). © The British Library Board, 2018.

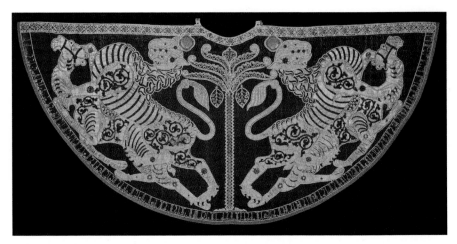

PLATE 2.4 Royal Workshop, coronation mantle of Roger of Sicily, made by the Royal Workshop, Palermo, Sicily, 1133–4. Red kermes-dyed samite (a heavy silk twill) with gold and silk embroidery, pearls, gold with cloisonné enamel, rubies, spinels, sapphires, garnets, glass, tablet weaving. 146 × 345 cm. Kunsthistorisches Museum Vienna, Weltliche Schatzkammer WS XIII 14. Reproduced courtesy of KHM-Museumsverband.

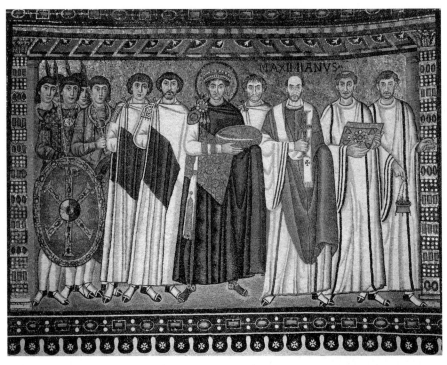

PLATE 3.1 Mosaic of Emperor Justinian and Bishop Maximianus, Basilica San Vitale, Ravenna, sixth century. Photograph by DeAgostini/A. dagli Orti. Courtesy of Getty Images.

PLATE 3.2 Stained glass showing scenes from the life of St. Thomas Becket, with King Henry II in the top scene, Canterbury Cathedral, Trinity Chapel, north aisle, *c.* 1220. Photograph by Angelo Hornak. Courtesy of Getty Images.

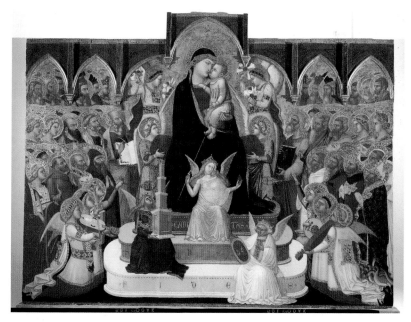

PLATE 4.1 Ambrogio Lorenzetti, *Maestà di Massa Marittima*, altarpiece, Tuscany, *c.* 1335. Photograph by Mondadori Portfolio. Courtesy of Getty Images.

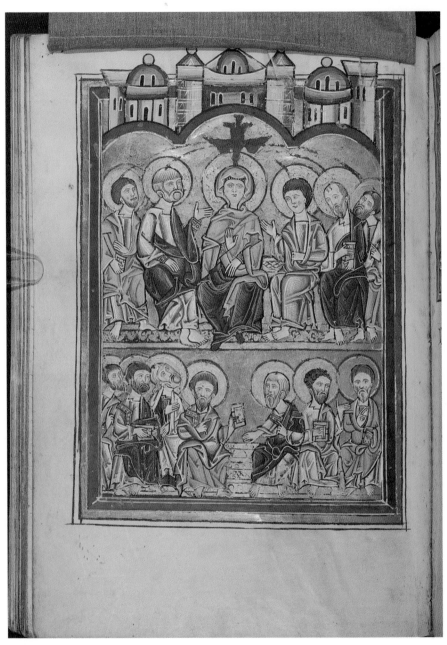

PLATE 4.2 The Wöltingerode Psalter (thirteenth century), Pentecost. Wolfenbüttel,
Herzog August Bibliothek, MS Cod. Guelf. 521 Helmst, fol. 108v. Photograph
courtesy of Herzog August Bibliothek Wolfenbüttel.

PLATE 4.3 Rood screen showing saints Simon and Thomas, St. Helen's Church, Ranworth, Norfolk, fifteenth century. Photograph by Martin Harris.

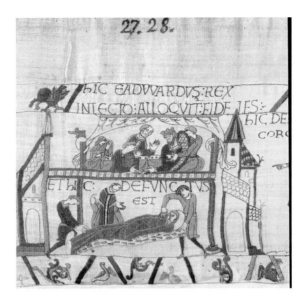

PLATE 5.1 The Bayeux Tapestry (detail), King Edward's death and shrouding. Above, his features and beard are bright red; below, the features of his corpse are black, eleventh century. Image by special authorization of the City of Bayeux.

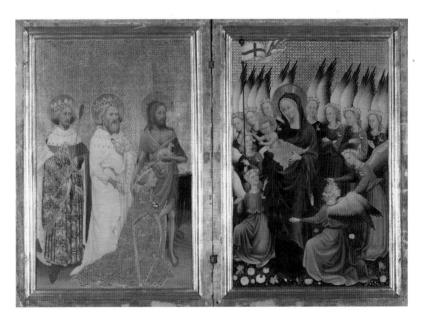

PLATE 5.2 The "Wilton Diptych," portable altarpiece, *c.* 1395–9.

(a) King Richard II presented to the Virgin and Child by his patron St. John the Baptist and saints Edward and Edmund. Richard, kneeling, wears cloth-of-gold.

(b) depicts the Virgin Mary and angels wearing blue, and the Christ Child wrapped in cloth-of-gold. Photograph © National Gallery, London.

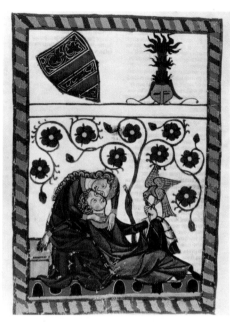

PLATE 7.1 Rudiger and Johannes Manesse, *The Manesse Codex* (1300–1340),
Konrad von Altstetten resting. Heidelberg, University of Heidelberg Library, fol. 249v.
Photograph by Universal Images Group/Hulton Fine Art. Courtesy of Getty Images.

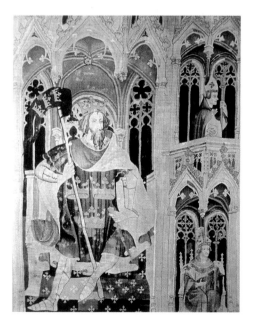

PLATE 7.2 The Nine Worthies Tapestries (detail), King Arthur, South Netherlandish,
c. 1400. The Met Cloisters, the Metropolitan Museum of Art, New York. Photograph
by Print Collector. Courtesy of Getty Images.

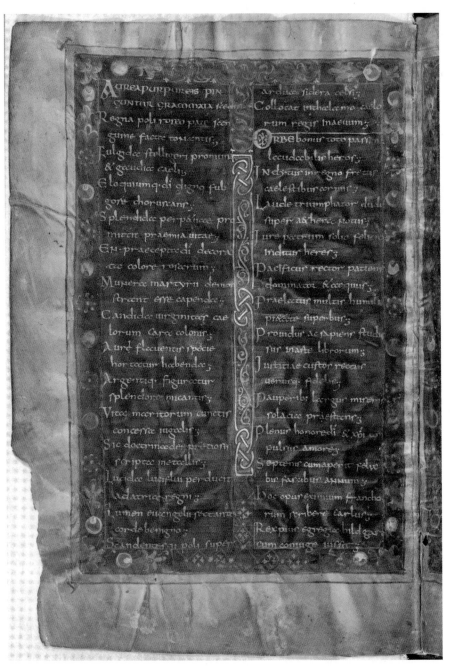

PLATE 8.1 Godescalc Lectionary (781–3), dedication, Aachen. Paris, Bibliothèque Nationale, Nouv. Acq. Lat. MS 1203, fol. 126v. Photograph courtesy of Bibliothèque Nationale de France.

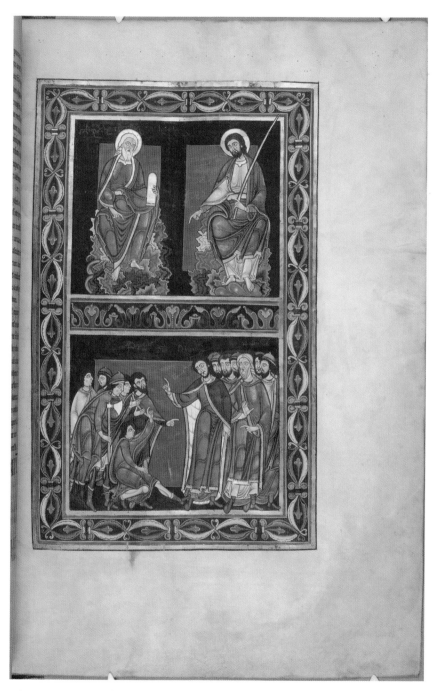

PLATE 8.2 Bury St. Edmunds Bible (*c.* 1135), frontispiece to the Book of Numbers. Cambridge, Corpus Christi College, MS 2, fol. 70r. Photograph by permission of the Parker Library, Corpus Christi College, Cambridge.

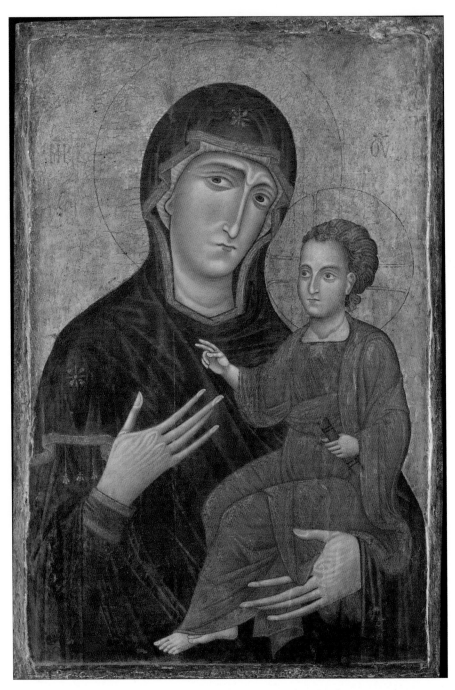

PLATE 8.3 Berlinghiero, *Madonna and Child*, *c*. 1230. New York, Metropolitan Museum of Art, MS 60.173. Photograph courtesy of Metropolitan Museum of Art, New York.

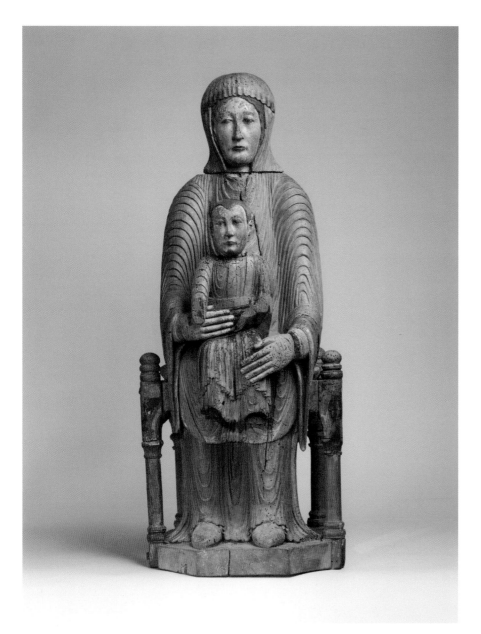

PLATE 8.4 *Virgin and Child in Majesty* ("Morgan Madonna"), Auvergne, *c.* 1175–1200. New York, Metropolitan Museum of Art, MS 16.32.194a, b). Photograph courtesy of Metropolitan Museum of Art, New York.

PLATE 9.1 Sala di Ruggero (Roger II), Royal Palace, Palermo, twelfth century. The decoration of the vault and upper parts of the walls consists of brightly colored mosaics depicting flora, fauna, and geometric patterns on a shimmering gold background. The lower register of the wall is clad with veined marble resembling a flowing textile hanging. Photograph © Alamy. Contributor: Really Easy Star; Toni Spagone.

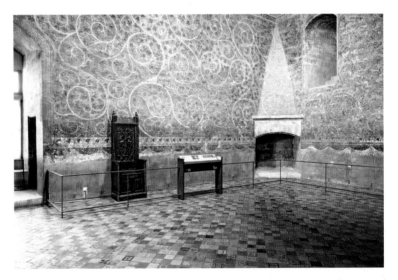

PLATE 9.2 Bedroom of Pope Benedict XII, Palais des Papes, Avignon, fourteenth century. The walls and chimney hood are uniformly painted with stylized yellow vine and oak scrolls on a blue background. A red textile hanging is depicted suspended from an architectural frieze in the lower part of the wall. The modern replica tiles are based on a pavement unearthed in another room. Photograph © Alamy. Contributor: Didier Zylberyng.

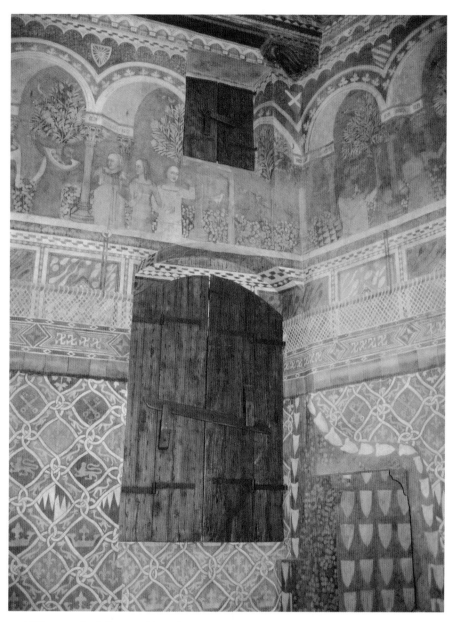

PLATE 9.3 Sala della Castellana di Vergi, Palazzo Davanzati, Florence, fourteenth century. The walls are painted with an illusionistic fresco. The top historiated scene is framed by arcaded architecture and set against trees and other verdure. Underneath, marble-clad walls are covered by diapered red and green tapestry. This complex decoration incorporates many heraldic elements. Photograph by Eva Oledzka, with the kind permission of the Ministerio dei Beni e delle Attività Culturali e del Turismo, Museo Nazionale del Bargello.

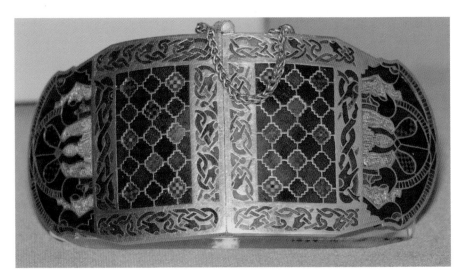

PLATE 10.1 Anglo-Saxon gold shoulder clasp, inlaid with garnets and blue-and-white checkered millefiori glass. From the royal ship burial, Sutton Hoo, Suffolk, early seventh century. British Museum. Courtesy of Getty Images.

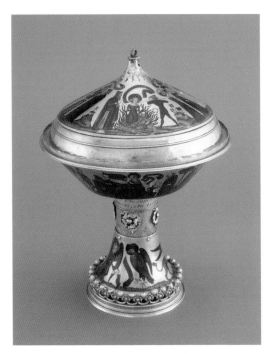

PLATE 10.2 The Royal Gold Cup, gold inlaid with richly colored translucent enamels and set with pearls, France, c. 1370–80 (with later additions to the stem). Photograph © Trustees of the British Museum.

its *crocus* or saffron color (White 1954: 49). The white of the unicorn, which is a symbol of Christ, represents divinity and purity (21). As these encyclopedic texts show, color was understood as a language or code revealing the hidden qualities and meanings of things. It was an essential and decipherable feature of the book of nature.

Lapidaries, herbals, and bestiaries indicate other important meanings of color in medieval culture. In these texts, colorful objects are often equated with distant lands, the marvelous, the exotic and rare, wealth, power, and sanctity. Especially in lapidaries and bestiaries, there is a direct correlation between color and orientalism or exoticism. Lapidaries state that emeralds come from the Nile, which has its source in the earthly paradise—a fitting correspondence given the association of green with life and Eden (Pannier 1882: 294). Bestiaries describe a wolf in Ethiopia whose mane contains all of the colors (White 1954: 61). In these texts, it is as if the further one goes from Europe, the more colorful the world becomes.

Another feature of these texts is crucial to appreciating the role of color in all medieval literature: colors could be evoked not only through use of color terms but also by mention of specific objects. This point may seem obvious but it bears discussion nonetheless, for color terminology varies from culture to culture and era to era. One culture's ways of evoking a given color, or associations with a color, may be very different from those of other cultures. Attention must therefore be given to the many ways in which medieval texts created the impression of color in readers' minds. For example, Piero de Crescenzi, in the *Liber ruralium commodorum* ("Book of Rural Benefits," fourteenth century), writes that a garden should be planted with "a great number and variety of medicinal and aromatic herbs, since they not only delight by their odor, but their flowers also refresh the sense of sight by their variety" (Bauman 2002: 101). This excerpt contains no direct color reference, but mention of a "variety [of] flowers" would have immediately conjured color associations, if not actual colors, in a medieval reader's imagination. Familiar color associations—pearls for white, carnations for red—were omnipresent in medieval culture and serve as a reminder that color may be evoked verbally in many different ways.

The influence of encyclopedic texts and their attention to color is apparent in late medieval travel narratives, which purport to offer first-person accounts of societies and nature beyond Europe. The most famous such accounts were those of the Venetian Marco Polo (1298), and of the fictional English knight John Mandeville (fourteenth century), both of whom used color to describe what they claimed to have seen and to convey the wondrous diversity of creation (Mandeville 2011; Polo 2016). We find echoes of lapidaries, herbals, and bestiaries in both works. Polo describes the region of Badakhshan, from which rubies and lapis lazuli come; he tells of a hill north of the khan's palace in Khanbaliq (modern Beijing), where Kubilai Khan had planted evergreens from

all over his empire; and he notes that the khan possessed a race of horses white as snow (Polo 2016: 38, 75, 65).

Mandeville writes that there are diamonds in India that are purplish or brown; that natural balm is clear and lemon colored, and adulterated if red or blackish; and that the phoenix is wondrously colored with a yellow neck, purple back and wings, and tail striped yellow and red (Mandeville 2011: 98, 32, 30). As in encyclopedias, these accounts also use color to describe people and social customs. Polo writes that the people of Pasciai are brown, and that the men wear earrings of gold, silver, pearls, and precious stones; that Kashmiris are brown and slim, and the women very beautiful; and that, in Maabar, children are covered with sesame oil to make them darker because darker skin is considered superior (Polo 2016: 39, 165). Mandeville writes that Nubians are Christians but are black because of the great heat of the sun; that the site of Christ's nativity is decorated with marble and painted in gold, blue, and other colors; and that in Samaria the Samaritans wrap their heads in red linen, Muslims wrap theirs in a white cloth, Christians in a blue or indigo cloth, and Jews in a yellow cloth (Mandeville 2011: 29, 42, 66).

These examples reveal the extent to which color was crucial to the formation of a vision of the world in late medieval Europe, during a period in which contact with extra-European realms increased rapidly because of trade, the crusades, missionary campaigns, and diplomacy. As a narrative device, color suggested the veracity of travel accounts by seeming to show that a writer was an eyewitness of what he or she described. Color references were also meant to impress the reader with striking information about the marvels of the wider world. Travel accounts, like encyclopedias, focused on the diversity of creation and on God's infinite creative power; strangely or unexpectedly colored peoples, objects, and creatures directly confronted the reader with this diversity. There is too a proto-ethnographic and proto-scientific use of color in these texts: Mandeville repeats the climatological theory of racial color we have already seen in Isidore, he and Polo comment on dress and jewelry as a defining form of cultural practice, and both authors give detailed and naturalistic descriptions of stones, plants, and animals (Figure 7.2). It is also worth noting those moments when color decenters or upends the European understanding of racial and religious hierarchy, as when Mandeville notes that Nubians are black but Christian, or when Polo writes that the people of Maabar, who so prize dark skin, paint their gods and their idols black and their devils white (Polo 2016: 165).

Other texts concerned with color, but of a more idiosyncratic character, may also be included in the encyclopedic tradition. *De diversis artibus* ("On Divers Arts") is a famous twelfth-century treatise, by a monk calling himself Theophilus, on the practice of painting, glassmaking, and metal work. The introduction promises that:

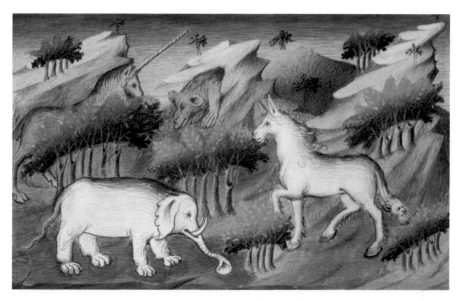

FIGURE 7.2 Marco Polo, *The Book of Marvels* (*c.* 1410), wild animals in Mien (Burma). Paris, Bibliothèque Nationale de France, MS fr. 2810, fol. 59v. Photograph by DeAgostini / M. Seemuller. Courtesy of Getty Images.

If you will diligently examine [this book], you will find in it whatever kinds and blends of various colours Greece possesses; whatever Russia knows of workmanship in enamels or variety of niello; [...] whatever gold embellishments Italy applies to various vessels or to the carving of gems and ivories; whatever France esteems in her precious variety of windows; whatever skilled Germany praises in subtle work in gold, silver, copper, iron, wood and stone.

(Theophilus 1961: 4)

As Theophilus makes clear, the purpose of his volume is not only to enable the production of art, but also to preserve knowledge acquired in former times and to aid proper worship of God. Theophilus believed that color, formed into art by human intelligence and skill, was necessary to devotional practice. The recipes that appear throughout the text for producing colors from various materials in different media are not only practical guides, but a blueprint for spiritually beneficial labor.

Theophilus's appreciation of color and art echoes that of Isidore, and embodies one side of a centuries-long debate in medieval Europe about the role of color in worship (see, for example, Pastoureau 1989b: 203–30; Rudolph 1990a, 1990b; Gage 1999; Huxtable 2014: 25–44). The most famous defense of color and art in churches is the account written by Abbot Suger in the 1140s of his reconstruction of the abbey church of St. Denis. A unique document in

medieval European history, Suger's text offers an encyclopedic account of the reasons for the rebuilding and of the work it involved. Suger recounts how he summoned masons, wall painters, bronze casters, sculptors, glassmakers, and metalworkers from across Europe to repair and rebuild the church, decorate it with frescoes and stained glass windows, and produce reliquaries and liturgical objects. He describes in detail the materials used to produce objects such as the golden altar frontal in the upper choir, with its "forty-two marks of gold [...] a multifarious wealth of precious gems, hyacinths, rubies, sapphires, emeralds and topazes, and also an array of different large pearls" (Suger 1979: 55). Suger justifies this labor, expense, and material wealth by arguing that contemplation of beautiful objects is beneficial to the mind and soul:

> Thus, when—out of my delight in the beauty of the house of God—the loveliness of the many-colored gems has called me away from external cares, and worthy meditation has induced me to reflect, transferring that which is material to that which is immaterial, on the diversity of the sacred virtues: then it seems to me that I see myself dwelling, as it were, in some strange region of the universe which neither exists entirely in the slime of the earth nor entirely in the purity of Heaven; and that, by the grace of God, I can be transported from this inferior to that higher world in an anagogical manner.
>
> (Suger 1979: 63–5)

Suger's descriptions here and elsewhere are intentional echoes of Revelation 21:19–21, which describes how the foundations of the Heavenly Jerusalem resemble precious stones and its streets gold. For Suger, the beauty of color participates in divinity and allows the mind to transcend the prison of materiality and to perceive eternal truths.

This section concludes with the other side of the medieval theological debate about color. The appreciation of color expressed in encyclopedic texts, in Theophilus's treatise, and in Suger's account, springs from many different motivations, but common to them all is the belief that color is essential to knowing the nature of creation. This view was not shared by all clerics, and its most famous opponent was St. Bernard, who in his *Apologia* ("Apology", twelfth century) argued strenuously against colorful art in churches (Rudolph 1990b). For Bernard, color represented vanity, greed, hypocrisy, and corruption. Art of the kind commissioned and defended by Suger was simply intended to attract contributions that would enrich the church; it gave patrons and worshipers alike a false sense of sanctity and closeness to God. One of Bernard's most famous declarations was "We are blinded by colors!" (*Caecitas colorum!*) (Huxtable 2014: 26), by which he meant that color imprisons us in sensory perception and the material world, thereby impeding spiritual growth. Although this volume focuses on the presence of color in medieval culture, it must be remembered that color also engendered deep misgivings, as evidenced not only in theological

works, such as those of Bernard, but also in monastic rules, Cistercian art, sumptuary laws, and critiques of fashion.

LITERATURE

With the exception of Old English literature, the copying of which probably began in the early eleventh century, vernacular literature began to flourish in medieval Europe in the late eleventh and early twelfth century, although vernacular oral traditions were much older. This literature reflected the values, beliefs, and anxieties of the warrior nobility for whom (and sometimes by whom) it was produced, often combined with the learning and doctrine of the clerics who composed and copied it. This hybrid production resulted in a literary tradition that encompassed many different genres, each of which had its own conceptions of color's role, meaning, and importance. The present survey addresses color in epic, lyric, romance, tales, and hagiography from across western Europe with the goal of introducing some of the principal ways in which color signified. It shows that vernacular literature drew on the encyclopedic tradition for many of its ideas about color, but it also frequently charted its own course in imagining color.

The first pan-European vernacular genre in the Middle Ages was the epic, the oldest written example of which is the Old English *Beowulf* (early eleventh century, though likely from an older oral tradition) (Heaney 2001). A striking fact about this work is that, while it has almost no mentions of any color in the rainbow, there are over one hundred mentions of gold. The world of *Beowulf* is not colorful in any modern sense. Instead, the visual aesthetic that dominates this text is the contrast between light and darkness. The Danes are Bright-Danes; warriors carry bright shields; as they approach land, Beowulf and his men espy bright cliffs; Heorot is a bright hall whose light glimmers over the land; time's passage is marked by the alternation between light and darkness, dawn and night. In contrast, Grendel dwells in darkness and is a dark death-shade; he is a despoiler in dark nights; Grendel and his mother inhabit the eternal night of the fen; the dragon flies at night. The other color that recurs throughout the epic is the red evoked by the many references to blood: smeared on the walls and floor of Heorot, drunk by Grendel, streaming from Grendel's wound (inflicted by Beowulf), and staining mail shirts.

Epics from other medieval European cultures share a very similar aesthetic. In *La chanson de Roland* ("The Song of Roland", France, eleventh to twelfth century), which tells of the war between Christians and Muslims in Spain, the darkness of night and of mountain valleys is contrasted with the bright sun and with shining arms and armor (Sayers 1957) (Figure 7.3). This text is somewhat more colorful than *Beowulf*: there are recurring references to blood, a few mentions or evocations of natural colors (green grass, olive branches, a

horse's white tail and yellow mane), descriptions of colored war banners, and references to a Muslim black as boiling pitch and to the lord of Ethiopia who rules over the black people.

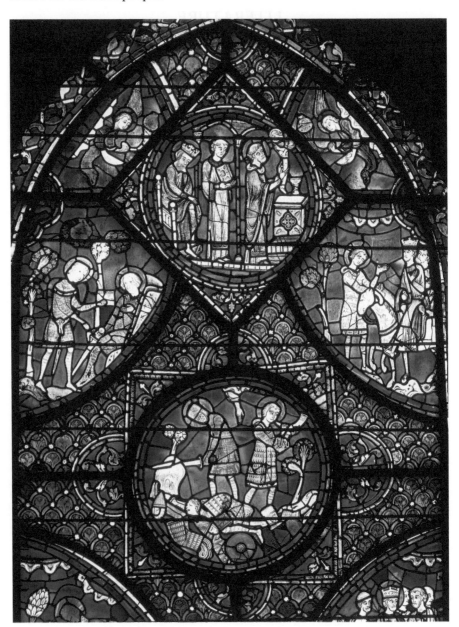

FIGURE 7.3 Cathedral of Notre-Dame de Chartres (detail), stained glass window showing Roland, c. 1225. Photograph by DeAgostini / A. dagli Orti. Courtesy of Getty Images.

El cantar de mio Cid ("The Lay of the Cid", Spain, twelfth or early thirteenth century), which recounts the adventures of a Christian mercenary in Spain, employs less color terminology than the *Roland*: the predominant color term is "blood"; there are also references to colors in clothing and armor (gold thread, red fur, carbuncles and rubies on helmets) (Raffel 2009). In these and other epics, as in *Beowulf*, the light/darkness contrast and blood are the chief visual tropes.

The palette of epics is elemental but nonetheless eloquent, operating as it does on multiple symbolic levels simultaneously. The light/darkness duo of course recalls Genesis' account of creation, and endows these texts with cosmic significance. Medieval European epics describe agonistic worlds in which universal forces clash and do battle. In them, light and darkness symbolize good and evil, God and the devil, Christianity and heresy or paganism, life and death, civilization and nature, order and chaos, humanity and monstrosity. The lack of color in epic may also be understood as a denial of corporeal pleasure and sensory indulgence; it reflects a stoic embrace of mortification and sacrifice that is necessary to the performance of heroic deeds. In this way, the epic shares a contempt for color that echoes that of figures such as St. Bernard.

Norse mythology is closely related to the epic tradition of northern Europe and shares with it a color aesthetic based on the light/darkness contrast, as is evident in the Icelandic *Prose Edda* (thirteenth century; Snorri Sturluson 2006). This compilation of Norse myths tells of the origins and ending of the world, the various regions of the universe, and of the gods, giants, elves, and demons who inhabit it. The gods, or *Æsir*, reside in a hall whose roof has golden shields for shingles; the rainbow bridge Bifröst (Shimmering Path) connects Ásgarðr (Home of Gods) to Miðgarðr (Middle Earth); Glaðsheimr (Bright Home), the temple of rulers, appears to be made of gold throughout and has furniture and utensils of gold; the light elves inhabit Álfheimr (Elf World) and are more beautiful than the sun; Odin's second son Baldr is so beautiful that light shines from him. Muspel, the southern or underworld realm, is a bright, hot land of fire ruled by Surt (the Black One), who defends it with a flaming sword; the dark elves live in the earth and are blacker than pitch; the path to Hel (the underworld for the dead) leads through dark valleys; at Ragnarök (Doom of the Gods), the battle at the end of the world, monstrous wolves will swallow the sun and moon, and the stars will disappear from the heavens. As in *Beowulf*, the most frequently recurring color term refers to gold, which reflects this metal's status in Nordic cultures and its assimilation to cosmic and eschatological symbolism.

Lyric poetry developed more or less simultaneously with epic, with which it contrasts in almost every way. While epic is long-form poetry concerned with public, martial performance and physical suffering, lyric poems are relatively short, meditative, subjective, and concerned with the intimate spaces of the

mind, heart, and court, and above all with love. The subjects of lyric poetry—the nature of love, feminine beauty, the pain of separation from the beloved, poetic inspiration—are much more richly "color coded" than are those of epic. In the poetry of the southern French troubadours, who established a lyric aesthetic imitated around Europe for centuries, color is a crucial element for evoking physical and spiritual beauty, desire, and the veneration that is the hallmark of *fin'amor* (the Occitan term for courtly love). Women have bright faces, beautiful bodies of fresh color, and are more beautiful and desirable than precious gems, roses, or lilies. Love itself is beautiful and white, more radiant than the sun, and causes lovers to change color.

Typical of lyric poetry is the connection between love and springtime or the month of May: poets describe natural scenes bursting with the colors of plants and birds, and poems abound with references to grass, fields, leaves, flowers, and fruits, all of which evoke a colorful spring spectrum. In the late Middle Ages, the term for "color" could signify a metaphor or rhetorical figure, a meaning with which poets frequently played to equate their poems with flowers or colorful objects. Later lyric poets subvert these chromatic codes: Petrarch emphasizes the association of love with light more than with color in his *Canzoniere* (fourteenth century; Petrarch 2002); Charles d'Orléans, a prisoner of war for twenty-five years, uses color ironically and emphasizes black to express his melancholy (fifteenth century; Currey 1969); and François Villon employs almost no color terminology in a corpus focused on earthly and moral decay (fifteenth century; Villon 1994).

The most prized and influential genre of medieval European literature—one which would change the course of literary history—was the romance, which appeared in the twelfth century. The term *romance* derives from the Old French word *romanz*, which meant "Romance vernacular." Originally, a romance was a tale of love and adventure written in the vernacular for the laity. Romances are concerned equally with chivalric exploits and courtly behavior, warfare and love, the body and the soul. They employ a broad color vocabulary for their descriptions and effects. The color rhetoric of romances draws on encyclopedic texts, epic, and lyric poetry, but adds an attention to the appearance of objects and to the atmospherics of color that far surpass these other genres.

Arthurian romances are among the earliest and have enjoyed pan-European, and indeed global, success for centuries. Color is crucial to evoking the desire, ceremony, elegance, mysticism, and adventure that are the staples of these stories. As in lyric poetry, love is associated with color: women have blonde or dark hair, white skin, eyes of various colors, and beauty surpassing flowers or gems; lovers change color in each other's presence; and love blossoms with the colorful spring. Arthurian romances are often punctuated by moments of great ceremony such as processions into court, hunting expeditions, banquets, trials, jousts, and religious services. These events are almost always described with

vivid references to colors: gleaming or colored armor and heraldic insignia, golden table vessels and candelabras, liturgical objects set with gems, the glowing Grail. Similarly, the courtly world of Arthurian romance is populated with refined objects and garments that evoke a world of extraordinary splendor and luxury. One finds numerous references to gold rings, gems, silk brocades, colorful trappings of horses, white linen, furs of various colors, tapestries, tents, and paintings. This expansive use of color evokes a marvelous world inhabited by exceptional people and marvelous beings—a world in which magic is possible, the divine is immanent, and emotions are strong enough to inspire heroic deeds or to destroy kingdoms.

The most famous use of color in the Arthurian canon is found in *Sir Gawain and the Green Knight* (late fourteenth century; O'Donoghue 2007). One of the most striking characters in literature, the Green Knight has green skin, green and bushy brows, a thick beard as green as a bush, green clothing, a green horse whose mane is plaited with green thread, and an axe whose head is of green steel. His eyes are red and spurs golden, and as he enters Arthur's court he carries a holly bough. The narrator notes that of all the marvels Arthur and his court had seen, this figure was the most marvelous—a meta-narrative comment that is meant to highlight for the reader just how strange and new this character is. When the Green Knight is beheaded, blood spurts from his neck and stains his garments. Later, when Gawain is armed, the text describes the colors of his garments, arms (notably his red shield), and accouterments, with recurring mention of the gold he wears.

Although a romance, *Sir Gawain and the Green Knight* in many ways recalls the color aesthetic of epic. Its elemental palette (green, gold, red) is likely meant to signify on several levels simultaneously. Much has been written about the symbolism of the Green Knight, who may represent eternal life, Christ, resurrection, a green man or spirit of the forest, yuletide, the seasons, fertility, or chivalric virtue and sacrifice. This latter association is certainly intended, since the Green Knight tests Gawain's courage and loyalty. This strange and vivid story lodges Gawain's heroic example in the reader's mind, and may be the most overtly moralizing and didactic use of color in any romance.[3]

Another early form of romance that also enjoyed great success was the genre known as the romance of antiquity. These romances were adaptations and expansions of ancient stories of Troy, Thebes, Alexander the Great, and Aeneas. Like Arthurian romances, these texts employ color to depict an ancient world that, although pagan in this case, is replete with the courtly and chivalric values and with the rich material culture so appreciated by the medieval nobility. Antiquity in these romances is "medievalized"—that is, described anachronistically—such that warriors ride horses, wear medieval armor, joust with lances and fight with swords and shields, and employ heraldic devices (even though heraldry did not appear until the twelfth century). As in the Arthurian

world, these romances possess a wealth of richly colored clothing and objects. The palace of Troy is painted with lush pigments and decorated with colorful statues; Alexander the Great sleeps in a richly painted bed, and has a tent whose four sides are each a different color (white, black, red, and green) and whose interior is decorated with objects made of gold, gems, carbuncle, topaz, and silk (Harf-Lancner 1994; Sainte-Maure 2017). The romances of antiquity, particularly the *Romance of Alexander*, draw on the color rhetoric of lapidaries and bestiaries to evoke an exotic and marvelous world. A famous example is Alexander's horse Bucephalus, who has spotted flanks, a tawny rump, and a tail purple like that of a peacock (Harf-Lancner 1994: 99). Color is used in the romances of antiquity to evoke a world that is both ancient and contemporary, strange and familiar.

One of the most famous and influential romance works does not resemble any of those previously mentioned and could just as easily have been included in the discussion of encyclopedic texts. The *Roman de la rose* ("*Romance of the Rose*", France, thirteenth century) is a lyric-narrative allegory of over 20,000 lines that recounts a man's attempt to possess his beloved, who is figured as a red rose (Horgan 1999). The action is set in a walled park or garden that is a *locus amoenus* ("a pleasant place," that is, an idyllic place), a secular Eden, an echo of the Song of Songs, and a reprise of the courtly gardens found in earlier romances. This basic lyric conceit is embroidered with numerous digressions on ancient history, myths, the nature of love and of art, the moral state of the world, and a host of other subjects. One of the most important aspects of this text's color aesthetic is its association of color with personification allegories. Baseness is full of black treason; Avarice is green as a chive and wears a worn, black cloak; Danger is black with flaming red eyes; False Seeming has a pale face and wears black and gray; Hypocrisy is black inside and white outside; Death is black; Old Age's hair is white as a lily; Idleness has blonde hair, a throat white as snow, and wears a chaplet of roses, a green robe, and white gloves; Pleasure has blond hair and white skin tinged scarlet; the God of Love wears a robe made of all the flowers of summer, and a chaplet of roses around which flutter all manner of colorful birds. Color is essential to establishing distinct and memorable characters who, although largely one-dimensional symbols, nonetheless represent a broad array of psychological states, social ranks, and social conventions. In few other texts are the moral, didactic, and mnemonic potentials of color exploited as fully as they are in the *Romance of the Rose*, whose use of color inspired authors from Dante to Chaucer to Renaissance poets.

Indeed, like the *Romance of the Rose*, Dante's *Divina commedia* ("Divine Comedy", fourteenth century) merits special attention not only as a monument of medieval literature but particularly for its varied use of vivid color imagery (Alighieri 1984–6). A striking aspect of the *Comedy* is that each of the three realms through which Dante travels—*Inferno* (Hell), *Purgatorio* (Purgatory),

and *Paradiso* (Heaven)—possesses its own chromatic characteristics. Hell, not surprisingly, is marked by a somber spectrum in which black and red predominate: the air is gloomy; the damned have black souls; streams have water that is purple black; swamps have black mire; devils are black; the fiery serpent is black as a peppercorn; Satan's three faces are red, yellow, and black respectively; cowards' faces are streaked with blood; suicides have stained the world blood red; the Furies are smeared with blood; Phlegethon is the river of boiling blood; fires burn throughout and cast a red glow. The most colorful figure in Hell is Geryon, the monster with a human head and serpent's body who is painted with every color, like a marvelous creature in the bestiary.

In Purgatory the color aesthetic is altered by the introduction of light: there is still smoke and fire around sinners undergoing purgation, but now Dante is stunned by the sun and by light emanating from angels, and there are more references to white objects (garments, marble). At the end of *Purgatorio*, Dante witnesses a mystical procession in the earthly paradise inspired by Revelation, visionary literature, and the Holy Grail ceremonies in Arthurian romance. This is the most colorful passage in the entire *Comedy*: Dante meets a woman gathering flowers, then sees seven golden candlesticks, seven beautifully clad ladies (one each in red, white, and green, four in purple), a chariot brighter than the sun surrounded by women in differently colored robes, seven figures crowned with roses, and a rain of flowers in which appears Dante's beloved Beatrice, who wears a pure white veil and cloak of green, and is surrounded by flame. In Heaven, Dante sees souls as points of light, Mary as a pure white rose, and the Trinity as three concentric rainbows, but otherwise there is very little color because what he "sees" is immaterial and beyond human comprehension. In this way Dante uses color not only to map his otherworldly pilgrimage, but also to assign moral and spiritual value to his experience and to show his ethical, intellectual, and spiritual evolution.

The late Middle Ages witnessed the development of more naturalistic forms of narrative in tandem with the expansion of cities and of the merchant class. The most famous examples of this new aesthetic are Boccaccio's *Decamerone* (*Decameron*, Italy, fourteenth century) and Chaucer's *Canterbury Tales* (England, fourteenth century). Both use the conceit of a frame tale inhabited by characters who tell stories. In Boccaccio, this is a group of young nobles who have left Florence to escape the plague, while in Chaucer the storytellers are pilgrims traveling to Canterbury. In the *Decameron*, most of the color vocabulary is reserved for the frame narrative: the youths tell their tales in gardens and meadows with green turf, trees, fruits, and all kinds of flowers from which garlands are made. The tales contain very little color terminology, concerned as they are with actions and their moral meaning more than with setting and symbolism. Color relates principally to the garden setting and is associated, as in lyric and romance, with youth, love, and pleasure (Boccaccio 2011).

Chaucer's color vocabulary is much richer and applies both to descriptions of his characters in the frame narrative and to their tales (Chaucer 2009). The Miller has a beard as red as any sow or fox, nostrils black and wide, and a white coat with a blue hood; the Summoner has a fire-red cherubim's face, black brows, white pustules, and loves to drink wine red as blood; the Sergeant of the law wears a multicolored coat girded with a belt of silk with small stripes; the Franklin's beard is white as a daisy; the Reeve has on a long outer coat of dark blue; the Prioress feeds her small hounds milk and fine white bread, has eyes gray as glass, a small red mouth, and about her arm is a set of coral beads adorned with large green beads, on which hangs a brooch of very bright gold. Here color is used for characterization to extraordinary effect. The tale with the most color terminology is that of the Knight, who recounts a romance set in antiquity that imitates exactly the way in which romances use color to evoke feminine beauty, springtime, fine clothing, and exoticism. Chaucer thus uses color in the service of his estates' satire; the appearance of each pilgrim and the stories they tell reflect their values and beliefs. Chaucer's colors are a bravura example of literary description and a remarkable adaptation of medieval color symbolism to a naturalistic and encyclopedic literary project.

Another major medieval genre in both Latin and the vernacular that deserves mention for its use of color terminology is hagiography. Saints' lives were one of the most widespread forms of narrative in medieval Europe, and like the other genres so far discussed, they used color to create vivid stories that would entertain and instruct. Many of the rhetorical tools and symbolic associations that we have already seen in other genres were prevalent too in hagiography. Longinus, the soldier who stabbed Christ in the side, became old and lost his sight but regained it when he rubbed his eyes with Christ's blood (Voragine 2012: 184). St. Anthony was visited by the demon of fornication in the form of a black child who informed the saint that the demon had been defeated (93–6). St. Paula was a pearl of inestimable value who said that she should disfigure her face with tears for having painted it with vermilion, white lead, and black against God's commandment (121–6). The ascetic St. Mary the Egyptian became black and burned from exposure to the heat of the sun (227–9). St. Sylvester, whose name signifies green in the contemplation of celestial things, disputed with the Jews before the Emperor of Rome. Sylvester explained that Christ is both human and divine by comparing Christ to cloth dyed purple: Christ's body is the wool, his divinity is the color that is not of the wool (62–71). In these examples, there is a range of familiar associations: blood is equated with salvation and healing; black with the demonic, but also with mortification; colors used in make-up with materialism, sin, and the need to mortify oneself; purple with royalty and divinity. Colors in hagiography may be positive or negative, sacred or profane, divine or demonic—they are always employed

strategically, to strike the reader's (or listener's) memory and lodge therein a vivid, didactic, and inspiring image.

This section concludes with a brief summary of the functions of color rhetoric in medieval vernacular literature. Color is used for the sake of description: it evokes in the imagination material realities. These may pertain to setting, to physical appearance or racial or geographical origin, to clothing, to jewels, to arms and armor, to heraldic devices, to furnishings, to plants, to animals, and to any number of other objects. Little discussed here but very important is ekphrasis: the verbal description of works of art. Medieval literature abounds with such descriptions, which are often meta-narrative commentaries on a character or scene (for example, the map of the world painted in Alexander the Great's tent, which signals his ambition for global conquest) (Harf-Lancner 1994: 195–9). Color creates atmosphere by assimilating objects, figures, or settings to the exotic, oriental, feminine, masculine, mystical, natural, courtly, royal, and so on. Color is a mnemonic device that helps readers to recall important aspects of a text. Space does not permit a lengthier discussion of this, but it should be noted that numerous treatises on the arts of memory insist on the importance of striking and strange color imagery.[4] Finally, color evokes the unseen order of the universe. It has been shown how color describes moral, social, and spiritual identity, but there is much more to say about color's relationship to medicine and psychology. A fuller account of color in medieval literature would address humoral, racial, and other scientific theories in both learned and lay milieus, as well as the ways in which color structured social categories such as gender and profession.

THEATER

Applied to medieval European society, the term *theater* encompasses a vast array of cultural practices: sacred and profane, in Latin and the vernacular; performed indoors and outdoors; occupying a moment or many days; involving one person or hundreds; and covering material ranging from the Bible and saints' lives to ancient history, farces, and allegorical commentaries on contemporary society. Medieval theater included liturgical plays, religious processions, mystery plays, miracle plays, morality plays, minstrel performance, farces, royal entries, and chivalric pageants. There was considerable continuity between the color symbolism present in encyclopedic and literary texts and that of theater, but with the significant difference that in theater, color was directly perceived and part of a living spectacle. Its meaning depended both on preexisting associations and on the context in which it appeared.

Another important distinction concerns the nature of the evidence for color's use and meaning. Literary texts employ color terms or references to colored objects such that the color intended is usually understood, whereas

most of the sources for theatrical productions, including the dramatic texts themselves, are silent about the colors of sets, costumes, and props. It must therefore be inferred how color was used and what it meant in medieval theater by examining other genres of medieval literature, manuscript illuminations, chronicles, paintings, accounts, and postmedieval documentation. Judiciously interpreted, these sources reveal a great deal about color's role in medieval theatrical performances (Pastoureau 2001b).

Medieval theater occurred in spaces destined principally for other activities; what we would recognize as theaters only appeared in the late Middle Ages. The earliest medieval theater was liturgical and performed in churches, a tradition that continues to the present (for example, Christmas plays). Performances could happen in guild halls, royal palaces, mansions, town squares, private courtyards, or taverns. They could be mobile: religious processions on feast days could wend through a city; stages could be constructed on wheels and moved around. As a result, there was no unified aesthetic for medieval theatrical settings, backdrops, and props—the modern notion of naturalistic staging was largely absent from medieval theatrical practice. Nonetheless, as productions grew larger and more complicated in the fourteenth century with the development of miracle and mystery plays, stages and decor also became more important.

Painted backdrops indicated setting, their wooden frames sometimes carved and painted to enhance the decorative effect. The entrance to hell was often depicted as the gaping mouth of a huge beast. Performance spaces could be decorated with tapestries, cloth hangings, or heraldic banners. Setting was also evoked with special effects: heaven could be a white cloud on which a figure was raised and lowered; hell might have actual fire or clouds of smoke. Props included painted statues, arms and armor, wooden furniture, plants, animals (dogs, birds, horses, donkeys), and numerous other objects that added brightness or color to the spectacle. Elaborately painted mechanical props in the form of dragons, giants, lions, and other creatures were not uncommon in the late Middle Ages. It is clear from late medieval and early modern records that great sums could be spent on the painting and props used in large urban events such as mystery and miracle plays and royal entries. This investment served several purposes: color created a festive atmosphere, attracted a public who would spend money, indicated setting (heaven, hell, Jerusalem), made the action visible and legible, displayed the wealth of the guilds and magnates who funded the performance, and honored the subject of the performance, whether God, a saint, a noble, or a king.

Costume was another theatrical element to which color was crucial. Characters' garb indicated who they were, especially in the larger productions, which could be attended by hundreds or even thousands of people. An actor might or might not speak, but his costume always spoke for him. Headgear (crowns, hats, garlands, wigs), beards, robes, gloves, belts, wings, claws, and tails all had

to be clearly visible, and not only their forms but also their colors had to be distinct so as to indicate the type of character intended. Saved souls were garbed in white, the damned were dressed in black and had faces blackened with coal. Angels wore different colors, in accordance with biblical and other traditions that describe a colorful heavenly host, but there are numerous references to their gilded faces. Whether this means the actors wore gilded masks or had painted faces remains an open question. Devils, on the other hand, generally wore grotesque masks; judging by manuscript illuminations and other sources, they were often dressed in dark cloth or furs to signal their bestial nature. Those portraying foreigners, fools, and villains might wear stripes, motley, or yellow, all of which could connote the strange or perfidious (Butterworth 2014; Smith et al. 2014). Performances incorporated heraldic insignia on surcoats, shields, and banners as a way of representing historical figures or of evoking a connection to a person, family, town, region, or kingdom.

Although medieval theatrical events were ephemeral and have left no immediate visual traces, we may nonetheless gain a sense of their color schemes by examining medieval painting. Given that late medieval and early modern painters often painted for theatrical productions too, it is assumed that there was considerable correspondence between the chromatic practices of paintings, plays, entries, and *tableaux vivants* (living pictures). A similar argument has been made for tapestries, which like theater were a monumental form of display; scholars argue too that certain manuscript illuminations echoed theatrical arrangements (Davidson 1977, 1991; Barber and Barker 1989; Pochat 1990; Weigert 2004). Based on these comparisons, we may imagine that late medieval theater was very colorful, and that this use of color was intimately connected to the symbolic language seen in literature. The cosmic and moral connotations of the contrast between light and darkness; the association of specific colors with sanctity and others with the diabolical; the use of color to indicate royalty, majesty, power, wealth, the orient, and social position; the suggestion of mood and atmosphere: all of this was wordlessly expressed with color in theater. It must be recalled too that medieval theater was open and frequently broke the fourth wall. It invited participatory viewing—even as spectators understood they were witnessing a representation, they were also invited to perceive the continuity between the performance and their reality. As in medieval literature, color in medieval theater was meant to strike the imagination and memory, and thereby to enhance the didactic and exemplary features of plays. Through color, movement, and sound, medieval theater vivified the stories that were the foundation of medieval European society.

CHAPTER EIGHT

Art

THOMAS DALE

The meaning of color in medieval European art is intimately connected with its materiality. As revealed in the dedication text of the Godescalc Lectionary made for Charlemagne between 781 and 783 (Paris, Bibliothèque Nationale, Nouv. Acq. Lat. MS 1203, fol. 126v), pigments were appreciated not only for their rarity and aesthetic qualities, but also for their religious and political resonances (see Plate 8.1). The scribe Godescalc explains that:

> the golden letters were written on pages painted purple. They reveal the celestial realm through the red colored blood of God and the shimmering joys of the starry heaven, and the Word of God, glimmering in the majestic luster, promises the sparkling reward of eternal life [...]. So the doctrine of God, written in precious metals leads those following the light of the Gospels with a pure heart into the shining halls of the kingdom flowing with light, and sets those who climb above the high stars of heaven's vault in the bridal chamber of the king of heaven forever.
>
> (Palazzo 2010a)

Godescalc links the purple-red and gold pigments to the dual nature of Christ as God and Word made flesh, demonstrating the role of color in contemplating the divine. At the same time, a theme of rulership placing Charlemagne in relation to the "king of heaven" is reinforced by the emulation of purple-dyed Tyrian codices with golden script from the imperial court of Constantinople. The text's evocative description of light also confirms that color was perceived less in terms of hue than of value—the relative brightness or darkness of the hue (Fayet 1992).

Some thirty years ago, Michel Pastoureau lamented that there was "a surprising absence" of art historians considering color (Pastoureau 1989a: 57); yet he also saw in art history the greatest potential to explore the broader cultural meanings of color. Over the past few decades, the study of color has flourished along the lines that Pastoureau and John Gage have advocated: namely the consideration of how color's use and meaning are culturally and socially constructed (Pastoureau 1989a; Gage 1993: 39–92). Pastoureau himself has published a series of books on the religious, literary, and heraldic understanding of individual colors (2001a, 2009, 2014), while Gage (1993, 1999) has written broad-ranging histories that include chapters on medieval art in relation to material history, optical science, and religious culture.

The function of color has long been explored as a measure of formal expression and taste as part of broader studies (for example, Dodwell 1993), but recent historiography is distinguished by a greater interest in integrating the technical aspects of color into iconographic and stylistic analysis. There have also been a number of attempts to establish an iconography of color in medieval art, based in part on scriptural and exegetical texts as well as secular literature, even though it is admitted that the meaning of any given color is multivalent and can shift according to specific contexts (Pulliam 2012; Petzold 2016; Panayotova 2016).

This chapter discusses the changing techniques and materials of color in relation to style and iconography, its capacity to bring figures alive, and the ways in which meaning was attached to changing values of different pigments over time. The focus here is on painted color in illuminated manuscripts, panel painting, and wood sculpture.

COLOR, MATERIAL, AND FORM IN MEDIEVAL PAINTING AND POLYCHROME SCULPTURE

Painted color survives best in illuminated manuscripts, because their folios are less exposed to light and are rarely subject to the deterioration and later restoration processes that have marred panel and mural painting or polychrome sculpture. The material basis of color and its meaning is highlighted by the very term used to describe manuscript painting: *miniature*, which derives not from the small scale of the picture but from *minium*, the red-colored pigment used for *rubrics*, or red painted initials (De Hamel 2001: 17). The specific materials and techniques of manuscript illumination have been increasingly incorporated into interdisciplinary studies of color (for example, Bucklow 2009; Panayotova 2016).

The earliest surviving illuminated manuscripts date from the fifth century, including the *Roman Vergil* and the *Quedlinburg Itala* fragments (Weitzmann 1977). In these manuscripts, color is used illusionistically following

Greco-Roman painting techniques creating the impression of space beyond a distinct red or gold frame by using atmospheric perspective with warm colors in the foreground and blues and purples in the background. Bodies are modeled using variations in tone to convey the contrast of light and shadow over clothed limbs and in flesh tones. This mode of using color is still current in the figural miniatures in a series of sixth-century purple-dyed codices now generally attributed to Constantinople, Syria-Palestine, or the eastern Mediterranean, including the *Vienna Genesis* (Vienna, Österreichische Nationalbibliothek, Cod. Theol. Gr. MS 31) and the *Rossano Gospels* (Rossano, Museo Diocesano, Cod. MS 042). The script in these codices is penned in liquid gold and silver.

It has long been assumed that the reddish-purple color of these codices, closely associated with the prestigious Tyrian-purple dyed garments reserved for Roman emperors (Henderson 1999: 122–35), was produced primarily from the glands of sea snails or whelks, but recent chemical analysis has proven that the dye was produced from folium or orchil derived from lichens (Quandt 2018). With the spread of Roman Christianity northward to the British Isles and the Carolingian Empire during the eighth and ninth centuries, the appearance of these luxury manuscripts was often imitated, sometimes for only selected folios in Gospel books. The imperial associations of the purple dye made it particularly attractive for use in books associated with Carolingian and Ottonian rulers, including: Charlemagne's *Godescalc Lectionary* (see Plate 8.1); the *Coronation Gospels* (Vienna, Kunsthistorisches Museum, MS SCHK.XIII.18); the *Registrum Gregorii* of Otto II (Chantilly, Musée Condé MS bis [15645]); and the later *Pericope Book* of Henry II (Munich, Bavarian State Library, Clm MS 4452) (Dodwell 1993: 52–6, fig. 43; 130–44, fig. 125).

Besides these luxurious applications of purple and gold, even the humblest form of text manuscript made use of color selectively to highlight headings or instructions, and to offer a form of visual indexing at a time when folios were not numbered. The standard black ink was used throughout for most of the text; by contrast, from the fifth century onward, it became common to use red for headings, including titles, chapter numbers, and instructions, in the case of liturgical texts. The instructional texts in red ink are recalled in the term *rubrics* derived from the Latin *rubrum* (red) (De Hamel 2001: 16–19).

The use of color in painted scenes in illuminated manuscripts shifts according to broader changes in style, as well as the range of available pigments and changing taste. The earliest manuscripts from the eastern Mediterranean, such as the *Vienna Genesis*, adhere to Greco-Roman techniques designed to convey the illusion of depth on the page, using conventions of color change from warm greens and browns in the foreground to cool blues in the background to give the impression of atmospheric perspective. Figures are modeled using a range of tones and highlights within a given hue.

As far as palette is concerned, some general trends over time and space within western Europe may be distinguished. Insular (British and Irish) manuscripts from the eighth and ninth centuries are limited to green (verdigris), orange from red lead, charcoal black, and orpiment yellow (Panayotova 2016), and it has generally been assumed that insular illuminators had a more abstract, decorative sense of color. This applies to the richly ornamented initial pages, such as the celebrated Chi Rho in the *Book of Kells* (Trinity College, Dublin, MS 58), in which color complements complex interlace patterns to simulate the effect of filigree, enamel, and garnet inlays in metalwork, highlighting the Greek letters that begin the name of Christ in the Gospel of the Incarnation from Matthew (Dodwell 1993: 82–90).

A similar argument has been made for the modeling of figural images, such as the Evangelist portraits in the *Lindisfarne Gospels* (London, British Library, Cotton MS Nero D.iv); though based on Mediterranean models, the brightly colored system of highlights in the mantles ties the figures to the frame of the image and the surface, denying an illusion of space (Schapiro 2005: 20–3). Challenging this view, Pulliam suggests that the bright red, green, and blue lines used on the Evangelists' robes were intended to evoke the illusion of radiant light, and the artist has used complementary colors to intensify the effect of simultaneous contrast (Pulliam 2012: 9). One further revision to our understanding of color in insular manuscripts is offered by Fuchs and Oltrogge (1994: 149–55). They have discovered that the painters of the *Book of Kells* used glazes—overpainting opaque color with translucent dye—and complex mixtures of different pigments to enhance the richness of palette, sometimes imitating techniques of Roman illusionism.

A more abstract use of color is linked with Mozarabic manuscripts made by Christian communities under Islamic rule in Spain between the tenth and twelfth centuries. In the numerous copies of the *Commentary on the Apocalypse* by Beatus of Liébana, a consistent palette comprises red ochre, pale blue, and green, together with bright red orange and yellow. Tonal modeling being absent, figures appear rather amorphous, but internal modeling is suggested by parallel fold lines in black, white, and red. In the later eleventh and twelfth centuries, instead of depicting colored figures against the bare parchment, a system of bright color fields serves as the background, paralleling what one finds in wall painting during the same period. Bolman (1999) has demonstrated that the choice of colors, though decorative, served crucial mnemonic functions for the monastic reader, based on an understanding of relative intensities of different colors. The choice of colors is dictated by four factors: the translation of key color words in the biblical text; the contrasting representation of sources of light (white, red, yellow, orange) or darkness (black, brown, blue); conventional iconographic symbolism; and a desire for variety.

In the painting of the Carolingian and Ottonian empires, in keeping with the ideology of Roman imperial revival, color is again put to the service of illusionism. This is particularly apparent in the manuscripts of the Court School of Charlemagne, ranging from the early essays in recapturing classical figure style in the *Godescalc Lectionary* commissioned by Charlemagne in 780 to the fully mastered classicism of the Evangelist portraits in the *Coronation Gospels* of Charlemagne. Each of the Evangelists is depicted within an illusionistic gilded or silver frame and set within a light-filled landscape rendered in impressionistic strokes; the classicizing poses and costumes are matched by the chiaroscuro modeling. The connection with the Roman Empire is also frequently reinforced by the use of purple parchment with gold or silver script. In certain instances, as in the canon tables of the *Harley Golden Gospels* (British Library, Harley MS 2788), the Carolingian artists also used color to simulate polished or carved marbles and precious gemstones, particularly in the canon tables, thereby alluding to the heavenly Jerusalem as described in Revelation 21:18–20 (Kessler 2004: 20–2).

Many of the same patterns of color usage are continued in Ottonian manuscript painting, including the tonal system of modeling flesh and drapery in individual figures as well as the selective use of purple parchment with gold or silver script. At the same time, in manuscripts produced in Trier and Reichenau one finds a more abstract use of color to provide foils for the figural narratives. In the *Gospels* of Otto III (Munich, Bavarian State Library, Clm. MS 4453) and the *Pericope Book* of Henry II, the Byzantine technique of icon painting is emulated in the Gospel narratives set against shimmering gold grounds, alluding to Christ as the divine light made visible. On the other hand, where colored backgrounds are included, there is a shift from the subtle blending of one color into another in the atmospheric backgrounds of the miniatures in the *Registrum Gregorii* to stripes of color or color fields in the *Gospels* of Otto III, and this process was enhanced in the early decades of the eleventh century in the manuscripts of Henry II's reign.

While the use of gold backgrounds in manuscripts can be traced back to at least the sixth century, when it was used in the form of liquid gold for the texts of purple codices in the Byzantine Empire, its regular use in European painting begins in the Carolingian Empire, especially in manuscripts associated with Charles the Bald (r.843–77), including his *Coronation Sacramentary* (Paris, Bibliothèque Nationale de France, lat. MS 1141), and in the late tenth century Ottonian manuscripts begin to adopt the lavish gold grounds for figural scenes found in Byzantine icons and illuminated manuscripts after iconoclasm. The dynastic ties between the two empires forged by the marriage of the Holy Roman Emperor Otto II to the Byzantine Princess Theophano seem to have played a role in this new fashion for gold grounds. The transcendent gold ground in Byzantine icons is applied both to sacred narratives in the *Gospels*

of Otto III, such as the *Washing of the Feet*, and to imperial portraits, such as that of Otto III in the *Liuthar Gospels*, which can be closely linked with Byzantine imperial portraiture (Mayr-Harting 1991: 57–72). The association of gold with divine light and kingship made the material appropriate in both settings and reinforced the Christo-mimetic ideas of Ottonian rulership, which identified the emperor as Christ's representative on earth. However, gold was still confined to the most prestigious royal or imperial commissions, and De Hamel suggests that its relative rarity in early medieval painting is due in part to the disruption of supply from the eastern Mediterranean with the rise of Islam (De Hamel 2001: 69–70).

Romanesque painting, the first pan-European style, spanning the late eleventh to the early thirteenth centuries, is distinguished by the use of a system of "damp folds" of drapery, which cling to limbs, and windblown garments that animate the figures; initially, the Benedictine Abbey of Montecassino played a crucial role in mediating Byzantine painting techniques in Italy and further afield through Benedictine affiliations, but later, Norman Sicily took a lead in disseminating Byzantine form and technique through its dynastic contacts further north in France and England (Demus 1970: 79–161). These approaches to color and modeling are illustrated by the *Bury Bible* and may reflect the philosophical turn around 1100 toward considering the physical body and its movements in direct relation to the animating power of the soul (Kohler 1941) (see Plate 8.2).

This impression is created coloristically using a three-tone system as suggested by Theophilus for both manuscript and mural painting, with dark tones of the hue outlining the contours of ovoid or circular compartments around the thighs, knees, and shoulders, and the middle tone with highlights within the compartments (Theophilus 1979: 20–3). The plasticity of these figures contrasts with the brightly colored planes of color behind them, such that they appear to project forward in relief. Unlike the colored backdrops that tend to flatten the entire composition of figural scenes in late Ottonian and Mozarabic manuscripts, distinct hues are applied in nested rectangles that suggest a form of measuring space by a series of colored planes. The fact that the warmer green rectangle appears in front of the surrounding ultramarine blue backdrop may even reflect the conventional color spectrum of the time that placed green at or near the middle of the scale of brightness and darkness, and blue much closer to black, thus playing on the perception of dark colors as being more distant from the eye. The association of color with planes and surfaces conforms with certain descriptions of vision in twelfth-century writings; contrasting with modern understanding of color in relation to the refraction of light, colors are understood to define the shape, size, and movement of objects and bodies (Fayet 1992: 54–5; Dale 2012: 33).

Although one cannot speak of hard and fast chronological divisions between Romanesque and Gothic, there is a general consensus that the

emergence of a newly naturalistic Gothic style emerges in painting around 1200 (Martindale 1967: 67–84; Morgan 2016b). What this means in practical terms is an abandonment of linear systems of modeling color, including the compartmentalization of damp fold techniques in favor of more gradual transitions of modeling in light and shadow, as evident from the *Ingeborg Psalter* (Chantilly, Musée Condé, MS 9) made for Queen Ingeborg, wife of Philip II of France, between 1195 and 1205. In the course of the thirteenth century, Byzantine art played a significant role as a source of inspiration for reviving a coloristic modeling of the flesh, especially in Italian manuscript illumination and panel painting—building up the flesh from a green earth underlayer and adding flesh tones and highlights in lead white with contrasting areas of shade tones in azurite blue (Szafran and Turner 2012; Thieme 2012).

As Paris led the way in the development of a distinctive, elegant style of illumination associated with the court, there was a shift away from an initial classicism to a somewhat mannered style, combining naturalistic modeling with elongated, proportional schemes and swaying poses. While the naturalistic technique of modeling flesh and drapery in graduated tones was maintained, there was an increasing interest in replicating textile designs with embroidered patterns in gold, both on individual garments and in tooled backgrounds of scenes. The proliferation of gold leaf in a much wider range of Gothic manuscripts in Europe beginning in the thirteenth century may be connected with the opening up of access to gold from the eastern Mediterranean in the wake of the Crusades, as well as the discovery of new sources closer to home in the region of Slovakia (De Hamel 2001: 69–70).

Toward the end of the twelfth century, gold leaf was substituted for powdered or shell gold to produce shimmering gold backgrounds for narratives, likely inspired by Byzantine mosaic techniques used in Norman Sicily (Petzold 2018). This becomes a standard convention in Gothic manuscript illumination, at least for manuscripts associated with prestigious royal and ecclesiastical patrons, as in the case of the *Psalter* of Saint Louis, made in Paris.

Another stylistic shift affecting color takes place at the beginning of the fourteenth century in response to the growing interest in the mechanics of vision and perspective. Parisian illuminator Jean Pucelle (fl. 1319–34) created architectural interiors rendered in perspective, and by the end of the fourteenth century, drawing on the perspectival advances of Giotto and other Italian painters, the Limbourg brothers had returned to techniques used in late antiquity to give the impression of the miniature as a window in space, reviving atmospheric perspective in landscapes and creating accurate portraits of architecture both interior and exterior (Martindale 1967: 242) as, for example, in the calendar pages of the *Très riches heures* of Jean, Duc de Berry (Chantilly, Musée Condé MS 65). Illusionism is heightened by a broadening of the palette to include many more mixed colors in the service of mimesis.

PANEL PAINTING

Panel painting is closely related to manuscript illumination in palette and technique (Bomford et al. 1990: 17–51), and certain prominent Italian painters of the Trecento (fourteenth century), such as Duccio and Pacino da Bonaguida, worked in both media (Palladino 2003: 48–50; Sciacca 2012). With the exception of a small number of panels from the sixth and seventh centuries in Rome, panel painting is rare in Europe before the twelfth century and mostly confined to the Italian and Iberian peninsulas until the mid-thirteenth century when, under the inspiration of Italian models, it began to become more common in German cultures of the Holy Roman Empire and in Scandinavia (for example, Jobst 2002; Plahter 2004).

The materials, techniques, and styles of panel painting between the twelfth and fifteenth centuries follow the main trends already discussed for manuscript illumination. The main differences in color as seen today is that certain pigments used in panel painting have deteriorated, and as panel paintings are often displayed in a ritual setting, colors have been subjected both to fading from exposure to natural light and to darkening as a result of varnishing, incense, and candlewax. Recent conservation work and technical analysis have allowed the restoration of radiant colors, and in some cases digital simulations have aided in recreating the original appearance of works, such as Pacino di Bonaguida's *Chiarito Tabernacle* (J. Paul Getty Museum, Los Angeles), in which the azurite blue pigment had drastically faded (Berns 2012; Patterson et al. 2012).

Among the earliest panel paintings of the twelfth century are devotional images created in Rome, Lazio, and Tuscany, which emulate Byzantine icon traditions with gold grounds, creating radiant backdrops evoking divine light. An example is the *Enthroned Christ* from Tivoli Cathedral, possibly made in Rome, which copies the Lateran icon in the Sancta Sanctorum known as the *Acheropita* (not made by human hands; Belting 1994: 64–8). While the face is painted in dark flesh tones, copying the aged surface of the Acheropita, Christ's tunic and mantle are shimmering golden yellow with vermilion contours, while the jeweled throne alone is distinguished by multiple colors simulating the effect of medieval mosaics in Rome. Also from the early twelfth century are the earliest surviving panel crosses, which come to eclipse the sculpted crucifix in Italian churches in the thirteenth century, as they combine the iconic devotional image of the body of Christ with narrative images from the life of Christ and even mimic certain sculptural effects by the tilting forward of the head and halo of Christ.

In these panels, as exemplified by the early twelfth-century Pisa cross in the Museo di San Matteo, the coloristic affect is to emphasize the pale flesh of the suffering body of Christ. Rendered according to Byzantine technique with a

dominant olive-green layer and lead-white highlights, it stands out against the blue of the cross itself, as do the bright vermilion streams of blood emanating from the wounds, enhancing the reality of the Passion and the fleshly body of Christ. The simplified modeling with strong contrast of light and shadow and with schematic, linear rendition of the chest and rib cage may also be understood to make the image more visible from below, as panel crosses were mounted on transom beams or rood screens high above the nave in Italian churches. Indeed, this lofty perch may also explain a certain simplification of the color scheme, as these panels could reach a height of six meters (Cooper 2017: 239–42).

The early thirteenth century witnesses the impact of the Fourth Crusade, which again brought Italy into direct contact with Byzantine icon painting. Berlinghiero's *Strauss Madonna* in the Metropolitan Museum conforms both to the Byzantine iconography of the *Hodegetria* and to Byzantine palette and modeling techniques (Belting 1994: 408)[1] (see Plate 8.3). In contrast to the relatively unmodulated flesh painting of the twelfth century, there are smooth transitions from shadow to light and tiny brush strokes blending the different flesh tones laid over an olive-green base. The sculptural form of body and head contrasts with the transcendent gold ground, which links the human incarnation of God with the divine light. The Virgin wears the typical ultramarine-colored robe signifying the celestial light she bears as Mother of God.

In the second half of the thirteenth century, the independent, devotional panel is expanded in scale and subject matter to create a heavenly court with angels, prophets, and saints flanking the throne of the Madonna. A significant coloristic development, the depiction of light via a network of gold lines or chrysography, has been explained by Folda (2015) as the Western transformation of the Virgin Mary from the Byzantine concept of human mother of God to the European notion of Mary as Queen of Heaven. Crusader icons produced in the Middle East and brought back to Europe would have served as intermediaries. However, it must be noted that the use of chrysography in Italy was already part of the coloristic practice of mosaic art in Tuscany, Rome, and Venice, and in artists, such as Paolo Veneziano, there is evidence of the direct impact of mosaic tradition from the ducal basilica on the painter's jewel-like colors emulating radiant glass tesserae and in the use of chrysography (White 1990: 433–6).

Italian painting of the Trecento (fourteenth century) was transformed by contact with French Gothic art. The impact is felt in the elongated proportions of Duccio's figures and the broader range of jewel-like colors. At the same time, the impact of ancient Roman sculptural art and late antique wall painting is seen in the painting of Pietro Cavallini and Giotto, who developed a strong sculptural approach to modeling with smooth transitions from dark to light tones replacing linear modeling (White 1990: 155–62, 309–43).

Catalonia provides a rare opportunity to see how panel painting worked together with other painted media as part of a larger polychrome environment

that animated church interiors, including altar frontals, painted ciboria (altar canopies), crucifixes, Throne of Wisdom figures (see the section on sculpture below), and monumental mural painting (Sureda 1981: 44–54). The antependia (altar frontals) share their subject matter, palette, and style with apse paintings that provided their backdrop, routinely representing the Madonna and Child or Christ in Majesty on the central axis flanked by narratives of the life of Christ or that of the locally venerated saint. Until the end of the thirteenth century, there is a consistent palette and technique; as in the case of manuscript illumination from Spain, the palette focuses on bright orange reds, yellows, pale yellow, and dark blue; figures are set against blocks of color, while faces are outlined in charcoal black and modeled in largely linear terms using parallel shadows in black and highlights in lead white. The colors complement the iconographic themes to impress the viewer with the living presence of Christ in the Eucharist celebrated on the altar and the saints whose relics are contained within. The primary change later in the thirteenth century is the introduction of tooled gold or tin grounds to animate the surfaces with reflected light, and relief designs on the frames in gesso often assimilated to metalwork patterns.

POLYCHROME SCULPTURE

Although sculpture is usually treated separately from painting as a medium, the palette and technique of applying color to polychromed wood sculpture demonstrate that it is a form of painting in three dimensions. Sculpture in the round, which had been largely banned by the beginning of the fifth century in the Christianized territories of the western Roman Empire, became common in the second half of the eleventh century for monumental crucifixes and figures of the enthroned Virgin and Child known as a *sedes sapientiae* (Throne of Wisdom), but must have been revived earlier during the Carolingian Empire when the earliest surviving metal-clad reliquary portraits, such as that of Ste Foy, were made (Forsyth 1972: 61–91) (see Plate 8.4). Metalwork sculptures were formed over a wooden core and in some instances, such as the sculpture of St. Césaire from the Abbey of St. Maurs (Auvergne-Rhône-Alpes, France) dating from the mid-twelfth century, metalwork was reserved for shimmering gold or silver gilt robes over the torso, while the head was distinguished by polychrome wood, enhancing the illusion of flesh (Figure 8.1).

Until recently, the analysis of color in sculpture has been largely neglected, in part due to the poor state of preservation and in part due to a post-Enlightenment preference for monochrome sculpture promoted by Herder, Schopenhauer, and Hegel, later reinforced by the documentation of sculpture in black-and-white photography and the removal of polychrome completely to reveal the bare wood (Panzanelli 2008: 9–11). Before assessing the meaning of color and its

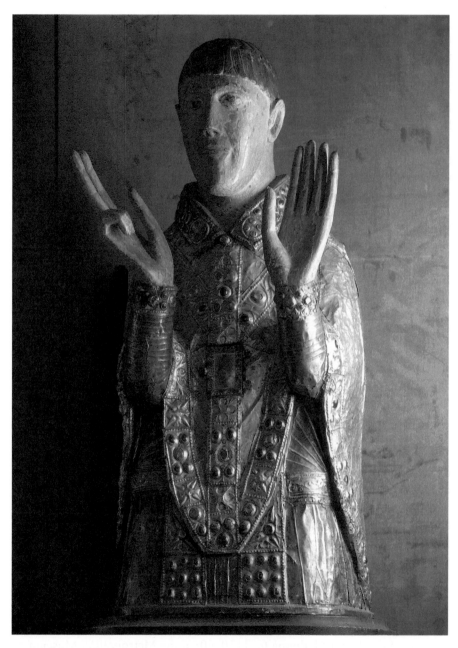

FIGURE 8.1 Abbey of St. Maurs, France, bust reliquary of St. Césaire, mid-twelfth century. Photograph by Mossot. Wikimedia Commons.

role in reinforcing the devotional function of statuary, it is necessary to observe that the range of the palette and sophistication of methods of applying color to medieval sculpture has been obscured until relatively recently due to the poor state of preservation of the original polychrome. Although the authoritative work by Ilene H. Forsyth (1972) on the *sedes sapientiae* figures devotes only a few paragraphs to color, new methods of conservation and technical analysis have begun to provide a clearer picture (Kargère and Rizzo 2010).

Beginning in the 1950s, German conservators began to remove late paint layers to uncover the original appearance of four key examples of German sculpture dated between the early twelfth and thirteenth centuries: the *Forstenried Crucifix*, the *Freudenstadt Lectern* from the Black Forest, the *Frauenberg Crucifix* from the Rheinland, and the *Cappenberg Crucifix* from Westphalia. The nearly complete color schemes recovered allowed Taubert (2015: 17–26) to theorize that there was a tension or disjuncture between color and sculptural form in the Romanesque pieces, and Willemsen (1974) went so far as to suggest that the color worked as a visual negation of volume comparable to what has been suggested for the color fields in manuscript and mural painting. Kargère and Rizzo (2010) offer a more nuanced assessment based on their close analysis of four examples in the Metropolitan Museum of Art, New York. They find evidence of tonal modeling in flesh and draperies, which relates to carved contours and drapery folds, alongside linear highlights and contours and the inclusion of oil medium in the flesh tones to animate the skin. They also demonstrate a high degree of illusionism in the rendition of fictive marbles adorning the thrones of the two Auvergne Madonnas, including *verde antico* and red porphyry (see Plate 8.4). Another significant addition that enhances the verisimilitude of these figures is the incorporation of tin ornaments varnished in yellow to suggest gold embroidery on the hems of the garments.

Beyond the contributions of color to the formal perception of sculpture and its techniques, the reconstruction of original schemes of medieval polychrome in sculpture has also laid a firmer foundation for iconographic studies and the probing of sculpture's function as devotional images within a multisensory ritual environment. As in the case of manuscript illumination and panel painting, color often serves significant semiotic functions, but meanings and preferences shift over time. Kargère and Rizzo (2010) show how the color of the Virgin's robe shifted within the twelfth century. The costume of the Autun Madonna (*c.* 1130–40) at the Metropolitan Museum of Art was originally dominated by a dark green tunic with the classic ultramarine blue confined to her veil and mantel falling over her shoulders; green was associated with virginity, new life, resurrection, and Paradise itself (Jackson 2016: 346). By contrast, the later twelfth-century *sedes sapientiae* figures in the same museum, both from a common Auvergne workshop—the *Morgan*

and *Montvianeix Madonnas*—combine a dominant ultramarine-blue mantle and veil with a vermilion tunic that is revealed primarily over the legs and beneath the sleeves of the blue mantle. Ultramarine blue came to be preferred as the primary color of the Virgin's robe, beginning in the twelfth century, due to its interpretation as representing heavenly light, an association that was affirmed in contemporaneous stained glass; while vermilion was linked with blood—both that of Christ and the martyrs (Pastoureau 2001a; Jackson 2016: 345–7). The two hues together thus emphasize Mary's role as mother of God incarnate. In later iconography, the celestial aspect emphasized either by blue or shimmering gold reflects the salience of the Virgin's role as "Queen of Heaven." In some cases, the artist simulates the effect of sumptuous, gold brocade textiles imported from Italy or the English gold-threaded textiles known as *opus anglicanum* (Oellerman 2015).

While color certainly contributed to symbolism and identification, it also played a significant role in appealing to the Pygmalion effect, the capacity for sculpture to come alive.[2] Within gray stone churches or unpainted wooden interiors, such as those of the Norwegian stave churches, polychrome allowed individual statues to stand out, especially when provided with lamps and candles to artificially light them. Indeed, Eric Palazzo has shown how polychromed statuary served to stimulate multisensory visionary experience among ascetics in Europe going back as far as the ninth century, according to the hagiographic texts he explored (Palazzo 2010b). The particular role of such sculptures in stimulating the senses and visionary experience is due to the fact that these images convey a particular presence by virtue of occupying real space and were perceived to come alive by virtue of their movement in liturgical processions and their incorporation into para-liturgical dramas including Epiphany plays (Forsyth 1972: 49–60), the rite of venerating the Cross on Good Friday, and the reenactment of the Deposition of the Cross on Holy Saturday. Less attention has been given to the role of color.

The careful rendition of flesh areas advocated in treatises, such as that of Theophilus, enhanced the idea that wooden sculpture could become flesh and blood, particularly given the association of wood itself with organic life. Reginald of Coldingham (*c.* 1170) offers a vivid account of St. Godric's vision of the polychrome wood sculptures of the Virgin and Child (see Plate 8.4), and the Crucifix, in which the Christ Child issued from the mouth of the Crucified Christ and was embraced by the arms of the Virgin, who kissed him before taking him into her lap. In narrating this wondrous vision, Reginald affirms that "human faith cannot doubt that the Son of God, who underwent death for us, can instill the breath of life into whatever he chooses. Indeed, he who just now instilled the vital breath into the wood obviously demonstrates through the wonderful mystery of such a great thing that he still lives and that he sees everything" (Palazzo 2010b: 20).

From the end of the thirteenth century to the fifteenth century, the illusionistic capacity of polychrome sculpture was pushed further to simulate different textures, including fur-lined clothing and metallic relief, and individually carved flowers added to hems of garments, and punched or stamped designs. At the dawn of the Reformation, monastic and conventual churches in northern Europe were filled with sculpted images of varying scales and functions: life-sized crucifixes, images of the Madonna and Child and the *Pietà* (*Vesperbild*), metal reliquary portraits, portable images of Christ in the sepulcher, smaller-scale "doll-like" images of the Christ Child, the crib, and the Visitation Group (Hamburger and Suckale 2008). The celebrated *Roetggen Pietà*, or *Vesperbild*, in Berlin enhances the grim realism of the Passion by molding the bright vermilion painted blood spewing from the wounds in high relief (Roller 2008: 345). Smaller-scale figures of Mary and the Visitation Group with rock-crystal wombs and of the Christ Child in a crib have been connected to visionary experience, serving as props by which nuns explored their own spiritual motherhood and union with Christ through a form of devotional role-playing (Hamburger 1989; Rublack 1996). The illusionism of these works is enhanced by incorporating actual materials, such as metalwork, rock crystal, and textiles (Roller 2008: 345; Kollandsrud 2014). Transcending the purely visual, these small-scale sculptures stimulated multiple senses, moving from vision and imagined hearing to the more intimate senses of touch and taste, fostering visions in which they appeared to come alive (Jung 2010).

By the end of the fourteenth century, the complexity of these multimedia works was such that the eminent sculptor Claus Sluter (1340–1405) collaborated with a specialist in polychrome, Jean Malouel (1365–1415), as well as a third artist, who focused on the application of gold leaf to create the so-called *Well of Moses*—a richly adorned monumental crucifix within the cloister of Champmol, France. Color here was used in combination with carefully crafted stucco relief as well as metalwork both to heighten illusionism of the Passion drama and to connect individual figures with the patron, Philip the Bold of Burgundy, whose preference for kermes-dyed, purple velvet garments is reflected in the mantle of Jeremiah (Nash 2008: 374).

FROM BLACK AND WHITE TO COLOR

Although an attempt has been made to classify the iconography of color in medieval art based on the use of biblical and exegetical texts, including encyclopedic works concerned with gemstones (Meier and Suntrup 2011), it has been accepted in recent surveys of medieval color iconography that interpretation is complicated by the multiple meanings ascribed to individual colors dependent on functional contexts as well as distinctive conditions of

culture and time period (Jackson 2016: 345; Petzold 2016: 441). Accordingly, color must be approached carefully within its specific setting.

Though considered to be colors at opposite ends of the spectrum, black and white also played a significant role in defining distinctive, formal modes in painting used variously to contrast underdrawing, grisaille, or sculptural modes with "living color."[3] Tilghman (2017) makes the argument that sections of the cross carpet pages in *The Lindisfarne Gospels* were deliberately left uncolored as a means of emphasizing the process by which God became flesh, even playing on the exposed skin of the vellum support. Dodwell has observed a number of cases in Anglo-Saxon manuscripts in which a fully colored figure of a sainted abbot or bishop is contrasted with a crowd of figures left in the form of an underdrawing to suggest a hierarchy of importance (Dodwell 1993: 104–7). He further suggests that this distinction may have motivated the preference for colored outline drawings in Anglo-Saxon manuscripts for monastic readers, who would have identified themselves with the "poor and worthless" beings described in chapter 7 of the *Rule* (Dodwell 1993: 104).

Similar modes were deployed in Italian wall painting for allegorical imagery, initially in the form of fictive textiles, but around 1300 Giotto simulated

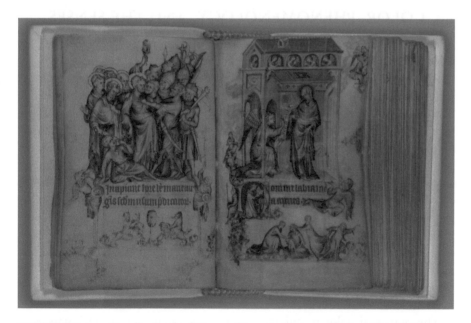

FIGURE 8.2 Jean Pucelle, *Book of Hours* of Jeanne d'Evreux (Paris, 1324–8), *The Betrayal of Christ / The Annunciation*. New York, Metropolitan Museum of Art, The Cloisters Collection 54.1.2, fols. 15v–16r. Photograph by Metropolitan Museum of Art, New York.

sculptural reliefs in gray stone to represent allegories of virtues and vices on the lower margins of full-color images of the *Life of Christ* and the *Infancy of the Virgin Mary* in the Arena Chapel, Padua (Bain 2012). A similar functional contrast is used in illuminated manuscripts in the fourteenth and fifteenth centuries as well as in northern European panel painting from around 1400, but Jean Pucelle perfected this mode of grisaille using it throughout the *Book of Hours* of Jeanne D'Evreux (1324–8) alongside architectural perspective to demonstrate the painter's power of illusionism (Morgan and Moody 2016) (Figure 8.2).

Besides offering a distinctive mode of visual representation for allegory, the contrast of unpainted sculpture and brightly colored figures in painted narratives mentioned above also suggests the idea of Pygmalion's power—the potential enlivenment of the sculpted figures. In manuscripts of the *Roman de la rose*, beginning in the early fifteenth century, the sculpture created by Pygmalion is initially depicted as a horizontal tomb effigy in grisaille, but in the course of the narrative it comes to life, shifting to a standing pose and then to a full polychrome image, thus demonstrating the power of contemporaneous polychrome sculpture on medieval viewers (Bleeke 2010).

COLOR, PHENOMENOLOGY, AND THE SENSES

As the above examples demonstrate, a primary function of color in medieval art was the incarnational: to transform the image into living flesh.

An early essay in the phenomenological interpretation of medieval color is Jean-Claude Bonne's (1983) study on the *St-Sever Beatus* (Paris, Bibliothèque Nationale, Lat. MS 9438); he proposes that viewing the striking colors of the manuscript facilitated access to the invisible God, the very material luminosity of the colors serving as a ritual complementing the liturgy. More recent scholarship has emphasized phenomenological perception of materials, colors, and light. Pentcheva has demonstrated how the gold and silver metalwork cladding of Romanesque reliquary portraits animate the saint's presence by generating a shimmering, flickering effect of reflected light; by contrast, the insertion of glass or enamel eyes with dark colored pupils fosters the illusion of a powerful reciprocal gaze with the saint (Pentcheva 2016). Panzanelli attributes to painted color on sculpture the same animating force: "color represents signs of life; the gaze becomes alive and penetrating with colored irises" (Panzanelli 2008: 2).

The power of color to animate the page is apparent even in instances in which the human figure is absent. In the case of the *Godescalc Lectionary*, the manuscript explored at the beginning of this essay (see Plate 8.1), Palazzo has suggested that color and materiality fashion the liturgical book as a form of sacred space (Palazzo 2010a: 61–8). The colors, shimmering gold script, and

images on the parchment pages stimulated a vision of the incarnate Christ that complemented the oral texts of the liturgy, the sacred perfume of incense, and ultimately the taste of real presence in the Eucharist.

COLOR, RACE, AND ETHNICITY

A significant area of recent research concerns the depiction of race and ethnicity through skin color. Black, though frequently associated with the diabolical and with death itself, has both positive and negative racial connotations. The inclusion of black Ethiopians among the monstrous races justified the depiction of black-skinned figures as evil-doers and slaves, going back to the sixth century when the *Ashburnham Pentateuch* manuscript was made (Verkerck 2001); and during the later Middle Ages black-skinned figures are frequently used as a means of visualizing non-Christian others, including Saracens from the Middle East and "Moors" closer to home in Spain (Hassig 1999; Patton 2016). The more naturalistic representation of black Africans, beginning in the thirteenth century, coincide with a new Aristotelian emphasis on empirical observation and is enhanced by contact with black Africans in the Holy Roman Empire. This led to a reappraisal of blackness and the promotion of positive images, such as the black magus (Kaplan 1985) and St. Maurice, a Christian convert from the Theban legion, who appears as a noble black knight, beginning with the celebrated painted stone sculpture at Magdeburg Cathedral (Devisse 2010; Heng 2014) (Figure 8.3).

St. Maurice was likely represented as a black African, in part at the behest of Frederick II whose expansionist desires for the Holy Roman Empire encompassed North Africa (Kaplan 2010: 13–14); the black African saint also offered a model of salvation extended to all races and the redemption of the sinful, normally identified with blackness (Heng 2014). As Caviness (2008) has shown, however, the enhanced knowledge of black Africans in western Europe also reinforced the racial category of whiteness through the dramatic shift around the mid-thirteenth century in visual representations of the skin of white Europeans. Prior to this time, artists had used a carefully modulated tonal system to represent rosy flesh, such as that described by Theophilus (1979: 14–20), whereas now a pure white skin color was preferred.

Ultimately, the power of color in medieval art lies not in an anachronistic abstract formal sensibility, but in the firm belief that color had the power to enliven and make people see and sense the presence of living bodies. It was that potency of color that could be used for good and ill to reinforce religious symbolism, communal and individual identity, social and religious status.

FIGURE 8.3 Statue of St. Maurice, Magdeburg Cathedral, *c.* 1245. Photograph by Terryrolf. Wikimedia Commons.

CHAPTER NINE

Architecture and Interiors: Transcendent Aspects of Color and Light

EVA OLEDZKA

INTRODUCTION

Medieval perception and appreciation of color's shine, radiance, brightness, and purity rather than merely of its Newtonian hue was rooted in the spiritual concept of light. Expressed in countless ways and in a myriad of media, this transcendent idea of beauty was captured in architecture on a particularly imposing and magnificent scale.

The aesthetic predilection for luminosity was conveyed primarily in Christian thought and in Neoplatonic philosophy founded by Plotinus (205–70 CE). His writings, which had a profound impact on medieval philosophy, discussed the notion of divinity (the Supreme One), identifying it with light, as an ideal representation of beauty and perfect wholeness. The sun, the stars, lightning, and fire as well as gold were thus expressions of incorruptible, supreme oneness and of its visual aspect, brilliant and pure color (Gage [1993] 2009: 26). Plotinus' tractate on beauty includes comments on architecture and follows these directly with a reflection on color associated with light:

> There is the beauty, conferred by craftsmanship, of all a house with all its parts, and the beauty which some natural quality may give to a single stone. This, then, is how the material thing becomes beautiful—by communicating

in the thought that flows from the Divine [...] But what accordance is there between the material and that which antedates all Matter? On what principle does the architect, when he finds the house standing before him correspondent with his inner ideal of a house, pronounce it beautiful? Is it not that the house before him, the stones apart, is the inner idea stamped upon the mass of exterior matter, the indivisible exhibited in diversity? [...] The beauty of colour is also the outcome of a unification: it derives from shape, from the conquest of the darkness inherent in Matter by the pouring-in of light, the unembodied, which is a Rational-Principle and an Ideal-Form. Hence it is that Fire itself is splendid beyond all material bodies, holding the rank of Ideal-Principle to the other elements, making ever upwards, the subtlest and sprightliest of all bodies, as very near to the unembodied; itself alone admitting no other, all the others penetrated by it: for they take warmth but this is never cold; it has colour primarily; they receive the Form of colour from it: hence the splendour of its light, the splendour that belongs to the Idea. All that has resisted and is but uncertainly held by its light remains outside of beauty, as not having absorbed the plenitude of the Form of colour.

(Plotinus 1956: 58–9)

The Greek Neoplatonist and theologian Pseudo-Dionysius the Areopagite (fl. *c.* 500) echoes the philosophy of Plotinus. In one of the most significant texts of medieval aesthetics, the chapter "On the Good and the Beautiful" of his treatise *De divinis nominibus* (On Divine Names), Pseudo-Dionysius identifies beauty with goodness and attributes it to harmony (*consonantia*) and luminosity (*claritas*) (Gage 1999: 104).

Accordingly, light, which was equated with the nature of God, became the foremost indicator of beauty. Radiance, clarity, and harmony were established as the principal virtues in art. In architectural exteriors and interiors, this philosophy was communicated through color and light effects of the construction materials themselves and via decoration applied to them. The main vehicles were the inherent colors and other physical properties of building fabrics: timber, brick, and stone. Nonstructural polychrome decoration was attained by application of ornate materials, above all multicolored and polished marble and other natural stone, as well as glass, ceramic tiles, plaster, bright pigments, and metals, mainly gold, silver, copper alloys, tin, and iron.

Flourishing in various periods and geographic areas, the dominant media of characteristically medieval architectural attempts at the merging of form, color, and light as expressions of metaphysical aesthetics were mosaics, stained glass, and murals. They were accompanied by an array of vividly colored and shimmering furnishings, textiles, and smaller artifacts. Such decoration was mainly typical of ecclesiastical contexts, but it was also present in high-status,

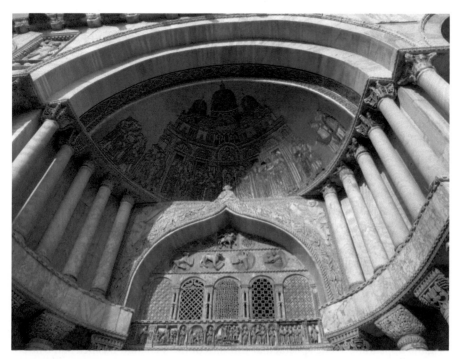

FIGURE 9.1 Porta di Sant' Alipio, Basilica di San Marco, Venice, thirteenth century. Gold and glass tesserae mosaic, light colored marble revetments, columns, reliefs, and carvings of the west facade. In the lunette, a mosaic representation of the medieval San Marco. Photograph by Eva Oledzka.

nonreligious buildings. As the medieval Western culture and its material world was dominated by religion and spirituality, the developments in church architecture were readily adapted to worldly demands and, intentionally or subliminally, mirrored in secular tastes (see Plate 9.1 and Figure 9.1).

SURVIVAL OF MEDIEVAL BUILDING SUBSTANCES, DECORATION, AND THE QUESTION OF RESTORATION

Discussion of color and light in medieval architecture is a challenging task due mostly to the low survival rate and patchiness of physical evidence, the sparseness of contemporary written accounts and documentation of past attitudes and intentions, uncertain reliability of visual sources, and the still unsystematic and incomplete scientific examination of the available fabric.

Although a number of medieval buildings or, rather, their parts, are still extant, none of them is in its "original" state. Decline was caused by the passage of time and adverse environmental conditions, as well as disasters

such as floods, earthquakes, fires, wars, and deliberate obliteration dictated by religious or political motives. Furthermore, changes of style and taste, repairs, and, ironically, well-meaning but heavy-handed attempts at restoration, have destroyed architectural structures and annihilated their fragile decoration.

Most medieval buildings have partially or completely vanished. If they were wooden, including their foundations (like the majority of early medieval constructions in northern Europe), their remnants are sometimes reduced to mere discolorations in the soil, which most of the time inform us about the layout of the building but not of its chromatic appearance. Many vestiges of stone architecture survive as foundations and sometimes also as pavements and other fragments, such as the early medieval church of Santa Reparata beneath the present Florence Cathedral. Numerous other medieval remnants have been integrated into later buildings, such as those of the original Carolingian St. Denis church forming the nucleus of Abbot Suger's (1081–1151) basilica.

The exterior and interior decorations of those edifices which had withstood adversities, were extremely susceptible to change. The most durable are polychrome stone components of floors, walls, and ceilings, exemplified by early Christian and Byzantine ecclesiastical mosaics or marble cladding. Even if repaired hundreds of years ago, they sometimes, at least partially, keep their original appearance. The spectacular mosaics of the Venetian Basilica San Marco, which were restored numerous times, illustrate this phenomenon (Figure 9.1). However, the methods employed in the earliest medieval and Renaissance restorations varied and ranged from faithful reconstruction to the replacement of the originals with completely new designs. Other mosaics and marble revetments may have kept their appearance but are sometimes not in situ, such as the *spolia* (reused stone) moved by Charlemagne (747[?]–814) from Rome and Ravenna to decorate his Palatine Chapel in Aachen. Finally, some mosaics have been obliterated on purpose: not many figurative mosaics predating iconoclasm survived, and they had to be subsequently replaced. This is comparable to the effect of the Reformation on church decoration, especially on murals, which were whitewashed, and on stained glass windows, many of which were shattered.

The visible, above-ground elements of surviving medieval buildings are often undecorated stone or brick. The paucity of documentation makes it impossible to tell how many were intended to retain their "natural" look. Sometimes, even if there was an obvious intention to chromatically enhance structural building material, whether by pigment, decorative brick, marble revetment, mosaic, colored plaster, or other decoration, innumerable elevations remained in a transitory state for centuries. Several medieval churches in Florence illustrate this phenomenon. The Basilica San Lorenzo's unfinished facade still consists of patched masonry.[1] The Florentine cathedral and the Church of Santa Croce also had unfinished frontages, but both received neo-Gothic marble facades in the nineteenth century.

Other currently bare exterior and interior building surfaces, which may look completed, do not prove that decoration was not applied to them in the past. Their present appearance can be the result of natural decay and weathering, but also of deliberate abrasion. Regrettably, decisions to scrape off embellishment were often taken by nineteenth-century restorers (discussed below).

Secular, civic, but especially residential buildings were even more vulnerable than their ecclesiastical counterparts. Decoration of domestic spaces, for instance, murals or tiled floors, has been at risk, not only because of intensive wear, but also due to frequent rebuilding and changes of fashion or use of the house. Most of them were replaced, though some remained in situ, often under layers of new decoration, plaster, or whitewash. Such remarkable survivals include the fourteenth-century murals uncovered at the beginning of the twentieth century in the Papal Palace of Avignon, and in the Florentine Palazzo Davanzati. Unfortunately, early restorations in both locations were so inadequate that many years of subsequent treatments were needed to reverse the damage they caused (Dunlop 2009: 34).

Medieval buildings that remained in use have been continuously maintained and repaired. Italy is especially rich in varied and interesting secular examples. Particularly early and well-documented preservation and restoration attempts can be illustrated by Petrarch's (1304–74) house in Arquà, which, together with his tomb at the nearby church, became a target of literary pilgrimages relatively soon after the poet's death. Although parts of its structure, external appearance, and interiors are still original, the house has been altered and thoroughly redecorated by the Venetian nobleman Paolo Valdezocco, when in 1546 he turned it into a museum celebrating Petrarch's life and work. The house became an international tourist attraction but not everybody approved of the method of its conservation. As early as 1550, Sperone Speroni, a scholar attempting to save Petrarch's house (now destroyed) in nearby Padua, criticized Valdezocco's refurbishment in his *Sommario in difesa della casa del Petrarca*:

> In Arquà Petrarch's tomb is so very honoured, as well as the house where he lived, that from great distances and very remote countries people come to visit the village; and especially revered there is his room. Now that it is in the hands of one of our compatriots, who has decorated it, I like to say something negative about this, stating that one should have conserved it in its ancient state, not only the room as such, but also the mortar and the dust should have been conserved, had that been possible.
>
> (Hendrix 2008: 23)

Subsequent restorations further preserved but at the same time reinterpreted and altered the house.[2] The purportedly genuine features range from partially reconstructed architectural components and pieces of furniture, to a mummified cat displayed in a wall niche. Remarkably, the remains of Petrarch's study

include a mural discovered in 1919, which was dated to the thirteenth century (Callegari 1925: 24–5). The upper register of the plastered white wall is decorated with a yellow-reddish-gray-brown acanthus frieze including coats of arms resembling those of Petrarch. Underneath are stylized, gray laurel (?) sprigs and an illusionistic representation of a red, veil-like hanging suspended with gray rings from a light brown rail (Figure 9.2). Above the floor, the wall is painted with a red skirting board.

Numerous restorations had an impact on the levels of authenticity in Arquà, and at present it is uncertain how much of Petrarch's material world could be confirmed as original by provenance research or scientific examination. Admittedly, most of Petrarch's memorabilia seem to belong to the nebulous realm of relics, and their significance is reinforced by the proximity of Petrarch's burial place. In consequence, the setting and its contents appeal mainly on an emotive level. Nevertheless, the surviving physical evidence of this curious domestic shrine is of outstanding importance.

At the opposite end of the architectural authenticity spectrum, although in the same category of writers' dwellings, is the house of Dante Alighieri (1265–1321)

FIGURE 9.2 The writer's study, Arquà Petrarca, Casa del Petrarca, fourteenth century. Simple wall decoration with heraldry, floral ornaments, and a simulated textile hanging suspended from a rod. Photograph by Eva Oledzka, with the kind permission of the Comune di Padova, Assessorato alla Cultura.

in Florence. This medieval-looking building, which became a museum of the poet in 1910, is in fact to a large extent a nineteenth-century historicist creation. It consists of the heavily remodeled remains of several structures that existed on the site identified as Dante's birthplace by a special government commission during the period of the formation of the Italian state in the 1860s (Lasansky 2004a: 59).

Other notable examples of Italian medieval domestic town houses are those of the (already mentioned) Palazzo Davanzati in Florence, and the Casa Datini in Prato. Both are well preserved and restored, decorated with brightly colored frescoes and painted ceilings, and open to the public. They were built by rich fourteenth-century merchants, and as such do not have the same allure as writers' houses; however, their importance lies largely in their socio-historical context, which in the case of the Casa Datini is supported by substantial documentation. Francesco Datini's (1335–1410) extensive archives recording his business and private matters incorporates bills and correspondence describing the minutiae of the building project, inclusive of some consideration of suitable decoration for the house, the choice of materials, and of the artists executing it. Unfortunately, a vast majority of medieval buildings have not shared the same lucky fate.

Mass restoration campaigns of medieval buildings became frequent at the beginning of the eighteenth century. They were incited by a broad interest in the culture, history, and art of the Middle Ages, directly prompted by antiquaries and particularly by the Gothic Revival movement. The main representatives of this wave of restoration programs in England were the architects James Wyatt (1746–1813) and Gilbert Scott (1811–78). Other notable architects such as Karl Friedrich Schinkel (1781–1841) and Guiseppe Partini (1842–95) carried out restorations in Germany and Italy, respectively. The French architect and theorist Eugène Viollet-le-Duc (1814–79) was a particularly prolific Gothic Revival specialist, who also influenced architectural restoration theory and practice in other countries, for instance, Partini's medieval *purismo* reconstructions in Siena or San Gimignano. Viollet-le-Duc's attitude toward restoration is summarized succinctly in the *Dictionnaire raisonné de l'architecture française du XIe au XVIe siècle* of 1858–65, where he writes: "To restore a building is not only to preserve it, to repair it, or to rebuild, but to bring it back to a state of completion such as may never have existed at any given moment" (Tyler 2009: 20).

This philosophy was opposed by the English art historian and essayist John Ruskin (1819–1900), who expressed his views in his essay *The Seven Lamps of Architecture* published in 1849:

> The first step to restoration [...] is to dash the old work to pieces; the second is usually to put up the cheapest and basest imitation which can escape detection [...] Do not let us talk then of restoration. The thing is a Lie from beginning to end.
>
> (Ruskin 1849: 180)

This assessment was written in protest at rebuilding campaigns in Italy, France, and England, which were extraordinarily damaging to the original structure. Likewise in response to these activities the "anti-scrape" Society for the Protection of Ancient Buildings was formed in 1877 by William Morris (1834–96) and others. The society's first campaign took place in 1879, when it joined Ruskin in the battle to save St. Mark's Basilica in Venice from over-restoration.

Today's international ethical principles of conservation, for example, minimal intervention, and reversibility, developed relatively slowly and did not prevent mistakes being made fairly recently. Examples can be traced in many locations, for instance, in San Gimignano, which has always been celebrated as one of the best conserved medieval towns. It looks deceptively authentic; however, its current uniform appearance is the result of numerous restorations and historicizing reconstructions attempting to make it look more medieval than it already was. The most extensive of these restorations were led by the Sienese architect Egisto Bellini (1877–1955) and took place as late as the 1920s and 1930s.[3]

THE INTERPLAY OF THE NATURAL COLORING OF ARCHITECTURAL MATERIALS WITH THE ENVIRONMENT

Buildings provided a functional, cultural, and spiritual context for most aspects of medieval life. Their form and color could effortlessly merge and blend with the surrounding landscape or dominate and contrast with it.

Medieval society revered visual beauty, and while it delighted in bright pigments and lustrous applied decoration, it also appreciated inherent colors and patterns of building materials. Stone, brick, and timber are generally considered appropriate in high-, middle-, and lower-status architecture, respectively. Nonetheless, the fabrics usually depended on regional resources. Hence, stone was more typical in southern Europe, while timber was widely used north of the Alps. Even affluent patrons regularly chose local, traditional materials (for example, reddish brick in the Baltic region, ocher *Pietraforte* in Florence, or gray *Calcare Cavernoso* in San Gimignano). Others opted for imports, such as the marble and stone used for facing some of the brick buildings of Venice (Oledzka 2016: 29). Architectural materials played a crucial role in the aesthetics of individual houses and in the appearance of the building complexes of monasteries, castles, palaces, towns, and villages. There was a wide range of browns of wood, reds (and to a lesser extent, yellows or grays) of brick, and a variety of hues, patterns and textures of stone.

While early Christian and Byzantine exteriors were often of uniformly colored brick, chromatically varied natural stone can frequently be seen in Romanesque and Gothic architecture. This is especially noticeable in the vivid patterns of elevations, and exemplified by the white and red colors of the checkered masonry

of Lorsch Abbey, Germany, or the alternating dark and light banded facades of the cathedrals of Le-Puy-en-Velay, France, and Genoa, Italy. Several Tuscan ecclesiastical facades, for instance, the Florentine Baptistery and the church of San Miniato al Monte, rely on strong contrasts between green Prato and white Carrara marble. Additional multicolored effects were achieved on Florence Cathedral and its bell tower by combining the traditional white and green elements with pink Maremma marble. The Campo dei Miracoli in Pisa (comprising the cathedral, bell tower, baptistery, and cemetery) is particularly striking on account of the dazzling near-whiteness of its stones. In Venice, the facade of the Doge's Palace owes its lightness not only to the coloring of the red Verona marble and white Istrian stone, but also to the openness of its sophisticated arcading.

Drawn from nearby quarries, woods, or fired from local clay, most medieval building fabric harmonized with the natural colors of the surrounding area. A notable exception is Venice, where material, such as marble, was transported, sometimes from afar. Yet the imported stones merge with their setting in a perfect way. The reason for this phenomenon is the masterly manipulation of natural light reflected in and amplified by the omnipresent water (Hills 1999: 1–21). Venice is a remarkable medieval town, whose appearance has been strongly influenced by favorable cultural and socio-economic factors and, above all, by its unique geographical location. Seafaring, international contacts, and trade resulted in a hybrid architecture linking European and exotic, mainly Byzantine, influences. Moreover, the lagoon, which sheltered the city from enemy attack, rendered town fortifications unnecessary. This created new possibilities and inspired the construction of non-defensive buildings, which were unthinkable in other medieval cities (Goy 1992: 17). The airy and intricate facades of houses along the canals were not only pierced by numerous ornamental windows, balconies, and arcades, but were frequently fitted with roundels of glass. Shimmering in the sun and reflected in water, glazing had a dazzling effect on the exteriors and interiors. The Venetian palazzo must have been far better lit with natural light than any other medieval house. It is no surprise that the Venetian island of Murano has been a production center of high-quality glass since the Middle Ages. The city exported not only vessels but also window glass and skilled artisans who fitted it (Thornton 1991: 28).

Supplementary sparkle was added to both secular and religious buildings by polished marble revetments, whose veining pattern often mirrored waves and ripples on water. These were enhanced by carved decoration and architectural sculpture, which provided engaging patterns accentuated by light and shade effects. The ornamentation was further intensified by brightly colored pigments and gilding. An iconic example encompassing all these elements is the Ca' d'Oro (Figure 9.3), built in the early 1400s for the Venetian merchant Marino Contarini: a house still medieval in its nature, and reutilizing spolia, although more lavishly decorated than its predecessors, such as the Ca' da Mosto (Hills 1999: 68–74).

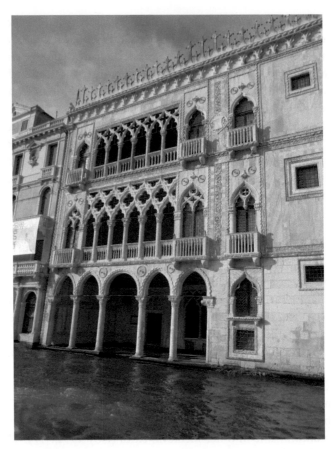

FIGURE 9.3 Ca' d'Oro, Venice, early 1400s. Water-facing facade clad with carved and decorated marble and pierced with numerous large apertures. Photograph by Eva Oledzka.

SECULAR AND ECCLESIASTICAL EXTERIORS WITH APPLIED POLYCHROME DECORATION

While glass, stone and marble cladding possessed unquestionable decorative merit, they also served a utilitarian purpose and shielded buildings from the elements. Plaster, a more cost-effective but less alluring facing, was applied for the same reasons. Naturally gray, it was often mixed with white lime or other pigments, enhancing the appearance of timber, brickwork, or masonry. There is little evidence for this practice from the early Middle Ages, but it is well documented in later periods.

Paint was not only mixed with plaster but also applied directly onto walls. Brick exteriors were often tinted red. Stone walls could be painted many hues, for instance, white, red, yellow, or gray, to either enhance or change the natural

color of facades.[4] Bright pigments such as red, but especially the extremely popular white, added striking radiance to architecture. Numerous buildings, both secular and ecclesiastic, and of varying social status, were painted with simple white limewash, which superbly reflected rays of light and bestowed a brilliant glow on facades. Those that were important and lucky enough to survive, for example, the White Tower in London (Figure 9.4), have often been redecorated with the same color over the centuries.[5] Many other whitewashed buildings either vanished, were repainted with another color, or were scraped clean, but both their existence and their once noticeable color have sometimes been handed down in place-names and recorded in historic documents. Medieval

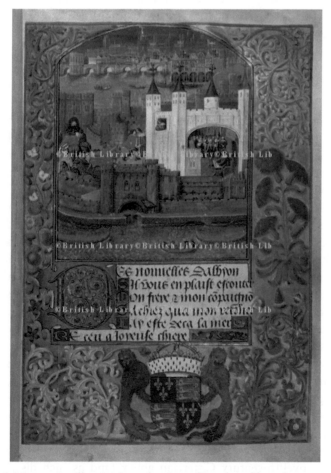

FIGURE 9.4 Manuscript illumination of a view of London, fifteenth century. The Tower of London and London Bridge are dominated by the White Tower. Detail from the poems of Charles, Duke of Orléans and "pseudo-Heloise." British Library, Royal MS 16 F.II, fol. 73r. Photograph © British Library.

place-names consisting of a combination of an adjective meaning "white" plus a noun, frequently refer to buildings and their color. *Whitechurch* and other regional equivalents of the Latin *alba ecclesia* belong to the most widespread names in this category in Europe. However, "white" could also refer to the natural color of stone (Hough 2006: 184).

Tinted plaster or painted walls were usually left without any additional embellishments, but in high-status buildings they were sometimes further decorated, for instance with simulated, regular masonry blocks and other architectural features, such as columns, arches, or pilasters. Their application is often found where the original masonry was uneven in color, in shape, or both. The joints between bricks and ashlar stones could be high- or low-lighted with contrasting colors, such as white, red, or black, making building materials and walls appear more uniform. In Gothic architecture, the horizontal building elements were sometimes camouflaged, and the vertical components characteristic of this style were accentuated. This phenomenon can be exemplified by the distribution of white and red pigments on the thirteenth-century St. Nicholas Chapel of Maria Laach Monastery in Germany, and in the multicolored (blue, red, and yellow) design of Strasburg Cathedral's west facade, designed by its architect Erwin von Steinbach (Phleps 1930: plates XXX and XLII). Pigments augmented, unified, and highlighted the colors of the architectonic structure. Paint was also often applied to create an optical illusion of architectural ornamentation, where there was none. Some houses were decorated with coats of arms, such as the Palazzo della Signoria in Florence, or even with historiated frescoes, for instance, the Casa Datini in Prato.

Churches and major civic buildings could be embellished with mosaics, polychrome historiated reliefs and figurative sculpture.[6] The facade of San Marco in Venice is a splendid example of a mosaic decorated exterior. A large portion of one of the elevations of St. Mary's Chapel at Malbork Castle, Poland, was decorated with a gigantic figure of the Virgin. Smaller ornaments habitually appeared on tympanum panels over church doorways across Europe. Not only wall surfaces but also windows, doors, and roofs were carriers of polychromy. Stained glass windows enriched the color of exteriors to some extent, though undoubtedly their effect was much more noticeable in the interiors. Doors of higher-status buildings were made of metal, for instance, bronze, and were sometimes gilded, such as those in the Florence Baptistery. If made of timber, they were decorated with elaborate iron hinges. In the high Middle Ages, the most striking color for door panels was red,[7] and Theophilus (fl. twelfth century) describes their manufacture in his treaty *De diversis artibus.* Even the doors of the twelfth-century Cistercian abbey (and as such disapproving of polychromy) in Maulbronn, Germany, were painted on both sides with cinnabar and minium (Phleps 1930: 106). Surprisingly, some medieval doors still have traces of historic red pigment, for instance, one dated to *c.* 1120 at Little

Hormead Church, Hertfordshire, England. Alas, it is not possible to establish the exact date of this decoration.[8] Equally, medieval roofs were decorated with metal finials, vanes, and colorful shingles or glazed tiles, which were sometimes arranged in geometrical patterns. Although restored and replaced, examples of such roofs can be seen on St. Stephen's Cathedral in Vienna and on the Hôtel Dieu de Beaune in Burgundy.

RELIGIOUS INTERIORS

As stated above, the treatment of color and light in architecture, and especially in ecclesiastical interiors, was strongly influenced by the concept of light present in Neoplatonic ideas and in Christian thought. In church architecture this is particularly perceptible at first in the early Christian and Byzantine interiors decorated with shimmering gold mosaics and illuminated by numerous lamps and candles, and later in the French Gothic cathedrals flooded with light pouring in through imposing stained glass windows. Above all, the revolutionary technological developments resulting in the transition to the Gothic style allowed for innovative means of the visual communication of these aesthetics. Luminous mosaics and stained glass were supplemented by murals, which ideally were executed with pure, bright pigments and sometimes aided by shiny glass or metal highlights.[9]

Contemporary textual sources assist in understanding the intended effect and perception of color and light in ecclesiastical buildings. Aesthetics of not only the principal or exemplary medieval interiors, but also of the insignificant ones in the remotest locations, depended largely on the interaction of natural and artificial light with building fabrics as well as other ornaments. Such ensembles aimed at representing Paradise.

> You have embellished the ceilings or walls with varied work in different colours and have, in some measure, shown to beholders the paradise of God, glowing with varied flowers, verdant with herbs and foliage, and cherishing with crowns of varying merit the souls of the saints. You have given them cause to praise the Creator in the creature and proclaim Him wonderful in his works. For the human eye is not able to consider on what work first to fix its gaze; if it beholds the ceilings they glow like brocades; if it considers the walls they are a kind of paradise; if it regards the profusion of light from the windows, it marvels at the inestimable beauty of the glass and the infinitely rich and various workmanship.
>
> (Theophilus 1961: 63)

The above fragment of the preface to chapter 3 of Theophilus's treaty *De diversis artibus*, addressing artisans and written probably at the beginning of the twelfth century, summarizes several of the characteristic and main points

of the predominant contemporary outlook on art (Dronke 1972: 73). Negative medieval attitudes to polychromy were in the minority, but they were prominent in Cistercian architecture, since Cistercians, in accordance with the writings of Bernard of Clairvaux (1090–1153), denounced color as luxury and favored whitewash and lack of decoration (52). Naturally, the reflective properties of white pigments conveyed the idea of brightness and luminosity more strongly than polychromy. Moreover, grisaille glass (clear glass decorated with grayish or monochrome painting) used in Cistercian abbeys let in much more natural light than its colorful counterparts. In fact, Theophilus, thought to be a practising artisan and a Benedictine monk, is in all likelihood polemizing with Bernard of Clairvaux's attack in his *Apologia* on the lavish decoration of Benedictine churches (Theophilus 1979: preface). Theophilus refers here specifically to the prevalent aesthetics of medieval ecclesiastical architecture, consistent with the traditional pseudo-Dionysian notion of art as a tool for reflecting the heavenly, but he also appears to go beyond this and, like Gregory of Nyssa (*c.* 335–*c.* 394), wants the artist to surpass this view and to actually create Paradise in reality (Dronke 1972: 73–4). Such reality, embodied in the newly restored church of Hagia Sophia at Constantinople, was exquisitely described by Paulus Silentiarius (d.575/580), a Greek poet in the age of Justinian. The following lines from his ekphrasis (poetic description of a work of art), written on the occasion of the new dedication of the church in 562 CE, concentrate on the striking colors and light effects of this iconic Byzantine space:

> Whoever lifts his eyes to the roof's fair firmament dares not gaze long, with head flung back, upon that circling meadow of the star-clad dance, rather, he looks to the fresh green hill below, craving to see the flower-banked mountain-stream's cascade, ripe corn, the leafy shelter of the forest, the leaping flocks, the olive-tree's winding stem, a vine with flowering tendrils bending towards it, and the calm blue gleam of the sea fretted by a sailor's foam- sprayed oars [...] Above the pillars, measureless curved arches like the many-coloured curve of Iris' bow [...] columns with great capitals: Graces with their golden locks flowing down, radiances of Thessalian marble.
>
> (Dronke 1972: 53)

Paulus continues with an account of the walls and the pavement of the church:

> The verdant stone of Karystos [...] and a dappled neck of Phrygian marble, roselike to behold, mingling with airy white, the loveliness of purple and silver flowers flashing together [...] porphyry glittering, danced on by little stars [...] Flashes of stone, gold-glistening crocus, that the Libyan sun heats with his golden beams and nurtures on the high ridges of a Moorish mountain, or that a Celtic cliff raises, deep-crystalline, milk poured on gleaming black flesh.
>
> (Dronke 1972: 54)

The poet also delights in the many-colored silk curtain, which shimmers with gold thread, compares the lighting of the church to ships of silver sailing in the air, and relishes in the ambo's (raised stand's) colors (red, white, silver, and gold), which have a glittering sheen, radiance, and translucence (Dronke 1972: 54–5).

Paulus's ekphrasis follows the classical rhetorical rules of this genre, however, his dynamic imagery of mutating, harmonious color schemes and of fluctuating light effects is filled with a sense of continuous rhythmic movement, a new idea that preoccupied artists of his age (Dronke 1972: 55–6). The Byzantine mosaics and their shimmer were a particularly fitting medium applied to this end. The light was reflected downwards from shiny marble, glass, and gold tesserae, which were set into the ceilings and walls at varying angles to amplify the dazzle. As many offices were held at night or before the dawn, the churches were lit by flickering flames of hundreds of oil lamps and candles. The religious images and the depictions of nature (such as water and waves, which was a favorite design for floors) must have seemed to be animated with a mystical inner life. The medieval viewer was overwhelmed by an illusion of catching glimpses of a vibrant supernatural realm on earth (Gage [1993] 2009: 39–58).

To most modern visitors, who see the usually much altered Byzantine churches during the day or lit by electric light, the awe-inspiring effect of their interior decoration is lost. However, mosaics have been appreciated for hundreds of years. Ambrogio Traversari (1386–1439), a Florentine humanist, who visited Ravenna in 1433, described San Vitale and the now demolished Basilica Ursiana in a letter to his countryman Niccolo Niccoli (1364–1437):

> I first looked at the superb cathedral with its silver altar, from which rise five silver columns, and with its silver baldaquin [canopy]. As if this were not enough, there are also marble capitals jutting from the altar, for the decoration of the church, and which in ancient times were clad in silver, most of which has survived. I must admit that I have not seen more beautiful holy edifices even in Rome. There are rows of huge marble columns, and the interior of the building is clad almost entirely with sheets of variegated marble and porphyry. I have scarcely seen more beautiful mosaics anywhere. I inspected the highly decorated Baptistry next to this large church, and then went to look at the most astonishing and magnificent church of San Vitale the Martyr, which is actually circular, and is decorated with every superior and excellent kind of mosaic. There are columns around the circumference of the Sanctuary, and various marble incrustations cover the inner walls. It has a raised platform [peripatum] from which the columns spring, and an altar of such shining [lucidam] alabaster that it reflects images like mirrors.

(Gage 1999: 103)

Traversari's interest in the Byzantine architecture and mosaics of Ravenna coincided with his work on a new Latin translation of Pseudo-Dionysius' writings. However, in Traversari's age, brightly colored stained glass and frescoes were the main artistic media in Florentine churches (Gage 1999: 104).

Depending on regional differences, the size, polychromy, and translucence of stained glass panes, as well as their overall impact on interiors, varied. Gothic architecture was not homogenous and ranged from French Gothic, which was structural and allowed for the substitution of a wall surface with glass, to Italian Gothic, where massive walls acquired elements of Gothic decoration. In consequence, Italian windows were small, but their polychrome effect was often enhanced by frescoes. These were especially popular in Italy from the beginning of the fourteenth century. Florentine and Sienese painters excelled in this art (Borsook 1980: xvii). The early masterpieces are Giotto's celebrated mural cycles in San Francesco, Assisi, the Arena Chapel in Padua, and the Baroncelli and Peruzzi chapels in the Florentine church of Santa Croce. Simone Martini's frescoes adorned the Papal Palace in far-away Avignon.

Antonio da Pisa, a glass painter, whose workshop was active in Florence in the late fourteenth century, recommended that stained glass color schemes should be coordinated with those of preexisting frescoes and advised the use of clear white glass to make windows joyful. Lorenzo Ghiberti, a goldsmith and designer of many stained glass windows of Florence Cathedral, contributed further to humanistic aesthetics through his work on optics, which was based on medieval authors and, among other aspects, discussed the role of light in glass painting (Gage 1999: 102).

Panes of stained glass allowed transmitted light to permeate buildings (Figure 9.5). Although visible on the exterior when heavily lit from inside buildings, their main appeal was the ability to immerse the interiors in colored or clear light. This was completely different to the earlier experience, which gradually went out of fashion, of relatively dark interiors lit by shimmer and dazzle reflected off gold or glass mosaic tesserae.

The rebuilding of the Carolingian Church of St. Denis, Paris, in the 1140s, masterminded by Abbot Suger and led by an unknown mason, revolutionized architecture by developing a ribbed vault supported by flying buttresses. Freed of their load-bearing function, masonry walls were opened and filled with glass. Like earlier Byzantine mosaics, Gothic stained glass was supposed to turn church interiors into a premonition of Paradise. Abbot Suger's words in *De Administratione (XXVII)*, quoting the inscription on the new gilded bronze doors of the west facade, exemplify his understanding of the role played by this new interior:

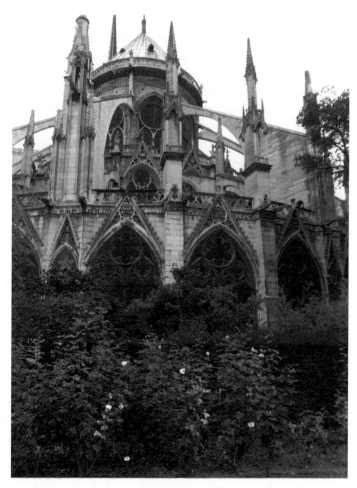

FIGURE 9.5 Apse, Notre-Dame de Paris, Paris, fourteenth century. A typical example of Gothic architecture: large stained glass windows and flying buttresses supporting the walls and vaults. Photograph by Eva Oledzka (taken in 2013 before the fire of 2019).

Bright is the noble work; but, being nobly bright, the work should brighten the minds, so that they may travel, through the true lights, to the True Light where Christ is the true door [...] The dull mind rises to truth through that which is material and, in seeing the light, is resurrected from its former submission.

(Suger 1979: 47)

Referring to Scripture and to the writings of Pseudo-Dionysius, who in Suger's time was erroneously identified with the patron of his abbey, Suger stressed the transcendent value of light. Similar power was attributed to gems, especially

the blue and green stones with white pearls decorating the Gates of Heavenly Jerusalem. These were represented not only on mosaics, such as the triumphal arch mosaic of Santa Maria Maggiore in Rome, but also embellished metalwork in the St. Denis treasury, such as the Cross of St. Eloy and the *Escrain* (screen) *de Charlemagne* (Gage [1993] 2009: 72). The rhetoric of medieval stained glass was closely related to that of precious and semiprecious stones, as this manufactured material could imitate the colors of the most important gems and represent the significance ascribed to them. Especially blue glass, linked with sapphire, the stone of stones, must have been installed in churches not only for its striking visual effect but mainly as an aid in meditation. As such, the new windows of St. Denis were suitably dominated by blue panes, of which Suger was proud and to which he referred as *saphirorum materia* (72).

Subsequently, blue became an essential color in early Gothic windows not only in France (for example, in the cathedrals at Bourges, Rouen, and Chartres, and the Sainte-Chapelle in Paris) but also in England (for example, in the cathedrals at Canterbury, Lincoln, and Salisbury, and at Westminster Abbey).[10]

The large-scale application of blue glass in church architecture co-occurred with the change of outlook on the physical properties of gems referred to as "sapphire." From around the twelfth century, descriptions of the praised characteristics of this stone started to include translucency, a quality "sapphires" of the preceding centuries did not necessarily have since, at that time, the word seemed to refer to the non-translucent and dark lapis lazuli, from which ultramarine, a pigment as expensive as gold, was made (Gage 1993: 73). Consonant with the development of the translucent sense of *saphirus*, is the apparent modification of the meaning of the blue color in mosaics and stained glass. In early mosaics, blue is usually associated with darkness and the cloud of unknowing, yet in the later Middle Ages it stands for heavenly light. Even though the naturalistic identification of blue with heaven existed in the mosaics of Ravenna and Rome, the true shift may be linked to the appreciation of blue stained glass (Gage 1999: 73; [1993] 2009: 73).

An analogy with the significance and admiration of the blue color in stained glass can be seen in its prestige in other types of contemporary material culture. Above all, through its association with ultramarine, though sometimes executed with other pigments, blue belonged to the most valued colors in murals and textiles and found its way not only into ecclesiastical but also secular interiors.[11]

SECULAR INTERIORS

The color effects of the majority of nonreligious interiors depended on paint, multicolored glazed tiles, dyed or embroidered textiles, and, to a lesser extent, window glass, which in the Middle Ages was still a rare luxury in buildings of lesser spiritual, cultural, and social prominence.

The survival rate of medieval secular interiors is very low in comparison to their ecclesiastical counterparts. The extant ones are fragmentary and have been altered to a considerable degree. Wall decoration, only infrequently supplemented by that of ceilings and floors, probably gives the best idea of medieval taste and the most widespread approach to ornaments and colors in secular settings. However, many medieval walls were in fact bare, and only rows of metal hooks, often just under the ceiling, like those in the front halls of the Palazzo Davanzati in Florence, indicate that they were once covered with textile hangings.

Gold (see Plate 9.1)

Early polychomy survives almost exclusively in stone buildings. The most outstanding specimens can be seen in the twelfth-century Royal Palace in Palermo, Sicily. Although influenced by Islamic art, the aesthetic principles of mosaics in Roger II's quarters are similar to those of Byzantine churches. Pale marble revetments cover the lower registers of the walls, and vaults are decorated with brightly colored geometric and figurative ornament, comprising religious and royal symbols set against a stupendous gold background. This decoration, used in the domestic setting as well as in the Palatine Chapel, was not a mere sign of conspicuous consumption. Coming from a new Norman dynasty, Roger II was eager to assert his power and to express his divine right to rule over Sicily through a medium best suited to this purpose (Borsook 1998: xxii).

Northern European early and high medieval secular timber buildings mostly disappeared, and their visual evidence is also rare. Although early representations of medieval interiors exist in art, they often lack detail. The phenomenon can be illustrated with Romanesque miniatures, which are heavily stylized and focus on foreground scenes presented against abstract architectural or gold backdrop (Oledzka 2016: 11). To some extent they resemble Byzantine mosaics, which makes it conceivable that gold was an ideal, although often unattainable, color in religious and secular interiors alike.

Written sources sometimes refer to interior domestic decoration, but they are vague and seldom inform about color. However, many mention textile hangings, the most precious of which were made with gold thread (Hyer and Owen-Crocker 2013). Indeed, external and internal gold ornaments are mentioned in descriptions of early medieval buildings, such as the hall Heorot, the seat of the King of the Danes in the Old English poem *Beowulf*. Interestingly, numerous gold foils, roughly contemporary with the composition of the poem and dating from the seventh or eighth centuries, have been excavated on the sites of Scandinavian large halls.[12]

Blue (see Plate 9.2)

Gold, silver, and other metals frequently added sparkle to pigments. Associated with heaven, blue-painted vaults were often enhanced with golden stars. Such

a splendid ceiling by Giotto survives in the Arena Chapel in Padua. When appropriate, stars were substituted by other ornaments, for example, *fleurs-de-lis*, a French royal device. Such decoration still survives in the late fourteenth-century Casa Datini in Prato (Dunlop 2009: 24).

Remarkable murals of yellow vine and oak scrolls inhabited by birds and squirrels on a blue background, attributed to Jean Dalbon, were executed in 1336–7 for Pope Benedict XII's bedroom in his palace at Avignon. They were, in all likelihood, inspired by earlier decorative schemes, such as the gold and blue mosaics of the fifth-century Mausoleum of Galla Placidia in Ravenna. As fourteenth-century French manuscripts often make use of almost identical golden scrolls on blue (or other colored) backdrops, sometimes showing them in building interiors, it is possible that such ornament also found its way to other rooms in France (Oledzka 2016: 110).

Green

Thirteenth- and fourteenth-century decoration schemes also combined gold accents with green walls and ceilings. They were documented in Henry III of England's chamber at Guildford and at Comtesse d'Artois' Chateau d'Hesdin (Banham 1977: 916). A room at the Byward Tower in the Tower of London is painted with a partially destroyed mural of a crucifixion group (*c.* 1390) on an imitated green textile with a gold pattern.

The color green was considered to be especially suitable for domestic interiors, as it was thought to promote health, calm the spirit, and soothe the eyes (Gage 1999: 96–7). A green bedroom of St. Louis, King of France, was supposed to help the royal pair conceive a male heir in 1238–9 (Pastoureau 2014: 76).

The motif of greenness appears repeatedly in medieval texts. The twelfth-century theologian, Hugh of St. Victor, applauded green as the most beautiful color in his *De tribus diebus*. Abbess Hildegard of Bingen (1098–1179), a mystic and poet, recurrently expressed the joy of the colors of nature. The *viriditas* (greenness) in her writings stands for holiness and paradise (Dronke 1972: 82–4).

Green paint was often favored for walls as a plain color or as the dominant pigment in murals depicting nature. Green dye was present and popular all over Europe with verdure wall-hangings representing dark green meadows of stylized, mainly red, yellow, and white, flowers (Oledzka 2016: 57).

A mural cycle in the study of Pope Clement VI, painted in 1343 by Italian artists and located next to the blue papal bedroom in the Avignon Palace, represents hunting and fishing and is dominated by green trees, rose bushes, and meadows. As Francesco Datini spent several decades in Avignon, it is likely that the green murals in his house in Prato were based on this decoration, though executed by Florentine artists (Oledzka 2016: 68).

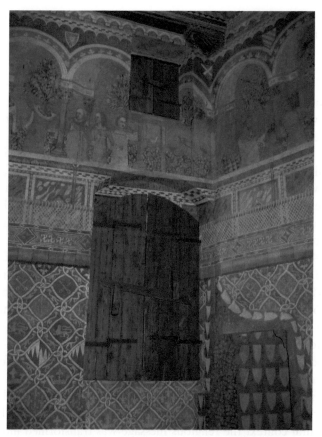

FIGURE 9.6 Sala della Castellana di Vergi, Palazzo Davanzati, Florence, fourteenth century. The walls are painted with an illusionistic fresco. The top historiated scene is framed by arcaded architecture and set against trees and other verdure. Underneath, marble-cladded walls are covered by diapered red and green tapestry. This complex decoration incorporates many heraldic elements. Photograph by Eva Oledzka, with the kind permission of the Ministerio dei Beni e delle Attività Culturali e del Turismo, Museo Nazionale del Bargello.

Moreover, highly stylized trees must have been a standard ornament appearing in the upper sections of Florentine domestic walls in the fourteenth century, as they are referred to in Franco Sacchetti's (1330/1335–1400) 170th tale of his *Trecentonovelle* simply as *alberi di sopra* (trees above). This type of mural can be seen in four rooms of the Palazzo Davanzati and is documented in many more houses of the Florentine *Centro Vecchio* (Old Center), which was demolished in the late nineteenth century (see Figure 9.6 and Plate 9.3). This decoration is similar to the scenes depicted in *Tacuinum Sanitatis* illustrating *gaudia* (joy) (Dachs 1993: 111).[13] This is noteworthy, as *Tacuina* were Italian

health manuals, and contain frequent images of outdoor verdure and of green-decorated interiors.

White and red

The color white has always been admired for its undisputable purity and reflective properties. In religious as well as in secular interiors, walls were frequently whitewashed. Sometimes they were decorated further, mainly with earth pigments. Stylized red rosettes, occasionally supplemented by green twigs and leaves, were a recurrent and admired motif. Rosettes were painted either onto visually undivided plain white surfaces or set in the middle of, sometimes simulated, white masonry. This ornament was especially popular in thirteenth- and fourteenth-century interiors. Famous survivals can be seen in the churches at Selling in Kent and Chalgrove in Oxfordshire, and at Durham Cathedral. In a late fourteenth-century Annunciation fresco attributed to Pietro di Miniato (1366–c. 1450) on the counter-facade (inner wall of the facade) of the church of Santa Maria Novella in Florence, white curtains adorned with red rosettes surround Mary's bed. In a devotional context, this ornament inevitably acquired religious connotations. For instance, in the Song of Songs, the white and red imagery of the lover's beauty has been traditionally interpreted as Christ's holiness and his Passion (Dronke 1972: 89).

Similar decoration has been documented in secular settings, for example in the palaces of Henry III of England. It is conceivable that in a domestic environment the meaning of these simplified images remained unchanged, but it is also probable that it took on another human layer, and that by the shift of architectural context the religious message was transformed into a worldly one stressing the virtues of love and chastity. A parallel phenomenon occurred in medieval literature, where, echoing the Song of Songs, red and white colors customarily indicated physical beauty (Dronke 1972: 89).

Several contemporary illuminations show rosettes in domestic settings. Numerous opening miniatures of the French manuscripts of the *Roman de la rose* depict the protagonist in his bedroom with the image of a rosebush projected onto the wall above his bed symbolizing earthly love appearing in a dream. A similar meaning is given to red rosebush imagery accompanying two lovers in the German *Codex Manesse* (c. 1300). However, in a border miniature of a contemporary Flemish psalter of c. 1320–30, rosette decoration is degraded to a wall ornament in a building, which could be interpreted as a place of ill-repute.[14]

The motif of white wall and red rose must have been ever-present. It is conceivable that the simplicity of the design and the aesthetic and symbolic appeal of the combination of its colors made it universally alluring. The ease and low cost of execution allowed for its replication in all types of buildings. From celebrated cathedrals to the bottom of the social scale such decoration

was applicable everywhere. Depending on the context, its connotation was also surprisingly adaptable and modifiable.

HISTORIATED AND ABSTRACT MURALS

Examples of murals dominated by one or two colors often exist within larger decorative schemes (see Plate 9.3). These can include multi-colored abstract geometrical, floral or zoomorphic patterns, coats of arms, illusionistic architecture, marbling or textiles, and narratives based on (often moralizing) literature and biblical texts. Decoration schemes combining all of these elements can be seen in the Palazzo Davanzati in Florence (see Plate 9.3). This multitude of ornament was usually arranged in several horizontal sections. The oldest historiated mural, in Castel Rodengo in South Tirol, depicts the story of Ywain and dates back to c. 1210–20 (Dunlop 2009: 140). It occupies the upper half of the wall, leaving the lower half free, probably for a textile hanging. Many other murals, often painted in the durable fresco technique, likewise survive in Italy (6). Although northern Europe also had patrons of monumental art, most of their commissions have now vanished, like those of Henry III of England. Even his famous painted chamber in Westminster Palace, luckily recorded in drawings, burned down in 1834. Notably, a large portion of the documented wall imagery of Henry III's houses was religious.[15]

CONCLUSION

Color preferences in medieval ecclesiastical and secular architecture and interiors overlapped to a considerable extent. As religion strongly permeated secular life, these two spheres often seamlessly mingled and shared means of visual expression. Therefore, the chromatic appearance of building exteriors was usually fairly uniform. Nevertheless, religious architecture characteristically made much more use of polychrome sculpture on facades as well as in interiors. Likewise, it was more frequently fitted with stained glass windows or decorated with gold mosaic, while civic and domestic buildings were usually painted with bright pigments and generally had fewer, and smaller, glazed windows. Interior decoration schemes of religious and secular settings alike often included biblical and moralizing subjects and idealized nature. Representations of deep blue sky glimmering with astral bodies, as well as colorful depictions of meadows, trees, and flowers were favored in both contexts. Submerged in a now occasionally greatly romanticized but in fact particularly turbulent medieval reality of war, natural disasters, epidemics, and anguish, buildings shut out external instability and chaos. While providing physical safety, architecture also conferred spiritual solace by creating a structured, beautiful, enlightening, and transcendent microcosm in an image of a supreme, more perfect, otherworldly realm.

Artifacts: Colors of Status and Belief

LESLIE WEBSTER

INTRODUCTION

Color is one of the key social signals in early and high medieval culture, which we now recognize as intrinsic to our understanding of these societies (Gage 1993). It can denote wealth and status, symbolize religious concepts and emotional states, and indicate societal roles. The raw materials used to create these cultural signifiers were also often important in their own right, for example, as prestige imports that increased in value according to the distance they traveled, or for the amount of time and effort required to produce the desired effect (Gage 1993: 75–6).

In recent years, growing attention has been given to the materiality and substance of objects, in examining the roles that they performed in society (Bynum 2011; Gerevini 2014). The role of color in the decoration of artifacts, from prestige jewelry, weapon fittings, glassware, and devotional objects down to humbler artifacts, such as beads and pottery, is especially revealing; it can provide a way into the medieval mindset, which is sometimes more direct and more personal than that delivered through the polychrome splendors of illuminated manuscripts or the blazons of heraldry. In the early part of the medieval period, from the fifth to the eleventh century, portable metalwork is a particularly important source of information on this topic, since written sources are limited, organic objects, such as embroidered textiles and painted wood, are extremely rare, and only occasional vestiges of the painted surfaces of stone

and ivory carving survive. By contrast, in the later medieval period, from the eleventh to the fifteenth century, the volume and variety of colored artifacts increased greatly, as the growth of craft guilds and specialized manufacturing centers enabled increased production of objects, available to a wider range of people.

This is a long and changeful period, and in this survey there is scope only for selective discussion. This chapter focuses primarily on the less well-documented early medieval period, before concluding with a short discussion of selected themes from the later Middle Ages. The chapter is divided into three chronological sections, with subheadings devoted to key examples.

FROM THE FIFTH TO SEVENTH CENTURY

An early medieval aesthetic

The largely Germanic peoples that dominated much of Europe after the collapse of official Roman authority in the fifth century had their own traditions of goldsmith's work, themselves influenced by Roman cultural signifiers and metalworking techniques. One such element was their characteristic zoomorphic ornament, which lies outside our scope; but another major characteristic, and probably the best-known early medieval color aesthetic, was the use of red garnet inlays, usually set in gold. This most favored gemstone was introduced into western Europe from the east, via Alans and other Hunnic tribes from the Steppes, where it decorated their swords and horse-trappings (Périn et al. 2001: cat. nos. 18, 19, 27, 29), as well as through East Germanic groups such as the Goths and Gepids, and their contacts with Byzantium. Its popularity in jewelry and other fine metalwork, and the imitative use of red and gold coloring on other artifacts dominates the period from the fifth to the seventh century right across Europe. This aesthetic owes much of its potency to the Roman association of the prized deep red *purpura* with imperial authority (Gage 1993: 16, 25–7). It is no surprise, then, that garnet was widely associated with another symbol of imperial power, the eagle; for example on the superb fifth- and sixth-century eastern Gothic garnet-inlaid eagle saddle-mounts and brooches from Apahida and Pietroasa (Romania), and Domagnano (San Marino) (Menghin et al. 1987: X.1a and b, 419–30; Périn et al. 2001: cat. no. 29), and later Anglo-Saxon versions, as on the shield and purse lid at Sutton Hoo, Suffolk, and on sword and saddle fittings from the Staffordshire Hoard (Bruce-Mitford 1978: 54–63, 508–11; Fern et al. 2019: 115–17, 150–1).

Along with garnet, gold was the other chief signifier of wealth and status among the elite, prized for its incorruptibility, its purity, and its brilliant color. Its accumulation, redistribution, and display were the principal ways in which the Germanic successor states maintained their power based on warfare and

tribute. Gold's unique luster and brilliant hue signaled that power and status. The dazzling combination of bold red garnets with gleaming gold found powerful expression in the possessions of the elite, as some of the most famous burial assemblages of the period show.

The immaculate workmanship of the shoulder clasps from the royal Anglo-Saxon ship burial at Sutton Hoo (see Plate 10.1) reveals the hand of a master craftsman who bonded Germanic motifs with Roman symbolism. The immediate impact is one of bold color contrasts—the glitter of deep red garnets, alongside the red, white, and blue miniature checkerboards of the millefiori inlays, the whole encased in gleaming gold—but the preeminent combination of gold and red, and the form of the clasps, based on the fittings of an imperial Roman cuirass (Bruce-Mitford 1978: 532–5), are also a statement of power, showing how ascendant Anglo-Saxon royalty wanted to be perceived. This gold and garnet metalwork appropriated a Roman past to accompany Germanic symbols of ancestral power and protection, the imperial associations of deep red garnet signaling an authority derived from the Roman past. The quantity and purity of the gold and gemstones brought from afar demonstrate the control of great wealth and specialized craft resources.

This bold aesthetic is reflected in other royal contexts, such as the Frankish King Childeric's (d.481/2) burial at Tournai, Belgium. Many of its contents evoke the trappings of late Roman power—gold imperial *solidi*, representing the *largitio* distributed by consuls and emperors, gold cross-bow brooches of the type worn by high-ranking officials of the empire, and a gold signet ring inscribed with the king's name and image in the imperial manner (Bardiès-Fronty et al. 2016: cat. nos. 1–3). But alongside these symbols of the late Roman elite were exquisite garnet-inlaid gold jewels and fittings of a purely Germanic type—sword fittings and horse harness fittings, along with over three hundred cicada appliqués, signifying rebirth. With the Roman gold coins and brooches, these ostentatiously colorful treasures proclaimed Childeric's status as a Germanic prince, as well as an heir to Roman power and authority.

Although there are many regional and chronological variations in elite garnet and gold jewelry, it remained a remarkably consistent expression of elite status across Germanic Europe for more than 250 years. There is, however, a significant gap between the evidence of the importance of color in artifacts such as these and the written sources. Although colors were distinguished and valued in the early medieval period as much as they are nowadays, they were often perceived and described differently. Moreover, though prestige objects are mentioned in Anglo-Saxon poetic and other literary texts, neither the bold colors of precious artifacts from this early period, nor details of its forms and decoration, find mention in such texts. Descriptions of artifacts are mainly confined to generic terms—arm-rings, neck-collars, bridles, wall hangings—and mentions of gold, value, craftsmanship, and glittering quality. Even where an

object is occasionally accorded some further description, as is the case with the boar-crested helmets, there is no mention of color—brilliance, not hue, dominates. Contemporary descriptions of ecclesiastical interiors and equipment reinforce a similar aesthetic of gleaming magnificence, light and shade, in which color is largely absent (for example, Campbell 1967: § xx). This emphasis on the shimmer and glitter of rich surfaces, suggests the flickering effects of flame and candlelight in the visualization of artifacts.

Those learned texts that discuss colors, including a number of Bede's biblical commentaries and the Anglo-Saxon lapidary texts, draw on patristic sources or on classical traditions. Explanations of color in these texts reflect particular intellectual and theological constructs and have greater relevance to the symbolism of color in ecclesiastical artifacts than to secular ones (Kitson 1978, 1983).

This gap between the literature and the artifacts familiar to us from archaeological contexts serves as a reminder that we have only partial understanding of the role played by color in the early medieval world; but it also underscores the importance of the evidence presented by artifacts created and used by early medieval people, as a witness to the roles that colors played in their lives. A selection of key examples follows.

Gemstones

The Germanic use of precious gemstones derives from late Antique traditions; prestige imports, they were traded along ancient routes from their sources in India, Sri Lanka, and Africa. The preeminent gemstone, garnet, was set either individually, *en cabochon,* or in elaborate gold (rarely, silver) cell-work known as cloisonné. The latter enabled whole surfaces to be covered with thin slices of the gemstones, cut into intricate geometric shapes to produce glittering sheets of deep red against a network of gold. The luminosity of the garnet was frequently heightened by inserting thin cross-hatched gold or silver foils beneath the gems, which by their presence or absence, or the nature of their cross-hatching, could also adjust the depth of hue, enabling the interplay of lighter or darker reds.

The nature and organization of workshops is much debated, including the degree to which master craftsmen may have been peripatetic, transferring their specialized skills in shaping, polishing, and setting the garnets from one princely patron to another (Arrhenius 1985: 162–82, 194–8). Archaeological evidence for garnet cutting and production comes mostly from rather late and modest contexts in which inferior garnets were being used or recycled, and may not reflect earlier practice (for example, Hinton 2000: 83–6, 111–15). Certainly, the existence of influential workshops, some possibly under royal patronage, is indicated by distinctive regional styles, as variously seen in the Gothic gem-inlaid buckles, the Frankish small garnet disc brooches, and the late

flowering of garnet cloisonné in East Anglia (Marzinzik 2013: cat. no. 82; Fern et al. 2019: figs. 6.4, 6.10).

However, this was by no means an entirely monochrome fashion; from early on, other precious stones and inlays, such as ivory, shell, and glass imitations, were used sparingly to add contrast to the array of garnets. For example, on the late fifth-century purse lid from Apahida, a small number of green glass insets are interspersed among the garnet cloisonnés (Périn et al. 2001: cat. no. 29.7), while in late sixth- and early seventh-century Anglo-Saxon England, small blue and green glass inlays widely occur amongst the garnets of larger disc- and composite brooches, such as the well-known brooch from grave 205 at Kingston Down, Kent (Webster 2012a: 67). The fact that glass imitations of sapphires, emeralds, and crystal were widely used suggests that the sought-after gemstones were in short supply. Nevertheless, the occasional appearance of sapphires and emeralds in high-status jewelry shows that these precious gems were sometimes available to Germanic elites—if not in the quantities that we see depicted in the spectacular parade of imperial jewelry displayed in the images of Emperor Justinian I and Empress Theodora in the famous apse mosaics of San Vitale at Ravenna (c. 547). Many of these, like the emerald flanked by two small sapphires on a garnet-inlaid gold belt mount from Milton Regis, Kent, were recycled from Roman or Byzantine jewelry; others, such as the deep blue sapphires set in two gold rings from the early sixth-century female grave 16 in the Frankish aristocratic and royal cemetery at St. Denis, near Paris, may have arrived as polished stones via Byzantium (Hadjadj 2007: 38). By the twelfth century, the sapphire was understood as representing purity, and it may possibly have carried this significance at an earlier date, for its association with the heavens. The translucent pale blue glass cabochons that decorate Frankish gold composite brooches in the early seventh century are clearly set in imitation of sapphires and reflect the value attached to this gemstone.

Blue and white inlays in general are more common than green ones; reused Roman blue agate intaglios occur in Anglo-Saxon and Frankish jewelry, such as the finger-rings from high-status burials at Snape, Suffolk, and Krefeld Gellep, Rhineland. The millefiori glass inlays favored in the Roman world and adopted into Celtic enameling (see below) in this period are also usually composed of blue-and-white checkered patterns and are occasionally copied in Anglo-Saxon seventh-century jewelry, with the rare addition of translucent red glass in the case of the Sutton Hoo shoulder clasps and purse lid. White inlays are also sometimes set in the center of an item of jewelry, as a contrasting setting for a garnet-inlaid gold stud, as on many Anglo-Saxon composite brooches; their composition varies from the relatively rare ivory, to shell, mother-of-pearl, and various white compositions. More rarely, gems of other colors appear—the great black-and-white Arabian onyx in a fifth-century gold crossbow brooch

from the Szilágy Somlyo (Romania/Hungary) hoard was surely chosen not so much for its color as for its size and perfection.

A high proportion of the earliest garnet and polychrome inlaid metalwork comes from male princely graves, and relates to the sword and rider equipment of the ruling elite; many of the grandest fifth-century inlaid brooches were insignia of rank worn by males. By the late fifth century, however, the distinctive red gem had been widely adopted into high-status female jewelry.

Unsurprisingly, the elite use of garnet produced a trickle-down effect, as women of lesser status adopted jewelry fashions (such as the sixth-century Anglo-Saxon and Frankish disc brooches) which used the gem more sparingly, and silver replaced gold, sometimes with additional gilding and black niello detail to add contrast.

Metal polychromy

As noted, many Anglo-Saxon written sources tend to describe artifacts in terms of their brightness rather than their hue. There is another aspect of early medieval jewelry and other fine metalwork, which reflects that perception. Some of the earlier prestige metalwork, especially from northwestern Europe, made little or no use of gems, adapting instead the subtle play of metal contrasts seen in the partly gilded silver and black niello inlays of late Roman military insignia of rank, such as sword and belt fittings, to their own forms and styles. Germanic people on the frontiers of the Roman Empire were well acquainted with late Roman military metalwork, through regular contacts with the army and in many cases through federate service in it. In southern Scandinavia, north Germany, and Anglo-Saxon England, styles of jewelry developed that placed emphasis on the contrast of shimmering gold and silver surfaces, often highlighted with delicate black niello detail. The colors here were limited in range, but nevertheless, they reflect a particular fascination with the subtle interplay of changing tones, brightness and dark, designed in part to give emphasis to the animal ornament which decorates their surfaces—for example, on an Anglo-Saxon square-headed brooch from Chessel Down, Isle of Wight (Webster 2012a: 16). The textural juxtaposition of plain and chip-carved metal surfaces accentuate the subtle color contrasts of gold and silver.

In sixth-century England, where garnets, gold, and silver were scarce outside the rich kingdom of Kent and its satellite settlements on the Isle of Wight, elaborate regional brooch types, such as large copper alloy square-headed and cruciform brooches, developed rich all-over gilding in imitation of gold, or a combination of gilding and silver plating, again to provide a glittering contrast (Webster 2012a: 25). Humbler versions offered imitations of silver and gold; fifth- and sixth-century bow brooches of polished copper alloy gave an approximation of reddish gold, while tinned surfaces of some disc-brooch types replicated silver.

Enameling

The early medieval fashion for red inlays in fine metalwork was not confined to Germanic tastes. In the Celtic west and north, the British, Irish, and Picts used opaque red enamel to decorate a very different range of personal prestige artifacts such as cloak pins, penannular brooches, and other distinctive clothing fasteners, such as the Irish latchets (Youngs 1989: cat. no. 24). Very few gold artifacts survive from this period, suggesting that gold was hard to obtain, and copper alloy was the normal substitute. However, among the Picts, who clearly had greater access to recycled Roman silver, a remarkable series of silver artifacts survives, including pins of various types, heavy neck chains, and a unique leaf-shaped plaque; these were elegantly decorated not only with red enameled curvilinear and geometric patterns, but sometimes with versions of the special symbols that distinguish their culture from that of other contemporary Celtic peoples (Goldberg 2015: 152–9, 166–7) (Figure 10.1).

Among the Irish and British, the much more common copper alloy would have provided a shining red-gold foil to the red enamel. On the latchets, pins, and penannular brooches of British and Irish metalwork, this red enamel work, sometimes with millefiori additions, continued the late Iron Age tradition of curvilinear largely abstract forms, their delicate tracery appearing as bright metal reserved against the enamel background (Marzinzik 2013: cat. no. 140).

FIGURE 10.1 Celtic copper alloy cloak-fastener (latchet), inlaid with red enamel, Dowris, County Offaly, Ireland, late sixth or seventh century. Photograph © Trustees of the British Museum.

One particular type of Celtic object in which enamel was used to great effect was the so-called hanging-bowl (Bruce-Mitford with Raven 2005). Their original use is uncertain, but it is likely that they were ceremonial containers for water. Although made in Celtic regions of Britain, they survive as prestige possessions in the burials of high-status Anglo-Saxons. The most elaborate of these, the largest of three from the Sutton Hoo ship burial, has an elaborate array of curvilinear designs set against red enamel but is also decorated with superb millefiori work in a wide range of colors, including a translucent blue and an opaque orange red.

Glass vessels

Glass drinking vessels were highly prized objects in the early medieval period for their translucent delicacy and their often elaborate forms. Important components of the feast, many were designed to be unstable when full to encourage ceremonial drinking. The distinctive coloration of these Germanic glass vessels reflects a continuation of late Roman technologies, the reuse of Roman and later cullet (recycled or waste glass), including mosaic tesserae, and, above all, the nature of the available resources (Freestone et al. 2008). Like fourth-century Roman glass, the range of colors is limited and, especially in the earlier part of the period, produced naturally during manufacture, without the use of additional colorants (Evison 2008: 3); it consists of a blue-green of varying hue and intensity, a rich brown, and, from the later sixth century, a distinctive bright cobalt blue, probably produced by the addition of Roman cullet. Even early on, however, some vessels were bicolored; for example, the fifth-century light blue-green Castle Eden claw-beaker has applied trails of blue glass, while in the seventh century bold red streaks begin to appear in some greenish glass vessels, evidently a deliberate addition (58, 155, plates 2, 7).

Significant centers of production continued Roman glassmaking traditions in northern France/Belgium and the Rhineland, their products reaching Scandinavia and Anglo-Saxon England. However, there is growing evidence for production in England, notably in Kent (Evison 2008: 7–8).

Beads

Bead necklaces are a ubiquitous female accessory throughout the fifth to seventh century. The most frequently occurring types were of amber and glass, less commonly, amethyst, rock crystal, and other materials.

Amber was worn in long strings, normally of roughly shaped beads, and was favored for its tawny translucency, as well as for its seemingly magical property of attraction. In England, these necklaces were especially common in areas of Anglian settlement, the beaches of which were sources of the resin.

Glass beads were common across western Europe, occurring in a wide variety of sizes, shapes, colors, and ornament (Guido 1999; Brugmann 2004). They are essentially decorative, though some types or designs may also have had an amuletic function. Multicolored beads were especially popular during the fifth and sixth centuries, usually in opaque glass decorated with trails and spots in contrasting colors. The color range covers reds, yellows, white, dark blues, green, and black. Translucent dark blue ring-shaped beads also occur, and from the early seventh century there is a tendency for the gaudy polychrome beads to gradually give way to simpler forms and single colors. This may reflect changes in the source of beads rather than in fashions. Although colored beads are one of the most widespread types of female (and occasionally male) jewelry, they carry status and must have been an important source of color variety in middle-ranking early Germanic costume.

Among the other colorful materials from which beads were made, amethyst and rock crystal were perhaps the most significant, though both were much less common than glass.

Because of its perceived whiteness, its shining transparency, and (in the best specimens) its freedom from flaws, rock crystal was a sought-after gem throughout the medieval period (see below). Following classical tradition, it was thought to be a permanent form of ice, from which it derived a wide range of symbolic properties. In the early medieval period, its supposed healing properties made crystal beads popular amulets, and the polished crystal spheres in gold or silver slings, which occur in some sixth-century graves, were probably thought to have had similar or related magical properties.

Amethyst was rare in the west until the late sixth century, when distinctive purple-blue droplet-shaped beads began to appear in necklaces in Lombardic, Frankish, Anglo-Saxon, and other northwestern Germanic burials (Drauschke 2010). Amethyst and similarly shaped sapphire beads were widely used in Byzantine necklaces and earrings in the sixth and seventh centuries. In imitation of the glowing jewels of Byzantine court dress, the traditional glass polychrome beads and paired or tripled brooches of Germanic female costume began to be replaced by elegant necklaces of gold beads and pendants, amethyst droplets, and dark garnet cabochon pendants, sometimes worn with a single imposing gem-inlaid central brooch, and with veiling attached with decorated pins. The amethyst droplets also appear on ecclesiastical metalwork, most spectacularly, as pendants on the royal Visigothic gold votive crowns from the Guarrazar (Spain) treasure (Bardiès-Fronty et al. 2016: cat. nos. 62–3).

Organic and stone artifacts

The cool, damp climate of much of western Europe is not conducive to the long-term preservation of organic materials such as wood, textiles, and leather, and especially not of any surface pigment or staining. Significant

survivals from the early medieval period, such as the multicolored Bayeux embroidery, usually owe their preservation to being housed in the relatively stable atmosphere of a stone building and to not having been subjected to significant disturbance.

We may reasonably assume that valuable wooden objects and high-status wooden structures were quite often painted; however, the nature and scale of this is hard to assess. A crumbling wall in the Anglo-Saxon poem "The Ruin" is described as stained with red, but in the probably didactic context of the poem its meaning may be metaphorical (Bradley 1982: 401). Very few items of painted or stained woodwork from the fifth to seventh century have survived to provide firm evidence of colors used; early examples include fourth-century shield boards with red-painted ornament from a sacrificial weapon deposit at Nydam, Denmark (Jørgensen et al. 2003: 268), and the late sixth-century lyre from Trossingen, Germany, where a black-soot or charcoal inlay was worked into the incised decoration to highlight it (Theune-Grosskopf 2006). A rare example from England is represented by the remains of a small painted box, containing a silver spoon and a copper alloy reliquary canister from the *c.* 600 Anglo-Saxon princely chamber-grave at Prittlewell, Essex (Webster 2019b). From the context, and judging by its precious contents, this was clearly an object of some status. It had been painted with a geometric and interlacing design in red, yellow, and white. The possible source of the bright yellow pigment may be indicated by the intriguing presence at the waist of a late sixth-century male burial from an Anglo-Saxon cemetery at Bradstow School, Broadstairs, Kent, of a lump of the bright yellow mineral, orpiment (arsenic sulphide), probably carried in a pouch. This unusual item, certainly imported, may have been intended for use as a pigment or possibly for medical purposes.

A unique painted stone object comes from the Sutton Hoo ship burial. On the whetstone/scepter, the use of bright red pigment on the bulbous terminals that surmount the enigmatic carved heads at each end of this extraordinary object emphasizes its status as a symbol of authority; the terminals are encased in delicate copper alloy cages, suggesting that these carved and painted knobs are special, to be protected from casual contact.

Evidence for dyed leather and fine textiles from Germanic burials (Wamers and Périn 2013: 100–24) confirms that brightly colored clothing and wall hangings (at Sutton Hoo, for instance) were also signals of status, with red again a dominant color. The examples above confirm that, combined with gold, red hues were favored as indicators of power and status among Germanic elites in this period. Red is also the color par excellence associated with early Celtic personal jewelry in this period. All this began to change, however, from the seventh century onwards.

FROM THE SEVENTH TO ELEVENTH CENTURY

As the shift to Byzantine-influenced dress and jewelry illustrates, the political, religious, and economic changes that accelerated from around the beginning of the seventh century brought about significant social changes, which were reflected in the material culture of the age. The changing lifestyles implied by new Anglo-Saxon fashions in jewelry followed increased political and trading contact with continental neighbors, as well as with the eastern empire. In the seventh century, intense competition between the kingdoms of Anglo-Saxon England, battling to consolidate and extend their power, encouraged the expression of this authority through colorful new symbols, such as the Sutton Hoo scepter and ever more elaborate weaponry, including the distinctive northern sword pommels from the Staffordshire Hoard with their striking double rings (Fern et al. 2019: endpiece). As kingdoms stabilized, new centers of commerce and production (*wics*) as well as fairs and markets developed. But it was the adoption of Christianity among the Germanic peoples that arguably brought about the greatest transformations, most notably in those regions where, as in Anglo-Saxon England, Christianity was not established before the beginning of the seventh century. A huge and very different range of artifacts was required to serve the needs of the church, while new access to learned texts introduced, among other things, biblical color symbolisms (Kitson 1978).[1]

At the same time, other aspects of material culture underwent subtle shifts in their significance, as they adapted to the expression of Christian thought and ideas; conspicuously, the distinctive animal ornament of pre-Christian Germanic artifacts was assimilated into the decoration of objects with specifically Christian functions, such as Gospel manuscripts and Christian grave markers. Garnet inlays underwent a similar assimilation. The great gold cross from the Staffordshire hoard, which was taken onto the battlefield as a sign of divine protection, is not only decorated with animal ornament that shares identical motifs with mounts from Sutton Hoo, but is inlaid with five large deep red cabochon garnets. The color of the stones has here taken on a new meaning, symbolizing the blood of Christ and the five wounds he suffered on the cross, supported by the stone's traditional association with exalted status. This type of cross, known as the *crux gemmata,* evokes the great jeweled cross erected by the Emperor Theodosius II (r.408–50) on the site of Golgotha. In many gem-encrusted versions, this vison was widespread throughout the early medieval period; but this particular example vividly illustrates how Anglo-Saxons rapidly adapted traditional signifiers, including color, to the modalities of the new religion (Webster 2019a).

The same meaning-shift is seen in garnet-inlaid pendants with five cabochons, or with cloisonné cross images that also appear at this time, sometimes with animal ornament. This association of red garnets with Christian imagery

continues into the eighth century, for example, in the garnet-inlaid cross on the lower cover of the *Lindau Gospels*, and manuscript decoration copying garnet inlays (Lasko 1994: 1–2; Fern et al. 2019: 153). But the nature of secular metalwork was also changing, in response to the decreasing availability of resources, including garnets and gold.

Silver and gold

Early in the seventh century, supplies of Byzantine gold coin to the west ceased, and by the end of the century silver had largely replaced gold as the dominant precious metal in both coinage and jewelry. From the late eighth century onwards, through Viking and other agencies, increasing supplies of silver from the Islamic caliphates entered into circulation in Europe, helping to augment the taste for prestige objects in silver, particularly in northern Europe.

Gold continued to be used for high-status metalwork, especially in ecclesiastical contexts, and is probably underrepresented in what survives today because high-value objects were vulnerable to seizure and theft. From the Carolingian and Ottonian empires, some magnificent examples of ecclesiastical goldwork survive (see below), and in Scandinavia and other areas of Viking activity, heavy twisted gold neck-rings and gold arm-rings have been found in hoards. But gold artifacts are relatively rare survivals from later Anglo-Saxon England, other than in the form of finger-rings, usually inlaid with contrasting black niello, and more rarely with enamels, gemstones, or Roman intaglios.

Silver artifacts possessed a restrained resonance. The Anglo-Saxon taste for the shimmering play of light and dark, rather than for hues, is amply reflected in the delicate interplay of silver, gilding, and black niello inlay seen in some of the finest secular silver jewelry from the eighth to eleventh century; the characteristic great disc brooches such as the Fuller Brooch, and those from the early ninth-century hoard from Pentney, Norfolk, make dramatic use of the contrast of black and white, while some have an openwork construction designed to allow the color of the underlying clothing to show through (Tait 1986: figs. 247, 249) (Figure 10.2).

Ecclesiastical metalwork also made a virtue of the scarcity of gold; the grand silver chalice made for Duke Tassilo of Bavaria (r.748–88) has figural panels and animal ornament judiciously emphasized with gilding and niello (Lasko 1994: 1), recalling Alcuin's comparison of the unity of human and divine in Christ to a chalice made of gold and silver, with the silver encasing the gold (Migne 1863: 295–6).[2]

On prestige weaponry, a particular taste for inlaying iron with silver, brass, or copper wires evolved, sometimes burnished to give the impression of a solid piece of metal; the metallic contrasts of two or three different colored metals against the gray steel background of a sword hilt or spear shaft could be striking (Stiegemann and Wemhoff 1999: section V, cat. nos. 84–5).

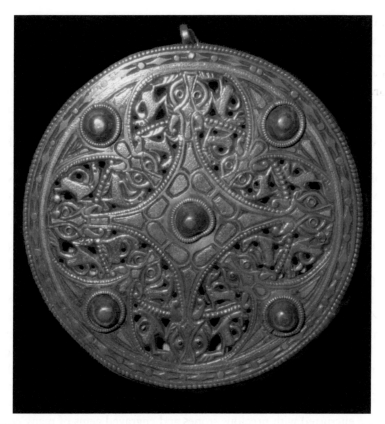

FIGURE 10.2 Anglo-Saxon, silver openwork brooch, known as the Strickland Brooch, inlaid with gold and niello, ninth century. British Museum. Courtesy of Getty Images.

Gemstones

Though later Anglo-Saxon secular artifacts exhibit a largely restrained taste for color, the case is very different where ecclesiastical artifacts are concerned. As with continental contemporary sources, there are many Anglo-Saxon texts describing the magnificence of ecclesiastical objects and, in particular, the use of colored gemstones to adorn altars and liturgical equipment. For example, Aldhelm's *c.* 700 poem on the church built by Bugga praises its golden chalice and cross studded with jewels (Lapidge and Rosier 1985: 47–9); while Stephen's near-contemporary *Life of Wilfrid* describes a great Bible presented by Wilfrid to his church at Ripon, its gold binding studded with gems, its vellum pages stained a royal purple, and its text written in gold (Colgrave 1927: ch. 17). Thanks to many later depredations, almost no fine Anglo-Saxon church metalwork survives, but numerous texts dwell on the polychrome richness of Anglo-Saxon ecclesiastical culture (Dodwell 1982).

Colored gems as well as antique cameos and intaglios, a notable feature of Frankish secular jewelry, appear on some of the earliest continental reliquaries (Stiegemann and Wemhoff 1999: section VIII, cat. nos. 15, 706), but it was under the Carolingian emperors that a major shift in the nature of decoration of court and church took place, reflected in the richly colored prestige artifacts associated with Charlemagne's grand vision of the restored cultural and intellectual Christian *Romanitas* proper to the status of Holy Roman Emperor. This was supported by an appropriately grand visual vocabulary. Brightly colored gem inlays are the keynote of luxury secular artifacts. Large and colorful disc brooches, such as a mid-eighth-century gold filigree example from Molsheim, Germany, or that found in the Carolingian trading center of Dorestad, Netherlands, from *c.* 800, suggest the kind of aristocratic jewelry worn at the Carolingian court. The former is set with pearls and red, blue, and yellow gems in a cruciform pattern surrounding a fine Roman cameo at its center, the latter with pearls, and with garnets and multicolored enamel inlays in the form of two intersecting crosses.

Many of the surviving ecclesiastical artifacts of this period excel in sheer magnificence. Two examples must suffice. The ninth-century purse-shaped reliquary of St. Stephen, once kept beneath the marble throne of Charlemagne in Aachen Cathedral, Germany, incorporates a jeweled cross at its centre, surrounded by a dense press of cabochon sapphires, emeralds, crystals, and other gems, referencing the gems of the Heavenly Jerusalem (Rev. 3 and 21). Most dramatic of all, the gold-sheeted seated figure of St. Foy in Conques, France, is encrusted with precious stones and engraved gems of many colors to create a sumptuous figure which must have inspired awe and devotion in equal measure (Gaborit-Chopin et al. 2001).

Colored stones appear in other contexts. Charlemagne and his successors acquired colored-marble and porphyry *spolia* from Roman buildings—green and purple were favored colors—to decorate their churches and palaces in the Roman manner (Stiegemann and Wemhoff 1999: section II, cat. nos. 57, 65, 67–9); and Charlemagne himself provided the distinctive black Tournai-type marble from quarries on his ancestral estates to create an epitaph for Pope Hadrian I in St. Peter's, and famously, a diplomatic gift of "black stones" to Offa (Story et al. 2005). Charles the Bald had a particular taste for precious and colorful *exotica*, represented by many gifts he presented to his favored abbey of St. Denis in Paris, including a magnificent Sassanian dish composed of carved garnet, rock crystal, and green glass inlays set in a gold framework (Gaborit-Chopin 1991: cat. no. 10). Among the Emperor's other remarkable gifts were the *Escrain de Charlemagne*, a large gold reliquary surmounted by a massive structure of jeweled arcades. When this was melted down in 1794, the tally of gemstones retrieved was 700 pearls, 2 aquamarines, 8 rubies, 11 amethysts, 135 emeralds, 209 sapphires, and 22 garnets (cat. nos. 12, 13).

Absence of color can also be important for its metaphorical resonances. Crystal continued to hold a particular place for its translucent clarity, as a symbol of purity and of a wider range of theological mysteries. In the Carolingian period, a number of magnificent large rock crystals were engraved with theological subjects such as the Crucifixion, baptism, and in the largest and grandest of these, which was made for Lothar II, King of the Franks, the biblical story of Susanna and the Elders (Kornbluth 1995: cat. no. 1). Because it offered no resistance to light, rock crystal was also a metaphor for spiritual enlightenment, of seeing clearly with what King Alfred the Great described as the "mind's eyes" (Pratt 2003); it is no accident that the Alfred Jewel, thought to be the handle of a manuscript pointer and thus an aid to reading and learning from the scriptures, is decorated with an enameled image of Sight, set beneath a flawless crystal through which the message of the image was perceived (Hinton 2008).

Enameling

As the range of colored gemstones increased, so the colors used in enameled artifacts changed. In Ireland and northern Britain, amber inlays were also widely used in the absence of gemstones. Alongside the familiar red and blue enamel and millefiori inlays, opaque yellow and green enamels were added to the Insular repertoire, appearing on jewelry, hanging bowls, drinking horns, and ecclesiastical artifacts; often they copy the cloisonné patterns of Germanic jewelry (Youngs 1989: cat. nos. 46–52, 44, 125). Among the most spectacular artifacts of the eighth and ninth centuries in Ireland are the two chalices from the Ardagh and Derrynaflan hoards and the paten and stand from the latter. These silver objects make their impact through elaborate polychrome contrasts; different kinds of surface treatment accentuate the interplay of the different hues offered by the conjunction of plain and lightly incised silver surfaces, complex gold filigree work, gilded chip-carving, and die-impressed silver and bronze sheet, all contrasted with brightly colored amber inlays or large studs with cloisonné enamels in red, blue, white, yellow, and green.

Colored enamels also became popular across continental Europe in this period, influenced by Byzantine enameling. From the mid-eighth century, mass-produced simple disc brooches were produced; these included the predominantly red-enameled so-called "saints' brooches" (*Heiligenfibeln*) from the Rhineland and brooches with enameled cross designs in red, green, blue, and white (Haseloff 1990). From the later tenth century, small gilded copper disc brooches set with geometric designs in blue, green, white, and yellow cloisonné enamel became fashionable in England and Scandinavia (Buckton 1986). The most elaborate enamelwork appears on royal and ecclesiastical objects, as on the great ninth-century altar frontal of Sant'Ambrogio in Milan (Lasko 1994: 43–4); but more ambitious enameling also appears on personal items such as gold rings and brooches, including elaborate figural and animal

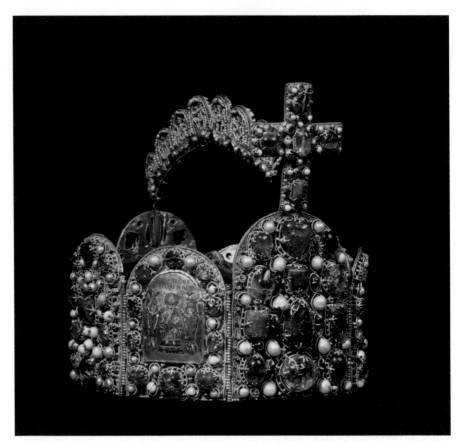

FIGURE 10.3 Imperial crown of the Holy Roman Empire, gold with polychrome cloisonné enamels, precious stones, and pearls, Ottonian Germany, late tenth or early eleventh century. Kaiserliche Schatzkammer, Hofburg Palace, Vienna. Courtesy of Getty Images.

images, reflecting the influence of manuscript illumination (Marzinzik 2013: cat. no. 72). In England, the gold, crystal, and enameled Alfred Jewel, though destined for ecclesiastical use, was personally commissioned by the king as part of his program of spiritual regeneration; the ambitious personification of Sight, which occupies its main surface, is skillfully enameled in blue, green, yellow, white, and red (Hinton 2008). Enamelwork from the Ottonian empire is particularly elaborate, showing the stylistic and technical influence of Italian and Byzantine models (Lasko 1994: 81–8) (Figure 10.3).

Glass

Glass too became more colorful in this period. Freestone notes "a significant increase in colourants in glass of the eighth century [...] which suggests

that more coloured glass has been recycled into the general stock in use"
(Freestone 2008: 41). Since this colored glass contains antimony opacifiers,
unlike the tin-opacified Byzantine glass, the increased production of colored
glass during the eighth and ninth centuries is likely to represent a growing
dependence upon old Roman material, as derelict buildings were stripped
of mosaic *tesserae* and other glass materials. Colored surface decoration also
increased: drinking vessels from sites as wide apart as Charlemagne's palace
at Paderborn, Germany, and the Scandinavian trading place at Birka, Sweden,
often have twisted *reticella* trails in contrasting colors applied to their
green-blue body surfaces; yellow, white, and blue are popular combinations
(Stiegemann and Wemhoff 1999: section III, cat. nos. 75–7; Evison 2008: cat.
nos. 17–18).

In churches, the need to protect their sacred contents from the destructive
actions of birds and the elements brought about the installation of plain and
colored window glass at many places. At the late seventh-century monastery
church of Jarrow, County Durham, Bede relates that Benedict Biscop brought
glaziers from Gaul to carry out the necessary work. Archaeological evidence
shows that the church was enriched by geometric and figural scenes constructed
from brilliantly colored panes of blue, green, red, and yellow (Stiegemann and
Wemhoff 1999: section III, cat. no. 95); shaped blue and blue-green window-
glass fragments were also found at the Anglo-Saxon abbey site at Whitby,
Yorkshire. Similarly colorful window glass has been excavated on Merovingian
and Carolingian monastic and palace sites, such as San Vincenzo al Volturno,
Italy, and Paderborn, Germany (Stiegemann and Wemhoff 1999: section III, cat.
nos. 66, 90; Bardiès-Fronty et al. 2016: cat. no. 163).

Glass imitations of jewels were also made in this period, for setting in both
secular and ecclesiastical artifacts. At the Anglo-Saxon monastic site at Whitby,
examples include a blue glass rectangular stud inlaid with a delicate gold grille
composed of two interlacing serpents, and an unusual turquoise glass jewel,
with a long-haired human bust in relief, possibly signifying Christ (Evison
2008: cat. nos. 212, 218).

Painted stone and organic artifacts

While decorated manuscripts are usually seen as the primary evidence for
painted decoration in the early medieval period, there is an ever-growing body
of evidence for the widespread use of pigment on stone, plaster, and organic
materials.

On stone carvings, red, white, and black pigments were used across
early medieval Europe to highlight decoration and inscriptions, including
those on runestones, where brown, yellow, blue, and green have also been
identified (Cather et al. 1990; Roesdahl 1991: 169) (see Plate 0.1). Vestiges of
paintwork, often on a gesso ground, survive on a number of Anglo-Saxon stone

monuments, though it is not always possible to determine at what date the paint was applied. Red, deep blue, white, black, and yellow are all recorded. However, the recently excavated early ninth-century sculpture of the archangel from an Annunciation scene at Lichfield Cathedral, Staffordshire, retains its original pigment, revealing a palette of white, black, golden yellow, and subtle tones of pink and red (Webster 2012a: 26–8). At St. Mary's, Deerhurst, Gloucestershire, traces of original red, yellow, and white paint have been found on various items of architectural sculpture, enabling the original appearance to be reconstructed; some details, such as the face of the Virgin, were simply painted onto a flattened surface, which was not the result of defacement, as previously thought (Gem and Howe 2008). This suggests that empty spaces in such monuments could have contained painted detail. Other lost elements of color in sculpture include glass settings and metal insets and additions (Tweddle 1990: 148–9).

There is also slight evidence to suggest that bone and ivory carvings were sometimes colored in the same way. Red, pink, blue, and green pigments have been identified, but, in general, pigment rarely survives in such contexts; however, traces of gold foil in the recesses of some carvings, attachments for hanging pearls and gems, and occasionally, blue and brown glass insets for the eyes of figures, show that, in their original state, many ivory carvings were by no means the austere pale images that have come down to us, but made brilliant by the addition of gold, gems, glass inlays, and pigment (Williamson and Webster 1990; Stiegemann and Wemhoff 1999: section III, cat. no. 2). The eighth-century whalebone Franks Casket was originally fitted with precious metal and probably jeweled mounts, long since vanished, and its dense carved decoration and inscriptions would very probably have been painted to aid legibility (Webster 2012b). The openwork structure of some small ivory crosses and crucifixes also suggests that they were intended to be mounted against a contrasting colored background, whether on a bookbinding or, worn as a pendant, over a garment. Humbler bone and antler artifacts were also sometimes colored—green, black, and red staining has occasionally been observed on objects such as combs and gaming pieces (MacGregor 1985: 67–70).

There is plenty of evidence, both archeological and documentary, for painted wooden objects. From the workshops at the Coppergate Viking site at York comes evidence of red painted wooden bowls for everyday use as well as of raw pigments—haematite and orpiment—used to decorate objects (Tweddle 1990: 152–3). At the other end of the spectrum were the icons that Benedict Biscop brought back from Rome to adorn his churches at Wearmouth and Jarrow.

In Scandinavia, wooden artifacts from archaeological sites and early wooden stave churches confirm a thriving tradition of painted decoration; from the early ninth-century Oseberg ship burial, furniture, wooden sledges, and posts from the boat were richly carved, with some of the ornament originally picked

out with red and black paint and gleaming metal studs. Examples of shields, oars, tent-poles, and building timbers have been found to have paint traces that show the presence of the same palette as seen on the runestones—red, white, and black, but also, sometimes blue, green, yellow, and brown (Roesdahl 1991: 86, 169–70).

Leather too was often stained or painted; some status-related secular objects such as decorated leather scabbards and belts have revealed traces of red coloring. The most remarkable Anglo-Saxon example of colored leather is the immaculately preserved binding of the Gospel of St. John that was placed in St. Cuthbert's coffin early in the eighth century; here, the decoration on front and back covers is carefully accentuated in colors that contrast with the deep reddish goatskin of the leather itself. The decoration is selectively picked out by filling lightly incised lines with what is now a gray-blue pigment, but that was probably originally a bolder hue (identified as indigo) and a bright yellow (identified as orpiment) (Webster 2015).

Embroidered textiles and tapestries

From at least the sixth century, costly Byzantine textiles were entering western Europe, where they were highly prized, as their survival in church treasuries and in princely burials, such as that of the sixth-century Frankish Queen Arnegunde, indicates (Wamers and Périn 2013: 100, 112–14). Like Arnegunde, Charlemagne was also buried wrapped in a red silk, with a woven design of a triumphal charioteer (Stiegemann and Wemhoff 1999: section II, cat. no. 17). Precious silks were often given as altar cloths, or gifted to major shrines, such as that of St. Cuthbert, where many Byzantine and oriental textiles were found. In 934, King Athelstan made many offerings to the saint's shrine, including a maniple and a figural silken stole, embroidered in tones of green, blue, red, and brown on a pale silk background, shot through with gold thread and dated by their association with Bishop Frithestan of Winchester (d.916). An eighth-century Anglo-Saxon altar frontal, presented to a shrine at Maaseyck, Belgium, has elaborate arcaded embroidery in a range of bright colors, including cherry red, blue, and green, highlighted with gold thread and pearls (Webster and Backhouse 1991: cat. no. 143).

Secular embroidery is rarer; a linen shift from the abbey at Chelles, France, associated with relics of the Frankish Queen Balthild (c. 627–80), has delicate red, blue, green, and yellow imitations of a jeweled cross and pendants of Byzantine type (Wamers and Périn 2013: 126–36). More ambitious embroideries depicted heroic deeds, perhaps as a background to *chansons de geste*, as has been suggested for the Bayeux textile.

The remarkable collection of textiles accompanying the two females buried in the Oseberg Viking ship includes not only imported luxury silks from central Asia, but also highly sophisticated woven tapestries in wool and linen. These

depict what seem to be elaborate mythological or religious scenes; their original bright colors have largely faded to brown and gray tones, but a carmine red survives and seems to have been the dominant color (Graham-Campbell 2013: figs. 54, 55).

Glazed pottery

It was not until the late eighth century in western Europe that pottery became a vehicle for colored decoration and glazes, moving widely through increasing trade and markets. Prior to that, color in pottery had been confined to the nature of the clay and its firing conditions, with decoration usually in the form of stamped and freehand motifs or rouletting. Continental innovations included pottery with red-painted splashes on a cream-colored ground, such as Badorf and Pingsdorf wares, made in the Rhineland, and for a short period in the eighth to ninth centuries the up market burnished blackware pitchers with tin appliqués, known as Tating ware. These found their way into high-status Viking graves, the royal residence next to the Abbey of St. Denis, Paris, and the Carolingian palace at Paderborn (Stiegemann and Wemhoff 1999: section III, cat. nos. 34–9).

Red-painted pottery was also made in England in the ninth century, at Stamford, Lincolnshire, but was superseded there by the fine lead-glazed wares, which are typical of the late Saxon and post-Conquest period. These relatively high-value wares occur in a range of colors, depending on glaze content and firing conditions. A pale yellow is typical, but orange, light green, and gray blue can also occur. A similar range of colors, with the addition of browns and darker greens, occurs on glazed wall and floor tiles from the late Saxon period, at Lincoln, York, Winchester, and other major ecclesiastical sites (Hinton 2005: 160).

FROM THE TWELFTH TO FOURTEENTH CENTURY: A BRIEF INTRODUCTION

The period 1100–1400 saw great societal transformations across western Europe, affecting every aspect of life. From the late eleventh century, technological and agricultural improvements led to a considerable increase in population (albeit temporarily mitigated by the great fourteenth-century plague) and social changes accelerated. These changes were accompanied by an explosion in the quantity and range of the surviving material data and the consequential yield of information that it provides. Many artifacts were increasingly produced on a commercialized basis, becoming more widely accessible. Objects, and images and texts relating to them, abound in huge numbers and are a significant source of information for the many very different roles that color performed in the Middle Ages; a detailed and contextualized survey of the topic in a period

of such abundance lies far beyond the scope of this chapter. This overview is simply intended as an introduction to a few of the avenues of exploration through which artifacts can reveal how color was used and what it meant.

In the medieval world, colors played an increasingly nuanced and wide-ranging role in social transactions and intellectual disciplines. Color was not only an integral part of social discourse, but of many contemporary beliefs and values; it imbued contemporary investigations of the material and spiritual worlds, and played an important role in the increasing systematization of cultural constructs such as heraldry or the symbolism of love and courtship. Accompanying the increasing complexity of social interactions and social stratification, new technologies enabled a richer and brighter range of colors in many media.

Various systems of color symbolism—the tinctures of heraldry, the amorous connotations of color in German love poetry (Gage 1993: 80–90), the colors associated with the liturgy, and traditional lapidary lore—had a particular impact on the use of color in artifacts. However, these symbolic interpretations were fluid, and the meanings of individual colors were wide-ranging and depended on the context of use. In love and courtship, for example, the colors of artifacts held special significance. By the fifteenth century, enameled and gem-set rings, brooches, collars, and other fine jewelry could express the qualities and aspirations of lovers; in the betrothal portrait of Ladislav V of Hungary and Madeleine of France, her jewels are predominantly rubies and pearls, signifying respectively marriage and health, and purity, while his brooch is set with a sapphire, regarded as a kingly gem and signifying chastity (Campbell 2009: 95–7). The gold heart-shaped brooch from the Fishpool, Nottinghamshire, hoard, buried in 1464, is decorated with opaque white and translucent blue enamel, probably to evoke purity and loyalty, and bears an inscription in white enamel, translated as "I am yours forever" (Hinton 2005: 242).

Medieval jewelry made particular use of precious and semiprecious stones (Hinton 2005: 187). The gem lore of medieval lapidaries, such as the *Liber lapidum* of Marbod of Rennes, drew on biblical and antique sources in ascribing symbolic resonance and medicinal powers to popular gemstones such as sapphires, rubies, amethysts, rock crystal, diamonds, garnets, and pearls, which certainly influenced particular choices; the chaste sapphire, for example, which occurs in some episcopal rings, also appropriately stood for peace and reconciliation (Campbell 2009: 46). A ring from Thame, Oxfordshire, is set with a large amethyst cross and is engraved on the inside with the crucifixion set against a background of red enamel, representing the color of martyrdom (Hinton 2005: 238–40). And for those who could not afford costly gems, cheap imitations were made using colored glass and foils (Hinton 2005: 189; Campbell 2009: 75).

Color was also important in establishing social identity through artifacts, such as the enameled livery badges, worn on the hat or on an outer garment to signal loyalty or affiliation (Campbell 2009: 102–3)—even the horses of a grand lord might wear badges with devices enameled in the appropriate heraldic colors. In the Wilton Diptych, Richard II (1367–c. 1400) wears a badge with his own emblem of the white hart, and angels sporting his badge accompany the Virgin. During the fifteenth-century Wars of the Roses, Yorkist or Lancastrian affiliation could be signaled by badges and collars with white or red roses (102–3), or similar colored emblems, like the probably Yorkist white-enameled swan badge of c. 1400 from Dunstable, Bedfordshire (Tait 1986: 138–40).

The development of new types of enameling introduced a range of lively hues into the repertoire. From the twelfth century onwards, major production centers, including the Meuse region (Belgium), Cologne (Germany), and Limoges (France), developed their own distinctive techniques and palettes, seen especially in religious objects, such as shrines, chalices, croziers, and smaller reliquaries, though secular objects were also produced (Lasko 1994: 193–8, 244–51). Translucent enameling, introduced in the thirteenth century, created a brilliant, jewel-like effect. The great lidded gold cup that was made for the Duc de Berry in the late fourteenth century is the most outstanding example (see Plate 10.2); it is decorated with scenes from the life of St. Agnes in which a brilliant crimson, royal blue, and green dominate, and the settings are subtly modulated to give a three-dimensional quality to the images.

Enamel was, of course, related to glassmaking, and glasswares too underwent changes in this period. Very different from the richly colored window glass of churches, the characteristic drinking vessels of the earlier part of the period were made in forest glasshouses, usually with greenish coloring derived from the plant ash used in the process; they were valued for their elaborate forms rather than for their color (Tait 1968: 127–8). Multicolored-enameled decoration on glass is known from the twelfth century, but it is in the fifteenth century that Venetian glassworks extended the technique, producing luxury cups and goblets for the tables of the rich, in deep greens and blues with colorful applied enameling (130–1, 151–2).

Tables of less exalted status might make do with pottery, but here too the restricted range of colored glazes and patterns, which characterized earlier medieval pottery, were superseded by more colorful green glazed or painted wares, sometimes in very elaborate forms (Figure 10.4).

In the thirteenth and fourteenth centuries, distinctive jugs and other vessels exported to British and Irish ports from the Saintonge district in western France are associated with the Gascony wine trade and reflect the wine-drinking habits and growing status of an expanding middle class. They are usually painted with lively birds, plants, and shields in yellow, green, and black, but include some startlingly ambitious constructions, such as an extraordinary jug from

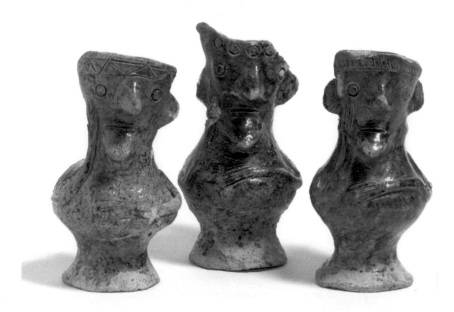

FIGURE 10.4 Three quirky green-glazed anthropomorphic jugs, London, thirteenth to fourteenth century. Museum of London Archaeology. Courtesy of Getty Images.

Exeter, which is in the shape of a tower inhabited by a lively group of bishops, women, and musicians, with a donkey's head as its spout—no doubt from a rich merchant's house (Hinton 2005: 216–17, plate G).

CONCLUSION

This chapter has traveled not only across a thousand years but across great cultural shifts. Of necessity, the scope has been restricted, with an inevitable bias toward high-end objects, the possessions of the privileged—not least because colored or stained everyday artifacts in leather, wood, or bone survive but poorly. But in the long journey from, for example, the carefully constructed power statements of Germanic garnet and gold to the cheap colored glass imitations of gemstones set in some medieval jewelry, there are constant themes, and not only at the upper levels of these changing societies. Color here assumes the role of an active agent in human affairs; it represents power, but also belief and affiliation; it can symbolize mediation between God and men, or protect from sickness; it may encourage and celebrate emotional and spiritual qualities; it identifies the lord and his servant, the thegn's hall, and the merchant's table. And unquestionably throughout, it invested these artifacts with a source of pleasure, comfort, and delight.

NOTES

Chapter 2

1. The title of this text, which is literally translated as "A Little Key to the Napkin," is thought to orginate in an early mistranslation from Greek.
2. The binding media suitable for use on paper, parchment, or vellum are water-based: gums, egg whites, and animal glues. Gums are water-miscible or water-soluble carbohydrate compounds that exude from certain trees. Egg white was prepared by beating it and then leaving it to stand. The liquid that separated out beneath the layer of foam was known as *glair* and was mixed with the pigment (Clarke 2011: 117–18, 188). Animal glues were prepared from animal skins by soaking and then boiling in water, producing a solution containing gelatin. Egg yolk was used as a binder for painting on wood panels. Linseed oil and, less commonly, walnut oil, were used as a paint medium and varnish ingredient. Pigments have a particularly saturated appearance in oil (White and Kirby 2009).
3. A lake pigment is an insoluble pigment made by precipitating or adsorbing an organic dye onto a suitable substrate.

Chapter 3

1. I refer to this concept in the meaning analyzed by Bourdieu (1984).
2. On the medieval terminology of colors, see the contributions in Bennewitz and Schindler (2012: 295–436).
3. Charles VI of France, for example, wore robes of blue and white at his coronation in 1380, according to the painting (*c.* 1455–60) by Jean Fouquet in his *Grandes chroniques de France* (Paris, Bibliothèque Nationale de France, Manuscrits français, 6465, fol. 457v; illustrated in Avril 2003: no. 26: 235–48).
4. Heidelberg, Universitätsbibliothek, Cod. Pal. Germ. MS 848.
5. Vienna, Kunsthistorisches Museum, Kunstkammer, catalog nos. 14–21.
6. The word *scarlet* at this date signifies a type of fabric, not a color.

Chapter 4

1. *Symbolum, collatio videlicet, id est coaptatio visibilium formarum ad demonstrationem rei invisibilis propositarum* (Hugo de S. Victore 1854: col. 960D). On the allegorical interpretation and symbolist mentality, see Chenu 1968: 99–145, esp. 106 on color.
2. Dijon—BM, n.d. Dijon, Bibliothèque Municipal, MS 173, fol. 41.
3. *Purpura dat regnum, fit purpura Gloria regni ... Puniceus color est toto venerabilis orbe.*
4. For a colored illustration, see Gaborit-Chopin 2005: 181.
5. The statute (known as Number 80): *De Litteris vel vitreis: Litterae unius coloris fiant, et non depicte. Vitreas albae fiant, et sine crucibus et picturis* (see Packer and Sliwka 2017: 27–8 and 213).
6. For an illustration from the *Liber divinorum operum* of Divine Love trampling on Satan and on Discord, see World Digital Library 2017. Lucca, Biblioteca Statale, MS 1942, fol. 1v. Thirteenth century.

Chapter 5

1. Bede (n.d.: II.1) reports Gregory's conversation as: "Rursus ergo interrogauit, quod esset uocabulum gentis illius. Responsum est, quod Angli uocarentur. At ille: 'Bene,' inquit; 'nam et angelicam habent faciem, et tales angelorum in caelis decet esse coheredes'" (Again he asked for the name of the race. He was told that they were called *Angli*. "Good," he said, "they have the face of angels, and such men should be fellow-heirs of the angels in heaven") (Bede 1994: 70). The attribution of the epigram to Creasy (1869: 102) (as in Wikiquote) is incorrect.
2. These may have been based not only on the biblical association of goodness with lightness but also on actual light-skinned people. Brown (2007) argues that angels in Byzantine art were based on the appearance of court eunuchs, pointing out that legislation under Justinian indicates that many of them came from eastern areas of the empire, the modern Caucasus, and had light eyes, hair, and skin. They wore white garments decorated with gold and acted (like angels) as messengers and intermediaries.
3. The concept of "mixed origin" was pushed much further back when the Natural History Museum and BBC TV Channel 4 announced on February 7, 2018, that new research on the bones of 10,000-year-old "Cheddar Man" suggested that he had dark skin, and that around 10 percent of his DNA is shared by the population of Britain today.
4. At Fairford, Gloucestershire, dated 896–1025; a "late Saxon" cemetery, Norwich, Norfolk; and North Elmham, Norfolk, dated *c.* 1100. I am grateful to Elizabeth Coatsworth for alerting me to these discoveries.
5. I am grateful to Christopher Monk for this reference.
6. The Magi are named and Balthasar is said to be *fuscus* (swarthy) in an eighth- or ninth-century text wrongly attributed to Bede, *Excerptiones Patrum, collectanea, flores ex diversis, quæstiones at parabolæ* (Patrologia Latina 94: 541). See Migne 1862.
7. See, for example, the altarpiece by the Flemish painter Hans Memling (1470–2), Museo del Prado, n.d.
8. Rogier van der Weyden's black Magus in his Vision of the Magi Panel in the *Bladelin Triptyche, c.* 1445–8 (Berlin, Gemäldegalerie der Staatlichen Museen) wears black and white in contrast to the red, blue, yellow, and gold of the other kings' clothing. See Art and the Bible, n.d.

9. I am grateful to Monica Wright for details from French literature.
10. Information from Sylvette Lemagnen, former Curator of the Bayeux Tapestry.
11. White wedding dresses only became fashionable after Queen Victoria of England was married in white court dress in 1840.
12. The colors were used in association with the *charges*, or devices, which could appear on shields. They might be geometric, such as bends and bars; animals, such as the lion; plants, such as the *fleur de lis*; or inanimate objects, such as buildings and ships.
13. I am grateful to John Friedman for this reference.
14. For images of the natural-colored silk vestments, see Kollmorgen 2009.

Chapter 6

1. "Secondary color terms," as used in the *Cultural History of Color*, refers to basic color terms that are not *primary* basic terms. Taking Modern English as an example, its primary terms are *red*, *green*, *yellow*, *blue*, *black*, and *white*, so the English *secondary* basic color terms, having emerged in the language later than the primary BCTs and considered to be less cognitively salient, are *brown*, *orange*, *pink*, *gray*, and *purple*. The term *secondary* is not used here to mean "non-basic." However, it is not always possible to make the distinction between primary and secondary BCTs in historical languages as there may be insufficient evidence.
2. Color semantics in, especially, but not exclusively, historical languages is considered in detail in Biggam (2012). The reader is introduced to various aspects of color studies, including the development of color systems across time. Probably the best-known model of BCC development (now named "the Universals and Evolution (UE) model") first appeared in 1969 (Berlin and Kay 1969: 4 [2]) and, having been revised many times, can now be found in Kay et al. (2009: 11).
3. Information about the referents of Old English color terms has been taken principally from the *Dictionary of Old English A to H* (2016) and from König (1957).
4. This does not mean that the Anglo-Saxons were unable to describe or indicate these colours since they had many *non-basic* color terms and phrases, for example, the compound adjective *geolurēad* (literally, "yellow red") denoted "orange," but this is not a BCT indicating an independent, abstract cognitive category.
5. It is, of course, common to refer to animals as, for example, "red" in Modern English, meaning "reddish brown," but the probable lack of a brown BCT in Old English makes this type of usage (known as *type modification*) more doubtful. For type modification, see Steinvall 2006.
6. The Old English non-basic color terms can be found in the classified color sections of the *Historical Thesaurus of the Oxford English Dictionary* (HTOED, 2009).
7. Eddic poetry is the usual name for the collection of Old Norse-Icelandic heroic and mythological lays called the *Poetic Edda*. Skaldic poetry is conventionally considered to be that part of Old Norse-Icelandic poetry, which in contrast to the anonymous eddic poetry, may be connected with the authorship of a particular poet (*skald*). Originally, skaldic poetry served as a eulogy for living, less often dead, kings or chieftains.
8. These adjectives are quoted in the masculine form. Latin expresses distinctions of case, number, and gender in nouns and adjectives, for example, *candidus* is the nominative, masculine, singular form; *candida* the nominative, feminine, singular; and *candidum* the nominative/accusative neuter singular. Introductory works on Latin color terms include the following: Baran 1983; Lyons 1999; and Romano 2003. On bright/dull pairs, see André 1949: 26; and Arias Abellán 1984.

9. Several studies are devoted to *caerul(e)us* and BLUE in Latin, among which are: André 1949: 162–83; Kristol 1978: 220–8; and Grossmann 1988: 111–12.

10. One of the suggested criteria for basicness, as listed by Berlin and Kay (1969: 6), is that "color terms that are also the name of an object characteristically having that color are suspect," although this criterion is only applied if there is doubt about the basicness of a term after consideration of their first four criteria.

11. A *hyperonym* (Italian: *arcilessema*) is a higher-level, superordinate term whose meaning includes the meanings of certain lower-level terms, just as English *red* (a hyperonym) includes the meanings of *scarlet*, *ruby*, and others.

12. This survey was conducted on the Brepols database, Library of Latin Texts—Online (LLT–O), which mainly contains literary texts and consists of about 140 million words from 300 BC to 1400 CE. See Brepols n.d.

13. A search in the *Corpus Corporum* of the University of Zurich reveals that the ratio in the use of *rutilus* to *ruber* is 1:2 before 200 CE, then 1:4 between 200 and 500, and 1:8 between 500 and 1000. See *Corpus Corporum* n.d.

14. For a synthesis of the social meanings of color terms, see Ronga 2009.

15. The Roman Catholic liturgy, established in the third to fourth centuries CE, is linked to the colors white, red, and purple from the sacred vestments worn at different times of the year.

16. The frequency of *rufus* is increased by the name Rufus, widespread at all times in Roman society.

17. A *hieromonk* is a priest-monk, a monk who became a priest, or a priest who took monastic vows, and who normally lives in a monastery or in a secular community without a family.

Chapter 7

1. There are few book-length studies of color in medieval European culture. See Pastoureau 1986, 2004; and Pleij 2004.

2. John 1: 4–5: "What has come into being in him was life, life that was the light of men; and light shines in darkness, and darkness could not overpower it"; John 8: 12: "I am the light of the world; anyone who follows me will not be walking in the dark, but will have the light of life."

3. For other interpretations of color in this romance, see Huxtable 2008.

4. On color in the medieval arts of memory, see Carruthers 1990.

Chapter 8

1. The *Hodegetria*, which depicts the Virgin Mary interceding with her right hand as she holds the Christ Child in her lap, was venerated in Constantinople as a portrait icon painted by St. Luke the Evangelist. Its name derives from the monastery where it was housed, dedicated to the care of the blind—the Monastery of the Hodegoi.

2. As described in Ovid's *Metamorphoses* and later in the medieval French romance, *Roman de la rose*. Pygmalion was a Greek sculptor from Cyprus who fell in love with the statue he carved of a beautiful woman; Aphrodite granted his prayer that it should come alive.

3. Grisaille is the technique of shaded drawing or painting in black and white.

Chapter 9

1. Designs for the San Lorenzo facade by Antonio and Giuliano da Sangallo, Jacopo Sansovino, Michelangelo, and Rafael were not executed. The previous facade of the cathedral was dismantled in the sixteenth century.
2. For an account of the restorations, see Callegari 1925.
3. For an account of the restorations, see Lasansky 2004b.
4. For an account of exterior medieval polychromy, see Phleps 1930. For newer research on brick polychromy and light, see, for example, Badstubner 2005; and Hills 1999.
5. The exterior and interior of the White Tower in the Tower of London were whitewashed in 1240 on the orders of Henry III (Thurley et al. 2000: 34).
6. For discussion of church facade polychromy, see Park 2002: 31–53.
7. Court cases took place in front of red church doors (Deimling 1997: 324–5).
8. I wish to thank Madeleine Katkov for a copy of the paint analysis report of 2010.
9. Artistic production in all media overlapped, but they surpassed one another in various periods and geographic areas. For instance, mosaics, which relied on reflected light, flourished in the early Christian and Byzantine period and declined in the high Middle Ages, though later instances exist, such as the interior and exterior of the Basilica San Marco, Venice. Stained glass, depending on transmitted light, reached its highest development in Gothic cathedrals beginning with Abbot Suger's St. Denis project of the 1140s. However, it had existed on a smaller scale for many centuries, for instance, in the Northumbrian Jarrow Monastery (682–870). Dichroic (two-colored) glass quarries (small panes) excavated there are reddish amber in transmitted light and a milky blue in reflected light, see Unwin 2013: 17.
10. The predominantly blue glass of St. Denis and of Chartres submerged their interiors in comparative gloom (Gage [1993] 2009: 69). However, in the thirteenth century, the windows let in more light, as blue panes were balanced by clear (white) glass. Other colors in French and English churches were red, green, and yellow. These hues dominated the German and Italian windows, as exemplified by the Notre Dame Cathedral, Strasbourg, and the Lower Church of San Francesco, Assisi.
11. Blue superseded purple, which had been the most venerated colour since antiquity. In architecture, purple can be seen as an accent, for example, in the sixth-century mosaics in Ravenna (the Empress Theodora's cloak in San Vitale, and Mary's and Christ's robes in Sant'Apollinare Nuovo).
12. For a discussion, see Clarke and Lamm 2004.
13. Vienna, Österreichische Nationalbibliothek, Cod. ser. nov. MS 2644, fol. 104v.
14. Oxford, Bodleian Library, MS Douce 6, fol. 160v.
15. For a discussion of Henry III's decoration cycles, see Borenius 1943; and Binski 1986.

Chapter 10

1. For biblical color symbolism, see "Textual sources" in Chapter Four, this volume.
2. I am grateful to David Ganz for drawing this reference to my attention.

BIBLIOGRAPHY

Adam Scotus. 1855. "De tripartito tabernaculo." In Jacques-Paul Migne (ed.), *Patrologiae cursus completus, series Latina*, vol. 198. Paris: Migne. Available online: http://patristica.net/latina/ (accessed May 23, 2020).

Adams, Noël. 2014. *Bright Lights in the Dark Ages: The Thaw Collection of Early Medieval Ornaments*. New York: Morgan Library and Museum.

Albertus Magnus. 1890. "Liber de sensu." In Albert Borgnet (ed.), Alberti Magni *Opera Omnia*, vol. 9. 38 vols. Paris: Vives.

Alhacen. 2006. *Alhacen on the Principles of Reflection*. Edited and translated by A. Mark Smith. 2 vols. Philadelphia: American Philosophical Society.

Alighieri, Dante. 1984–6. *The Divine Comedy*. Translated by Mark Musa. 3 vols. London: Penguin.

Amalarius, Metensis. 2014. *On the Liturgy*. 4 vols. Cambridge, MA: Harvard University Press.

Anderson, Joanne W. 2019. "The Loom, the Lady and her Family Chapels: Weaving Identity in Late Medieval Art." *Medieval Clothing and Textiles*, 15: 157–82.

André, Jacques. 1949. *Étude sur les termes de couleur dans la langue latine*. Paris: Klincksieck.

Anglo-Norman Dictionary (AND). 2005–. General editor, William Rothwell. Edited by Stewart Gregory, William Rothwell, and David Trotter, vols. 1–. 2nd edn. London: Maney.

Arias Abellán, Carmen. 1984. "*Albus–candidus, ater–niger* and *ruber–rutilus* in Ovid's *Metamorphoses*: A Structural Research." *Latomus*, 43: 111–17.

Arias Abellán, Carmen. 1994. *Estructura semántica de los adjectivos de color en los tratadistas latinos de agricultura y parte de la enciclopedia de Plinio*. Seville: Universidad de Sevilla.

Aristotle. 1984a. "Meteorology." Translated by E.W. Webster. In Jonathan Barnes (ed.), *The Complete Works of Aristotle*. 2 vols. Princeton, NJ: Princeton University Press.

Aristotle. 1984b. "On Sense and Sensibles." Translated by J.I. Beare. In Jonathan Barnes (ed.), *The Complete Works of Aristotle*. 2 vols. Princeton, NJ: Princeton University Press.

Aristotle. 1984c. "On the Soul." Translated by J.A. Smith. In Jonathan Barnes (ed.), *The Complete Works of Aristotle*. 2 vols. Princeton, NJ: Princeton University Press.

Aristotle. 1984d. "Physics." Translated by R.P. Hardie and R.K. Gaye. In Jonathan Barnes (ed.), *The Complete Works of Aristotle*. 2 vols. Princeton, NJ: Princeton University Press.

Aristotle. 1984e. "Problems." Translated by E.S. Forster. In Jonathan Barnes (ed.), *The Complete Works of Aristotle*. 2 vols. Princeton, NJ: Princeton University Press.

Arrhenius, Birgit. 1985. *Merovingian Garnet Jewellery*. Stockholm: Almqvist and Wiksell.

Art and the Bible. n.d. "The Vision of the Magi." Available online: https://www.artbible.info/art/large/812.html (accessed May 26, 2020).

Arwidsson, Greta. 1977. *De Gräberfunde von Valsgärde III: Valsgärde 7*. Uppsala: Uppsala Universitets Museum för Nordiska Fornsaker.

Augustine, St. 2010. "De libero arbitrio." In Peter King (ed. and trans.), *Augustine On the Free Choice of the Will, On Grace and Free Choice, and Other Writings*. Cambridge: Cambridge University Press.

Averroes. 1550. "Averrois paraphrasis [: De sensu et sensibilibus]." In *Aristotelis Stagiritae libri omnes ad animalium cogitionem attinentes*, vol. 6. 11 vols. Venice: Iuntas.

Avril, François. 2003. *Jean Fouquet: Peintre et enlumineur du xve siècle*. Paris: Bibliothèque Nationale de France.

Bacon, Roger. 1900. "Scientia experimentalis." In John Henry Bridges (ed.), *The Opus majus of Roger Bacon*, vol. 2. 3 vols. London: Williams and Norgate.

Bacon, Roger. 1937. "De sensu et sensato." In Robert Steele (ed.), *Opera hactenus inedita Rogeri Baconi*, fascicle 14. Oxford: Clarendon Press.

Bacon, Roger. 1996. *Roger Bacon and the Origins of* Perspectiva *in the Middle Ages*. Edited and translated by David C. Lindberg. Oxford: Clarendon Press.

Badstubner, Ernst, ed. 2005. *Licht und Farbe in der mittelalterlichen Backsteinarchitektur des südlichen Ostseeraums*. Berlin: Lukas.

Bain, Jill. 2012. "Signifying Absence: Experiencing Monochrome Imagery in Medieval Painting." In Louise Bordua and Robert Gibbs (eds.), *A Wilder Trecento: Studies in 14th–Century European Art Presented to Julian Gardner*. Leiden: Brill.

Bakhilina, Natalia. 1975. *Istorija tsvetooboznachenij v russkom jazyke* (A History of Color Terms in the Russian Language). Moscow: Nauka.

Banham, Joanne. 1977. *Encyclopaedia of Interior Design*, vol. 2. Chicago: Fitzroy Dearborn.

Baran, Neculai V. 1983. "Les caractéristiques essentielles du vocabulaire chromatique latin: Aspect général, étapes du développement, sens figurés, valeur stylistique, circulation." In Wolfgang Haase and Hildegard Temporini (eds.), *Aufstieg und Niedergang der Römischen Welt*, vol. 2, part 29. Berlin: De Gruyter.

Barber, Richard, and Juliet Barker. 1989. *Tournaments: Jousts, Chivalry and Pageants in the Middle Ages*. Woodbridge: Boydell.

Bardiès-Fronty, Isabelle, Charlotte Denoël, and Inès Villela-Petit, eds. 2016. *Les temps Mérovingiens; trois siècles d'art et de culture (451–751)*. Paris: Éditions de la Réunion des Musées Nationaux.

Bauman, Johanna. 2002. "Tradition and Transformation: The Pleasure Garden in Piero de' Crescenzi's *Liber ruralium commodorum*." *Studies in the History of Gardens and Designed Landscapes*, 22(2): 99–141, 101.

Bédat, Isabelle, and Béatrice Girault-Kurtzeman. 2004. "The Technical Study of the Bayeux Embroidery." In Pierre Bouet, Brian Levy, and François Neveux (eds.), *The Bayeux Tapestry: Embroidering the Facts of History: Proceedings of the Cerisy Colloquium (1999)*. Caen: Presses Universitaires de Caen.

Bede. 1994. *On the Tabernacle*. Translated by Arthur G. Holder. Liverpool: Liverpool University Press.

Bede. 2013. *Bede: Commentary on Revelation*. Translated by Faith Wallis. Liverpool: Liverpool University Press.

Bede. n.d. *Historia ecclesiastica gentis anglorum: liber secundus*. Available online: http://www.thelatinlibrary.com/bede/bede2.shtml (accessed May 23, 2020).

Belting, Hans. 1994. *Likeness and Presence: A History of the Image before the Era of Art*. Translated by Edmund Jephcott. Chicago: University of Chicago Press.

Benhamou, Reed. 1984. "Verdigris and the Entrepreneuse." *Technology and Culture*, 25: 171–81.

Bennewitz, Ingrid, and Andrea Schindler, eds. 2012. *Farbe im Mittelalter: Materialität—Medialität—Semantik*. 2 vols. Berlin: De Gruyter.

Berlin, Brent, and Paul Kay. 1969. *Basic Color Terms: Their Universality and Evolution*. Berkeley: University of California Press.

Berns, Roy S. 2012. "Image Simulation of the Blue Background in Pacino di Bonaguida's Chairito Tabernacle Using Color and Imaging Sciences." In Christine Sciacca (ed.), *Florence at the Dawn of the Renaissance: Painting and Illumination, 1300–1350*. Los Angeles: J. Paul Getty Museum.

Bicchieri, Marina. 2014. "The Purple Codex Rossanensis: Spectroscopic Characterization and First Evidence of the Use of the Elderberry Lake in a 6th-century Manuscript." *Environmental Science and Pollution Research*, 21: 14150. Available online: https://www.researchgate.net/publication/262985784 (accessed May 23, 2020).

Biggam, Carole Patricia. 1997. *Blue in Old English: An Interdisciplinary Semantic Study*. Amsterdam: Rodopi.

Biggam, Carole Patricia. 1998. *Grey in Old English: An Interdisciplinary Semantic Study*. London: Runetree Press.

Biggam, Carole Patricia. 2001. "*Ualdenegi* and the Concept of Strange Eyes." In Christian J. Kay and Louise M. Sylvester (eds.), *Lexis and Texts in Early English: Studies Presented to Jane Roberts*. Amsterdam: Rodopi.

Biggam, Carole Patricia. 2006a. "Knowledge of Whelk Dyes and Pigments in Anglo-Saxon England." *Anglo-Saxon England*, 35: 23–55.

Biggam, Carole Patricia. 2006b. "Political Upheaval and a Disturbance in the Colour Vocabulary of Early English." In Carole Patricia Biggam and Christian J. Kay (eds.), *Progress in Colour Studies*, vol. 1, *Language and Culture*. Amsterdam: John Benjamins.

Biggam, Carole Patricia. 2010. "The Development of the Basic Colour Terms of English." In Alaric Hall, Olga Timofeeva, Ágnes Kiricsi, and Bethany Fox (eds.), *Interfaces Between Language and Culture in Medieval England: A Festschrift for Matti Kilpiö*. Leiden: Brill.

Biggam, Carole Patricia. 2012. *The Semantics of Colour: A Historical Approach*. Cambridge: Cambridge University Press.

Bill, Jan. 2008. "Viking Ships and the Sea." In Stefan Brink (ed.), in collaboration with Neil Price, *The Viking World*. London: Routledge.

Binski, Paul. 1986. *The Painted Chamber at Westminster*. London: Society of Antiquaries of London.

Bioletti, Susan, Rory Leahy, John Fields, Bernard Meehan, and Werner Blau. 2009. "The Examination of the Book of Kells Using Micro-Raman Spectroscopy." *Journal of Raman Spectroscopy*, 40: 1043–9.

Biron, Isabelle, Pete Dandridge, Mark T. Wypyski, and Michel Vandevyver. 1996. "Techniques and Materials in Limoges Enamels." In John P. O'Neill, Teresa Egan, Margaret Aspinall, Cynthia Clark, Kathleen Howard, Mary E.D. Laing, Jacolyn A. Mott, and Ellen Shultz (eds.), *Enamels of Limoges, 1100–1350*. New York: Metropolitan Museum of Art and Harry N. Abrams.

Bleeke, Marian. 2010. "Versions of Pygmalion in the Illuminated Roman de la Rose (Oxford, Bodleian Library, Ms. Douce 195): The Artist and the Work of Art." *Art History*, 33(1): 28–53.

Blockmans, Wim. 1988. "Rituels publics." In Walter Prevenier (ed.), *Princes et bourgeois: Images de la société dans les Pays-Bas bourguignons 1384–1530*. Antwerp: Mercatorfonds.

Blockmans, Wim, and Esther Donckers. 1999. "Self-Representation of Court and City in Flanders and Brabant in the Fifteenth and Early Sixteenth Centuries." In Wim Blockmans and Antheun Janse (eds.), *Showing Status: Representations of Social Positions in the Late Middle Ages*. Turnhout: Brepols.

Boccaccio, Giovanni. 2011. *The Decameron*. Translated by G.H. McWilliam. London: Penguin.

Boldrick, Stacy, David Park, and Paul Williamson, eds. 2002. *Wonder: Painted Sculpture from Medieval England*. Leeds: Henry Moore Institute.

Bolman, Elizabeth. 1999. "De Coloribus: The Meanings of Color in Beatus Manuscripts." *Gesta*, 38(1): 22–34.

Bologna, Ferdinando. 1975. *Il soffitto della Sala Magna allo Steri di Palermo e la cultura feodale siciliana nell'autunno del medioevo*. Palermo: Flaccovio.

Bomford, David, Jill Dunkerton, Dillian Gordon, Ashok Roy, with Jo Kirby. 1990. *Art in the Making: Italian Painting before 1400*. London: National Gallery.

Bond, Melanie. 2019. *Dressing the Scottish Court, 1543–1553: Clothing in the Accounts of the Lord High Treasurer of Scotland*. Woodbridge: Boydell and Brewer.

Bonne, Jean-Claude. 1983. "Rituel de la couleur: Fonctionnement et usage des images dans le sacramentaire de Saint-Étienne de Limoges." In Dominique Ponneau (ed.), *Image et signification: Rencontres de l'École du Louvre*. Paris: Éditions Léopard d'Or.

Borenius, Tancred. 1943. "The Cycle of Images in the Palaces and Castles of Henry III." *Journal of the Warburg and Courtauld Institutes*, 6: 40–50.

Borsook, Eve. 1980. *The Mural Painters of Tuscany: From Cimabue to Andrea del Sarto*. 2nd edn. Oxford: Clarendon Press.

Borsook, Eve. 1998. *Messages in Mosaic: The Royal Programmes of Norman Sicily (1130–1187)*. Woodbridge: Boydell Press.

Bourdieu, Pierre. 1984. *Distinction: A Social Critique of the Judgement of Taste*. Cambridge, MA: Harvard University Press.

Boust, Clotilde, Anne Maigret, and Jérôme Rumolo. 2018. "Étude par imagerie scientifique de la tapisserie de Bayeux." In Sylvette Lemagnen, Shirley Ann Brown, and Gale Owen-Crocker (eds.), *L'invention de la Tapisserie de Bayeux: naissance, composition et style d'un chef-d'oeuvre médiéval*. Colloque international, Musée de la Tapisserie de Bayeux, 22–25 septembre 2016. Bayeux: Point de Vues / Ville de Bayeux.

Boyer, Carl. 1959. *The Rainbow: From Myth to Mathematics*. New York: Yoseloff.

Bradley, Mark. 2009. *Colour and Meaning in Ancient Rome*. Cambridge: Cambridge University Press.

Bradley, S.A.J. 1982. *Anglo-Saxon Poetry*. London: Dent.

Brate, Erik, and Elias Wessén. 1924–36. *Södermanlands runinskrifter*. Stockholm: Norstedt; Uppsala: Almqvist and Wiksell.

Brepols. n.d. "Library of Latin Texts—online (LLT-O)." Available online: http://www.brepols.net/Pages/BrowseBySeries.aspx?TreeSeries=LLT-O (accessed May 26, 2020).

Broecke, Lara, ed. and trans. 2015. *Cennino Cennini's* Il libro dell'arte. London: Archetype.

Brøndsted, Johannes. 1965. *The Vikings*. Translated by Kalle Skov. Harmondsworth: Penguin.

Brook, George Leslie, ed. 1964. *The Harley Lyrics: The Middle English Lyrics of MS. Harley 2253*. 3rd edn. Manchester: Manchester University Press.

Brown, Amelia R. 2007. "Painting the Bodiless: Angels and Eunuchs in Byzantine Art and Culture." Available online: https://www.academia.edu/506467/Painting_the_Bodiless_Angels_and_Eunuchs_in_Byzantine_Art_and_Culture (accesssed May 23, 2020).

Brown, Katherine L., and Robin J.H. Clark. 2004. "The Lindisfarne Gospels and Two Other 8th Century Anglo-Saxon/Insular Manuscripts: Pigment Identification by Raman Microscopy." *Journal of Raman Spectroscopy*, 35: 4–12.

Brown, Michelle P. 2011. *The Lindisfarne Gospels and the Early Medieval World*. London: British Library.

Browne, Clare, and Michaela Zöschg. 2016. "The Bologna Cope." In Clare Browne, Glyn Davies, and M.A. Michael with the assistance of Michaela Zöschg (eds.), *English Medieval Embroidery, Opus Anglicanum*. New Haven, CT: Yale University Press; London: Victoria and Albert Museum.

Browne, Clare, Glyn Davies, and M.A. Michael, eds. 2016. *English Medieval Embroidery: Opus Anglicanum*. New Haven, CT: Yale University Press.

Bruce-Mitford, Rupert L.S. 1978. *The Sutton Hoo Ship-Burial, 2: Arms, Armour and Regalia*. London: British Museum Publications.

Bruce-Mitford, Rupert L.S., with Sheila Raven. 2005. *The Corpus of Late Celtic Hanging-Bowls*. Oxford: Oxford University Press.

Brückmann, Georg C. 2012. *Altwestnordische Farbsemantik*. Munich: Herbert Utz Verlag.

Brugmann, Birte. 2004. *Glass Beads from Anglo-Saxon Graves: A Study of the Provenance and Chronology of Glass Beads from Early Anglo-Saxon Graves Based on Visual Examination*. Oxford: Oxbow.

Bucklow, Spike. 2009. *The Alchemy of Paint: Art, Science and Secrets from the Middle Ages*. London: Marion Boyars.

Bucklow, Spike. 2014. "Reflections and Translations: Carving and Painting Rood Screens." In Noelle Streeton and Kaja Kollandsrud (eds.), *Paint and Piety: Collected Essays on Medieval Painting and Polychrome Sculpture*. London: Archetype.

Buckton, David. 1986. "Late 10th- and 11th-Century Cloisonné Enamel Brooches." *Medieval Archaeology*, 30: 8–18.

Buko, Andrzej. 2008. *The Archaeology of Early Medieval Poland: Discoveries—Hypotheses—Interpretations*. Leiden: Brill.

Burns, Thea. 2017. Compositiones variae: *A Late Eighth-Century Craftsman's Technical Treatise Reconsidered*. London: Archetype.

Butterworth, Philip. 2014. *Staging Conventions in Medieval English Theatre*. Cambridge: Cambridge University Press.

Bynum, Caroline W. 2011. *Christian Materiality. An Essay on Religion in Late Medieval Europe*. New York: Zone Books.

Callegari, Adolfo. 1925. *La casa del Petrarca in Arqua e il suo ultimo restauro*. Padua: Penada.

Camille, Michael. 1996. *Gothic Art: Visions and Revelations of the Medieval World*. London: Weidenfeld and Nicolson.

Campbell, Alistair, ed. 1967. *Æthelwulf, De abbatibus*. Oxford: Clarendon Press.

Campbell, James. 1982. "The Lost Centuries: 400–600." In James Campbell, Eric John, and Patrick Wormald (eds.), *The Anglo-Saxons*. Oxford: Phaidon.

Campbell, Marian. 2009. *Medieval Jewellery in Europe, 1100–1500*. London: V&A Publishing.

Cardon, Dominique. 2007. *Natural Dyes: Sources, Tradition, Technology and Science*. London: Archetype.

Carruthers, Mary. 1990. *The Book of Memory: A Study of Memory in Medieval Culture*. Cambridge: Cambridge University Press.

Cather, Sharon, David Park, and Paul Williamson, eds. 1990. *Early Medieval Wall Painting and Painted Sculpture in England*. Oxford: British Archaeological Reports.

Caviness, Madeline. 1998. "Hildegard as Designer of the Illustrations to Her Works." In Peter Dronke and Charles Burnett (eds.), *Hildegard of Bingen: The Context of her Thought and Art*. London: Warburg Institute.

Caviness, Madeline. 2008. "From the Self-Invention of the Whiteman in the Thirteenth Century to *The Good, the Bad and the Ugly*." *Different Visions: A Journal of New Perspectives in Medieval Art* 1: 1–33.

Charisius, Flavius Sosipater. 1964. *Flavii Sosipatri Charisii Ars grammaticae libri V*. Edited by Carolus [Karl] Barwick. Rev. edn. Leipzig: Teubner.

Chatzidakis, Nano. 2008. "Icons." In Robin Cormack and Maria Vassilaki (eds.), *Byzantium 330–1453*. London: Royal Academy of Arts.

Chaucer, Geoffrey. 1987. *The Riverside Chaucer*. Edited by Larry D. Benson. 3rd edn. Oxford: Oxford University Press.

Chaucer, Geoffrey. 2009. *The Canterbury Tales*. Translated by Burton Raffel. London: Penguin.

Chenu, Marie-Dominique. 1968. *Nature, Man and Society in the Twelfth Century: Essays on New Theological Perspectives in the Latin West*. Toronto: University of Toronto Press.

Chibnall, Marjorie. 1993. *Anglo-Norman England, 1066–1166*. Oxford: Blackwell.

Childs, Wendy R. 2010. "Painters' Materials and the Northern International Trade Routes of Late Medieval Europe." In Jo Kirby, Susie Nash, and Joanna Cannon (eds.), *Trade in Artists' Materials: Markets and Commerce in Europe to 1700*. London: Archetype.

Clarke, Helen, and Kristina Lamm, eds. 2004. *Excavations at Helgö XVI: Exotic and Sacral Finds from Helgö*. Stockholm: Almqvist and Wiksell.

Clarke, Mark. 2011. *Mediaeval Painters' Materials and Techniques: The Montpellier Liber diversarum arcium*. London: Archetype.

Coatsworth, Elizabeth, and Gale R. Owen-Crocker. 2018. *Clothing the Past: Surviving Garments from Early Medieval to Early Modern Western Europe*. Leiden: Brill.

Cocheris, H., ed. 1860. *Le blason des couleurs en armes*. Paris: Aubry. Available online: https://archive.org/details/leblasondescoul00sicigoog (accessed May 23, 2020).

Cockayne, T.O. 1865. *Leechdoms, Wortcunning and Starcraft of Early England*, vol. 2. London: Longman, Green.

Colgrave, Bertram, ed. 1927. *Eddius Stephanus, Life of Bishop Wilfrid*. Cambridge: Cambridge University Press.

Constable, Giles. 1967. *The Letters of Peter the Venerable*. 2 vols. Cambridge, MA: Harvard University Press.

Constable, Giles. 1987. "The Ceremonies and Symbolism of Entering Religious Life and Taking the Monastic Habit, from the Fourth to the Twelfth Century." *Segni e riti nella chiesa altomedievale occidentale*, 33: 771–834.

Cooper, Donal. 2017. "Recovering the Lost Rood Screens of Medieval and Renaissance Italy." In Spike Bucklow, Richard Marks, and Lucy Wrapson (eds.), *The Art and Science of the Church Screen in Medieval Europe: Making, Meaning and Preserving*. Woodbridge: Boydell and Brewer.

Corpus Corporum. n.d. "Home." University of Zurich. Available online: http://mlat. uzh.ch/MLS/index.php?lang=0 (accessed May 26, 2020).

Crane, Susan. 2002. *The Performance of Self: Ritual, Clothing, and Identity during the Hundred Years War*. Philadelphia: University of Pennsylvania Press.

Crawford, Jackson. 2016. "*Bleikr, Gulr*, and the Categorization of Color in Old Norse." *Journal of English and Germanic Philology*, 115: 239–52.

Creasy, Edward. 1869. *History of England from the Earliest to the Present Time*, vol. 1. London: James Walton.

Crowfoot, Elisabeth, Frances Pritchard, and Kay Staniland. 1992. *Textiles and Clothing c.1150–c.1450*. London: HMSO.

Currey, Ralph Nixon, trans. 1969. *Formal Spring: French Renaissance Poems of Charles d'Orléans and Others*. Freeport: Books for Libraries Press.

Cutler, Anthony. 2008. "At Court." In Robin Cormack and Maria Vassilaki (eds.), *Byzantium 330–1453*. London: Royal Academy of Arts.

Dachs, Monika. 1993. "Zur ornamentalen Freskendekoration des Florentiner Wohnhauses im späten 14. Jahrhundert." *Mitteilungen des Kunsthistorischen Instituts in Florenz*, 37(1): 71–129.

Dahl, Camilla Luise. 2009. "*Mengiað klæthe* and *tweskifte klædher*. Marbled, Patterned and Parti-Coloured Clothing in Medieval Scandinavia." In Kathrine Vestergård Pedersen and Marie-Louise B. Nosch (eds.), *The Medieval Broadcloth: Changing Trends in Fashions, Manufacturing and Consumption*. Oxford: Oxbow Books.

Dale, Thomas E.A. 2012. "Transcending the Major/Minor Divide: Romanesque Mural Painting, Colour, and Spiritual Seeing." In Colum Hourihane (ed.), *From Minor to Major: The Minor Arts in Medieval Art History*. Princeton, NJ: Princeton University Press.

Daniec, Jadwiga Irena. 1971. "Poland's Romanesque Art within European Artistic Currents: Discoveries Since the Second World War." *Polish Review* 16(3): 59–70.

Daniéloue, Jean. 1960. *The Bible and the Liturgy*. Darton: Longman and Todd.

Davidson, Clifford. 1977. *Drama and Art: An Introduction to the Use of Evidence from the Visual Arts for the Study of Early Drama*. Kalamazoo: Medieval Institute, Western Michigan University.

Davidson, Clifford. 1991. *Illustrations of the Stage and Acting in England to 1580*. Kalamazoo: Medieval Institute, Western Michigan University.

Davies, Brian H. 2003. "Did the Medieval Illuminator Know How to Prevent Oxidative Damage?" *Dyes in History and Archaeology*, 19: 24–31.

Davies, Norman. 1984. *God's Playground: A History of Poland*, vol. 1. New York: Columbia University Press.

de Gruben, Francoise. 1997. *Les chapitres de la Toison d'Or à l'époque bourguignonne (1430–1477)*. Leuven: Leuven University Press.

De Hamel, Christopher. 2001. *The British Library Guide to Manuscript Illumination: History and Techniques*. London: British Library.

Deimling, Barbara. 1997. "Medieval Church Portals and their Importance in the History of Law." In Rolf Toman (ed.), *Romanesque: Architecture, Sculpture, Painting*. Cologne: Konemann.

DeLancey, Julia A. 2010. "Shipping Colour: *Valute*, Pigments, Trade and Francesco di Marco Datini." In Jo Kirby, Susie Nash, and Joanna Cannon (eds.), *Trade in Artists' Materials: Markets and Commerce in Europe to 1700*. London: Archetype.

Della Porta, Giambattista. 2018. "De refractione." In A. Mark Smith (ed. and trans.), *Optical Magic in the Late Renaissance*. Philadelphia: American Philosophical Society.

Demus, Otto. 1970. *Byzantine Art and the West, The Wrightsman Lecture*. New York: New York University Press.

Devisse, Jean. 2010. "The Black and His Color: From Symbols to Realities." In David Bindman and Henry Louis Gates (eds.), *The Image of the Black in Western Art*, vol. 2, *From the Early Christian Era to the "Age of Discovery,"* Part 1, *From the Demonic Threat to the Incarnation of Sainthood*. New edn. Cambridge, MA: Belknap Press.

Dictionary of Old English A to H Online (DOE). 2016. Edited by Angus Cameron et al. Toronto: Dictionary of Old English Project.

Dijon—BM. n.d. "ms._0173." Available online: http://www.enluminures.culture.fr/documentation/enlumine/fr/BM/dijon_129-01.htm (accessed May 24, 2020).

Dodwell, Charles Reginald. 1982. *Anglo-Saxon Art: A New Perspective*. Manchester: Manchester University Press.

Dodwell, Charles Reginald. 1993. *The Pictorial Arts of the West 800–1200*. New Haven, CT: Yale University Press.

Drauschke, Jörg. 2010. "Byzantine Jewellery? Amethyst Beads in East and West during the Early Byzantine Period." In C. Entwistle and N. Adams (eds.), *"Intelligible Beauty": Recent Research on Byzantine Jewellery*. London: British Museum Press.

Dronke, Peter. 1972. "Tradition and Innovation in Medieval Western Color-imagery." *Eranos Jahrbuch*, 41: 51–107.

Dunlop, Anne. 2009. *Painted Palaces: The Rise of Secular Art in Early Renaissance Italy*. University Park: Pennsylvania State University Press.

Etimologicheskij slovar' russkogo jazyka (ESRJa) (Etymological Dictionary of the Russian Language). 1996. By Max Vasmer. Translated and edited by Oleg Trubachëv. 3rd Russian edn. 4 vols. Moscow: Terra.

Etimologicheskij slovar' slavjanskikh jazykov (ESSJa) (Etymological Dictionary of the Slavic Languages). 1974–. vols 1–. Moscow: Nauka.

Etymologický slovník jazyka staroslověnského (ESJS) (Etymological Dictionary of the Old Church Slavonic Language).1989–. vols 1–. Prague: Academy of Sciences of the Czech Republic.

Evangelatou, Maria. 2003. "The Purple Thread of the Flesh: The Theological Connotations of a Narrative Iconographic Element in Byzantine Images of the Annunciation." In Antony Eastmond and Liz James (eds.), *Icon and Word: The Power of Images in Byzantium: Studies Presented to Robin Cormack*. Aldershot: Ashgate.

Evison, Vera I. 2008. *Catalogue of Anglo-Saxon Glass in the British Museum*. London: British Museum Press.

Fayet, Sylvie. 1992. "Le regard scientifique sur les couleurs à travers quelques encyclopédistes latin du XIIe siècle." *Bibliothèque de l'École des Chartes*, 150: 51–70.

Fern, Chris, Tania Dickinson, and Leslie Webster, eds. 2019. *The Staffordshire Hoard: An Anglo-Saxon Treasure*. London: Society of Antiquaries.

Fernie, Eric Campbell. 2014. *Romanesque Architecture: The First Style of the European Age*. New Haven, CT: Yale University Press.

FitzHugh, Elisabeth West. 1986. "Red Lead and Minium." In Robert L. Feller (ed.), *Artists' Pigments: A Handbook of their History and Characteristics*, vol. 1. Cambridge: Cambridge University Press; Washington, DC: National Gallery of Art.

FitzHugh, Elisabeth West. 1997. "Orpiment and Realgar." In Elizabeth West FitzHugh (ed.), *Artists' Pigments: A Handbook of their History and Characteristics*, vol. 3. Washington, DC: National Gallery of Art; Oxford: Oxford University Press.

Folda, Jaroslav. 2015. *Byzantine Art and Italian Panel Painting: The Virgin and Child Hodegetria and the Art of Chrysography*. Cambridge: Cambridge University Press.

Forsyth, Ilene H. 1972. *Throne of Wisdom: Wood Sculptures of the Madonna in Romanesque France*. Princeton, NJ: Princeton University Press.

Foy, Danièle. 2000. "Technologie, géographie, économie: les ateliers de verriers primaires et secondaires en Occident: Esquisse d'une évolution de l'Antiquité au Moyen Âge." In *La route du verre: Ateliers primaires et secondaires du second millénaire av. J.-C. au Moyen Âge; Colloque organisé en 1989 par l'Association Française pour l'Archéologie du Verre (AFAV)*. Lyon: Maison de l'Orient et de la Méditerranée Jean Pouilloux.

Frankopan, Peter. 2015. *The Silk Roads: A New History of the World*. London: Bloomsbury.

Freestone, Ian C. 1992. "Theophilus and the Composition of Medieval Glass." In Pamela B. Vandiver, James R. Druzik, George Segan Wheeler, and Ian C. Freestone (eds.), *Materials Issues in Art and Archaeology III; Symposium Held April 27–May 1, 1992, San Francisco, California, U.S.A.* Pittsburgh: Materials Research Society.

Freestone, Ian C., and Mavis Bimson. 1995. "Early Venetian Enamelling on Glass: Technology and Origins." In Pamela B. Vandiver, James R. Druzik, José Luis Galvan Madrid, Ian C. Freestone, and George Segan Wheeler (eds.), *Materials Issues in Art and Archaeology IV; Symposium Held May 16–21,1994, Cancún, Mexico*. Pittsburgh: Materials Research Society.

Freestone, Ian C., Michael J. Hughes, and Colleen P. Stapleton. 2008. "The Composition and Production of Anglo-Saxon Glass." In Vera I. Evison (ed.), *Catalogue of Anglo-Saxon Glass in the British Museum*. London: British Museum Press.

Friedman, John Block. 2000. *The Monstrous Races in Medieval Art and Thought*. New York: Syracuse University Press.

Friedman, John Block. 2013. "The Iconography of Dagged Clothing and its Reception by Moralist Writers." *Medieval Clothing and Textiles*, 9: 120–38.

Friedman, John Block. 2018. "Eyebrows, Hairlines, and 'Hairs Less in Sight': Female Depilation in Late Medieval Europe." *Medieval Clothing and Textiles*, 14: 81–112.

Fuchs, Robert, and Doris Oltrogge. 1994. "Colour Material and Painting Technique in the Book of Kells." In Felicity O. Malhoney (ed.), *The Book of Kells: Proceedings of a Conference at Trinity College, Dublin, 6–9 September 1992*. Aldershot: Ashgate.

Gaborit-Chopin, Danielle. 1991. *Le trésor de Saint-Denis*. Dijon: Éditions Faton.

Gaborit-Chopin, Danielle. 2005. *La France romane au temps des premiers Capétiens (987–1152): Paris, Musée du Louvre, 10 mars–6 juin 2005*. Paris: Musée du Louvre.

Gaborit-Chopin, Danielle, Elisabeth Taburet-Delahaye, and M.-C. Bardoz. 2001. *Le trésor de Conques*. Paris: Éditions du Patrimoine.

Gabrieli, Bernardo Oderzo. 2012. "L'inventario della spezieria di Pietro Fasolis e il commercio dei materiali per la pittura nei documenti piemontesi (1332–1453). Parte prima." *Bollettino della Società Storica Pinerolese*, 29: 7–43.

Gabrieli, Bernardo Oderzo. 2013. "L'inventario della spezieria di Pietro Fasolis e il commercio dei materiali per la pittura nei documenti piemontesi (1332–1453). Parte seconda." *Bollettino della Società Storica Pinerolese*, 30: 7–53.

Gärtner, Otto, and Anja Schliebitz. 1993. "History." In Otto Gärtner and Anja Schliebitz, *Baedeker's Sicily*. English edn. by Alec Court. Peterborough: Jarrold.

Gage, John. 1993. *Colour and Culture: Practice and Meaning from Antiquity to Abstraction*. London: Thames and Hudson.

Gage, John. [1993] 2009. *Colour and Culture: Practice and Meaning from Antiquity to Abstraction*. 4th edn. London: Thames and Hudson.

Gage, John. 1999. *Color and Meaning: Art, Science, and Symbolism*. London: Thames and Hudson.

Garrison, Eliza. 2012. *Ottonian Imperial Art and Portraiture: The Artistic Patronage of Otto III and Henry II*. Farnham: Ashgate.

Gem, R., and E. Howe. 2008. "The Ninth-Century Polychrome Decoration at St Mary's Church, Deerhurst." *Antiquaries Journal*, 88: 109–64.

Gerevini, Stefania. 2014. "Christus crystallus: Rock Crystal, Theology, and Materiality in the Medieval West." In James Robinson, Lloyd de Beer, with Anna Harnden (eds.), *Matter of Faith: An Interdisciplinary Study of Relics and Relic Veneration in the Medieval Period*. London: British Museum.

Gettens, Rutherford J., and Elizabeth West FitzHugh. 1993a. "Azurite and Blue Verditer." In Ashok Roy (ed.), *Artists' Pigments: A Handbook of their History and Characteristics*, vol. 2. Washington, DC: National Gallery of Art; Oxford: Oxford University Press.

Gettens, Rutherford J., and Elizabeth West FitzHugh. 1993b. "Malachite and Green Verditer." In Ashok Roy (ed.), *Artists' Pigments: A Handbook of their History and Characteristics*, vol. 2. Washington, DC: National Gallery of Art; Oxford: Oxford University Press.

Gettens, Rutherford J., Robert L. Feller, and W.T. Chase. 1993a. "Vermilion and Cinnabar." In Ashok Roy (ed.), *Artists' Pigments: A Handbook of their History and Characteristics*, vol. 2. Washington, DC: National Gallery of Art; Oxford: Oxford University Press.

Gettens, Rutherford J., Hermann Kühn, and W.T. Chase. 1993b. "Lead White." In Ashok Roy (ed.), *Artists' Pigments: A Handbook of their History and Characteristics*, vol. 2. Washington, DC: National Gallery of Art; Oxford: Oxford University Press.

Godman, Peter. 1985. *Poetry of the Carolingian Renaissance*. London: Duckworth.

Goldberg, Martin. 2015. "Out of a Roman World, c.AD 250–650." In Julia Farley and Frazer Hunter (eds.), *Celts: Art and Identity*. London: British Museum Press.

Goolden, Peter, ed. 1958. *The Old English Apollonius of Tyre*. London: Oxford University Press.

Goy, Richard J. 1992. *The House of Gold: Building a Palace in Medieval Venice.* Cambridge: Cambridge University Press.

Graham-Campbell, James. 2013. *Viking Art.* London: Thames and Hudson.

Gratuze, Bernard, Isabelle Soulier, Jean-Noël Barrandon, and Danièle Foy. 1995. "The Origin of Cobalt Blue Pigments in French Glass from the Thirteenth to the Eighteenth Centuries." In Duncan R. Hook and David R.M. Gaimster (eds.), *Trade and Discovery: The Scientific Study of Artefacts from Post-Medieval Europe and Beyond.* London: Department of Scientific Research, British Museum.

Green, Caitlin. 2015. "A Great Host of Captives? A Note on Vikings in Morocco and Africans in Early Medieval Ireland and Britain." [Blog] September 12. Available online: http://www.caitlingreen.org/2015/09/a-great-host-of-captives.html (accessed May 23, 2020).

Grinberg, Ana. 2017. "Robes, Turban and Beard: 'Ethnic Passing' in *Decameron* 10.9." *Medieval Clothing and Textiles,* 13: 67–81.

Grodecki, Louis. 1976. *Les vitraux de Saint-Denis: étude sur le vitrail au XIIe siècle.* Paris: Centre national de la recherche scientifique.

Grosse, Rolf. 2004. *Suger en question: Regards croisés sur Saint-Denis.* Munich: Oldenburg.

Grosseteste, Robert. 1912. "De iride." In Ludwig Bauer (ed.), *Die philosophischen Werke des Robert Grosseteste, Bischofs von Lincoln.* Münster: Aschendorff.

Grosseteste, Robert. 2013. "De colore." In Greti Dinkova-Bruun, Giles Gasper, Michael Huxtable, Tom McLeish, Cecilia Panti, and Hannah Smithson (eds. and trans.), *The Dimensions of Colour: Robert Grosseteste's* De Colore. Toronto: Pontifical Institute.

Grossmann, Maria. 1988. *Colori e lessico: Studi sulla struttura semantica degli aggettivi di colore in catalano, castigliano, italiano, romeno, latino ed ungherese.* Tübingen: Gunter Narr.

Grossmann, Maria, and Paolo D'Achille. 2016. "Italian Colour Terms in the BLUE Area: Synchrony and Diachrony." In João Paulo Silvestre, Esperança Cardeira, and Alina Villalva (eds.), *Colour and Colour Naming: Crosslinguistic Approaches.* Lisbon: Centro de Linguística da Universidade de Lisboa, and Universidade de Aveiro.

Guido, Margaret. 1999. *The Glass Beads of Anglo-Saxon England c. AD 400–700: A Preliminary Visual Classification of the More Definitive and Diagnostic Types.* London: Society of Antiquaries.

Hadjadj, Reine. 2007. *Bagues Mérovingiennes: Gaule du Nord.* Paris: Chevau-Légers.

Hahn, Thomas. 2001. "The Difference the Middle Ages Makes: Color and Race before the Modern World." *Journal of Medieval and Early Modern Studies,* 31(1): 1–37.

Hamburger, Jeffrey, 1989. "The Visual and the Visionary: The Image in Late Medieval Monastic Devotions." *Viator,* 20: 161–81.

Hamburger, Jeffrey, and Robert Suckale. 2008. "Between this World and the Next: The Art of Religious Women in the Middle Ages." In Jeffrey Hamburger and Susan Marti (eds.), *Crown and Veil: Female Monasticism from the Fifth to the Fifteenth Centuries.* New York: Columbia University Press.

Harf-Lancner, Laurence, trans. *Le roman d'Alexandre.* 1994. Paris: Librairie Générale Française.

Harrison, Dick, and Kristina Svensson. 2007. *Vikingaliv.* Värnamo: Fälth and Hässler.

Haseloff, Günther. 1990. *Email im frühen Mittelalter: Frühchristliche Kunst von der Spätantike bis zu den Karolingern.* Marburg: Hitzeroth.

Hassig, Debra. 1999. "The Iconography of Rejection: Jews and Other Monstrous Races." In Colum Hourihane (ed.), *Image and Belief: Studies in Celebration of the Eightieth Anniversary of the Index of Christian Art*. Princeton, NJ: Princeton University Press.

Hawthorne, John G., and Cyril Stanley Smith, eds. and trans. 1979. *Theophilus: On Divers Arts*. New York: Dover.

Hayward, Maria. 2012a–j. "Budge," "Coney," "Ermine," "Fox," "Lambskin," "Lettice," "Marten," "Miniver," "Sable," "Squirrel fur." In Gale R. Owen-Crocker, Elizabeth Coatsworth, and Maria Hayward (eds.), *Encyclopedia of Dress and Textiles in the British Isles c. 450–1450*. Leiden: Brill.

Heaney, Seamus, trans. 2001. *Beowulf: A New Verse Translation*. New York: Norton.

Heck, Martin, Thilo Rehren, and Peter Hoffmann. 2003. "The Production of Lead-Tin Yellow at Merovingian Schleitheim (Switzerland)." *Archaeometry*, 45: 33–44.

Helwig, Kate. 2007. "Iron Oxide Pigments, Natural and Synthetic." In Barbara H. Berrie (ed.), *Artists' Pigments: A Handbook of their History and Characteristics*, vol. 4. Washington, DC: National Gallery of Art; London: Archetype.

Henderson, George. 1999. *Vision and Image in Early Christian England*. Cambridge: Cambridge University Press.

Hendrix, Harald. 2008. "The Early Modern Invention of Literary Tourism: Petrarch's Houses in France and Italy." In H. Hendrix (ed.), *Writers' Houses and the Making of Memory*. New York: Routledge.

Heng, Geraldine. 2014. "An African Saint in Medieval Europe: The Black St Maurice and the Enigma of Racial Sanctity." In Vincent William Lloyd and Molly Harbour Bassett (eds.), *Saints and Race: Marked Flesh, Holy Flesh*. New York: Routledge.

Herne, Gunnar. 1954. *Die slavischen Farbenbenennungen: Eine semasiologisch-etymologische Untersuchung*. Uppsala: Almquist and Wiksell.

Herrero Carretero, Concha. 1988. *Museo de telas medievales: Monasterio de Santa María la Real de Huelgas*. Madrid: Patrimonio Nacional.

Hildegard, St. 1990. *Scivias*. New York: Paulist Press.

Hildegard, St. 2018. *The Book of Divine Works*. Washington, DC: Catholic University of America Press.

Hill, Peter M. 2014. "Selected Lexical-Semantic Groups (Colour Terms, Kinship Terms)." In Karl Gutschmidt, Sebastian Kempgen, Tilman Berger, and Peter Kosta (eds.), *Die slavischen Sprachen/The Slavic Languages: Ein internationales Handbuch zu ihrer Struktur, ihrer Geschichte und ihrer Erforschung = An International Handbook of their Structure, their History and their Investigation*, vol. 2. Berlin: De Gruyter Mouton.

Hills, Paul. 1999. *Venetian Colour: Marble, Mosaic, Painting and Glass, 1250–1550*. New Haven, CT: Yale University Press.

Hinton, David. 2000. *A Smith in Lindsey. The Anglo-Saxon Grave at Tattershall Thorpe, Lincolnshire*. London: Society for Medieval Archaeology.

Hinton, David. 2005. *Gold and Gilt, Pots and Pins. Possessions and People in Medieval Britain*. Oxford: Oxford University Press.

Hinton, David. 2008. *The Alfred Jewel and Other Late Anglo-Saxon Decorated Metalwork*. Oxford: Ashmolean Museum.

Hiscock, Nigel. 2003. *The White Mantle of Churches: Architecture, Liturgy, and Art around the Millennium*. Turnhout: Brepols.

Historical Needlework Resources. n.d. "Welcome." Available online: https://medieval.webcon.net.au/ (accessed May 24, 2020).

Historical Thesaurus of the Oxford English Dictionary with Additional Material from A
 Thesaurus of Old English (HTOED). 2009. By Christian Kay, Jane Roberts, Michael
 Samuels, and Irené Wotherspoon. 2 vols. Oxford: Oxford University Press.
Horgan, Frances, trans. *The Romance of the Rose*. 1999. Oxford: Oxford University
 Press.
Hough, Carole. 2006. "Colours of the Landscape: Old English Colour Terms in
 Place Names." In Carole P. Biggam, and Christian J. Kay (eds.), *Progress in Colour
 Studies*, vol. 1. Amsterdam: Benjamins.
Hourihane, Colum, ed. 2010. *Looking Beyond: Visions, Dreams, and Insights in
 Medieval Art & History*. Princeton, NJ: Princeton University Press.
Howard, Helen. 2003. *Pigments of English Medieval Wall Painting*. London:
 Archetype.
Hugo de S. Victore. 1854. "Commentariorum in hierarchiam coelestem S. Dionysii
 Areopagitae secundum interpretationem Joannis Scoti..." In Jacques-Paul Migne
 (ed.), *Patrologiae cursus completus, series Latina*, vol. 175. Paris: Migne. Available
 online: http://patristica.net/latina/ (accessed May 23, 2020).
Huxtable, Michael J. 2008. "Colour, Seeing, and Seeing Colour in Medieval
 Literature." PhD thesis, Durham University.
Huxtable, Michael J. 2014. "The Relationship of Light and Colour in Medieval
 Thought and Imagination." In Kenneth P. Clarke and Sarah Baccianti (eds.),
 On Light. Oxford: Society for the Study of Medieval Languages and Literature.
Hyer, Maren Clegg, and Gale R. Owen-Crocker. 2013. "Woven Works: Making
 and Using Textiles." In Maren Clegg Hyer and Gale R. Owen-Crocker (eds.), *The
 Material Culture of Daily Living in the Anglo-Saxon World*. Liverpool: Liverpool
 University Press.
Isidore of Seville. 2006. *Etymologies*. Translated by Stephen A. Barney, W.J. Lewis,
 J.A. Beach, and Oliver Berghof. Cambridge: Cambridge University Press.
J. Paul Getty Museum. n.d. "The Vision of Zechariah." Available online: http://www.
 getty.edu/art/collection/objects/105136/unknown-maker-the-vision-of-zechariah-
 italian-about-1300/ (accessed May 24, 2020).
Jackson, Deirdre. 2016. "Colour and Meaning." In Stella Stoyanova, with Deirdre
 Jackson and Paola Ricciardi (eds.), *Colour: The Art & Science of Illuminated
 Manuscripts*. Turnhout: Brepols.
Jacoby, David. 2009. "Venetian Commercial Expansion in the Eastern Mediterranean
 8th–11th Centuries." In Marlia Mundell Mango (ed.), *Byzantine Trade, 4th–12th
 Centuries: The Archaeology of Local, Regional and International Exchange. Papers of
 the 38th Spring Symposium of Byzantine Studies*. Farnham: Ashgate.
James, Edward. 1982. *The Origins of France: From Clovis to the Capetians 500–1000*.
 Basingstoke: Macmillan.
James, Edward. 1988. *The Franks*. Oxford: Basil Blackwell.
James, Liz. 2008. "At Church." In Robin Cormack and Maria Vassilaki (eds.),
 Byzantium 330–1453. London: Royal Academy of Arts.
Jenkins, Marilyn. 1993. "al-Andalus: Crucible of the Mediterranean." In John P.
 O'Neill (ed.), *The Art of Medieval Spain, A.D. 500–1200*. New York: Metropolitan
 Museum of Art.
Jobst, Christoph. 2002. "Das Soester Kreuzigungsretabel in der Berliner
 Gemäldegalerie und das Kreuz aus St. Kathartinenthal im Basler Historischen
 Museum." In Barbara Mundt (ed.), *Fragen an ein Kunstwerk im Museum:*

Kolloquium für Barbara Mundt im Berliner Kunstgewerbe-Museum. Berlin: Verein der Freunde des Kunstgewerbemuseums.

Jørgensen, Lars, Birger Storgaard, and Lone Gebauer Thomsen, eds. 2003. *The Spoils of Victory: The North in the Shadow of the Roman Empire.* Copenhagen: National Museum.

Johnstone, Pauline. 2002. *High Fashion in the Church: The Place of Church Vestments in the History of Art from the Ninth to the Nineteenth Century.* Leeds: Maney.

Jolly, Penny Howell. 2002. "Marked Difference: Earrings and 'the Other' in Fifteenth-Century Flemish Art." In Désirée G. Koslin and Janet E. Snyder (eds.), *Encountering Medieval Textiles and Dress: Objects, Texts, Images.* New York: Palgrave Macmillan.

Jónas Kristjánsson. 1980. *Icelandic Sagas and Manuscripts.* Reykjavík: Iceland Review.

Jung, Jacqueline. 2010. "The Tactile and the Visionary: Notes on the Place of Sculpture in the Medieval Religious Imagination." In Colum Hourihane (ed.), *Looking Beyond: Visions, Dreams, and Insights in Medieval Art & History.* Princeton, NJ: Princeton University Press.

Kaplan, Paul. 1985. *The Rise of the Black Magus in Western Art.* Studies in the Fine Arts, Iconography, 9. Ann Arbor, MI: UMI Research.

Kaplan, Paul. 2010. "Introduction to the New Edition," In David Bindman and Henry Louis Gates (eds.), *The Image of the Black in Western Art,* vol. 2, part 1, *From the Demonic Threat to the Incarnation of Sainthood.* Cambridge, MA: Belknap Press.

Kargère, Lucretia, and Adriana Rizzo. 2010. "Twelfth-Century French Polychrome Sculpture in the Metropolitan Museum of Art: Materials and Techniques." *Metropolitan Museum Studies in Art, Science, and Technology,* 1: 39–72.

Kauffmann, Michael. 1984. "Bible: The Bury Bible, Part I, Genesis–Job." In George Zarnecki, Janet Holt, and Tristram Holland (eds.), *English Romanesque Art 1066–1200: Hayward Gallery, London, 5 April–8 July 1984.* London: Weidenfeld and Nicholson; Arts Council of Great Britain.

Kay, Paul, Brent Berlin, Luisa Maffi, William Merrifield, and Richard Cook. 2009. *The World Color Survey.* Stanford, CA: CSLI Publications.

Kerttula, Seija. 2002. *English Colour Terms: Etymology, Chronology and Relative Basicness.* Helsinki: Société Néophilologique.

Kessler, Herbert L. 1996. "The Function of *vitrum vestitum* and the Use of *materia saphirorum* in Suger's St. Denis." In Jerome Baschet and Jean-Claude Schmitt (eds.), *L'Image: Fonctions et usages des images dan l'Occident médiéval.* Paris: Le Léopard d'Or.

Kessler, Herbert L. 2004. *Seeing Medieval Art.* Peterborough, ONT: Broadview Press.

Keynes, Simon. 2018. "The Emergence of a Kingdom of England." In Claire Breay and Joanna Story (eds.), *Anglo-Saxon Kingdoms: Art, Word, War.* London: British Library.

Kirby, Jo, Maarten van Bommel, and André Verhecken. 2014. *Natural Colorants for Dyeing and Lake Pigments: Practical Recipes and their Historical Sources.* London: Archetype and CHARISMA.

Kirchner, Eric. 2015. "Color Theory and Color Order in Medieval Islam: A Review," *Color Research and Application,* 40: 5–16. https://doi.org/10.1002/col.21861.

Kirchner, Eric, and Mohammed Bagheri. 2013. "Color Theory in Medieval Islamic Lapidaries: Nīshābūrī, Tūsī and Kāshānī." *Centaurus,* 55: 1–19.

Kitson, Peter. 1978. "Lapidary Traditions in Anglo-Saxon England: Part I, the Background; the Old English Lapidary." *Anglo-Saxon England,* 7: 9–60.

Kitson, Peter. 1983. "Lapidary Traditions in Anglo-Saxon England: Part II, Bede's *Explanatio apocalypsis* and Related Works." *Anglo-Saxon England*, 12: 73–123.

Klemettilä, Hannele. 2006. *Epitomes of Evil: Representation of Executioners in Northern France and the Low Countries in the Late Middle Ages*. Turnhout: Brepols.

König, Günter. 1957. "Die Bezeichnungen für Farbe, Glanz und Helligkeit im Altenglischen." PhD thesis, Johannes Gutenberg University of Mainz.

Kohler, Wilhelm. 1941. "Byzantine Art in the West." *Dumbarton Oaks Papers*, 1: 61–87.

Kollandsrud, Kaja. 2014. "A Perspective on Medieval Perception of Norwegian Church Art." In N.L.W. Streetom and K. Kollandsrud (eds.), *Paint and Piety: Collected Essays on Medieval Painting and Polychrome Sculpture*. London: Archetype.

Kollmorgen, Gregor. 2009. "Catholic Bamberg: The Vestments of Pope Clement II and Other Treasures from the Diocesan Museum." New Liturgical Movement, May 29. Available online: http://www.newliturgicalmovement.org/2009/05/catholic-bamberg-vestments-of-pope.html#.WhndgVVl-Uk (accessed May 26, 2020).

Kornbluth, Genevra. 1995. *Engraved Gems of the Carolingian Empire*. University Park: Pennsylvania State University Press.

Koslin, Désirée G. 2002. "Value-added Stuffs and Shifts in Meaning: An Overview and Case Study of Medieval Textile Paradigms." In Désirée G. Koslin and Janet E. Snyder (eds.), *Encountering Medieval Textiles and Dress: Objects, Texts, Images*. New York: Palgrave Macmillan.

Kowalska-Pietrzak, Anna. 2007. "History of Poland During the Middle Ages." In E. Bielawska Batorowicz (ed.), *Poland: History, Culture and Society*. Lodz: Wydawnictwo Uniwersytetu Łódzkiego.

Krapp, George Philip. 1931. *The Junius Manuscript*. New York: Columbia University Press.

Krapp, George Philip, and Elliott Van Kirk Dobbie. 1936. *The Exeter Book*. New York: Columbia University Press.

Kristol, Andres M. 1978. *Color: Les langues romanes devant le phénomène de la couleur*. Berne: Francke.

Kühn, Hermann. 1993a. "Lead-Tin Yellow." In Ashok Roy (ed.), *Artists' Pigments: A Handbook of their History and Characteristics*, vol. 2. Washington, DC: National Gallery of Art; Oxford: Oxford University Press.

Kühn, Hermann. 1993b. "Verdigris and Copper Resinate." In Ashok Roy (ed.), *Artists' Pigments: A Handbook of their History and Characteristics*, vol. 2. Washington, DC: National Gallery of Art; Oxford: Oxford University Press.

Kul'pina, Valentina. 2007. "Sistema tsvetooboznachenij russkogo jazyka v istoricheskom osveshchenii" (A System of Russian Color Terms from the Historical Perspective). In Alexander Vasilevich (ed.), *Naimenovanija tsveta v indoevropejskikh jazykakh: sistemnyj i istoricheskij analiz* (Terms of Color in Indo-European Languages: Systematic and Historical Analysis). Moscow: KomKniga.

Kunicki-Goldfinger, Jerzy J., Ian C. Freestone, Iain McDonald, Jan A. Hobot, Heather Gilderdale-Scott, and Tim Ayers. 2014. "Technology, Production and Chronology of Red Window Glass in the Medieval Period—Rediscovery of a Lost Technology." *Journal of Archaeological Science*, 41: 89–105.

Kvlividze, Nina. 2002. "Bes: Izobrazhenija" (Demon: Pictures). In *Pravoslavnaja Enciklopedija* (Orthodox Encyclopedia), vol. 4. Available online: http://www. pravenc.ru/text/78216.html#part_2 (accessed May 23, 2020).

La Niece, Susan, Stefan Röhrs, and Bet McLeod, eds. 2010. *The Heritage of* Maître Alpais: *An International and Interdisciplinary Examination of Medieval Limoges Enamel and Associated Objects*. London: British Museum.

Lachaud, Frédérique. 2002. "Dress and Social Status in England before the Sumptuary Laws." In Peter Coss and Maurice Keen (eds.), *Heraldry, Pageantry and Social Display in Medieval England*. Woodbridge: Boydell.

Lambert, Bart. 2006. *The City, the Duke and their Banker: The Rapondi Family and the Formation of the Burgundian State (1384–1430)*. Turnhout: Brepols.

Lamm, Jan Peder, and Hans-Åke Nordström, eds. 1983. *Vendel Period Studies: Transactions of the Boat-grave Symposium in Stockholm, February 2–3, 1981*. Stockholm: Statens Historiska Museum.

Lapidge, Michael, and James Rosier, trans. 1985. *Aldhelm: The Poetic Works*. Cambridge: Brewer.

Larsen, Henning, ed. 1931. *An Old Icelandic Medical Miscellany: MS Royal Irish Academy 23 D 43 with Supplement from MS Trinity College (Dublin) L-2-27*. Oslo: Dybwad.

Lasansky, D. Medina. 2004a. *The Renaissance Perfected: Architecture, Spectacle, and Tourism in Fascist Italy*. University Park: Pennsylvania State University Press.

Lasansky, D. Medina. 2004b. "Urban Editing, Historic Preservation, and Political Rhetoric: The Fascist Redesign of San Gimignano." *Journal of the Society of Architectural Historians*, 63(3): 320–53.

Lasko, Peter. 1994. *Ars sacra 800–1200*. New Haven, CT: Yale University Press.

Latham, Ronald E. 1976. *The Travels of Marco Polo*. Harmondsworth: Penguin.

Le Goff, Jacques. 2009. *Saint Louis*. Translated by Gareth Evan Gollrad. Notre Dame, IN: University of Notre Dame Press.

Le Nain de Tillemont, Louis Sébastien. 1847–51. *Vie de Saint Louis, roi de France*. Paris: Renouard.

Lecuppre-Desjardin, Elodie. 2004. *La ville des cérémonies: Essai sur la communication politique dans les anciens Pays-Bas bourguignons*. Turnhout: Brepols.

Leyser, Karl. 1983. "The Crisis of Medieval Germany." *Proceedings of the British Academy, London*, 69: 409–43.

Lindberg, David. 1966. "Roger Bacon's Theory of the Rainbow: Progress or Regress?" *Isis*, 57: 235–48.

López, Gisela Ripoll. 1993. "The Formation of Visigothic Spain." In John P. O'Neill (ed.), *The Art of Medieval Spain, A.D. 500–1200*. New York: Metropolitan Museum of Art.

Lyons, John. 1999. "The Vocabulary of Color with Particular Reference to Ancient Greek and Classical Latin." In A. Borg (ed.), *The Language of Colour in the Mediterranean*. Wiesbaden: Otto Harrassowitz.

MacGregor, Arthur. 1985. *Bone, Antler, Ivory and Horn*. London: Croom Helm.

Mactaggart, Peter, and Ann Mactaggart. 1980. "Refiners' Verditers." *Studies in Conservation*, 25: 37–45.

Magocsi, Paul Robert. 1996. *A History of Ukraine*. Seattle: University of Washington Press.

Maguire, Henry. 2008. "From Constantine to Iconoclasm." In Robin Cormack and Maria Vassilaki (eds.), *Byzantium 330–1453*. London: Royal Academy of Arts.

Mandeville, John. 2011. *The Book of John Mandeville with Related Texts*. Edited and translated by Iain Macleod Higgins. Indianapolis, IN: Hackett.

Mango, Cyril. 2008. "Byzantium: A Historical Introduction." In Robin Cormack and Maria Vassilaki (eds.), *Byzantium 330–1453*. London: Royal Academy of Arts.

Marti, Susan, Till-Holger Borchert, and Gabriele Keck, eds. 2008. *Splendeurs de la cour de Bourgogne*. Brussels: Mercatorfonds.

Martin, Janet. 2009. "The First East Slavic State." In Abbott Gleason (ed.), *A Companion to Russian History*. Chichester: Wiley-Blackwell.

Martindale, Andrew. 1967. *Gothic Art*. London: Thames and Hudson.

Marzinzik, Sonja. 2013. *Masterpieces: Early Medieval Art*. London: British Museum Press.

Massing, Ann, ed. 2004. *The Thornham Parva Retable: Technique, Conservation and Context of an English Medieval Painting*. London: Harvey Miller.

Materialy dlja slovarja drevnerusskogo jazyka (MSDRJa) (Materials for the Dictionary of the Old Russian Language). 1893–1912. 3 vols. St. Petersburg: Imperial Academy of Sciences.

Mayr-Harting, Henry. 1991. *Ottonian Book Ilumination: An Historical Study*. Oxford: Harvey Miller.

Mayr-Harting, Henry. 1999. *Ottonian Book Illumination: An Historical Study*. 2nd edn. London: Harvey Miller.

Meek, Christine. 2014. "Clothing Distrained for Debt in the Court of Merchants of Lucca in the Late Fourteenth Century." *Medieval Clothing and Textiles*, 10: 97–128.

Meier, Christel. 1972. "Die Bedeutung der Farben im Werk Hildegards von Bingen." *Frühmittelalterliche Studien*, 6: 245–355.

Meier, Christel, and Rudolph Suntrup. 2011. *Lexikon der Farben-bedeutungen im Mittelalter*. Cologne: Böhlau.

Mellinkoff, Ruth. 1993. *Outcasts: Signs of Otherness in North European Art of the Late Middle Ages*. 2 vols. Berkeley: University of California Press.

Menghin Wilfried, Tobias Springer and Egon Wamers, eds. 1987. *Germanen, Hunnen und Awaren: Schätze der Völkerwanderungszeit*. Nürnberg: Verlag Germanisches Nationalmuseum.

Mezentsev, Volodymyr I. 1987. "The Masonry Churches of Medieval Chernihiv." *Harvard Ukrainian Studies*, 11(3/4): 365–83.

Michler, Jürgen. 1989. "La Cathédrale Notre-Dame de Chartres: Reconstitution de la polychromie originale de l'intérieur." *Bulletin monumental*, 147: 117–31.

Migne, Jacques-Paul. 1862. "Patrologiae cursus completus: sive biblioteca universalis,integra uniformis, commoda, oeconomica." Internet Archive. Available online: https://archive.org/details/patrologiaecurs63unkngoog (accessed May 26, 2020).

Migne, Jacques-Paul, ed. 1863. *Alcuin, Adversus Elipandum*. Paris: Migne.

Miller, Maureen C. 2014. *Clothing the Clergy: Virtue and Power in Medieval Europe c. 800–1200*. Ithaca, NY: Cornell University Press.

Monnas, Lisa. 2012. "Cloth of Gold." In Gale R. Owen-Crocker, Elizabeth Coatsworth, and Maria Hayward (eds.), *Encyclopedia of Dress and Textiles in the British Isles c. 450–1450*. Leiden: Brill.

Monnas, Lisa. 2014. "Some Medieval Colour Terms for Textiles." *Medieval Clothing and Textiles*, 10: 25–57.

Morgan, Nigel. 2016a. "Embroidered Textiles in the Service of the Church." In Clare Browne, Glyn Davies, and M.A. Michael (eds.), *English Medieval Embroidery: Opus Anglicanum*. New Haven, CT: Yale University Press.

Morgan, Nigel. 2016b. "Modelling in Manuscript Painting, c.1050–c.1500." In Stella
 Panayotova, with Deirdre Jackson and Paola Ricciardi (eds.), *Colour: The Art &*
 Science of Illuminated Manuscripts. Turnhout: Brepols.
Morgan, Nigel, and Elizabeth Moody. 2016. "Grisaille in Manuscript Painting
 c. 1320–c. 1450." In Stella Panayotova, with Deirdre Jackson and Paola Ricciardi
 (eds.), *Colour: The Art & Science of Illuminated Manuscripts*. Turnhout: Brepols.
Müller-Christensen, Sigrid. 1960. *Das Grab des Papstes Clemens II im Dom zu*
 Bamberg. Munich: Bruckmann.
Munns, John. 2016. *Cross and Culture in Anglo-Norman England: Theology, Imagery,*
 Devotion. Woodbridge: Boydell Press.
Munro, John H. 1983. "The Medieval Scarlet and the Economics of Sartorial
 Splendour." In N.B. Harte and K.G. Ponting (eds.), *Cloth and Clothing in Medieval*
 Europe: Essays in Memory of Professor E.M. Carus-Wilson. London: Heinemann.
Munro, John H. 2007. "The Anti-red Shift—To the Dark Side: Colour Changes in
 Flemish Luxury Woollens, 1300–1500." *Medieval Clothing and Textiles*, 3: 55–95.
Munro, John H. 2012. "Scarlet." In Gale R. Owen-Crocker, Elizabeth Coatsworth,
 and Maria Hayward (eds.), *Encyclopedia of Dress and Textiles in the British Isles*
 c. 450–1450. Leiden: Brill.
Munro, John H., and Gale R. Owen-Crocker. 2012. "Purple." In Gale R. Owen-
 Crocker, Elizabeth Coatsworth, and Maria Hayward (eds.), *Encyclopedia of Dress*
 and Textiles in the British Isles c. 450–1450. Leiden: Brill.
Murjanov, Mikhail. 2008. "K interpretacii staroslavjanskikh tsvetooboznachenij"
 (Towards the Interpretation of Old Church Slavonic Color Terms). In Mikhail
 Murjanov, *Istorija knizhnoj kul'tury Rossii. Ocherki* (Essays on the History of
 Russian Written Culture), vol. 2. Rev. edn. St. Petersburg: Mir.
Museo del Prado. n.d. "Triptych of the Adoration of the Magi." Available online:
 https://www.museodelprado.es/en/the-collection/art-work/triptych-of-the-adoration-
 of-the-magi/0efd3706-0f54-4a23-87e3-dc8cd930e85a (accessed May 26, 2020).
Muthesius, Anna. 2008. *Studies in Byzantine, Islamic and Near Eastern Silk Weaving*.
 London: Pindar Press.
Najemy, John M. 2008. *A History of Florence 1200–1575*. Oxford: Blackwell.
Nash, Susie. 2000. "The Parement de Narbonne: Context and Technique." In Caroline
 Villers (ed.), *The Fabric of Images: European Paintings on Textile Supports in the*
 Fourteenth and Fifteenth Centuries. London: Archetype.
Nash, Susie. 2008. "'The Lord's Crucifix of Costly Workmanship': Colour,
 Collaboration and the Making of Meaning on the Well of Moses." In Vinzenz
 Brinkmann, Oliver Primavesi, and Max Hollein (eds.), *Circumlitio: The Polychromy*
 of Antique and Mediaeval Sculpture. Frankfurt: Liebieghaus Skulpturensammlung.
Nash, Susie. 2010. "'Pour couleurs et autres choses prise de lui …': The Supply,
 Acquisition, Cost and Employment of Painters' Materials at the Burgundian Court,
 c.1375–1419." In Jo Kirby, Susie Nash, and Joanna Cannon (eds.), *Trade in Artists'*
 Materials: Markets and Commerce in Europe to 1700. London: Archetype.
National Museum in Szczecin. n.d. "Middle Ages." Photograph 14/17. Available
 online: https://muzeum.szczecin.pl/en/collections/archaeology/middle-ages.
 html#fancybox-14 (accessed May 24, 2020).
Nelson, Janet L. 1994. "Kingship and Empire." In Rosamund McKitterick (ed.),
 Carolingian Culture: Emulation and Innovation. Cambridge: Cambridge University
 Press.

Newton, Stella Mary. 1980. *Fashion in the Age of the Black Prince: A Study of the Years 1340–1365*. Woodbridge: Boydell.

Nockert, Margareta. 1985. *Bockstenmannenoch hans Dräkt*. Falkenberg: Stiftelsen Hallends Länsmuseer.

Normanskaya, Julia. 2005. *Genezis i razvitije sistem cvetooboznachenij v indoevropejskikh jazykakh* (Origin and Development of the Systems of Color Terms in Indo-European Languages). Moscow: Institute of Linguistics of the Russian Academy of Sciences.

Norseng, Per G. 2010. "The Trade in Painters' Materials in Norway in the Middle Ages. Part 1: The 'Silent' Trade in Painters' Materials in Norway in the High Middle Ages." In Jo Kirby, Susie Nash, and Joanna Cannon (eds.), *Trade in Artists' Materials: Markets and Commerce in Europe to 1700*. London: Archetype.

Norton, Christopher, and David Park. 2012. *Cistercian Art and Architecture in the British Isles*. Cambridge: Cambridge University Press.

O'Donnell, James. 2005. *Augustine: A New Biography*. New York: Ecco.

O'Donoghue, Bernard, trans. 2007. *Sir Gawain and the Green Knight*. New York: Penguin.

O'Neill, John P., editor-in-chief. 1993. *The Art of Medieval Spain, A.D. 500–1200*. New York: Metropolitan Museum of Art. Available online: http://cdm16028. contentdm.oclc.org/cdm/compoundobject/collection/p15324coll10/id/111171 (accessed May 23, 2020).

Oanta-Marghitu, Rodica, Gheorghe Niculescu, Doina Seclâman, Roxana Bugoi, and Migdonia Georgescu. 2009. "The Gold Belt Buckle from Apahida III (Romania), 5th Century AD." *ArcheoSciences* 33: 227–33. https://doi.org/10.4000/archeosciences.2250.

Oellermann, E. 2015. "On the Imitation of Textile Structures in Late Gothic Polychromy and Panel Painting." In Johannes Taubert (ed.), *Polychrome Sculpture: Meaning, Form, Conservation*. Translated by Carola Schulman. Los Angeles: Getty Conservation Institute.

Oledzka, Eva. 2016. *Medieval & Renaissance Interiors in Illuminated Manuscripts*. London: British Library Publications.

Oniga, Renato. 2007. "La terminologia del colore in latino tra relativismo e universalismo." *Aevum Antiquum*, 7: 269–84.

Oresme, Nicole. 1974. "Nicole Oresme on Light, Color, and the Rainbow: An Edition and Translation, with Introduction and Critical Notes, of Part of Book Three of his *Questiones super quatuor libros Meterororum*." PhD thesis, University of Wisconsin, Madison.

Orna, Mary Virginia, Manfred J.D. Low, and Norbert S. Baer. 1980. "Synthetic Blue Pigments: Ninth to Sixteenth Centuries. I. Literature." *Studies in Conservation*, 25: 53–63.

Orna, Mary Virginia, Manfred J.D. Low, and Maureen M. Julian. 1985. "Synthetic Blue Pigments: Ninth to Sixteenth Centuries. II. 'Silver blue'." *Studies in Conservation*, 30: 155–60.

Ostrogorsky, Georg. 1996. *Byzantinische Geschichte 324–1453*. Munich: Beck.

Owen-Crocker, Gale R. 2004. *Dress in Anglo-Saxon England*. Rev. edn. Woodbridge: Boydell.

Owen-Crocker, Gale R. 2012. "Naming of Cloths." In Gale R. Owen-Crocker, Elizabeth Coatsworth, and Maria Hayward (eds.), *Encyclopedia of Dress and Textiles in the British Isles c. 450–1450*. Leiden: Brill.

Packer, Leila, and Jennifer Sliwka. 2017. *Monochrome: Painting in Black and White*. London: National Gallery.

Palazzo, Eric. 2010a. "Art et liturgie: Nouvelles approches athropologique et épistémologique." *Anales de Historia del Arte* (extra issue 2): 31–74.

Palazzo, Eric. 2010b. "Visions and Liturgical Experience in the Early Middle Ages." In Colum Hourihane (ed.), *Looking Beyond: Visions, Dreams, and Insights in Medieval Art & History*. Princeton, NJ: Princeton University Press.

Palladino, Pia. 2003. *Treasures of a Lost Art: Italian Manuscript Painting of the Middle Ages and Renaissance*. New Haven, CT: Yale University Press.

Panayotova, Stella. 2016. "Colour in Illuminated Manuscripts." In Stella Panayotova, with Deirdre Jackson and Paola Ricciardi (eds.), *Colour: The Art & Science of Illuminated Manuscripts*. Turnhout: Brepols.

Panayotova, Stella, Deirdre Elizabeth Jackson, and Paolo Riccardi. 2016. *Colour: The Art & Science of Illuminated Manuscripts*. London: Harvey Miller.

Pannier, Léopold. 1882. *Lapidaires français des XIIe, XIIIe, et XIVe siècles*. Paris: Vieweg.

Panzanelli, Roberta. 2008. "Beyond the Pale: Polychromy and Western Art." In Roberta Panzanelli, Eike D. Schmidt, and Kenneth Laptin (eds.), *The Colour of Life: Polychromy in Sculpture from Antiquity to the Present*. Los Angeles: J. Paul Getty Museum.

Park, David. 2002. "The Polychromy of English Medieval Sculpture." In Stacy Boldrick, David Park, and Paul Williamson (eds.), *Wonder: Painted Sculpture from Medieval England*. Leeds: Henry Moore Institute.

Parkhurst, Charles. 1990. "Roger Bacon on Color: Sources, Theories & Influence." In Karl-Ludwig Selig and Elizabeth Sears (eds.), *The Verbal and the Visual: Essays in Honor of William Sebastian Heckscher*. New York: Italica Press.

Pastoureau, Michel. 1985. "Vizi e virtù dei colori nella sensibilità medievale." *Rassegna* 23(3): 5–13.

Pastoureau, Michel. 1986. *Figures et couleurs: Études sur la symbolique et la sensibilité médiévales*. Paris: Le Léopard d'Or.

Pastoureau, Michel. 1987. *L'uomo e il colore*. Florence: Giunti.

Pastoureau, Michel. 1989a. *Couleurs, images, symboles: Études d'histoire et d'anthropologie*. Paris: Éditions Léopard d'Or.

Pastoureau, Michel. 1989b. "L'Église et la couleur, des origines à la Réforme." *Bibliothèque de l'École des Chartes*, 147: 203–30.

Pastoureau, Michel. 2000. *Bleu: Histoire d'une couleur*. Paris: Le Seuil.

Pastoureau, Michel. 2001a. *Blue: The History of a Color*. Translated by Mark Cruse. Princeton, NJ: Princeton University Press.

Pastoureau, Michel. 2001b. *The Devil's Cloth: A History of Stripes and Striped Fabric*. Translated by Jody Gladding. New York: Columbia University Press.

Pastoureau, Michel. 2004. *Une histoire symbolique du Moyen Âge*. Paris: Le Seuil.

Pastoureau, Michel. 2008. *Noir: Histoire d'une couleur*. Paris: Le Seuil.

Pastoureau, Michel. 2009. *Black: The History of a Color*. Translated by Jody Gladding. Princeton, NJ: Princeton University Press.

Pastoureau, Michel 2012. *The Colour of Our Memories*. Cambridge: Polity Press.

Pastoureau, Michel. 2013. *Vert: Histoire d'une couleur*. Paris: Le Seuil.

Pastoureau, Michel. 2014. *Green: The History of a Colour*. Translated by Jody Gladding. Princeton, NJ: Princeton University Press.

Pastoureau, Michel. 2016. *Rouge: Histoire d'une couleur*. Paris: Le Seuil.

Pastoureau, Michel. 2017. *Red: The History of a Color*. Princeton, NJ: Princeton University Press.

Patterson, Catherine, Alan Phenix, and Karen Trentelman. 2012. "Scientific Investigation of Painting Practices and Materials in the Work of Pacino di Bonaguida." In Christine Sciacca (ed.), *Florence at the Dawn of the Renaissance: Painting and Illumination, 1300–1350*. Los Angeles: J. Paul Getty Museum.

Patton, Pamela. 2016. "An Ethiopian-Headed Serpent in the Cantigas de Santa Maria: Sin, Sex, and Color in Late Medieval Castile." *Gesta*, 55(2): 213–38.

Peake, James R.N., and Ian C. Freestone. 2012. "Cross-Craft Interactions between Metal and Glass Working: Slag Additions to Early Anglo-Saxon Red Glass." In Wendy Meulebroeck, Karin Nys, Dirk Vanclooster, and Hugo Thienpont (eds.), *Integrated Approaches to the Study of Historical Glass—IAS12. Proceedings of SPIE—The International Society for Optical Engineering* 8422, 842204: 1–12.

Pegolotti, Francesco Balducci. 1936. *La pratica della mercatura*. Edited by Allan Evans. Cambridge, MA: Mediaeval Academy of America.

Pentcheva, Bissera. 2016. "Glittering Eyes: Animation in the Byantine *Eikōn* and the Western *Imago*." *Codex Aquilarensis*, 32: 209–36.

Périn, Patrick, Michel Kazanski, and Françoise Vallet, eds. 2001. *L'Or des princes barbares. Du Caucase à la Gaule, Ve siècle après J.-C.* Paris: Éditions de la Réunion des Musées Nationaux.

Perrin, M., ed. 1997. *Rabani Mauri In honorem sanctae crucis*, 2 vols., *Corpus Christianorum Continuatio Medievalis*. Turnhout.

Petrarch. 2002. *Canzoniere: Selected Poems*. Translated by Anthony Mortimer. London: Penguin.

Petzold, Andreas. 1992. "His Face like Lightning: Colour as Signifier in the Representation of the Holy Women at the Tomb." *Arte Medievale*, 6: 149–55.

Petzold, Andreas. 1995. *Romanesque Art*. London: Weidenfeld and Nicolson.

Petzold, Andreas. 1999. "Of the Significance of Colours: The Iconography of Colour in Romanesque and Early Gothic Book Illumination." In Colum Houricane (ed.), *Image and Belief: Studies in Celebration of the Eightieth Anniversary of the Index of Christian Art*. Princeton, NJ: Princeton University Press.

Petzold, Andreas. 2016. "The Iconography of Color." In Colum Hourihane (ed.), *The Routledge Companion to Medieval Iconography*. New York: Routledge.

Petzold, Andreas. 2018. "The Use of Colour in Romanesque Manuscript Illumination." In Chloë N. Duckworth and Anne E. Sassin (eds.), *Colour and Light in Ancient and Medieval Art*. New York: Ashgate; Abingdon: Routledge.

Phleps, Hermann. 1930. *Die farbige Architektur bei den Römern und im Mittelalter*. Berlin: Wasmuth.

Plahter, Unn. 2004. *Painted Altar Frontals of Norway, 1250–1350*, vol. 2, *Materials and Technique*. London: Archetype.

Plahter, Unn. 2010. "The Trade in Painters' Materials in Norway in the Middle Ages. Part 2: Materials, Techniques and Trade from the Twelfth Century to the Mid-Fourteenth Century." In Jo Kirby, Susie Nash, and Joanna Cannon (eds.), *Trade in Artists' Materials: Markets and Commerce in Europe to 1700*. London: Archetype.

Plato. 2000. *Timaeus*. Translated by Donald Zeyl. Indianapolis, IN: Hackett.

Pleij, Herman. 2004. *Colors Demonic and Divine: Shades of Meaning in the Middle Ages and After*. Translated by Diane Webb. New York: Columbia University Press.

Plesters, Joyce. 1993. "Ultramarine Blue, Natural and Artificial." In Ashok Roy (ed.), *Artists' Pigments: A Handbook of their History and Characteristics*, vol. 2. Washington, DC: National Gallery of Art; Oxford: Oxford University Press.

Plotinus. 1956. *The Enneads*. Translated by Stephen MacKenna. 2nd edn. Revised by B.S. Page. London: Faber.

Pochat, Götz. 1990. *Theater und bildende Kunst: im Mittelalter und in der Renaissance in Italien*. Graz: Akademische Druck u. Verlagsanstatt.

Polo, Marco. 2016. *The Description of the World*. Translated by Sharon Kinoshita. Indianapolis, IN: Hackett.

Porck, Thijs. 2019. *Old Age in Early Medieval England: A Cultural History*. Woodbridge: Boydell.

Porck, Thijs. 2020. "Gerontophobia in Early Medieval England: Anglo-Saxon Reflections on Old Age." In Maren Clegg Hyer and Gale R. Owen-Crocker (eds.), *Sense and Feeling in Daily Living in the Anglo-Saxon World*. Liverpool: Liverpool University Press.

Prache, Anne. 2008. *Notre-Dame de Chartres: Image de la Jérusalem céleste*. Paris: Centre National De La Recherche Scientifique.

Pratt, David. 2003. "Persuasion and Invention at the Court of King Alfred the Great." In Catherine Cubitt (ed.), *Court Culture in the Early Middle Ages: Proceedings of the First Alcuin Conference*. Turnhout: Brepols.

Prevenier, Walter, ed. 1998. *Princes et bourgeois: Images de la société dans les Pays-Bas Bourguignons 1384–1530*. Antwerp: Mercatorfonds.

Prevenier, Walter, and Wim Blockmans. 1984. *The Burgundian Netherlands*. Cambridge: Cambridge University Press.

Pseudo-Aristotle. 1984. "On Colours." Translated by T. Loveday and E.S. Forster. In Jonathan Barnes (ed.), *The Complete Works of Aristotle*. Princeton, NJ: Princeton University Press.

Ptolemy. 1996. "Optics." In A. Mark Smith (ed. and trans.), *Ptolemy's Theory of Visual Perception*. Philadelphia: American Philosophical Society.

Pulliam, Heather. 2011. "Looking to Byzantium: Light, Colour, and Cloth in the Book of Kells Virgin and Child Page." In Colum Houricane (ed.), *Insular and Anglo-Saxon Thought in the Early Medieval Period*. Princeton, NJ: Princeton University Press.

Pulliam, Heather. 2012. "Color." "Medieval Art History Today—Critical Terms." Special issue of *Studies in Iconography*, 33: 3–14.

Quandt, Abigail. 2018. "The Purple Codices: A report on current and future research and conservation treatments." In M. J. Driscoll (ed.) *Care and Conservation of Manuscripts*, 16. Copenhagen.

Raffel, Burton, trans. 2009. *Song of the Cid*. New York: Penguin.

Rakhilina, Ekaterina. 2007. "O semantike prilagatel'nykh cveta" (On the Semantics of the Adjectives of Color). In Alexander Vasilevich (ed.), *Naimenovanija tsveta v indoevropejskikh jazykakh: sistemnyj i istoricheskij analiz* (Terms of Color in Indo-European Languages: Systematic and Historical Analysis). Moscow: KomKniga.

Rapp-Buri, Anna, and Monica Stucky-Schürer. 2001. *Burgundische Tapisserien*. Munich: Hirmer Verlag.

Reilly, Bernard F. 1993. "Medieval Spain, A.D. 500–1200". In John P. O'Neill (ed.), *The Art of Medieval Spain, A.D. 500–1200*. New York: Metropolitan Museum of Art.

Reynolds, Roger. 1999. "Clerical Liturgical Vestments and Liturgical Colors in the Middle Ages." In Roger Reynolds (ed.), *Clerics in the Early Middle Ages: Hierarchy and Image*. Aldershot: Ashgate.

Ricciardelli, Fabrizio. 2007. *The Politics of Exclusion in Early Renaissance Florence.* Turnhout: Brepols.

Richter, Ernst Ludwig. 1988. "Seltene Pigmente im Mittelalter." *Zeitschrift für Kunsttechnologie und Konservierung,* 2: 171–7.

Roberts, Jane, and Christian Kay with Lynn Grundy. 1995. *A Thesaurus of Old English in Two Volumes.* London: King's College Centre for Late Antique and Medieval Studies.

Roesdahl, Else. 1991. *The Vikings.* London: Penguin.

Roller, Stefan. 2008. "The Polychromy of Mediaeval Sculpture: A Brief Overview." In Vinzenz Brinkmann, Oliver Primavesi, and Max Hollein (eds.), *Circumlitio: The Polychromy of Antique and Mediaeval Sculpture.* Frankfurt: Liebieghaus Skulpturensammlung.

Romano, Elisa. 2003. "Il lessico latino dei colori: il punto sulla situazione." In Simone Beta, and Maria Michela Sassi (eds.), *I colori nel mondo antico: esperienze linguistiche e quadri simbolici.* Siena: Cadmo.

Ronga, Irene. 2009. "L'eccezione dell'azzurro: Il lessico cromatico fra scienza e società." *Cuadernos de Filología Italiana,* 16: 57–9.

Rublack, Ulinka. 1996. "Female Spirituality and the Infant Jesus in Late Medieval Dominican Convents." In Bob Scribner and Trevor Johnson (eds.), *Popular Religion in Germany and Central Europe.* New York: Saint Martin's Press.

Rudolph, Conrad. 1990a. *Artistic Change and Saint-Denis.* Princeton, NJ: Princeton University Press.

Rudolph, Conrad. 1990b. *The "Things of Greater Importance": Bernard of Clairvaux's Apologia and the Medieval Attitude Toward Art.* Philadelphia: University of Pennsylvania Press.

Ruskin, John. 1849. *The Seven Lamps of Architecture.* London: Smith, Elder.

Russkij etimologicheskij slovar' (RES) (Russian Etymological Dictionary). 2007–. By Aleksandr Anikin. vols. 1–. Moscow: Nestor-Istorija.

Sainte-Maure, Benoît. 2017. *The Roman de Troie by Benoît de Sainte-Maure: A Translation.* Translated by Glyn S. Burgess and Douglas Kelly. Cambridge: Brewer.

Sayers, Dorothy L., trans. 1957. *Song of Roland.* Harmondsworth: Penguin.

Schapiro, Meyer. 1973. *Words and Pictures: On the Literal and the Symbolic in the Illustration of a Text.* The Hague: Mouton.

Schapiro, Meyer. 2005. *The Image of Forms: Lectures on Insular Manuscript Art.* New York: Pierpont Morgan Library.

Schirò, Giuseppe. 1992. *Monreale: City of the Golden Temple.* Palermo: Mistretta.

Schmitz-von Ledebur, Katja. 2008. "Les parements liturgiques de l'Ordre de la Toison d'Or." In Susan Marti, Till-Holger Borchert, and Gabriele Keck (eds.), *Splendeurs de la cour de Bourgogne.* Brussels: Mercatorfonds.

Schweppe, Helmut. 1997. "Indigo and Woad." In Elizabeth West FitzHugh (ed.), *Artists' Pigments: A Handbook of their History and Characteristics,* vol. 3. Washington, DC: National Gallery of Art; Oxford: Oxford University Press.

Sciacca, Christine, ed. 2012. *Florence at the Dawn of the Renaissance: Painting and Illumination, 1300–1350.* Los Angeles: J. Paul Getty Museum.

Seneca. 2010. *Natural Questions.* Translated by Harry Hine. Chicago: University of Chicago Press.

Simionescu, Mihaela. 2015. "Ceramics Praises the Psalms: 'The Holy Trinity' Church from Siret." *ANASTASIS: Research in Medieval Culture and Art,* 2(2): 165–74.

Simon, David L. 1993. "Late Romanesque Art in Spain." In John P. O'Neill (ed.), *The Art of Medieval Spain, A.D. 500–1200*. New York: Metropolitan Museum of Art.

Slovar' drevnerusskogo jazyka 11–14 vekov (SDRJa) (A Dictionary of the Old Russian Language of the Eleventh–Fourteenth Centuries). 1988–. vols. 1–. Moscow: Nauka.

Slovar' russkogo jazyka 11–17 vekov (SRJa) (A Dictionary of the Russian Language of the Eleventh–Seventeenth Centuries). 1975–. vols. 1–. Moscow: Nauka.

Smith, A. Mark. 2015. *From Sight to Light: The Passage from Ancient to Modern Optics*. Chicago: University of Chicago Press.

Smith, A. Mark, and Arnaldo Pinto Cardoso. 2008. *The* Treatise on the Eyes *by Pedro Hispano*. Lisbon: Alêtheia Editores.

Smith, Cyril Stanley, and John G. Hawthorne. 1974. "*Mappae clavicula*: A Little Key to the World of Medieval Techniques." *Transactions of the American Philosophical Society*, 64(4): 1–128.

Smith, Darwin, Gabriella Parussa, and Olivier Halévy (eds.). 2014. *Le théâtre français du Moyen Âge et de la Renaissance*. Paris: Éditions l'Avant-scène Théâtre.

Snorri Sturluson. 2006. *The Prose Edda*. Translated by Anthony Faulkes. New York: Penguin.

Soffía Guðný Guðmundsdóttir, and Laufey Guðnadóttir, with Anne Mette Hansen. 2015. "Book Production in the Middle Ages." In Matthew James Driscoll and Svanhildur Óskarsdóttir (eds.), *Manuscripts from the Arnamagnæan Collection*. Copenhagen: Museum Tusculanum Press.

Sosson, Jean-Pierre. 1977. *Les travaux publics de la ville de Bruges, XIVe–XVe siècle*. Brussels: Pro Civitate.

Spinei, Victor. 2009. *The Romanians and the Turkic Nomads North of the Danube Delta from the Tenth to the Mid-Thirteenth Century*. Leiden: Brill.

Spufford, Peter. 2002. *Power and Profit: The Merchant in Medieval Europe*. London: Thames and Hudson.

Spufford, Peter. 2010. "Lapis, Indigo, Woad: Artists' Materials in the Context of International Trade before 1700." In Jo Kirby, Susie Nash, and Joanna Cannon (eds.), *Trade in Artists' Materials: Markets and Commerce in Europe to 1700*. London: Archetype.

Staley, Lynn, ed. 1996. *The Book of Margery Kemp*. Available online: http://d.lib. rochester.edu/teams/text/staley-book-of-margery-kempe-book-i-part-i (accessed May 23, 2020).

Staufer, Annemarie. 2008. "Les tissus de luxe à la cour de Bourgogne." In Susan Marti, Till-Holger Borchert, and Gabriele Keck (eds.), *Splendeurs de la cour de Bourgogne*. Brussels: Mercatorfonds.

Stein, Robert. 1999. "Gifts of Mourning-Cloth at the Brabantine Court in the Fifteenth Century." In Wim Blockmans and Antheun Janse (eds.), *Showing Status: Representations of Social Positions in the Late Middle Ages*. Turnhout: Brepols.

Steinvall, Anders. 2006. "Basic Colour Terms and Type Modification: Meaning in Relation to Function, Salience and Correlating Attributes." In Carole P. Biggam and Christian J. Kay (eds.), *Progress in Colour Studies, volume 1: Language and Culture*. Amsterdam: John Benjamins.

Stiegemann, Christoph, and Matthias Wemhoff, eds. 1999. *799: Kunst und Kultur der Karolingerzeit*. 3 vols. Mainz: Phillip von Zabern.

Story, Joanna, Judith Bunbury, Anna Candida Felice, Gabriele Fronterotta, Mario Piacentini, Chiara Nicolais, Daria Scacciatelli, Sebastiano Sciuti, and Margherita

Vendittelli. 2005. "Charlemagne's Black Marble: The Origin of the Epitaph of Pope Hadrian I." *Papers of the British School at Rome*, 73: 157–90.

Strabo, Walafrid. 2009. *On the Cultivation of Gardens*. Translated by James Mitchell. San Francisco: Ithuriel's Spear.

Straubhaar, Sandra Ballif. 2005. "Wrapped in a Blue Mantle: Fashions for Icelandic Slayers?" *Medieval Clothing and Textiles*, 1: 53–65.

Stubbs, W., ed. 1887–9. *William of Malmesbury* De gestis regum Anglorum. 2 vols. London: Eyre and Spottiswoode.

Subtelny, Orest. 2000. *Ukraine: A History*. 3rd edn. Toronto: University of Toronto Press.

Suger (Abbot). 1867. *Liber de rebus in administratione sua gestis*. Edited by Lecoy de la Marche. Paris: Jules Renouard.

Suger (Abbot). 1979. *Abbot Suger on the Abbey Church of St. Denis and Its Art Treasures*. Edited and translated by Erwin Panofsky and Gerda Panofsky-Soergel. 2nd edn. Princeton, NJ: Princeton University Press.

Sureda, Joan. 1981. *La pintura románica a Catalunya*. Madrid: Alianza.

Sylvester, Louise M., Mark C. Chambers, and Gale R. Owen-Crocker. 2014. *Medieval Dress and Textiles in Britain: A Multilingual Sourcebook*. Woodbridge: Boydell.

Szafran, Yvonne, and Nancy Turner. 2012. "Techniques of Pacino di Bonaguida Illuminator and Panel Painter." In Christine Sciacca (ed.), *Florence at the Dawn of the Renaissance: Painting and Illumination, 1300–1350*. Los Angeles: J. Paul Getty Museum.

Tachau, Katherine. 2014. "Scholastics on Colors in the Mind, Colors in the World." In Luca Bianchi and Chiara Crisciani (eds.), *Forme e oggetti dell conoscenza nel XIV secolo*. Florence: SISMEL, Edizioni del Galuzzo.

Tait, Hugh, ed. 1968. *Masterpieces of Glass*. London: Trustees of the British Museum.

Tait, Hugh, ed. 1986. *Seven Thousand Years of Jewellery*. London: British Museum Publications.

Taubert, Johannes. 2015. *Polychrome Sculpture: Meaning, Form, Conservation*. Translated by Carola Schulman. Los Angeles: Getty Conservation Institute.

Theophilus. 1961. *De diversis artibus: The Various Arts*. Translated by C.R. Dodwell. London: Nelson.

Theophilus, 1979. *On Divers Arts: The Foremost Medieval Treatise on Painting, Glassmaking, and Metalwork*. Translated by John G. Hawthorne and Cyril Stanley Smith. New York: Dover.

Theophilus. 1986. *Theophilus, The Various Arts*, De diversis artibus. Edited and translated by C.R. Dodwell. Oxford: Clarendon Press.

Theune-Grosskopf, Barbara. 2006. "Die vollstandig erhaltene Leier des 6 Jahrhunderts aus Grab 58 von Trossingen, Baden-Württemberg, Kreis Tuttlingen." *Germania*, 84: 93–142.

Thibodeau, Timothy, ed. 2007. *The* Rationale divinorum officiorum *of William Durand of Mende: A New Translation of the Prologue and Book One*. New York: Columbia University Press.

Thibodeau, Timothy, ed. 2010. *William Durand on the Clergy and their Vestments: A New Translation of Books 2 and 3 of the* Rationale divinorum officiorum. Scranton, PA: University of Scranton Press.

Thieme, Cristina. 2012. "Inkarnate des 12. und 13. Jahrhunderts in der Toskana und in den Dalmatien." In Esther Wipfler (ed.), *Kunsttechnik und Kunstgeschichte:*

Das Inkarnat in der Malerei des Mittelalters. Munich: Zentralinstitut für Kunstgeschichte.

Thoby, Paul. 1959. *Le crucifix, des origines au Concile de Trente*, vol. 1. Nantes: Bellanger.

Thomas, Alfred. 1998. *Czech Literature and Society, 1310–1420*. Minnesota: University of Minnesota Press.

Thomas Aquinas. 2005. "On Sense and What is Sensed." In Kevin White and Edward Macierowski (trans.), *Commentaries on Aristotle's* On Sense and What is Sensed *and* On Memory and Recollection. Washington, DC: Catholic University of America Press.

Thompson, Daniel V., ed. and trans. 1960. *The Craftsman's Handbook* Il libro dell' arte *by Cennino d'A. Cennini*. New York: Dover.

Thornton, Peter. 1991. *The Italian Renaissance Interior 1400–1600*. London: Weidenfeld and Nicolson.

Thurley, Simon, Edward Impey, and Peter Hammond. 2000. *The Tower of London*. London: Historic Royal Palaces Agency.

Tilghman, Benjamin. 2017. "Pattern, Process, and the Creation of Meaning in the Lindisfarne Gospel." *West 86th: A Journal of Decorative Arts, Design History, and Material Culture*, 24(1): 3–28.

Tite, Michael, Trinitat Pradell, and Andrew Shortland. 2008. "Discovery, Production and Use of Tin-Based Opacifiers in Glasses, Enamels and Glazes from the Late Iron Age Onwards: A Reassessment." *Archaeometry*, 50: 67–84.

Tweddle, Dominic. 1990. "Paint on Pre-Conquest Sculpture in South-East England." In Sharon Cather, David Park, and Paul Williamson (eds.), *Early Medieval Wall Painting and Painted Sculpture in England*. Oxford: British Archaeological Reports.

Tyler, Norman. 2009. *Historic Preservation: An Introduction to Its History, Principles, and Practice*. New York: W.W. Norton.

Unwin, Christina. 2013. *Kaleidoscope: Colour and Light in the World of Bede; Catalogue*. [Jarrow: St. Paul's Parish Church Council].

Uzzell, Hazel. 2012. "Dyeing." In Gale R. Owen-Crocker, Elizabeth Coatsworth, and Maria Hayward (eds.), *Encyclopedia of Dress and Textiles in the British Isles c. 450–1450*. Leiden: Brill.

V&A. 2017. "Altarpiece with 45 Scenes of the Apocalypse." Available online: http://collections.vam.ac.uk/item/O89176/altarpiece-with-45-scenes-of-altarpiece-master-bertram/ (accessed May 24, 2020).

Van der Velden, Hugo. 2000. *The Donor's Image: Gerard Loyet and the Votive Portraits of Charles the Bald*. Turnhout: Brepols.

Van Uytven, Raymond. 1998. *De zinnelijke Middeleeuwen*. Leuven: Davidsfonds.

Vasilevich, Alexander, Svetlana Kuznetsova, and Sergey Mishchenko. 2005. *Tsvet i nazvanija tsveta v russkom jazyke* (Color and Terms of Color in the Russian Language). Moscow: KomKniga.

Veale, Elspeth M. 1966. *The English Fur Trade in the Later Middle Ages*. Oxford: Clarendon Press.

Vedeler, Marianne. 2014. *Silk for the Vikings*. Oxford: Oxbow Books.

Verkerck, Dorothy. 2001. "Black Servant, Black Demon: Color Ideology in the Ashburnham Pentateuch." *Journal of Medieval and Early Modern Studies*, 31(1): 57–77.

Victoir, Géraldine. 2012–2013. "La polychromie de l'ancienne infirmerie d'Ourscamp (Oise)." *Tijdschrift voor Interieurgeschiedenis en Design* 38: 29–49.

Villon, François. 1994. *Complete Poems*. Translated by Barbara N. Sargent-Baur. Toronto: University of Toronto Press.

Vincent of Beauvais. 1591. "Speculum naturale Vincentii." In Vincent of Beauvais, *Speculi Maioris Vincentii Burgundi praesulis Belvacensis ...*, vol. 1. 4 vols. Venice: apud Nicolinum.

Voragine, Jacobus de. 2012. *The Golden Legend*. Translated by William Granger Ryan. Princeton, NJ: Princeton University Press.

Wallace, Birgitta. 2008. "The Discovery of Vinland." In Stefan Brink, in collaboration with Neil Price (eds.), *The Viking World*. London: Routledge.

Walton Rogers, Penelope. 1997. *Textile Production at 16–22 Coppergate*. York: Council for British Archaeology.

Wamers, Egon, and Patrick Périn, eds. 2013. *Königinnen der Merowinger*. Regensburg: Schnell und Steiner.

Warr, Cordelia. 2010. *Dressing for Heaven: Religious Clothing in Italy, 1215–1545*. Manchester: Manchester University Press.

Webster, Leslie. 2012a. *Anglo-Saxon Art: A New History*. London: British Museum Press.

Webster, Leslie. 2012b. *The Franks Casket*. London: British Museum Press.

Webster, Leslie. 2015. "The Decoration of the Binding." In Claire Breay and Bernard Meehan (eds.), *The St Cuthbert Gospel: Studies on the Insular Manuscript of the Gospel of John*. London: British Library.

Webster, Leslie. 2019a. "The Christian Objects, Function and Significance." In Chris Fern, Tania Dickinson, and Leslie Webster (eds.), *The Staffordshire Hoard. An Anglo-Saxon Treasure*. London: Society of Antiquaries.

Webster, Leslie. 2019b. "The Painted Decoration on the Box." In L. Blackmore, I. Blair, S. Hirst, and C. Scull (eds.), *The Prittlewell Princely Burial: Excavations at Priory Crescent, Southend-on-Sea, Essex, 2003*. London: Museum of London Archaeology.

Webster, Leslie, and Janet Backhouse, eds. 1991. *The Making of England: Anglo-Saxon Art and Culture, AD 600–900*. London: British Museum Press.

Weigert, Laura. 2004. *Weaving Sacred Stories: French Choir Tapestries and the Performance of Clerical Identity*. Ithaca, NY: Cornell University Press.

Weitzmann, Kurt. 1977. *Late Antique and Early Christian Book Illumination*. New York: George Braziller.

Werckmeister, Otto Karl. 1993. "Art of the Frontier: Mozarabic Monasticism". In John P. O'Neill (ed.), *The Art of Medieval Spain, A.D. 500–1200*. New York: Metropolitan Museum of Art.

White, John H. 1990. *Art and Architecture in Italy, 1250 to 1400*. 2nd edn. London: Penguin.

White, Raymond, and Jo Kirby. 2009. "Materials and Techniques: Medium Analysis." In Paul Binski, and Ann Massing, with Marie Louise Sauerberg (eds.), *The Westminster Retable: History, Technique, Conservation*. Cambridge: Hamilton Kerr Institute, University of Cambridge; London: Harvey Miller.

White, T.H. 1954. *The Book of Beasts*. New York: Dover.

Wild, Benjamin. 2012a. "Livery (uniform)." In Gale R. Owen-Crocker, Elizabeth Coatsworth, and Maria Hayward (eds.), *Encyclopedia of Dress and Textiles in the British Isles c. 450–1450*. Leiden and Boston: Brill.

Wild, Benjamin. 2012b. "Order of the Garter." In Gale R. Owen-Crocker, Elizabeth Coatsworth, and Maria Hayward (eds.), *Encyclopedia of Dress and Textiles in the British Isles c. 450–1450*. Leiden: Brill.

Willemsen, Ernst. 1974. "Die Bedeutung der Oberfläche bei der spätgotische Polychromie." In Heniz Althöfer, Rolf E. Straub, and Ernst Willemsen (eds.), *Beiträge zur Untersuchung und Konservierung mittelalteriche Kunstwerke*. Munich: Deutscher Kunstverlag.

Williams, Ann. 2014. "Harold II." In Michael Lapidge, John Blair, Simon Keynes, and Donald Scragg (eds.), *The Wiley Blackwell Encyclopedia of Anglo-Saxon England*. 2nd edn. Chichester: Wiley.

Williamson, Paul, and Leslie Webster. 1990. "The Coloured Decoration of Anglo-Saxon Ivory Carvings." In Sharon Cather, David Park, and Paul Williamson (eds.), *Early Medieval Wall Painting and Painted Sculpture in England*. Oxford: British Archaeological Reports.

Wilson, David M. 2008. "The Development of Viking Art." In Stefan Brink, in collaboration with Neil Price (eds.), *The Viking World*. London: Routledge.

Winny, James, ed. and trans. 2007. *Sir Gawain and the Green Knight: Middle English Text with Facing Translation*. Peterborough: Broadview Press.

Wischermann, Heinfried. 1997. "The Romanesque Period in Central Europe." In Rolf Toman (ed.), *Romanesque: Architecture, Style, Painting*. Cologne: Könemann.

Witelo. 1572. "Perspectiva." In Friedrich Risner (ed.), *Opticae thesaurus Alhazeni Arabis libri septem*. Basel: per Episcopios.

Wixom, William D. 1997. "Byzantine Art and the Latin West." In Helen C. Evans and William D. Wixom (eds.), *The Glory of Byzantium: Art and Culture of the Middle Byzantine Era A.D. 843–1261*. New York: Metropolitan Museum of Art.

Wolf, Kirsten. 2005. "Reflections on the Color of Esau's Pottage of Lentils (*Stjórn* 160.26–161.9)." *Gripla*, 2005: 251–7.

Wolf, Kirsten. 2006a. "The Color Blue in Old Norse-Icelandic Literature." *Scripta Islandica*, 57: 55–78.

Wolf, Kirsten. 2006b. "Some Comments on Old Norse-Icelandic Color Terms." *Arkiv för nordisk filologi*, 121: 173–92.

Wolf, Kirsten. 2009. "The Color Grey in Old Norse-Icelandic Literature." *Journal of English and Germanic Philology*, 108: 222–38.

Wolf, Kirsten. 2010. "Towards a Diachronic Analysis of Old Norse-Icelandic Color Terms: The Cases of Green and Yellow." *Orð og tunga*, 12: 109–30.

Wolf, Kirsten. 2015. "Non-Basic Color Terms in Old Norse-Icelandic." In Jeffrey Turco (ed.), *New Norse Studies: Essays on the Literature and Culture of Medieval Scandinavia*. Ithaca, NY: Cornell University Press.

Wolf, Kirsten. 2017. "The Color Brown in Old Norse-Icelandic literature." *NOWELE*, 70(1): 22–38.

Wolter-von Dem Knesebeck, Harald. 2017. "Bernhard von Clairvaux und das Bild- und Kunstverständis bei den Zisterziensern." In Gabriele Uelsberg, Lothar Altringer, Georg Mölich, Norbert Nussbaum, and Harald Wolter-von Dem Knesebeck (eds.), *Die Zisterzienser: Das Europa der Klöster*. Bonn: LVR-Landesmuseum.

World Digital Library. 2017. "The Book of Divine Works." Available online: https://www.wdl.org/en/item/21658/view/1/11/ (accessed May 24, 2020).

Wormald, Patrick. 1982a. "The Age of Bede and Æthelbald." In James Campbell, Eric John, and Patrick Wormald (eds.), *The Anglo-Saxons*. Oxford: Phaidon.

Wormald, Patrick. 1982b. "The Ninth Century." In James Campbell, Eric John, and
 Patrick Wormald (eds.), *The Anglo-Saxons*. Oxford: Phaidon.
Yarza Luaces, Joaquín, and Matteo Mancini. 2005. *Vestiduras ricas: El monasterio de
 las Huelgas y su Época 1170–1340*. Madrid: Patrimonio Nacional.
Youngs, Susan, ed. 1989. *The Work of Angels*. London: British Museum Press.
Zaliznjak, Andrej. 2004. *Drevnenovgorodskij dialekt* (The Old Novgorod Dialect).
 Moscow: Jazyki Slavjanskoj Kul'tury.

CONTRIBUTORS

Carole P. Biggam is Honorary Senior Research Fellow in English Language and Linguistics at the University of Glasgow, UK.

Wim Blockmans is Professor Emeritus of Medieval History at Leiden University and former Rector of the Netherlands Institute for Advanced Study, The Netherlands.

Mark Cruse is Associate Professor of French in the School of International Letters and Cultures at Arizona State University, USA.

Thomas Dale is Professor of Art History and Director of the Medieval Studies Program at the University of Wisconsin-Madison, USA.

Jo Kirby is an independent scholar. She was formerly a senior scientist in the National Gallery, London, UK.

Roman Krivko is Assistant Professor in the Department of Slavonic Studies at the University of Vienna, Austria.

Piera Molinelli is Professor of General Linguistics in the Department of Letters, Philosophy, and Communication at the University of Bergamo, Italy.

Eva Oledzka is Western Manuscripts and Special Collections Librarian at the Bodleian Library, University of Oxford, UK.

Gale R. Owen-Crocker is Professor Emerita, former Professor of Anglo-Saxon Culture and Director of the Manchester Centre for Anglo-Saxon Studies, the University of Manchester, UK.

Andreas Petzold worked until recently as Associate Lecturer within the field of art history at the Open University, UK.

A. Mark Smith is Emeritus Professor of History and History of Science at the University of Missouri, USA.

Leslie Webster is a specialist in early medieval material culture and Keeper Emerita of Britain, Europe, and Prehistory in the British Museum, UK.

Kirsten Wolf is Torger Thompson Chair and Kim Nilsson Professor of Old Norse and Scandinavian Linguistics at the University of Wisconsin-Madison, USA.

INDEX